Picturing Migrants

The Charles M. Russell Center Series
on Art and Photography of the American West

B. Byron Price, *General Editor*

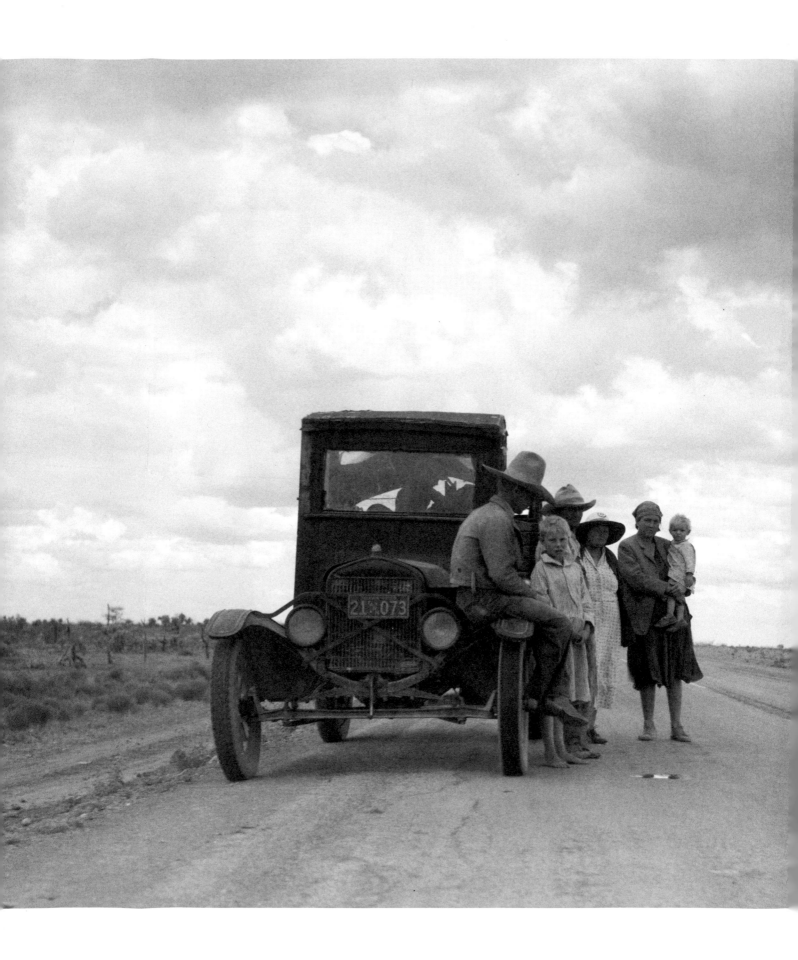

Picturing Migrants

The Grapes of Wrath and
New Deal Documentary Photography

James R. Swensen

University of Oklahoma Press : Norman

FRONTISPIECE: Dorothea Lange, photograph from a group captioned, in part, "Three related Oklahoma drought refugee families near Lordsburg, New Mexico" (see p. 14 for full caption). May 1937. *Library of Congress, LC-USF34-016675-C*

LIBRARY OF CONGRESS CATALOGING-IN-PUBLICATION DATA

Swensen, James R.
 Picturing migrants : The grapes of wrath and New Deal documentary photography / James R. Swensen.
 pages cm. — (The Charles M. Russell Center Series on art and photography of the American West ; volume 18)
 Includes bibliographical references and index.
 ISBN 978-0-8061-4827-4
 1. Steinbeck, John, 1902–1968. Grapes of wrath. 2. Steinbeck, John, 1902–1968—Sources. 3. Steinbeck, John, 1902–1968—Influence. 4. Literature and photography—United States—History—20th century. 5. Documentary photography—United States—History—20th century. 6. Migrant agricultural laborers—United States—History. 7. Depressions—1929—United States. 8. Dust Bowl Era, 1931–1939. 9. New Deal, 1933–1939. 10. United States. Farm Security Administration. I. Title.
 PS3537.T3234G893 2015
 813'.52—dc23

 2015002780

Picturing Migrants: The Grapes of Wrath *and New Deal Documentary Photography* is Volume 18 in The Charles M. Russell Center Series on Art and Photography of the American West.

The paper in this book meets the guidelines for permanence and durability of the Committee on Production Guidelines for Book Longevity of the Council on Library Resources, Inc. ∞

1 2 3 4 5 6 7 8 9 10

To Katie

and to my grandparents,

Mel and Beth Foxley, and

Russel B. and Beulah Swensen.

Their stories and experiences

sparked my interest in and

admiration for this rich

period of American history.

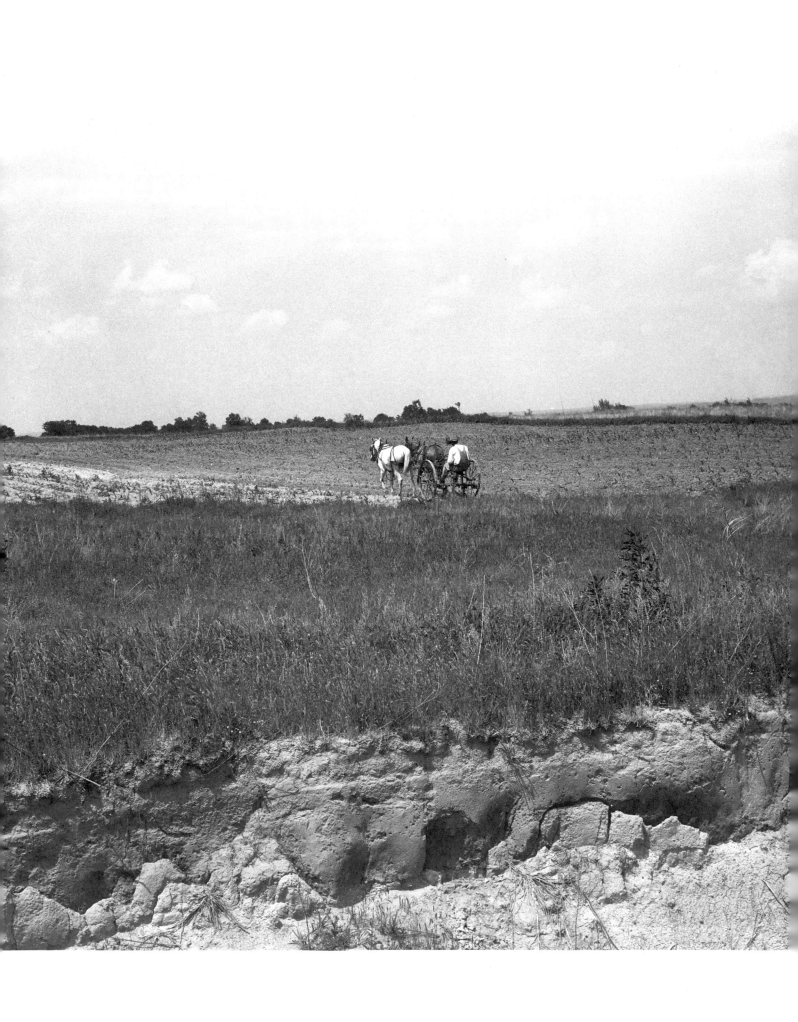

Migrants—

Their hopes buried in the
burned-out soil, they packed
their belongings and moved on.
A tragic but significant
piece of American History.
It needed to be recorded.

ROY STRYKER, "The Lean Thirties," 1960

Contents

Acknowledgments

This book would not have been possible without the help and support of a number of individuals and institutions. Emily Morgan, Erin O'Toole, Katie Samson, and Daphne Srinivasan provided counsel and advice in the project's earliest phases. The same is true of my faculty advisors at the University of Arizona—Dr. Keith McElroy, Dr. Sarah J. Moore, Dr. Douglas Nickel, and Dr. Stacie Widdifield. A Jane Welch Williams Award provided the original impetus for this project and a University of Arizona Medici Scholarship, generously funded by Mrs. Louise Nash Robbins, enabled me to conduct research in Texas and California. I am also grateful to Susan Shillinglaw and Robert DeMott who gave me encouragement after looking at the project when it was only a few pages long. I would also like to thank Thomas Barrow, Dr. Betsy Fahlman, Kevin Hearle, Steve Liss, Rondal Partridge, Françoise Poos, Breezy Taggart, Josi Ward, and so many others whose names I have forgotten for giving me an encouraging word or assistance along the way. I am also indebted to my dear friend Dr. Adam Bradford of Florida Atlantic University for his continued interest in my work. His ideas and advice benefited my manuscript immensely.

I would also like to thank the dedicated staffs of the Martha Heasley Cox Steinbeck Center at San Jose State University, Special Collections at Stanford University, the Wittliff Collection at Texas State University, the Center for Creative Photography, and the Bancroft Library at the University of California, Berkeley, for their assistance. Nancy Calhoun at the Muskogee Public Library helped me locate key people and places in eastern Oklahoma. I am also indebted to the staff at the Library of Congress, Beverly W. Brannan and Jeff Bridgers in particular, for their help at a crucial stage in this project's development. This book would not have been made without the support of Byron Price, Chuck Rankin, and the staff at the University of Oklahoma Press. I am particularly grateful to Dr. David Wrobel for his careful reading of my manuscript and his advice.

There were many who helped with the images used in this book. Jasminn Winters at the Library of Congress, Drew Johnson and Nathan Kerr at the Oakland Museum of Art, as well as Judy Bankhead, Ken Light, and Dale Maharidge and Michael Williamson were particularly willing to assist me. I also acknowledge my colleagues at Brigham Young University for their support.

I am deeply thankful for the ongoing support and love of my family. Thank you to Swen, Gretel, Dean, and Donna for helping us through this process. Most importantly, I am grateful for my wife, Katie, and my children. They made every long day of researching and writing better by being nearby.

Picturing Migrants

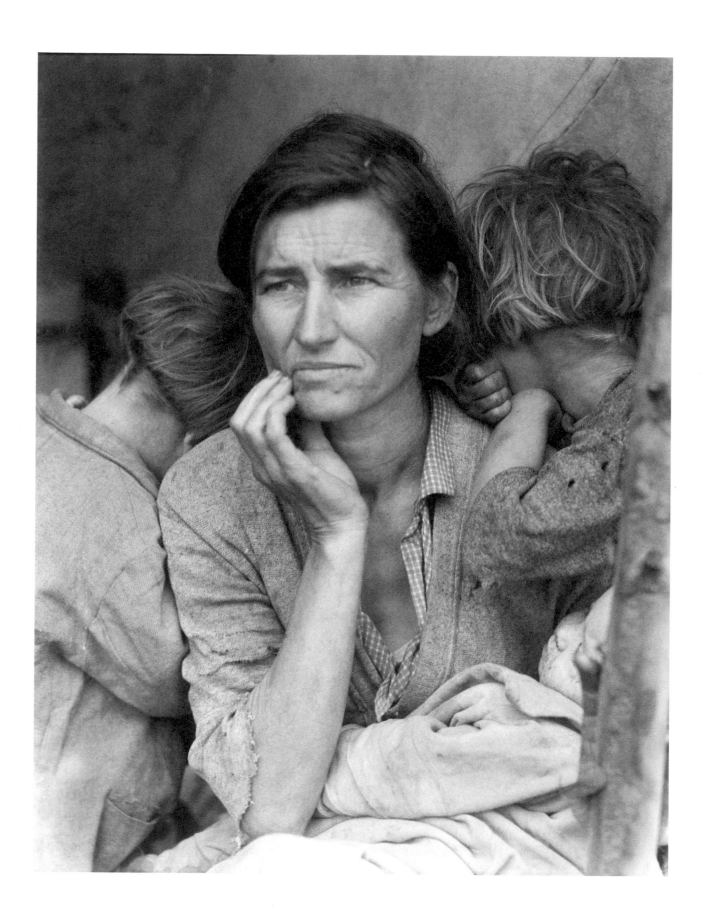

Introduction

When you think of the Great Depression in the United States what comes to mind?

Increasingly the answer to this question depends less on personal experiences and more on the symbols and icons that have come to define this important period in American history. Very likely the images that come to your mind include the concurrent drought on the Great Plains, known to history as the Dust Bowl. Perhaps more specifically, John Steinbeck's novel *The Grapes of Wrath* or Dorothea Lange's 1936 photograph "Migrant Mother" cross your mind.

Even if you have never read John Steinbeck's *The Grapes of Wrath,* you probably know what it is about. Whether through the film or stage version, opera, or songs, its themes of an Oklahoma farm family forced off their land by drought and their determination to find a better life in California, and its figures of migrants and labor organizers, continue to carry a strong cultural currency. Though written in 1939—ten years after the crash of Wall Street—Steinbeck's novel has become the most enduring literary work of the Depression era. The same might be said of Dorothea Lange's image of a destitute pea picker in Nipomo, California, in 1936 (figure 1). Most likely you have seen it before and you may recall the title "Migrant Mother," even if you cannot say who took the photograph or what the subjects' names were. Lange's photograph has become a veritable icon of poverty. The woman in Lange's image, an Oklahoma native named Florence Thompson, has become the "Migrant Madonna," and her image has transcended its original time and place.[1] This image has also become the quintessential example of what we know today as Farm Security Administration (FSA) photography. The FSA photographs have helped create a public perception of the Depression. As scholar Alan Trachtenberg noted, the FSA photography archive has become one of the "prime cultural artifacts" of the era.[2]

Together the photography of the FSA and Steinbeck's novel have formed an important core to our perception of the Great Depression. They have shaped our collective memory of many of the period's key events, including the Dust Bowl and the long caravans of destitute migrants heading west in search of a better existence.[3] Aligned in time and ideology, Steinbeck's *Grapes of Wrath* and FSA photography have become nearly synonymous. The coupling of Steinbeck's novel with Lange's photograph is appropriate in more ways than their iconic status. Photography was, and still is, closely intertwined with Steinbeck's novel. Photographic images, particularly those from the FSA, influenced the formation of Steinbeck's ideas, just as the novel later influenced FSA photographers and the work they produced. Although Steinbeck's novel derived from multiple sources, photography did play a key role in the crystallization of his ideas and helped him create a work that was both visceral and believable. Not only did photography factor into the book's creation, but it also determined how the novel was received and interpreted after its publication, as well as how it has been remembered since then. In fact, the writing of the novel was only the beginning of a complicated interplay between the visual image and the written word, between a subjective novel and seemingly objective documentary photographs. This interchange played out

FIGURE 1. Dorothea Lange, "Migrant Mother." The original caption reads, "Destitute pea pickers in California. Mother of seven children. Age thirty-two. Nipomo, California." 1936. *Library of Congress, LC-USF34-009058-C*

in the offices of the Franklin Roosevelt administration's New Deal in Washington, the desolate fields of the Midwest, on the busy migrant thoroughfares of Oklahoma and the West, in the FSA camps in California, and even on the silver screen.

This book examines the connections between *The Grapes of Wrath* and the photography of the Great Depression and the New Deal. It explores the rich connections between these two cultural icons, a topic that has long been neglected. Nearly forty years ago scholar Robert J. Doherty suggested that such an investigation would be forthcoming.[4] For decades it has been obligatory to discuss one when discussing the other. Yet although many researchers have discussed certain aspects of the connections, the rich and meaningful interplay between these two bodies of work has not been closely investigated. Few have looked at the ways in which they are stitched together. They are two distinct bodies of work that grew out of a similar context: *The Grapes of Wrath* is not a literary description of FSA photographs, any more than the work of the FSA is a photographic depiction of the novel.[5] Yet in significant ways they share a similar message and subject matter. It was not inevitable that they would be linked in our modern consciousness, but over time and through various media they have been knitted together in the public's perception of the Depression, and have come to symbolize this important period of American history.

The deep connections between Steinbeck and the FSA were brought home to me several years ago in the immediate aftermath of the powerful Hurricanes Katrina and Rita, which hit the Gulf Coast and Texas within a few months of each other in 2005. During the unfolding disaster of Katrina, I watched a newscast that paired Steinbeck's text with familiar FSA images to frame the staggering wave of migration as residents fled the hurricane's historic devastation. The resulting migration was the largest since the days of the Dust Bowl, and the icons of the 1930s seemed the best way to contextualize what was occurring.[6] The same has been true more recently in the midst of what we call the "Great Recession." Difficult times are back and the echoes of the 1930s are all around us.[7] Cimarron County, located in Oklahoma's panhandle, is facing the worst drought since it was the heart of the infamous Dust Bowl.[8] Not long after the crash of the housing market and the fall of Lehman Brothers, President-Elect Barack Obama was shown on the cover of *Time* magazine in the guise of Franklin Delano Roosevelt, with pince-nez glasses, a fedora, a long-stemmed cigarette, a full smile, and the headline: *The New New Deal*.

The connections with the 1930s were not lost on those making key decisions in the "New New Deal." Ben Bernanke, then-chairman of the Federal Reserve, is a student and scholar of the period. As a self-described "Great Depression buff," Bernanke wrote, "The issues raised by the Depression, and its lessons, are still relevant today."[9] When he wrote these words in 2000, no one, not even he, could have realized how prescient they were or how close we would come to a similar economic precipice. In 2011 Errol Morris asked, "What can we of the Great Recession learn from the photographs of the Great Depression?"[10] The answer to Morris's query is "a great deal." The lessons of the Great Depression are closer than ever before, and its signifiers have greater currency now than they did even a decade ago.

If an investigation of the FSA and *Grapes of Wrath* is so pertinent, why has it been so long in arriving? The answer to this question has much to do with how the topics have been treated in the past. In any area of scholarship there is a tendency to remain fixed in the confines of one's area of expertise. Not surprisingly literary scholars are unlikely to look beyond Steinbeck's novels. They know of the FSA, and Lange in particular, but their practice has been to use these images as illustrations. The interconnection of Steinbeck's novel and this body of photography has been brought up over the years, but always tangentially to larger issues in the life and career of the author.

On the other side, past investigations on the FSA have been similarly limited. Many photo-historians have noted the rich connections between the FSA and *The Grapes of Wrath*, but few have explored this terrain, due in part to past presentations of the subject. By and large, FSA scholarship has taken three different approaches. The first tends to look at the project as a whole. The studies that take this approach tend to select and reselect the most famous images made during the eight-year span of the agency. This approach also focuses on Roy Stryker, the chief of the FSA's Historical Section and the individual who held the project together.[11] The second approach focuses attention on the photographers. Instead of books on the FSA we see investigations of particular photographers, most frequently of Walker Evans and Dorothea Lange, but also of Ben Shahn, Russell Lee, John Vachon, Jack Delano, Marion Post Wolcott, and others.[12] (Interestingly, one of the more important figures of the FSA, Arthur Rothstein, the first photographer Stryker hired, has not been the subject of a significant monograph.)[13] This approach, the so-called star system, tends to favor the individuality of the photographer rather than the collective agenda of the Historical Section.[14] This tactic also creates artists out of photographers by furthering the creation of styles and oeuvres or, as critic Martha Rosler posited, dismembering the FSA corpus "*auteur by auteur.*"[15]

The last general trend in FSA scholarship is the state-by-state investigation. By now most states have a book or exhibition catalog highlighting the work of Roy Stryker's team in that particular state.[16] While all three approaches have their place and are important in understanding the FSA, they all are limited in their ability to address the broader themes and challenges that the New Deal, and by extension the FSA, faced in the Great Depression. Many of the larger problems facing the United States were too broad to be contained in one state and were too extensive and complex to be covered by one photographer.

One of the most pressing issues facing the United States during the 1930s was the great overland migration. All across the nation record numbers of tenant farmers, sharecroppers, and agricultural day laborers were leaving their lands and their way of life and taking to the road to look for employment and the means of survival. This complex and difficult issue affecting much of the country was treated by activists, New Deal bureaucrats, and writers like Steinbeck. Multiple FSA photographers across America also documented the migration.

Critic Abigail Solomon-Godeau has noted that documentary projects deal with collective issues rather than those affecting individuals.[17] This is particularly true of the coverage of the great migration. No one photographer could possibly have covered such a pervasive and entrenched topic. In 1938 the photographer Edward Steichen asserted, "It is not the individual pictures or the work of individual photographers that make [the FSA] pictures so important, but it is the job as a whole as it has been produced by the photographers as a group that makes it such a unique and outstanding achievement."[18] In order to investigate the connections between the FSA and Steinbeck, it is necessary to go beyond the usual treatment of these two icons. Doing so requires the crossing of disciplines and a greater dialogue with existing histories and sources.

There is another important factor that likely explains why this topic has never been treated. Although nearly all FSA photographers worked with migrants in some capacity, Dorothea Lange and Russell Lee were notable for the time they spent with America's refugees. For this reason the work of these photographers comes closest to Steinbeck's novel. Though many scholars have looked superficially at the links between Lange and Steinbeck, nearly all have neglected Lee's work. Lee's exclusion is one of the most significant omissions in efforts to understand the FSA. In any comprehensive treatment of the Historical Section it is simply not possible to ignore the contributions of Stryker's most prolific photographer. More than

anyone else Lee represented the FSA: he took more photographs than any other FSA employee, and he enjoyed special access to his boss, Roy Stryker. Lee was, however, of a very different temperament than the two most important luminaries of the FSA—Dorothea Lange and Walker Evans—whose independent spirits and artistic sensibilities have attracted scholarly and critical attention. This is particularly true of Evans, who reveled in rebelling against Stryker. In contrast, Lee was a yes-man to a federal bureaucracy. In the post-Watergate, post-Vietnam era this loyalty understandably did not sit well with many scholars. In sharp contrast to Evans, Lee was not antisocial and misanthropic but genial and inviting.[19] Furthermore, he could be painted as too loyal to Stryker, too wealthy, too white, too nice, too male. In the 1970s—a time when photographers could finally see themselves as artists—the elderly Lee continued to portray himself as a photographer and historian. Nothing more.

Past FSA scholarship has also favored the early years of the project. Stryker's Historical Section began in July 1935 under the aegis of the Resettlement Administration and was transferred in 1937 to the Farm Security Administration in the Department of Agriculture. Highlighting the work from 1935–36, which is commonly seen as the golden period of the Historical Section, puts the focus on Evans, Lange, and Ben Shahn. Thus, in a very real sense, much of FSA scholarship is actually Resettlement Administration scholarship. The quality of work produced in the early years of the Historical Section is indisputable. Walker Evans's *American Photographs* (1938) and recent scholarship on Ben Shahn attest to the high level of achievement.[20] However, there has always been a tendency to focus on the early years at the expense of the FSA period after 1938, when Lee and Rothstein were Stryker's primary photographers. If the later years of the Historical Section are ignored, downplayed, or inaccurately treated, important phases and themes are lost.

In broadening the scope of this investigation, it is also necessary to incorporate the contributions of other figures that played a role in the dialogue on migration. Wider narratives simply require a wider cast of characters. In addition to Steinbeck, Roy Stryker, and the FSA photographers, it is necessary to look at other important figures like the economist Paul S. Taylor, Lange's collaborator and husband. Authors and activists like Carey McWilliams, Sanora Babb, and Edwin Lanham also played a role, as did the photographer Horace Bristol. Within the FSA there were others like Tom Collins, a migrant camp director and Steinbeck confidant, and regional bureaucrats like Jonathan Garst and Frederick G. Soule, who were instrumental behind the scenes in shaping how the migrants were presented. Lastly, any discussion that looks at the links between *The Grapes of Wrath* and the photography of the FSA must include a discussion of the migrants. We do not have the names or individual histories of most of these migrants, but there are a select few whose names are remembered because of the FSA. Migrants like Florence Thompson (the "Migrant Mother") and the Elmer Thomas family of eastern Oklahoma (real-life proxies for Steinbeck's fictional Joad family) will be important participants in this text.[21]

As is probably clear by this point, my prior training and research have focused on the history of photography. Yet while my investigation leans on photography first, it also relies heavily on the life and work of John Steinbeck. To gain insight into the author, I relied on the extensive work of many Steinbeck scholars, including Robert DeMott and Jackson Benson. I also depended on the scholarship of cultural historians such as James Gregory and Walter Stein, who have deeply explored the context of the period and the specifics of the overland migration. I gained further understanding of the period by "returning to the documents," including letters and other correspondence, federal reports, and interviews.[22] The most important documents I use in this text, however, are Steinbeck's novel and the photographic images. Together they will form the primary foundation of the investigation that follows.

When John Steinbeck began organizing and assembling the materials that would become the basis of *The Grapes of Wrath,* he relied heavily on a host of sources and experiences. Part I, chapters 1–3, focuses on the period prior to the publication of Steinbeck's novel, from the perspectives of Lange and her husband, Paul Taylor (chapter 1), and Steinbeck (chapter 2). This was a period of development for both Steinbeck and the photographers of the FSA. FSA photographs were an important influence in the development of Steinbeck's ideas and future narrative. Of central importance to this discussion is the eponymous migrant. Numbering in the tens of thousands, these destitute refugees and their plight became the common subject of Dorothea Lange's camera and Steinbeck's seminal novel. Chapter 3 investigates the collaboration between Steinbeck and the photographer Horace Bristol. Although disappointing for Bristol in a variety of ways, their combined work among destitute migrants in California contributed to Steinbeck's "wall of background" and buttressed his story with documentary evidence.

When Steinbeck finally published *The Grapes of Wrath* in April 1939, it became an instant success. In the excitement and furor over the book, many rushed to prove or challenge the authenticity of the novel. In part II, chapters 4–9, I investigate the period after the novel's release. More specifically I explore the work of FSA photographer Russell Lee, a supporter of the embattled author. Shortly after reading *Grapes of Wrath,* Lee decided to create a photographic illustration, or shooting script, of the novel, based in eastern Oklahoma, the home of Steinbeck's fictional Joad family. Chapter 4 focuses on Lee's work in Oklahoma and on how Steinbeck's novel and other sources framed his experience. As part of his documentation Lee sought out and recorded migrant families—proxy Joads—as they migrated west. The exploration of Lee's work with migrants in Oklahoma continues in chapter 5, with particular emphasis on his documentation of the family of Elmer Thomas. Lee's step-by-step documentation of the Thomas family as they prepared to leave for California provided evidence that Steinbeck did not fabricate the plight of the migrants. In general, however, what Lee found on the ground in Oklahoma and beyond painted a far richer and more complicated story than what he gained from his careful reading and emulation of the text. His face-to-face encounters with migrants also highlighted certain aspects that are not found in the novel. This is particularly clear in Lee's documentation of Oklahoma City slums and the small village of Pie Town, New Mexico. As seen in chapter 6, these locales revealed new depths of the migrant experience.

As promoter of the FSA files, Roy Stryker was eager to take advantage of *Grapes of Wrath*'s growing fame to further the needs and programs of his agency. In addition to supporting Lee and others in the field, Stryker initiated an ambitious exhibition program designed to broadcast the goals and accomplishments of his agency on a grassroots level. Chapter 7, "Displaying Grapes and Wrath," centers on one of the FSA's most successful displays, the "Grapes of Wrath Exhibition." By drawing on Steinbeck's text and growing notoriety, Stryker and his team were able to reach new audiences in dynamic ways and thereby to link the efforts of the Historical Section with Steinbeck's most famous novel.

One of the most important keys to the success and longevity of *Grapes of Wrath* is its adaptability to other forms that reach new audiences. Chapter 8, "A Straight Picture," investigates the creation of the film adaptation of the novel, produced by Darryl F. Zanuck and directed by John Ford. Not only did the film further broadcast the essential message of Steinbeck's novel but, like the book, it depended on a variety of sources, including FSA photography, to give it an air of documentary truth. In spite of the film's hard edge and topical subject, it became a commercial and critical success. It was in the context of the film that Stryker sent Arthur Rothstein to California to document a key aspect of the FSA's greater program—the migrant worker camps that dotted the

state. In *The Grapes of Wrath* Steinbeck painted a rosy picture of the camps. A camp was the only time and place in the novel where the Joads were treated with kindness and respect. Rothstein's documentation of the Tulare and Shafter camps in California built upon Steinbeck's account by documenting what was right and decent about the controversial federal program. Rothstein's most remarkable contribution to this discussion was a series of migrant portraits that gave a human face to the oft-debated nature of the American refugee.

During World War II and the growth and prosperity that followed, the debate over *The Grapes of Wrath* and the great migration was silenced. As Americans sought to forget about the hard times of the not-so-distant past, Steinbeck's work and the FSA photography were relegated to a distant memory. With the rise of a new generation distanced in time from the Depression came renewed attention to its key cultural symbols. Chapter 9, "Icons of the Great Depression," explores the rising reputation of Steinbeck's novel and FSA photography in the decades after the 1930s. Not only did both receive new scrutiny and praise, but they became increasingly linked as the preeminent icons of the Great Depression.

In sum an investigation of the multivalent and dynamic ways in which *The Grapes of Wrath* and the photography of the FSA interacted over the decades reveals that they not only left their imprint on each other, but together became two of the most important and sustained cultural icons in American history.

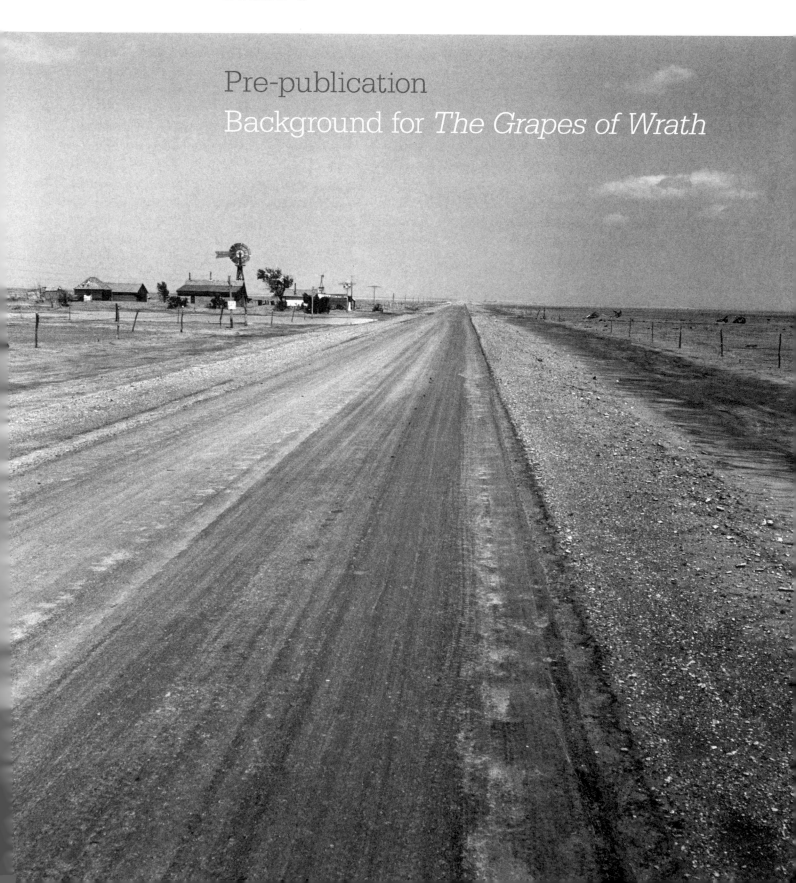

PART I

Pre-publication
Background for *The Grapes of Wrath*

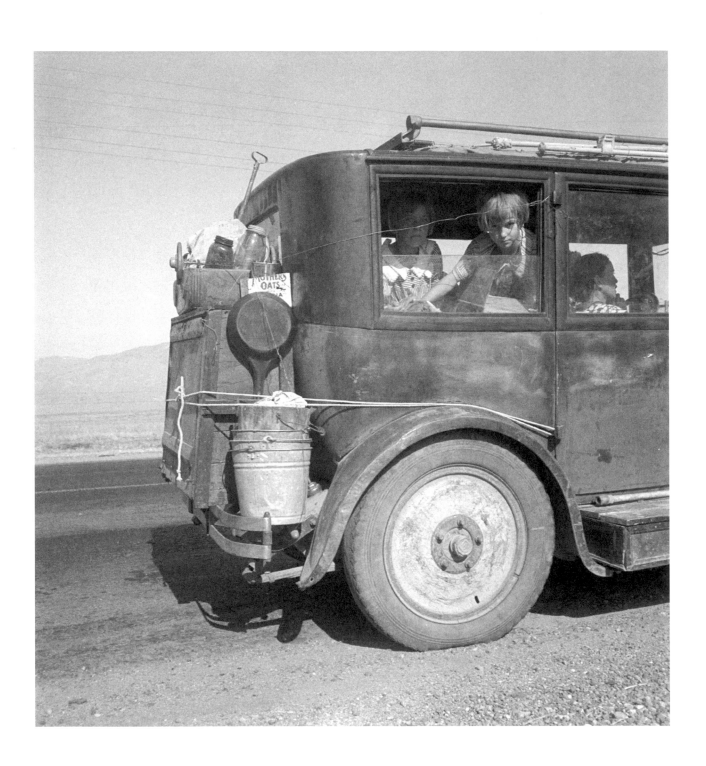

Gathering Migrants

Dorothea Lange and Paul S. Taylor

One of the most noteworthy aspects of the Great Depression was that nearly everyone was affected by the hard times. For bankers and sharecroppers, miners and storeowners, the Depression had devastating effects. As the popular song of the time suggested, *your brother* could have used a dime regardless of who you were. The Depression was the great leveler. The economic hardships of the period produced unprecedented numbers of individuals and families set adrift in search of employment and brighter prospects. Although the Great Depression affected families across the globe, in the United States images of the wayworn migrant dominated the portrait of the Depression, perhaps best exemplified by John Steinbeck's Joad family and Lange's "Migrant Mother." More than eighty years after the beginning of the Great Depression the poverty-stricken migrant has become the icon and emblem of this era. There were other types—like the distraught businessman or displaced factory worker—that could have reified that age of turmoil and upheaval. Due in large part to the staying power of John Steinbeck's prose and the FSA's images, however, the migrant continues to loom large in the public consciousness. Whether rightfully or not, migrants are the most enduring symbols of the hardship of the Great Depression. Most investigations of migrant portraits begin by looking at the artists who created them. Naturally we tend to look to those individuals whose lives and faces are well known. Whole biographies have been written on people like Dorothea Lange and John Steinbeck, but almost none about the eponymous migrant, whose life may have been equally heroic but was far less visible.

FIGURE 2. Dorothea Lange, "Drought refugees from Abilene, Texas, following the crops of California as migratory workers. 'The finest people in this world live in Texas but I just can't seem to accomplish nothin' there. Two year drought, then a crop, then two years drought and so on. I got two brothers still trying to make it back there and there they're sitting,' said the father. August, 1936." *Library of Congress, LC-USZ62-131315*

Migration has always been a part of American life. From the time the first Europeans emigrated to the New World there has consistently been a push to move on and a desire for a better life. It could be argued, therefore, that the constant search for a new, more promising future has been a core component of the American ethos and mythos. For many the American West held the greatest promise. Increasingly Americans became explorers, trailblazers, frontiersmen, pioneers, Sooners, and homesteaders. The migrants were driven by ideals, hope, and economic realities. These motivations did not change in the 1930s, when hard times forced many to look to the western horizon. The volume and visibility of the migration reached a new high, however. Scholar James N. Gregory estimated that more than a million migrants were on the road during the 1930s.[1] This was not a migration for social advancement but an outward manifestation of need.[2] Although migration affected every corner of the United States, the most visible and remembered was that from the Midwest to the fields of California (figure 2). According to Berkeley economist Paul S. Taylor, the migrant problem seemed distant for some. "But it isn't a long way off," he wrote.

> The trek to the Pacific Coast is not just the product of a great drought on the Plains. That stream of human distress is the end-result of a long process going on from New Jersey to California and from North Dakota to Florida. It's the most dramatic end-result, and most Americans do not know how pervasive and widespread are the forces which produce it. Nor do they realize how close to home and how deep these forces strike.[3]

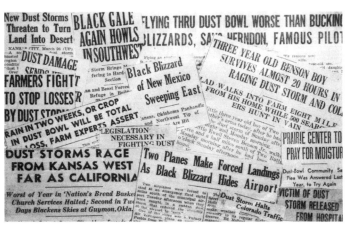

Uprooted from their land for a variety of reasons, these refugees had little to lose and were willing to gamble everything for the illusory promise of a better future in the West.

In truth, the great migration was not caused by a single cataclysmic event, but was a process that gradually unfolded and had many causes.[4] Rural families throughout the United States were already poor and susceptible before the Dust Bowl drove them to desperation. In 1936 it was estimated that around four million farm people were living on an average income of $1 a week—about 5 percent that of an average American household.[5] In addition to endemic poverty, rural populations throughout the United States were also plagued by rising unemployment and lower labor demands caused by the advent of mechanized farming. Even the land, once their ally, seemed to have turned against them. Drought, submarginal lands, and poor farming techniques aggravated the aforementioned problems and forced thousands of families to look elsewhere for survival.[6] Large swirling storms of dust that was once soil ravaged the landscape and quickly became the most famous signs of hardship and futility (figures 3 and 4). These problems were visible, others were not. Farmers were hurt by ill-conceived local and federal policies, and declines in foreign markets that cut demand for their crops.

Regardless of the cause, for many the solution was the same—the road. Farm refugees came from all over, but the greatest numbers originated in the Midwest farming states of Kansas, Missouri, Texas, Arkansas, and Oklahoma. The majority of migrants were sharecroppers, tenant farmers, and farm day laborers who knew little beyond the skills needed to harvest a crop. Tied to the land but lacking the resources to weather the storms of economic hardship, they were a susceptible population with little to lose.

By the thousands these immigrants fled the world they knew and pushed toward what seemed to be their last refuge. Over the early thirties the numbers of migrants on the road increased steadily. For many, California was their intended destination; from 1935 to 1938, an estimated 350,000–400,000 migrants flooded into California.[7] More than 90,000 migrants entered the state in 1937 alone.[8] On one day, November 20, 1937, 3,000 people entered California from Arizona.[9] For California residents it seemed there were more migrants coming into the state in 1937 than there were 49ers nearly a century earlier. Life in the state was irrevocably changing.

Migrants arrived in California from all over the nation, but the most visible symbol of the

Depression was the migrant from Oklahoma—the so-called Okie. Oklahoma was in dire straits during the Depression. After years of relative prosperity, its population felt "keenly the pinch of economic depression" and one-half of the state's population was reportedly on relief.[10] Carey McWilliams recorded that as the topsoil blew away in drought-induced clouds of dust between 1935 and 1940, 33,247 farms were lost in the state—a rate of eighteen per day. This substantial loss propelled tens of thousands of Oklahomans to search elsewhere for work.[11] This exodus was not lost on anyone at the time. Government reports estimated that two-fifths of the entire migrant population was from Oklahoma (figure 5).[12] According to Paul S. Taylor, "The roots of Oklahomans in the land are shallow. . . . By a curious symbolic coincidence, Oklahoma is the most wind-blown state in the country, its newly broken red plains are among the worst eroded, and its farm people are among the least rooted to the soil."[13] The combination of trying conditions and a propensity to move, Taylor concluded, made the state's denizens "the most footloose in the country."[14] Not surprisingly the Oklahoma refugee soon became *the* symbol of the migration, and the pejorative "Okie" became a catchphrase for any migrant, regardless of his or her state of origin.

Fifty years earlier Oklahoma "Sooners" had made their way to the Midwest by horse and wagon; their descendants fled the state in a different fashion. Automobiles made the flight of the 1930s possible (figure 6). A decade or so earlier such massive mobilization would have been unimaginable. By 1930 there were more than twenty-six million cars in America.[15] Although unaffordable for many, the automobile facilitated migrants' flight and, for those pickers who followed the cycle of crop harvests, increased the range of crops they could cover. Automobiles enabled refugees to roam farther and faster than their ancestors could have dreamed possible. California remained their most tantalizing goal. As Woody Guthrie opined, "California is a paradise to live in or see." With access to automobiles, a new life in California was, in theory, only days, not months, away.

Seasonal migrants were always needed in California to harvest fruit and vegetables along the coast and inland in the Central and Imperial Valleys. Traditionally these workers were primarily Mexican or Filipino "fruit tramps" or "bindle-stiffs"—single men with the flexibility to

FIGURE 5. Dorothea Lange, "Blowing dust in the Oklahoma panhandle." June 1938. *Library of Congress, LC-USF34-018179-E*

FIGURE 6. Dorothea Lange, "Migrant children from Oklahoma on California highway," March 1937. *Library of Congress, LC-USF34-016441-E*

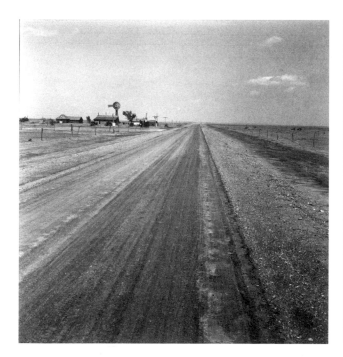

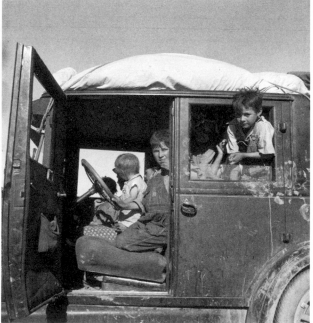

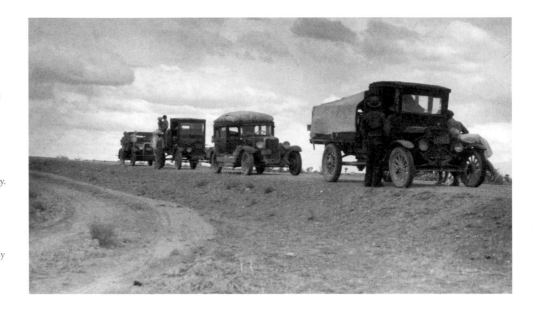

FIGURE 7. Dorothea Lange, "Three related drought refugee families stalled on the highway near Lordsburg, New Mexico. From farms near Claremore, Oklahoma. Have been working as migratory workers in California and Arizona, now trying to get to Roswell, New Mexico, for work chopping cotton. Have car trouble and pulled up alongside the highway. 'Would go back to Oklahoma but can't get along there. Can't feed the kids on what they give you (relief budget) and ain't made a crop there you might say for five years. Only other work there is fifty cents a day wages and the farmers can't pay it anyways.' One of these families has lost two babies since they left their home in Oklahoma. The children, seventeen months and three years, died in the county hospital at Shafter California, from typhoid fever, resulting from unsanitary conditions in a labor camp." May 1937.

Library of Congress, LC-USF34-016676-C

travel from area to area. The mass exodus from the U.S. Midwest, however, represented a new and different dynamic. By the middle of the decade 85 percent of all migrants were displaced white Americans.[16] These migrants also traveled as families, bringing their possessions (figure 7).[17] Families arrived by the thousands and quickly outnumbered the few available jobs. For those who found employment, the life of a fruit tramp family could be arduous. With its mild climate and extended growing season, California offered a panoply of crops that required harvesting year-round. The season for lettuce and navel oranges began in January, peas in March, onions and cucumbers in April, cherries in May, peaches beginning in June, and cotton in October, to name just a few. Harvests are always time-sensitive, so migrant workers were often required to work long hours seven days a week. The wages they received for their labor were meager—seventeen to thirty cents for picking fruit, for example, or ninety cents per hundred pounds of cotton picked.[18] The average yearly income for a migrant worker in California was estimated at $450. According to the Department of Agriculture, this was twenty-five dollars less than the minimum cost for an adequate diet for a family of four.[19] The camps run by growers were also spartan and often unsanitary. In all, it was difficult for a migrant to survive, much less get ahead. Each crop, moreover, had its own physical demands and challenges, from hunching over a furrow to dangling on a limb of a fruit tree. Yet few registered complaints. They needed the work and many, as former tenant farmers, sharecroppers, and agricultural day-laborers, were accustomed to toiling on the land.

In spite of the difficult work, so many refugees came that the local labor markets were soon oversaturated. There were always twice as many eager workers as employment opportunities.[20] For the farmers-landowners, these workers were different from the migratory pickers to whom they were accustomed. As Charles Todd observed, the Okies had "all the advantage of desperation" over other picking populations.[21] As U.S. citizens they could not be deported as previous workers could be, nor did they silently leave after the harvest was over. Rather, having families in tow made them less mobile and harder to hide, and often caused them to stay around after the crop. They also expected a certain standard of living and possessed the right to vote.[22]

At this time of change only one thing was certain: the massive influx would permanently alter the demography of California. The unfolding migration produced population spikes in numerous counties. Fourteen counties experienced more than 20 percent population growth. Kern County,

located in the San Joaquin Valley, experienced an influx of 52,554 migrants (63.6 percent population growth).[23] As wave after wave of migrants came west, California residents were placed in a difficult position. Most wanted to be accommodating but they had their limits. Posing both a threat to the old system and a vast reservoir of cheap labor, these new migrants represented both perils and possibilities. On the one hand, they were accepted and manipulated to fit the needs of California's burgeoning agricultural market. On the other hand, many Californians feared their growing numbers, power, and potential to organize. Not surprisingly, many saw the refugees as a nuisance and a blight on the sunny history of the state. They were stereotyped as lazy drunks and social leeches who were incapable of being absorbed into proper Californian society.[24]

Albeit that assistance from local governments was slow to come, help arrived from above. President Franklin D. Roosevelt was eager to support the migrants, and he used the various powers of his New Deal to that end. The migrant was clearly among the one-third of the nation that Roosevelt mentioned in his Second Inaugural Address as "ill-housed, ill-clad, and ill-nourished." "Alphabet agencies" like the RA (Resettlement Administration) and others sprang into existence to provide for displaced migrants. Some of the policies, however, did more harm than good. The Agricultural Adjustment Act (AAA), for example, which raised the price of farm goods by limiting yields, ended up damaging more than helping the rural poor. The act effectively removed farmland from production, leaving the most vulnerable farmers, namely sharecroppers and tenant farmers, unable to work the land and forced to look elsewhere for sustenance. Even though some of the results were suspect or questionably legal, Roosevelt's administration continued trying to assist the rural poor.

Bureaucrats within the Roosevelt administration were not the only ones to realize the human cost and tragedy of the migration. In California John Steinbeck, Dorothea Lange, and her future husband, the economist Paul Schuster Taylor, were among those who witnessed the growing migrant problem and believed they needed to take action. Like many others they sought to use their talents to mitigate hardship. The dislocated migrant would become an important theme for all three. In fact, it might easily be argued that the migrant was the most important theme of their mature oeuvres.

Years before Dorothea Lange began photographing the great overland migration she was a portrait photographer catering to wealthy families in the San Francisco Bay Area. A native of Hoboken, New Jersey, Lange came to California in 1918.[25] When a plan to travel around the world with a close friend was grounded by a pickpocket, she established a successful photography studio in 1919, and one year later married the striking and eccentric western painter Maynard Dixon, who was twenty-five years her senior. The couple became an established and flamboyant part of the San Francisco bohemian scene. In addition to maintaining successful career, Lange also raised their two sons: Daniel, born in 1925, and John Eaglefeather, who arrived four years later. Having little buffer against the effects of the Great Depression, Dixon and Lange struggled to keep their careers and family afloat. As the couple's marital and financial hardships rose, the boys were eventually placed in a boarding school while Lange and Dixon lived in their separate studios.

The year 1933 represented an important transition for Lange. Separated from her family she found it increasingly difficult to ignore the scenes of hardship outside her Gough Street studio. As witnessed in her seminal "White Angel Breadline" and other works, Lange was lured to the poor and the streets (figure 8). Her efforts resulted in a documentation of the destitute but provided much more than that: her view was one of great empathy for the dispossessed. Originally she did not know what she was going to do with this new body of work, but she believed that it was important. As her friend John Collier, Jr., noted, once Lange left her studio "she figuratively never came back."[26]

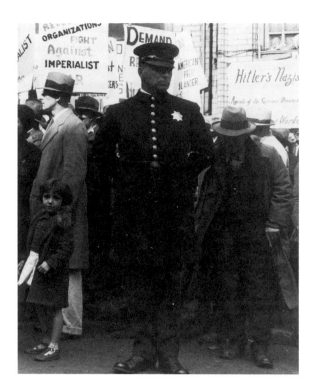

In 1934 her work from the streets came to the attention of the Berkeley economist Paul S. Taylor through an exhibition at Willard Van Dyke's Brockhurst Gallery. Instantly Taylor knew the work had relevance. Born in 1895, the same year as Lange, Taylor had completed his Ph.D. at the University of California, Berkeley, after studies at the University of Wisconsin and distinguished service in France during World War I. Taylor went on to a long and highly successful career as an agricultural economist at Berkeley. At heart Taylor was a humanist and humanitarian who used his talents and energy to ameliorate the hardships of the less fortunate. As Jan Goggans has written, academically Taylor was a labor economist and social scientist; morally he was a Progressive reformer in the Populist tradition.[27] In 1931 he received a Guggenheim Fellowship to study the patterns and lives of Mexican migrants working in the fields of the West. This opportunity put him on the roads and taught him the conditions of being a migrant. Ultimately it helped lay the groundwork for him to become one of the leading authorities on migration in the United States.

Early on Taylor realized the potential of photography to contribute to his work. In 1926 he began using the camera as a tool of social science.[28] Throughout the rest of the twenties and into the early thirties he made his own photographs, which he often published with his writings.[29] After seeing Lange's work in Van Dyke's gallery he invited her and others, including Imogen Cunningham, to help him document a self-help cooperative set up by the Oakland-based Unemployed Exchange Association (UXA) in Oroville, California. The UXA's purpose was to help displaced workers become more self-sufficient.[30] After two days of fieldwork with the photographers Taylor knew that he had found his collaborator in Lange. From that point forward Lange and Taylor became increasingly connected, professionally as well as personally: After working in the field together they realized that they had fallen in love.[31] Taylor found not only his photographer but also his second wife. In December 1935 both Taylor and Lange divorced their spouses, and they were married in Nevada. After the ceremony they went out and worked. In truth, the marriage of Taylor and Lange was a union of two like-minded individuals and the beginning of a long and rewarding collaboration.[32]

Prior to their marriage Taylor had worked part time as a consultant for the California Division of Rural Rehabilitation of the State Emergency Relief Administration (SERA). Eventually he was also able to get Lange on the payroll as a "clerk-stenographer," since his superiors saw the services of a photographer as superfluous.[33] SERA was interested in finding ways to assist migrants across the state. So were Lange and Taylor. From their vantage point in California they were in an excellent position to observe what was taking place, and they were some of the first to understand the significance of the overland migration. As Taylor and Lange worked in ever-expanding circles of coverage, they gained greater insight into the challenges facing the nation.

In many ways it is fitting that much of their best mature work was devoted to the plight of migrants. In 1935 *Survey Graphic* noted that Taylor and Lange "have complemented each other admirably in presenting the mixture of hope and discouragement they found among the drought refugees that have come to their state.[34] Taylor's investigation of migration spanned his entire working career. Priding herself on her keen eye and insight, Lange began to notice the migrants in 1934 and was one of the first to record what she was seeing and experiencing. From 1935 to 1941 the great migration was the most important theme in Lange's and Taylor's work. Lange turned to her camera, and Taylor to his pen, and thereby gave the migrants a voice and a face that helped the nation to see and understand them.

In the spring of 1935 Taylor and Lange traveled to the California-Arizona state line to observe what was taking place. On April 7, Paul Taylor wrote to his friend Paul Kellogg, editor of *Survey Graphic,* "We watched the drought refugees stream over the border from Arizona, Texas, Oklahoma, Arkansas, etc. In dire distress, all household goods and the tow-headed children aboard their rattling vehicles. They were fleeing drought, depression, crop reduction, oil-control, and everything else that has cut employment and livelihood."[35]

For Lange this was not a migration as much as a seismic shift in the history of California and the world she knew (figure 9). Witnessing the migration left a deep impact on her, and she commented on her experiences in interviews throughout her life. Although there are discrepancies in her recollections, Lange was clearly stunned by the human deluge. "What is this? What is this?" she remembered asking herself of the sight. "They were voiceless, you see, and we were the people who met them," she recounted.[36] Elsewhere she commented, "That was the beginning of the first day of the landslide that cut this continent. . . . This shaking off of people from their own roots. . . . It was up to that time unobserved."[37]

As the flood of migrants increased, Taylor and Lange continued to record it "at the ground level."[38] They saw the drifting populations and desired to record and understand the phenomenon. According to Taylor, "Dust, drought, and protracted depression have exposed also the human resources of the plains to the bleak winds of adversity. After the drifting dust clouds drift the people; over the concrete ribbons of highway which lead out in every direction come the refugees. We are witnessing the process of social erosion and a consequent shifting of human sands in a movement which is increasing and may become great."[39]

Lange, too, was moved by the social impact of the erosion, as evinced by her recollection of an early encounter with California's new refugees:

I went down to Imperial Valley, California, to photograph the harvesting of one of the crops . . . the early peas or the early carrots. The assignment was the beginning of the migration, of the migratory workers as they start there in the early part of the season and then as they moved up I was going to follow it through. . . . I had completed what I was going to do, and I started on the way home, driving up the main highway, which was right

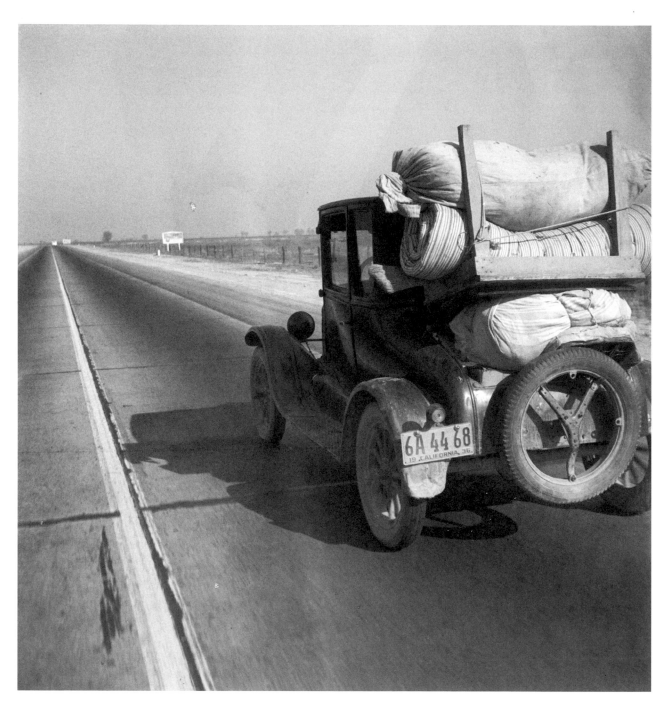

FIGURE 9. Dorothea Lange,
"Drought refugee's car on U.S.
Highway 99 between Bakersfield
and Famoso, California. Note:
the photographer passed twenty-
eight cars of this type (drought
refugees) between Bakersfield
and Famoso, thirty-five miles,
between 9:00 and 9:45 in the
morning." November 1936.

Library of Congress, LC-USF34-009976-E

through the length of the state, and it was a very rainy afternoon. I stopped at a gas station to get some gas, and there was a car full of people, a family, there. . . . They looked very woebegone to me. . . . I looked at the license plate on the car, and it was Oklahoma. . . . I approached them and asked . . . something about which way they were going, were they looking for work[?] . . . And they said, "We've been blown out." . . . They told me about the dust storm. They were the first arrivals I saw. These were the people who got up that day quick and left. They saw they had no crop back there. They had to get out.

The migrant had become a new part of the visual fabric of California, and Lange recognized the change. She continued, "All of that day, driving for the next . . . three or four hundred miles, I saw these people. And I couldn't wait, I photographed it. . . . Luckily my eyes were open to it. I could have been like all the other people on that highway and not seen it. As we don't see what's right before us. We don't see it till someone tells us."[40]

Observation was not enough for Taylor and Lange, and soon they began to act on what they were seeing and what they believed needed to take place. To bring the migration to light and show the rest of the nation what was happening out west, Taylor and Lange put their energies into drafting a series of reports, or "Notes from the Field" as they called them. These "Notes" contained photographs by Lange, explanatory texts and statistics by Taylor, and maps hand-drawn by Maynard Dixon. These were designed to draw attention to the migrants who were being blown across the nation and expose their plight to those who could help their cause. The first report, titled "Establishment of Rural Rehabilitation Camps for Migrants in California," highlighted the need for federal camps to house the refugees.[41]

Even though the reports were rich in Taylor's observations and analysis, they were overwhelmingly visual and dominated by Lange's stark photographs of "rattle trap jalopies, the tent villages, and dazed faces of Texans and Oklahomans."[42] She also provided handwritten captions that included quotations from the subjects (figure 10). Thus, Lange's photographs were not designed to be mere illustrations of the text but were dynamically presented and choreographed to highlight the scenes and experiences of the migrants. The specific purpose of these reports, Taylor later recounted, was to bring the conditions he and Lange saw into the offices of New Deal officials.[43] In June some of the Lange-Taylor reports made their way to Washington, DC,

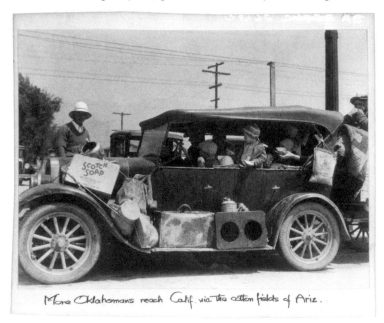

More Oklahomans reach Calif. via the cotton fields of Ariz.

FIGURE 10. Dorothea Lange, "Oklahoma dust bowl refugees. San Fernando, California." June 1935.

Library of Congress, LC-USF34-002613-C

and through the efforts of Lawrence Hewes, a friend and supporter of Taylor's, landed on the desks of individuals like Rexford Tugwell, head of the Resettlement Administration; Secretary of Agriculture Henry Wallace; and Secretary of the Interior Harold Ickes.[44] According to Hewes, Lange's images, in particular, produced a "powerful effect" in the nation's capital.[45]

Eventually Taylor and Lange's reports found their way to Roy Stryker, head of the RA's Historical Section.[46] The Historical Section began in 1935 when Rexford Tugwell, the RA chief and a member of Roosevelt's "Brain Trust," invited his former colleague from Columbia University, Roy Stryker, to join him in his agency. The purpose of the Historical Section was to garner support for the RA, a controversial agency with the mandate to assist America's rural poor. To accomplish this task Stryker would employ a talented cadre of photographers to generate positive support, that is, propaganda, for its controversial programs. Upon taking the position Stryker received few guidelines from Tugwell, who knew that the press was not going to be kind to their efforts. Tugwell informed Stryker that their "problem is to try to tell the rest of the world that there is a lower third, that they are human beings like the rest of us."[47] More specifically his objective was to "insist and insist again and again that depressed farmers have human dignity and that they will maintain themselves if given the chance on adequate soil."[48]

Feeling his way forward Stryker relied heavily on individuals like photographers Walker Evans and Arthur Rothstein, the latter a recent graduate from Columbia, as well as the artist Ben Shahn, a member of the RA's Special Projects section. When two of the Lange-Taylor reports arrived at the Historical Section, Stryker and his team took notice. Shahn remembers their impact: "This was a revelation, what this woman was doing," he remembered. "Roy's whole direction changed."[49] Stryker agreed; writing to Lange in September 1935 Stryker exclaimed, "You did a splendid job and it represents the type of thing we are very anxious to have."[50] Lange was soon on the payroll.

Under Stryker's system each photographer was assigned stewardship over a particular region. Lange was responsible for Region IX—the Far West—which included nine western states. This assignment placed Lange in a perfect position to document the so-called migrant problem. Two of her states, California and Arizona, were the most common destinations for those seeking a new life. Stryker also recognized the importance of documenting the migration in Washington state. The saga of the migrant was "a tragic piece of history," Stryker commented. "It had to be recorded."[51] Instead of issuing "shooting scripts" detailing what Lange was to photograph, as he did with other photographers, Stryker trusted her instincts, stepped back, and allowed her to respond to what she was experiencing.[52] Whether on California's roads, in the camps, or on the streets, Lange was empowered to document each detail. Although many of Stryker's photographers took photos of migrants, he considered Lange's work to be the best. "If you look at the pictures she did of the immigrants, hers was the greatest collection of immigrants," Stryker noted.[53] The subject clearly dominated Lange's efforts and thoughts. John Vachon remembered that when she visited the Historical Section offices in Washington, DC, the only thing on her mind and lips was the state of the migrant.[54]

During her tenure with Stryker, Lange made thousands of photographs of migrants. Lange's images reveal a world filled with newcomers. She documented roads teeming with jalopies carrying new arrivals and roadside squatter camps crowded with transients. She captured migrants who were simply "blowed out."[55] In addition to capturing their images, Lange also recorded their words, often including quotations in her captions or as notes on the backs of photographs. Together the photographs and quotations offered a deep knowledge of her subjects. They revealed the desperate situations and dire straits that many faced. A family she found near Bakersfield reported that all they could do was "drift, drift, drift."[56] On another occasion Lange found a family from Oklahoma penniless and stuck living along the highway. "Can't make it," they reported

to her, "Want to go back. Ate our car. Ate up our tent. Living like hogs." Another couple took a moment's break from picking peas to confide to Lange, "Ma'am, I've picked peas from Calipatria to Ukiah. This life is simplicity boiled down" (figures 11 and 12).

The roads of California and the West were Lange's lifelines to the migrants. Where they went, she went. Like her they were tied to the roadways and seldom permitted to penetrate the state's prosperous farms. She found migrants everywhere. On U.S. Highway 99, the so-called Dirty Plate Trail, which runs through the heart of the Central Valley, she recorded having encountered twenty-eight drought-refugee cars between 9:00 and 9:45 one morning (figure 13). The RA was in the business of resettlement, but these people, Lange reported, were in the process of "self-re-settlement" (figure 14). Lange found former farmers, tradesmen, and wage earners coming from Missouri, Texas, Arkansas, and Oklahoma. All were now refugees fleeing the dust and desperation of the Midwest. Taylor wrote they were "like the dust on their farms, literally blown out."[57] They knew they were not welcome. One told Lange, "We don't want to go where we'll be a nuisance to anybody."[58] Desperate for survival, however, they could not afford to be polite.

FIGURE 11. Dorothea Lange, "Drought refugees. Penniless Oklahomans camped along highway. Came seven months ago. 'Can't make it. Want to go back. Ate up our car. Ate up our tent. Living like hogs.' California." February 1936.
Library of Congress, LC-USF34-001821-C

FIGURE 12. Dorothea Lange, "Pea pickers in California. 'Ma'am, I've picked peas from Calipatria to Ukiah. This life is simplicity boiled down.'" March 1936.
Library of Congress, LC-USF34-001804-C

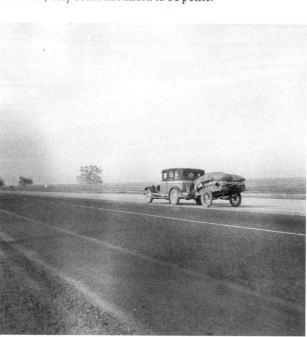

FIGURE 13. Dorothea Lange, "Migrant family on U.S. Highway 99 between Bakersfield and Famoso, California. Note: the photographer passed twenty-eight cars of this type while driving thirty-five miles between 9:00 and 9:45 in the morning." November 1936.
Library of Congress, LC-USF34-009975-E

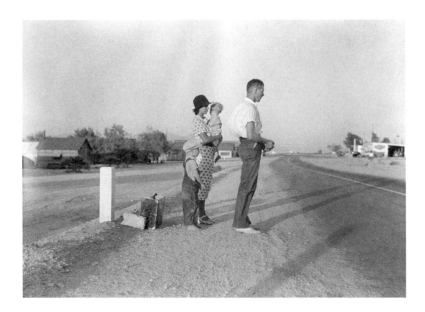

Their lives were painfully transparent and available to Lange's lens, exposed in a new way to the outside world. She found individuals who were penniless and had little gasoline left in their tanks. Many were stopped alongside the road, attempting to repair worn-down motors or flat tires, or simply calculating where to go next. Their lives were stop-and-start. In roadside Hoovervilles she recorded families living in tents, trailers, and assorted shacks, struggling to find food and stay healthy in poor, unsanitary conditions. This was a daunting task, and many of the families Lange encountered had already lost young children to illness and poverty. In the heart of the Central Valley Lange recorded the words of one young mother, "Broke, baby sick, car trouble!" (figure 15). The mother's curt statement summed up the migrant experience.

In March 1936, while returning from an assignment in southern California, Lange followed her instincts and investigated, on her own accord, a frozen pea-picking camp near Nipomo, California.[59] Out of the hundreds of destitute migrants, Lange focused her attention on one

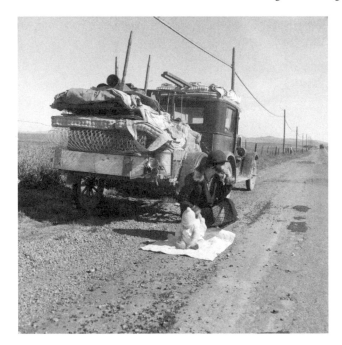

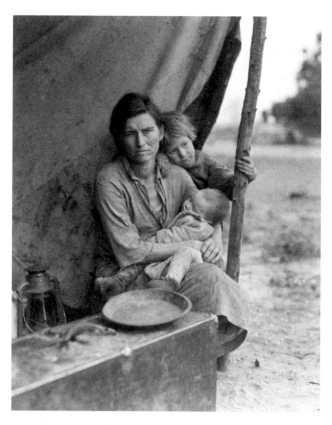

FIGURE 16. Dorothea Lange, "Migrant agricultural worker's family. Seven children without food. Mother aged thirty-two. Father is a native Californian. Nipomo, California." March 1936.

Library of Congress, LC-USF34-T01-009095-C

family—the family of Florence Owens Thompson. She took six photographs of the family, carefully working her way closer to the mother and her youngest children. As she worked she talked to her subject. Upon returning to her studio in Berkeley, she developed and printed the images and sent two of them to the *San Francisco News,* which shortly thereafter published them with a call for help (figure 16). Within days food and supplies were rushed to the destitute migrants. Lange had known that her images could make a difference, but in this instance she witnessed the immediate impact of her photographs and their power to move people beyond words.[60]

Not long after this event, a second image by Lange of the same family from Nipomo began appearing in the press. The most intimate of the photographs Lange took that cold March day, it featured Thompson holding her infant daughter, Norma, in her lap, while two slightly older daughters, Katherine and Ruby, lean plaintively on their mother's shoulders with their heads turned from the camera. The most notable detail of the photograph is the woman's facial expression and her delicately placed hand, which connote an admixture of emotions, including suffering, despair comingled with perseverance, and courage.[61] This was the work that became known as "Migrant Mother" and elevated Thompson to the status of Madonna of the Migrants.

On March 11, 1936, the *San Francisco News* printed the image on its editorial page with a brief and impassioned plea to support the programs of the federal government, including the migrant camps. "What does the 'New Deal' mean to this Mother and her Children?" the text began.

> This remarkable photograph epitomizes the human side of one of California's oldest and grayest problems—the plight of nearly 200,000 men, women, and children who move from valley to valley with the crops and live in wretched improvised shelters as they perform the labor on which our harvests depend. Here, in the fine strong face of this mother . . . is the tragedy of lives in squalor and fear, on terms that mock the American dream of security and independence and opportunity in which every child has been taught to believe.

The brief, mixed-media editorial concluded, "The conscience of California should find its voice in a demand that the Federal Government be encouraged to go ahead with its plans for these sorely needed camps."

Lange originally titled her photograph "The Oklahoman," even though she never asked the woman's name or history.[62] Lange's assumption was correct, however. Thompson was born on September 1, 1903, in eastern Oklahoma. In 1926 she migrated to Oroville, California, with her husband, Cleo, and their three children.[63] She gave birth to three more children out west. After Cleo died, she worked in the fields and did other odd jobs to support her family. In 1933 she migrated back to Oklahoma, and soon after the birth of a daughter, returned with her family and parents to California. Thompson returned to the fields, working near Shafter and following the crops throughout the southern part of the state. During a move to Watsonville in 1936 the family's car broke down well short of their target, leaving them temporarily stranded in the pea-picking fields of Nipomo. It was there that Lange found and photographed Thompson and her children. Although Lange and Thompson remembered the details of that day differently, the result of their brief encounter was an image that resonated with all who viewed it: thousands can tell you how it affected them.[64] The image quickly grew in popularity and use, becoming one of the most recognized photographs in the world. According to Stryker it was not only Lange's best work, but the definitive photograph in the FSA files.[65] Despite its later acclaim and proclaimed universality, Lange's best-known work was deeply and originally connected to the migrant problem.

Their work with the migrants in the West revealed to Lange and Taylor that the migrant problem was far more complicated than it appeared on the surface. In a note to Stryker Lange explained that the subject of migratory labor was too narrow and needed to be contextualized within an investigation of larger forces transforming farm work. Industrial farming, for example, was not only transforming California but was "producing the greatest human dislocation and turmoil."[66] Lange tried to capture this complexity in her photographs.

In talking to the refugees in California Lange and Taylor also learned about the world they had been forced to flee. A Texas farmer told Lange, "The finest people in this world live in Texas but I just can't seem to accomplish nothin' there. Two year drought, then a crop, then two years drought and so on. I got two brothers still trying to make it back there and there they're sitting" (see figure 2, caption). To capture the rest of the story, Lange followed the roads back to Texas and Oklahoma. There she found people ravaged by drought, hard times, and "yellow dust." Between Dallas and Austin she photographed broken-down jalopies filled with families (figure 17). One family told her, "It's tough but life's tough anyway you take it."

In 1936 Lange and Taylor made their first of two trips to Oklahoma.[67] Their purpose was to see "what the recent refugees to California had left behind. . . . These were times of drought and prolonged Depression."[68] Near Muskogee the father of one young family reported, "After three years, dry years, not a thing a fellow like me can do. I'd get out and go to California like the rest of them if I could get ahold of some money and get shed of my cows. Ain't done a day's work in four months."[69] In eastern Oklahoma Lange and Taylor found not dust storms but individuals plagued by a series of crop failures.[70] They also traveled to the town of Sallisaw in eastern Oklahoma, and Lange photographed its denizens standing and squatting along the town's main street with nothing to do but speculate about the drought, the government, and when it would rain (figure 18). "These fellers," one farmer told Lange, "are goin' to stay right here till they dry up and die too."[71]

On the other side of the state Lange photographed families in a shantytown named Elm Grove near Oklahoma City. Lange wrote of the camp, "On the outskirts of a modern Oklahoma City within sight of its gleaming skyscrapers. The rent, one dollar, is collected by the city and the

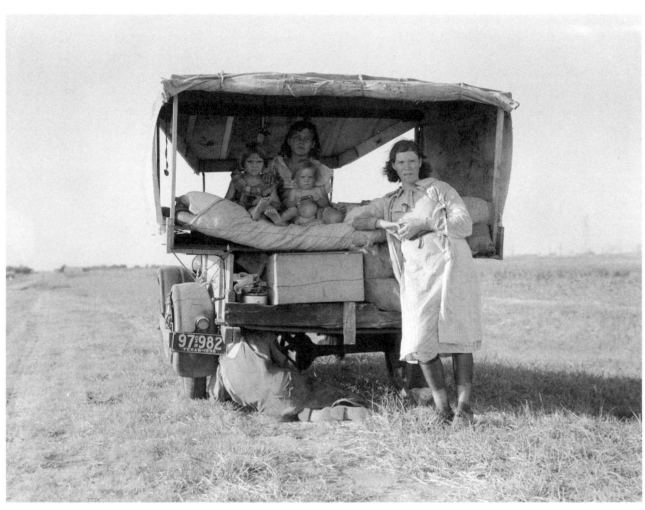

FIGURE 17. Dorothea Lange, "Family between Dallas and Austin, Texas. The people have left their home and connections in South Texas, and hope to reach the Arkansas Delta for work in the cotton fields. Penniless people. No food and three gallons of gas in the tank. The father is trying to repair a tire. Three children. Father says, 'It's tough but life's tough anyway you take it.'" August 1936. *Library of Congress, LC-USF34-009740-C*

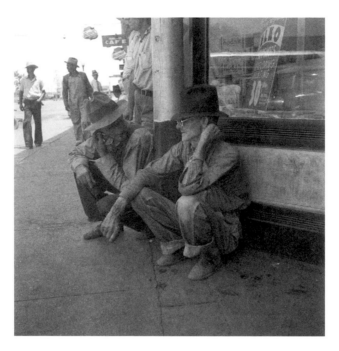

health officer is in charge, although there is no sanitation" (figure 19). The first migrant families
arrived at the camp in 1931, and over the next decade it averaged more than 1,500 residents, half
of whom were once farmers. A 1934 study found forty broken-down jalopies on-site. The same
study reported the inhabitants were rife with sickness and disease, and Lange described them
as living in "miserable poverty" (figure 20). Elm Grove was considered the "dead-end—the last
degradation," for those migrants who were unable or unwilling to start out on Route 66.[72] She
photographed the shacks loosely constructed of sheet metal, cardboard, tin, discarded lumber,
and gunnysacks, with dirt floors. The best-known photograph from this series, which became
known as "Damaged Child," depicts a battered, hard-eyed, possibly mentally handicapped young

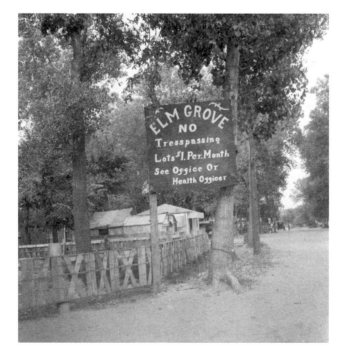

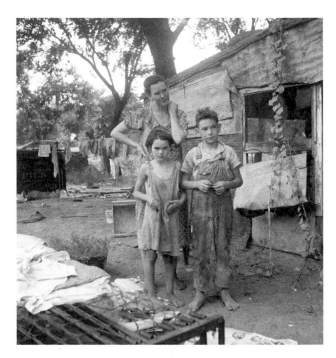

FIGURE 20. Dorothea Lange, "People living in miserable poverty, Elm Grove, Oklahoma County, Oklahoma." August 1936.

Library of Congress, LC-USF34-009694-E

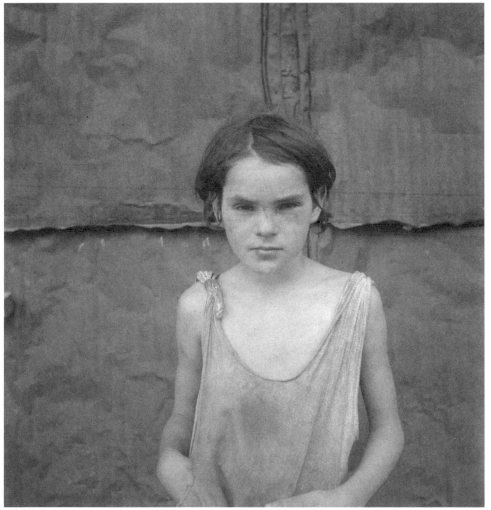

FIGURE 21. Dorothea Lange, "Damaged Child, Shacktown, Elm Grove, Oklahoma, 1936."

© Dorothea Lange Collection, Oakland Museum of California, City of Oakland. Gift of Paul S. Taylor.

girl (figure 21). One of the most powerful images of her career, this photograph clearly had a great impact on the photographer. Seeing the photograph decades later, Lange still became overcome with emotion.[73]

At this time Lange and Taylor began to envision a larger collaborative effort beyond the reports and images they were sending to Washington. By 1938 their vision had coalesced into the concept of a book that would explore the issue of the American refugee. They were already thinking of how they could "convey understanding, easily, clearly, and vividly." Through this text they would bring to light "the most ragged, half-starved, forgotten element in our population."[74] All of their experiences, and indeed all of the material they were collecting—the data, handbills, newspaper clippings, migrants' words, and photographs—would become the foundation of their 1939 publication *American Exodus: A Record of Human Erosion*.

Lange's contemporaries realized that she was in pursuit of the "uglier parts of the social scene."[75] What made her work important, however, was that she was able to capture the "tin-can tourists" in a manner that showed them as human victims of unfortunate circumstances. More than anyone else she photographed the full experience of the migrant. Although he never acknowledged Lange's direct influence, there is little doubt the images she captured in California and the West from 1935 to 1937 touched John Steinbeck and influenced *The Grapes of Wrath*. Her photographs of wayworn drought refugees and of cars heavily laden with all of their earthly possessions would find their way into scenes in the novel (figures 22 and 23). Many other details would also resonate in Steinbeck's descriptive language.

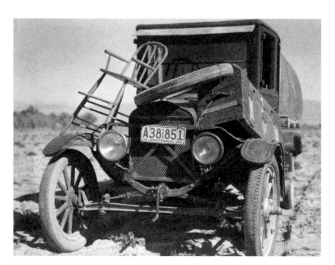

FIGURE 22. Dorothea Lange, "Car of drought refugee on edge of carrot field in the Coachella Valley, California." Spring 1937.
Library of Congress, LC-USF34-016418-C

FIGURE 23. Dorothea Lange, "1936 drought refugee from Polk, Missouri. Awaiting the opening of orange picking season at Porterville, California." November 1936.
Library of Congress, LC-USF34-009988-C

Researching Migrants

John Steinbeck

At nearly the same time as Dorothea Lange began photographing migrants and Roy Stryker was initiating his efforts with the Historical Section of the Resettlement Administration, John Steinbeck experienced a series of events that would culminate in the writing of his most famous novel, *The Grapes of Wrath*. Important works of art and literature often have lengthy gestations, and this was true of his novel. Leading up to the writing of his book, Steinbeck compiled a wealth of material that included his own experiences, interviews with migrants, the writings of others, and photographs.

Unlike the other key figures in this text, Steinbeck was a native of California. He was born in 1902 in Salinas into a family that did not have direct ties with the land; his father was a bookkeeper and treasurer for Monterey County. Despite this, young Steinbeck grew up with an appreciation of rural life that later appeared in his writings. At that time at least, California was an agricultural

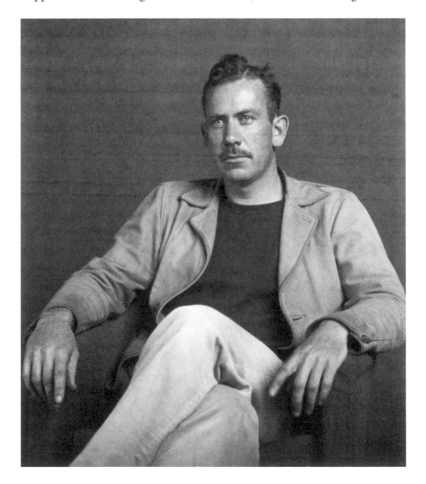

FIGURE 24. Sonya Noskowiak, "John Steinbeck," ca. 1935.

© Noskowiak estate.

state. Early in his life Steinbeck decided to become a writer and developed an interest in rural life and the lives of farmers, vagabonds, and wanderers. He also became adept at finding humor and tragedy in the fields and hills of his native California. After a rocky beginning his career took off in 1935 with his fourth novel, *Tortilla Flat,* which detailed the mock-heroic escapades of a group of rowdy Mexican American *paisanos* in Monterey. This work showed his interest in earthbound subjects and the means of life and survival. He was also a keen observer and chronicler of the changes that were taking place around him (figure 24). Eventually, he had dealt with agricultural matters so long that he was recognized as an expert on rural affairs.[1]

Steinbeck's next novel continued his interest in the common people but took a deeper and darker turn. Throughout the 1930s California was affected by strikes throughout the state.[2] Written in 1934 and published the following year, *In Dubious Battle* explored organized labor's turbulent crusade in California's pea-picking industry. Steinbeck's novel was based on real-life experiences, which brought him in direct contact with migrant labor and labor organizers, including Cecil McKiddy, a native of Oklahoma.[3] Admittedly highly exploitative and militant, Steinbeck's fifth novel achieved only limited success.[4] His novel showed no deference to either side and was attacked as too "red" by opponents of organized labor and as not strident enough by those on the far left.[5] Steinbeck was more interested in exploring the human dilemma than in taking a political position on a specific event. Thus, a small labor dispute in a California orchard became "the symbol of man's eternal, bitter warfare with himself."[6]

Despite its shortcomings, *In Dubious Battle* proved to be an important step toward the writing of *The Grapes of Wrath.* It showed that Steinbeck could find powerful narratives within current events. In responding to what was happening around him, he could also find broader themes of struggle and identity. His research would also expose the underlying violence of rural life. According to filmmaker Pare Lorentz, Steinbeck had seen this violence firsthand in his hometown of Salinas.[7] Steinbeck biographer Jackson Benson noted that Steinbeck extracted certain elements from *In Dubious Battle*—namely, "the blindness and brutality of the migrant camps"—and combined these with the helpless misery of the migrants from Oklahoma to create the foundation for his next full novel, *Grapes of Wrath.*[8]

As Steinbeck turned to the migrant as the subject of his next work he realized that for his narrative to have power and credibility, this novel would need greater research and depth than his earlier ones. According to Jackson Benson and Anne Loftis, Steinbeck sought "truth" accurately taken from life. To achieve this "he realized, he must write about things he knew or learned about through careful observation."[9] From the early thirties on Steinbeck became fastidious about accuracy and authenticity. He increasingly wanted to correctly capture his subjects' habits of speech and mannerisms, as well as the circumstances of their lives. Accuracy, however, was only a means to an end.[10] Ultimately, Steinbeck sought to explore universal themes in his writing. As a writer Steinbeck was also growing in popularity and strength. His character studies were becoming more convincing and his themes more powerful. According to one contemporary critic, Steinbeck's work featured "warm powerful portraits of common men, [with] each book showing some advance over the one preceding, each book showing great power moving toward maturity."[11]

The knowledge and experiences that proved pivotal to writing *The Grapes of Wrath* came initially from a series of articles Steinbeck wrote for the *San Francisco News.*[12] In the summer of 1936 at the home of his neighbors Lincoln Steffens and his young wife, Ella Winters, Steinbeck met George West, chief editor of the *News,* who proposed the article project to him. The purpose of the articles was to publicize California's increasing and ever more acute migrant problem. This

FIGURE 25. Unknown photographer, Jonathan Garst. *Library of Congress, LC-USF344-003888-ZB*

project was extremely important for Steinbeck because it brought him into the fields and shanties of the refugees. He saw how they lived and heard their stories of what life had been like back home and why they had had to flee to the West. Steinbeck was a good listener, and he internalized many of the anecdotes and details he heard.

Realizing that he needed more information on the migrants and their plight, Steinbeck expanded his research. At West's suggestion he went to the Resettlement Administration's Region IX headquarters in San Francisco in the late summer of 1936. There he met acting director Dr. Jonathan Garst, a liberal New Deal administrator with a history of working in agriculture (figure 25).[13] Because there was considerable public opposition to the FSA and its programs, "the officials of the agency were pleased to have a writer of Steinbeck's stature and sympathies investigating the problem and their efforts to alleviate it."[14] Over the next few years the Region IX office was quick to lean on Steinbeck and his growing reputation. Steinbeck, in turn, used his position to make his own demands. He demanded that Garst, "the good man," hire an assistant for an overworked camp manager, and even threatened to generate bad publicity if the office did not send oranges to migrants.[15]

Key to his future success, Steinbeck was also put in touch with other members of Garst's staff. He met Frederick Soule, a former newspaper man and the head of the region's Information Division; Soule's assistant, Helen Horn Hosmer; and Dr. Omer Mills, the regional economist.[16] Like Garst himself, these employees came from diverse backgrounds, were well educated, and were committed to Roosevelt's New Deal.[17] By proxy they also became committed to Steinbeck.

Local information divisions were critical to the FSA. They led grassroots efforts to promote public support for the agency's programs. FSA director Dr. William Alexander opined, "Let the local offices give the local people the truth about the FSA."[18] To that end local officials like Garst and Soule provided information and reports to anyone who was interested.[19] Soule let Steinbeck go through the files, and Soule's staff provided him with information on FSA migrant camps, statistics, and other information. Soule and Garst were also in touch with Stryker and worked closely with Lange to create images documenting the region's problems and federal programs without pretensions or "arty" airs.[20] At the time Pare Lorentz commented that "anyone who worked with the problems of the land and the farmer was indebted to them [Soule and Garst]."[21]

Another connection from the Regional Office proved to be just as pivotal for Steinbeck. Through the office's assistance Steinbeck was put in touch with Eric H. Thomsen, managing director of the government camps for migratory laborers. Thomsen, a native of Denmark, had a colorful past and a deep commitment to the cause. In August 1936 he also became Steinbeck's first guide to the camps.[22] Together they traveled to the federally run camp in Arvin, known as "Weedpatch."

The first camps were built in late 1935 in Marysville, north of Sacramento, and later near Arvin in Kern County. Paul Taylor had advocated for the creation of camps in 1934 and became a key figure in their implementation. Using his personal connections and his faculties he was instrumental in securing federal funding for the building of the first camps.[23] Later he was even referred to as the "father of the migrant camps."[24] Camps were designed to provide a place for the migrants free of the squalor and filth of the ad hoc squatter camps sardonically known as "Hoovervilles," or "Little Oklahomas." Despite fears that they would promote labor organizing and disease, the camps originally had the backing and financial support of local communities. By 1940 there would be fifteen permanent camps in operation in California.[25]

Thomsen was also important for introducing Steinbeck to Tom Collins, then manager of the Arvin migrant camp. Like Thomsen, Collins lived an interesting, peripatetic life.[26] Eventually, he became the first FSA camp director at Marysville and later operated several other camps. In many ways he was considered the ideal camp director: he was hard working, committed to helping destitute migrants, and fully dedicated to the FSA program.[27] In 1935 Dorothea Lange photographed the camp manager as he guided her through the migrant camp (figures 26 and 27). Lange's images correspond well with descriptions of Collins. According to his daughter, he was "always so thin, just a bit of a man, never weighing over 140 pounds."[28] Steinbeck wrote, "He had a small moustache, his graying, black hair stood up on his head like the quills of a frightened porcupine, and his large, dark eyes, tired beyond sleepiness, the kind of tired that won't let you sleep even if you have time and a bed."[29] Collins was a good ally for Steinbeck. As manager he knew the camps well and had experience with their inhabitants. More importantly the migrants liked and trusted him because of his tireless service on their behalf.[30] To them he was sincere and patient and seemed always to be smiling.[31]

With Collins as his guide Steinbeck toured around the camps and their council meetings. They also traveled outside the camps to see what life was like beyond the government facilities.[32] Steinbeck was clearly trying to learn all he could. Of this period Steinbeck wrote "[Collins] and I traveled together, sat in the ditches with the migrant workers, lived and ate with them. We heard a thousand miseries and a thousand jokes. We ate fried dough and sowbelly, worked with the sick and the hungry, listened to complaints and little triumphs."[33]

Collins was more than Steinbeck's means of access to the camps; he was also a keen observer who actively compiled information on the migrants, including their different dialects and speech patterns, manners, songs, anecdotes (funny and odd), sayings, inventories, editorials on living conditions, and other pertinent details.[34] He collected all of these observations into what was referred to as the "Big Book."[35] Eventually, he passed on the book to Steinbeck to further his research. "Down the country I discovered a book like nothing in the world," Steinbeck noted of his boon.[36] One migrant who worked alongside Steinbeck at this time remembered him carrying around a large binder with loose pages sticking out like porcupine quills—probably a notebook but perhaps the Big Book.[37] According to Benson, Collins was probably Steinbeck's most important background source for *The Grapes of Wrath*, which Steinbeck dedicated to Collins, the Tom "who lived it."[38]

Based on the information gleaned from the Regional Office and his experiences with Thomsen and Collins at Arvin, Steinbeck wrote a series of articles, which were published in the *San Francisco News* October 5–12, 1936. In these articles, collectively titled *The Harvest Gypsies,* Steinbeck employed what Benson called "investigative, advocacy reporting" designed to make visceral what California's newcomers were experiencing.[39] Writing these *News* articles also helped Steinbeck grasp the breadth and severity of the migrant problem. "Poverty-stricken after the destruction of their farms," he wrote, "their last reserves used up in making the trip, they have arrived so beaten and destitute that they have been willing at first to work under any condition and for any wages offered. This migration started on a considerable scale about two years ago and is increasing all the time."[40] With the increasing migration came a corresponding response from Steinbeck, who would dedicate the next three years of his life to telling their story. He did not know it at the time, but his articles also presaged the arc of his most important book.

To counterpoint Steinbeck's prose, *San Francisco News* editor West also procured photographs from Dorothea Lange to publish with the articles.[41] In all, West, with Steinbeck's help, selected thirteen of Lange's images, including a photograph of Florence Thompson, for the lead article (figure 28).[42] Together, Lange's photographs and Steinbeck's prose captured the plight of the migrants. In his articles he described how the "highways swarm with harvesters driven by hunger and the threat of hunger from crop to crop, from harvest to harvest, up and down the state." Later in the series Steinbeck traced a family of five from Oklahoma who traveled to California in their old Dodge truck when their "ranch dried up and blew away."[43] The family was probably similar to those Lange photographed at the time (figure 29), but through longer contact with them, Steinbeck was able to detail their suffering in a way Lange's photographs did not.

For many overland refugees the trip to California came at a tremendous sacrifice. The pursuit of a dream turned into a saga of loss. While looking for work "chopping" (picking grapes) and living in a squatter camp outside Bakersfield, the unnamed family lost work due to injury then a teenage son to a burst appendix, and was forced to sell the car to buy food. "This can not go on indefinitely," Steinbeck hazarded, urging Californians to stop denying the problem and take responsibility for helping those who harvested the food they ate. He also pledged his ardent support for the camp system that restored "dignity and decency that had been kicked out of the migrants by their intolerable mode of life."[44] As these articles demonstrate, Steinbeck, Lange, and Taylor clearly shared similar views and concerns for the migrants.

FIGURE 28. Dorothea Lange, "Migrant agricultural worker's family. Seven hungry children. Mother aged thirty-two. Father is a native Californian. Destitute in pea picker's camp, Nipomo, California, because of the failure of the early pea crop. These people had just sold their tent in order to buy food. Of the twenty-five hundred people in this camp most of them were destitute." March 1936. *Library of Congress, LC-USF34-009093-C*

FIGURE 29. Dorothea Lange, "Oklahoma mother of five children, now picking cotton in California, near Fresno." November 1936. *Library of Congress, LC-USF34-009839-C*

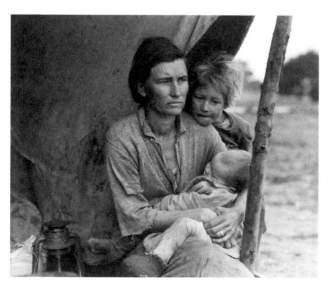

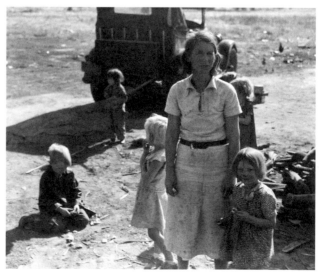

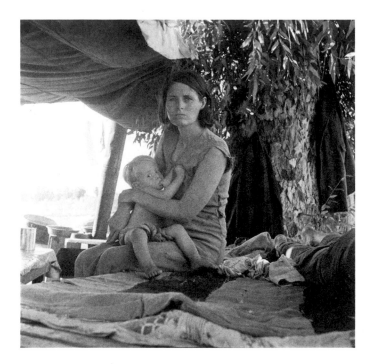

FIGURE 30. Dorothea Lange, "Drought refugees from Oklahoma camping by the roadside. They hope to work in the cotton fields. The official at the border (California-Arizona) inspection service said that on this day, August 17, 1936, twenty-three car loads and truck loads of migrant families out of the drought counties of Oklahoma and Arkansas had passed through that station entering California up to 3 o'clock in the afternoon."

Library of Congress, LC-USF34-009665-E

The *News* series marked the first time that Steinbeck's prose and Lange's images were paired together. Although they moved in similar circles and shared common interests, friends, and associates, Steinbeck and Lange did not meet until the spring of 1939.[45] Though they may not have known each other personally, they must have known of each other's work. They were products of the same political environment and were united in investing their talents and influence in the same cause.[46] There were many points of contact between the two. As early as 1934, Steinbeck's wife, Carol, the other individual to whom *Grapes of Wrath* was dedicated, worked in the offices of the California State Emergency Relief Agency (SERA) with Taylor and Lange.[47] In the FSA Regional Office Soule and Garst were strong proponents of both Lange and Steinbeck, and supplied the latter with research material.[48] Circumstantial evidence suggests strongly that Steinbeck examined the FSA photographs of Lange and others.[49] He likely also saw her work in a multitude of popular venues, like the magazines *Life, Fortune, Look,* or *Survey Graphic.*[50] Indeed as the so-called migrant problem worsened, Lange and Steinbeck's visibility heightened and their work increasingly grew together.

Following the *News* article series Steinbeck's and Lange's work would be seen together in other contexts. In 1938 Lange's photograph of a young mother nursing her child as her family languished on the California state border appeared on the cover of the twenty-five-cent pamphlet *Their Blood Is Strong,* a reprinting of Steinbeck's *News* article series, titled *Harvest Gypsies* (figure 30).[51] The profits from the sale of the pamphlet went to the Simon J. Lubin Society to aid migrants, directed by Helen Hosmer.[52] During the cotton strike of 1938 around Bakersfield, California, Lange photographed the activities of the Steinbeck Committee, which used the author's name and growing fame to fight for the rights and welfare of migrant workers.[53] Steinbeck and Lange must have realized that they were walking the same path. The connections were not lost on those residents of the Arvin camp who wrote to thank the author for his *Harvest Gypsies* articles, which, they believed, *explained* and *showed* their plight to the public.[54]

In February 1937 Steinbeck's novella *Of Mice and Men* was published. Set in California's fields, the story follows two wanderers, quick-minded George Milton and the slow, gentle giant

Lennie Small, as they search for work and a place of refuge. Instead of finding rest and a place to raise rabbits, the two migrant laborers encounter suspicion, fear, and danger. Far more somber than *Tortilla Flat*, the tragic story nonetheless resonated with readers and became a success. It was quickly turned into a play and received the Drama Critics' Circle Award the same year. The success of this novel provided the Steinbecks with a level of financial security to which they had never been accustomed. With the extra funds they decided to spend the summer traveling in Europe, visiting Scandinavia and the Soviet Union. The trip was designed to be a respite from work and other concerns. Yet it seems that even while abroad Steinbeck never forgot the migrants and their problems.[55]

Upon his return to the United States later that summer, Steinbeck stopped in Washington, DC, and visited the federal offices of the FSA.[56] There he met with FSA head Dr. Will Alexander and his chief deputy, C. B. "Beanie" Baldwin (figure 31). The FSA had a natural ally in Steinbeck, who desired to use his talents for their benefit and by then had the concept for *Grapes of Wrath* in his mind. In his *Harvest Gypsies* articles he had praised the FSA's federal camps as a humane system of handling the migrant issue and had advocated for a larger federal role in aiding migrant labor.[57] Steinbeck found the federal agency to be equally receptive as the regional office in San Francisco. As a staunch proponent of the poor, Baldwin, a Southerner, was prepared to embrace Steinbeck even if it meant alienating many Californians.[58] Baldwin and the FSA were willing to use any means at their disposal to assist the migrants, a fact which led critic Philip Bancroft to suggest that the FSA change its name to the MPA—"The Migrant Promotion Administration."[59]

Even prior to Steinbeck's visit to Washington, the RA and the FSA had demonstrated a willingness to use innovative techniques to broadcast the need for and the successes of their programs. The RA employed artists like Ben Shahn and the photographers of the Historical Section to get its message out. Around 1935 it also recruited the untried filmmaker Pare Lorentz to create a film on the need for federal assistance in rural America. With an initial budget of $6,000 Lorentz produced

FIGURE 31. Jack Delano, "C. B. Baldwin, Administrator, Farm Security Administration." *Library of Congress, LC-USF34-014128-D*

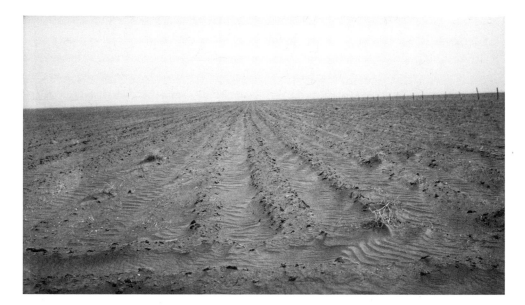

FIGURE 32. Dorothea Lange, "An example of how listing soil into furrows helps impede erosion. Mills, New Mexico." May 1935. *Library of Congress, LC-USF34-002814-E*

The Plow That Broke the Plains, one of the most influential films of the Great Depression. This visually stunning work benefited from the talents of Lorentz's filmmakers/photographers Ralph Steiner, Paul Strand, and Leo Hurwitz.[60] (After weeks of filming throughout the Midwest, Strand and Hurwitz eventually left the project for political reasons and due to Lorentz's inexperience.) In preparation for making his film, Lorentz studied the Historical Section photographs (figure 32), and recruited Dorothea Lange to help him with images of migrants along U.S. Highway 99 in California.[61] Lorentz's ability to create, in his words, a "picturization" of the problems facing rural America was broadly influential. Lorentz's films, in turn, influenced both Stryker's photographers and John Steinbeck.[62]

When Steinbeck visited Washington, he told the FSA administrators of his desire to write a novel based on migrant workers in California. "I'm writing about people and I have to live as they live," he told Baldwin.[63] Anxious to assist the young writer, Alexander and Baldwin made the extensive resources of their administration available to him.[64] This important exchange was a fulfillment of John Tagg's assertion: "The state needs the powers of documentary, and documentary serves the power of the state."[65] As Baldwin tells the story of this meeting,

> John Steinbeck got in touch with us. . . . He had gotten terribly interested in our work
> with migrant workers, we had built migratory labor camps, we had established a medical
> program for them, and these were really the poorest people in the country, subject to all
> the hazards of the worst part of our system. And Steinbeck said he wanted to do this book,
> but he said, "You know, my method of working may be different from many novelists, I'm
> going to have to live this thing for a while." I guess he said that if he was going to do it,
> something would have to be worked out. Well, we'd read then, I guess, *Of Mice and Men*
> and a number of Steinbeck's other books and we certainly thought that he was the person
> to do it. So we said sure, we'd give him our fullest cooperation.[66]

Elsewhere Baldwin stated, "Steinbeck told us he wanted to write a novel about migrant workers but, as he expressed it, he needed the experience of a migrant worker if it was to be a realistic story of how they actually lived."[67] Alexander and Baldwin agreed to continue to pay Tom Collins's salary while allowing him to assist Steinbeck.[68] With Alexander's assurance Steinbeck again availed himself of Collins's knowledge and experience as the pair researched several of

California's camps and Hoovervilles.[69] By the time he returned home, Steinbeck had succeeded in getting much of his research subsidized by the federal government.[70]

The FSA stimulated Steinbeck's ongoing research in at least one other way. Baldwin, who later became the head of the FSA, remembered bringing the author to the Historical Section, where he spent time with Roy Stryker.[71] Stryker and Steinbeck had much in common, centered on their interest in rural America and concern for the poor. Both were ardent supporters of the New Deal, though Steinbeck preferred to keep his politics low key. They even shared a common enemy—the Associated Farmers growers' organization.[72] Steinbeck did not hesitate to blame it for many of the problems in California, and Stryker denounced it as "one of America's greatest menaces."[73]

Years later Stryker recalled Steinbeck's visit: "I remember when Steinbeck came in and looked at the pictures for a couple days. Those tragic, beautiful faces were what inspired him to write *Grapes of Wrath*. He caught in words everything the photographers were trying to show in pictures."[74] Later Stryker even believed that Steinbeck based the appearance of his protagonists, the Joad family, on the photographs.[75] Stryker may have jumped to this conclusion, but Steinbeck undoubtedly was influenced by what he saw. At the time of Steinbeck's visit the file consisted, in Stryker's estimation, of twenty thousand images, which was a sizable resource.[76] After immersing himself in the files for more than a day, Steinbeck must have been influenced by what he had seen. He was not the first writer influenced by the FSA photographs. The poet Archibald MacLeish published *Land of the Free* (1938), a book that featured eighty-seven FSA images and an original poem intended to illustrate them.[77]

It is tantalizing to ponder what Steinbeck may have seen on his visit to the Historical Section files and, more important, what inspiration he took from the burgeoning collection. He would have seen photographs of the poverty, places, and people of the great migration. Furthermore, the files enabled Steinbeck to look freely at the details and faces of America's living refugees.[78] Thereby, he also welded his vision with that of the FSA in terms of subject matter and mutual interest. Over the years many historians have speculated on the level of congruence. Maren Stange, for example, wrote that the FSA images were the "visual analogues of social concern that motivated the novels of John Steinbeck."[79] Vicki Goldberg concurred, noting that the novel was influenced to an "unusual degree" by the photographs.[80] Steinbeck scholars have also noted the links, albeit to a lesser degree. Arthur Krim, for one, suggested that Steinbeck may have chosen Sallisaw as the Joad family's home through looking at Lange's images of the town.[81]

Upon deeper examination it seems quite plausible that many of the details Steinbeck mined from the photographs later appeared in his book.[82] Decades after the book's release many continued to note this connection. In 1974 English professor D. G. Kehl argued that the links between the novel and FSA photographs were so strong that the novel could be read like a "string of verbal pictures."[83] Steinbeck's description of "fat-assed [deputies] with guns slung on fat hips, swaggering through the camps" could equally well describe Ben Shahn's photograph of the backside of a deputy taken during the 1935 strike in Morgantown, West Virginia (figure 33).[84] Upon deeper examination Kehl saw links between Steinbeck's text and many other images, including a photograph by Theodor Jung of displaced farm clients who strongly resemble Grandma and Grandpa Joad (figure 34).[85]

Kehl postulated that Steinbeck also acquired his "verbal pictures" from looking at the FSA images in Archibald MacLeish's *Land of the Free*, which was published while Steinbeck was writing his novel.[86] Steinbeck owned a copy of this book and several other books containing FSA

FIGURE 33. Ben Shahn, "A deputy with a gun on his hip during the September 1935 strike in Morgantown, West Virginia." September 1935. *Library of Congress, LC-USF33-006121-M3*

FIGURE 34. Theodor Jung, "Prospective clients whose property has been optioned by the government, Brown County, Indiana." October 1935. *Library of Congress, LC-USF33-004051-M4*

images, which he must have mined for visual inspiration.[87] Contemporary reviewers frequently noted the similarities between the two works.[88]

During his visit to the FSA offices in Washington, DC, Steinbeck undoubtedly viewed photographs by Shahn, Evans, Rothstein, and Lee, but it is the work of Dorothea Lange that evokes the most similarities. This should not be surprising: her focus was the West and her work stood out in Stryker's Historical Section. As early as 1941 Lorentz remarked that the Historical Section had taken more from her vision than she had from its. "She is their chief," Lorentz professed.[89] Stryker's assistant, Edwin Rosskam, noted that Lange was unique among Stryker's team: whereas most FSA photographers simply performed their perfunctory duties when documenting the agency's programs, Lange created notable, deeply felt investigations that demonstrated her level of total intellectual and emotional commitment.[90]

Even through Steinbeck never directly acknowledged Lange as his primary influence, many scholars concur that it was she who had the greatest visual impact on the author. According to William Stott and others, Steinbeck credited Lange's pictures as inspiring him to investigate the migrants' plight.[91] In addition, most of the images in *Land of the Free* are hers.[92] Richard Steven Street suggested that the work of both Lange and Taylor had pronounced effects on the author.[93] Photo-historian Sally Stein believes that Lange's pictures "first suggested the dramatic possibilities of such a story and also guided Steinbeck to additional sources notably the labor camps and camp supervisors Lange had documented."[94] Likewise, Carol Shloss claims that Steinbeck's novel was formed in the "footsteps" of Dorothea Lange and Paul S. Taylor beginning in 1935, and that his work merely echoed the ideology and imagery that marked their collaborative effort. Shloss also asserted that Steinbeck mirrored the Lange-Taylor reports "with almost uncomfortable closeness." "His only original contribution," she remarked, "to telling the story of migratory labor was the addition of case studies to illustrate Taylor's more abstract points."[95] Other scholars, such as Anne Loftis, are more reserved in crediting Lange for Steinbeck's vision.[96] In truth, it would be difficult to ascertain who learned or saw what first. This is in fact a moot point. Both Lange and Steinbeck were reacting to a similar picture that was playing out throughout California.[97] Whether captured in words or images, the subject matter was the same.

There are, however, traces of Lange's probable influence on the writer. Steinbeck's repeated symbol of men with nothing to do but squat "on their hams" finds its visual translation in Dorothea Lange's photograph of an agricultural worker near Holtville, California, in 1937, and the aforementioned group of idle men from Sallisaw, the home of the fictional Joads, in August

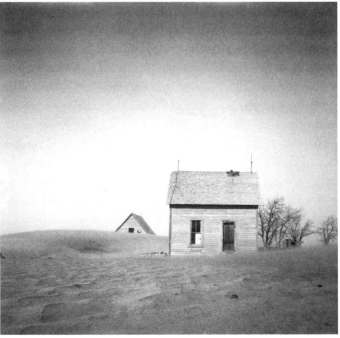

FIGURE 37. Arthur Rothstein, "Plow covered by sand. Cimarron County, Oklahoma." April 1936. *Library of Congress, LC-USF34-004043-E*

1936 (figure 35). In describing the plight of the faceless migrant Steinbeck wrote, "The two men squat on their hams and the women and children listen. Here is the node, you who hate change and fear revolution. Keep these two squatting men apart; make them hate, fear, suspect each other."[98] In both cases debilitating hardship forced men to become idle, bewildered, and threatened. Moreover, Lange's captions could also have influenced Steinbeck.[99] In describing the exchanges of those who had been "dusted out" and "tractored out" Steinbeck echoed the terse and stark quality of Lange's carefully recorded captions.

In terms of the influence of FSA photographs on Steinbeck one aspect has not been examined. As the home of Steinbeck's protagonists, the Joads, the state of Oklahoma played an important role in the novel. As the source of thousands of migrant families, it was also an important subject for FSA photographers. One series of images undoubtedly left an impression on Steinbeck. In April 1936 Arthur Rothstein visited the heart of the Dust Bowl, Cimarron County in the Oklahoma Panhandle, and documented the ravages of erosion and whirling sands (figure 36). He photographed the ubiquitous sands choking out the farmers, fields and orchards, highways, and an entire way of life (figure 37). Like Steinbeck's novel, Rothstein's photographs depict the farmers' constant battle against the onslaught of the Dust Bowl. These images would provide an important theme and symbol for Steinbeck's work.

As part of his work in Oklahoma that spring, Rothstein photographed the Coble family running to their shed in the face of an oncoming storm. The image, known as "Fleeing a Dust Storm," quickly became an icon of the FSA and an emblem of the swirling dirt and dunes of the Dust Bowl (figure 38). It was featured in *Land of the Free* and early on became one of the more widely disseminated images of Stryker's section. Later that fall Steinbeck wrote in his notes of a "dust storm and the wind and the scouring of the land. And then quiet . . . and the dust piled up like little snow drifts."[100] As his note—the earliest extant mention of the theme of *Grapes of Wrath*—indicates, Steinbeck was exploring similar terrain, which he likely experienced first through Rothstein's imagery.

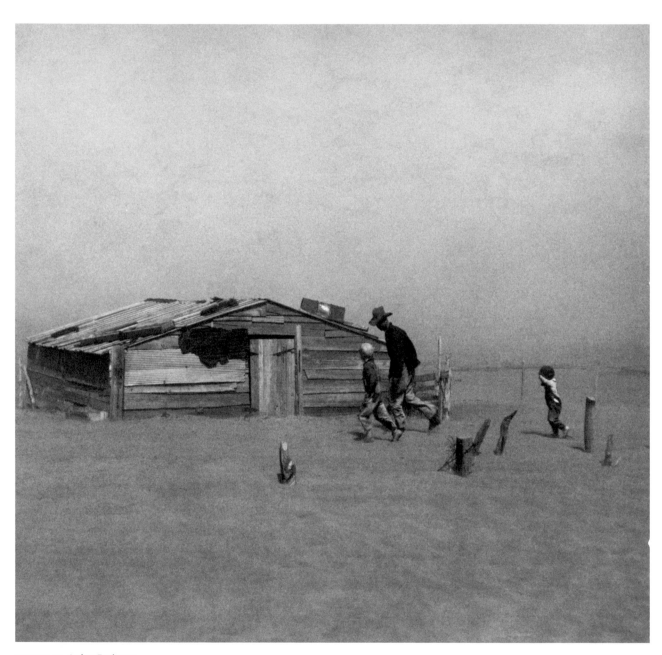

FIGURE 38. Arthur Rothstein,
"Farmer and sons walking
in the face of a dust storm.
Cimarron County, Oklahoma."
April 1936. *Library of Congress, LC-
USF34-004052*

Even before the infamous "Black Blizzard" of April 1935, the area in and around the Oklahoma Panhandle had already been hit by a succession of dust storms and economic hardships.[101] According to Federal Emergency Relief Administration reports, dust had driven out all but three of the forty families who had lived in the townships near Boise City.[102] Between February and April 1935 the Kansas Weather Bureau reported only thirteen dust-free days. "We are getting deeper and deeper in the dust," professed Reverend M. E. Markwell of Boise City in 1935.[103] Inspired by *The Plow That Broke the Plains* Rothstein followed filmmaker Pare Lorentz from Amarillo to Oklahoma. In the panhandle of the state he documented the American "Sahara," the nation's own "Arabian Desert."[104]

As writers like Alice Lent Covert and Sanora Babb pointed out, however, this was no enchanted locale, and no pretty stories could come out of a landscape like that.[105] The dusts that altered the landscape of the Midwest were deadly. During the Dust Bowl infant mortality increased by 66 percent and death from respiratory infections tripled.[106] Rothstein himself was not immune to the dangers of the Dust Bowl. Blowing dust caused permanent damage to his right eye and ruined two cameras.[107]

In California Steinbeck met refugees of the Dust Bowl, and their stories undoubtedly left vivid impressions on him. Their accounts also helped form his vision of the landscape that he would later portray in his text. Steinbeck's Oklahoma was a land of withering sun, with few trees and little shade to offer respite. Mirroring Rothstein's photographs, in *Grapes of Wrath* dust is a powerful symbol of futility and a changing relationship with the land. Dust is everywhere and covers everything.[108] "Dust comin' up an' spoilin' everything, so a man didn't get enough crops to plug up an ant's ass," Steinbeck wrote.[109]

The images and stories of the Oklahoma Dust Bowl proved particularly important for Steinbeck. For years it was believed that he conducted research in Oklahoma and "moseyed west with the refugee parade."[110] Until biographer Jackson Benson proved otherwise, many believed that Steinbeck "followed the trail of the migrants" and experienced the misadventures of the "Okies" firsthand.[111] From Steinbeck's descriptions many believed that he "traveled to Oklahoma and hooked up with a family, the Joads, which had been dusted off its farm and was headed west."[112] Throughout his life Steinbeck implied through silence and wry smiles that he did in fact make such a trip late in 1937.[113] In later years he even talked about his "Oklahoma Trip" as if it were real.[114] In reality he made no Oklahoma research trip and his narrative of the Dust Bowl was based on secondhand knowledge. Steinbeck did travel through Oklahoma along Route 66 on his return from Europe in 1937. On that occasion, however, the Steinbecks traveled comfortably and by themselves in their new car.[115] This was not the most direct route home, but Carol Steinbeck did not recall her husband making a conscious effort to conduct research for his future book along the way.[116] Such "windshield tourism" was a far cry from the involved research Steinbeck conducted in California.

Steinbeck's information on Oklahoma and the overland migration was gleaned from other sources. The names of the cities through which the Joads traveled could have been gathered from maps; the experiences and details could have come from Collins and his experiences in the camps.[117] Many of the details, including the raw visual data, must have been gleaned from photographs.[118] The FSA photographs helped construct a surrogate experience that played an important part in creating a believable story.

Working for Life

John Steinbeck and Horace Bristol

Upon his return to California after visiting the FSA offices in Washington, DC, John Steinbeck began again to gather the information that would help him write a convincing account of the plight of Dust Bowl refugees and their diaspora. He rejoined Tom Collins and traveled incognito in what he called "the old pie wagon" throughout the Central and Imperial Valleys. His travels with Collins were not the only follow-up to his research in Washington, DC. Seeing the files of photographs that Stryker's team had assembled must have revealed that photographs could be a vital complement to his work with migrants. The images forced Steinbeck to think differently about photography and to look for other opportunities to incorporate it in the field. To gain a visual understanding of the migrant situation in California, Steinbeck relied not only on the images of Dorothea Lange and the other FSA photographers but also on a loose partnership with a young *Life* magazine photographer named Horace Bristol.

Horace Bristol was a twenty-eight-year-old California native who became interested in a photography career. By the time he contacted Steinbeck, he had already enjoyed some success contributing photographs to *Time, Sunset,* and *Fortune* magazines. In 1937 he accepted a position with *Life*—a prestigious opportunity for a young, relatively inexperienced photographer. What really interested him, though, was not images of animals or celebrities, but the plight of the state's fieldworkers. He came by this focus honestly. He was a friend of Lange's and Taylor's and was particularly influenced by Lange's work in the "muddied lettuce and pea fields" of central California.[1] Moreover, like his mentors, Bristol realized that what was happening around him was an "epochal story" that he wanted to be a part of.[2] Believing that photographs were "social documents," Bristol followed Taylor, Lange, and Otto Hagel to the fields of the Central Valley to explore in depth the plight of poor migrant laborers (figure 39).[3] Bristol was particularly impressed by the photographers' championing of what they termed the "tripod" of photograph, caption, and text.[4] "After I worked with Dorothea, I wanted to do a story," Bristol remembered. "I thought that it would be a really great essay for *Life*."[5] He later envisioned a book: "[Lange's] vivid description of what she found prompted me to ask if I could accompany [Lange and Taylor] on one of their trips. This experience led to another trip with them, and another, until I was so emotionally involved myself that I decided to undertake a photographic book on the subject."[6] Over the next year Bristol invested a great deal of time and energy in making his ideas a reality.

Young and ambitious, Bristol was clearly lured by the prospect of collaboration with Steinbeck. In early 1937, Bristol first approached Steinbeck with the idea of jointly creating an article focusing on the plight of migrants in California. He would contribute the images and Steinbeck, who was not famous at the time, would write the corresponding text. Steinbeck may not yet have been famous, but as the author of *Harvest Gypsies* and *Of Mice and Men,* he was the logical choice for such a venture.[7] "Here's a man who's going to be sympathetic to what I want to do," Bristol recounted.[8] Eventually Steinbeck agreed to work with Bristol, and their collaboration

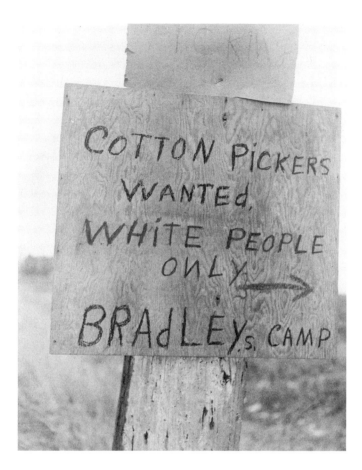

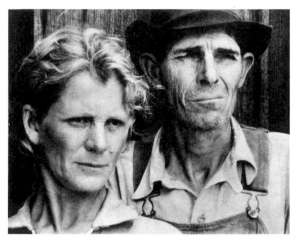

FIGURE 39. Hansel Mieth and Otto Hagel, "Signs in the Valleys of California," 1934. © 1998 *Collection Center for Creative Photography, The University of Arizona Foundation.*

FIGURE 40. Margaret Bourke-White, "Couple, Maiden Lane, Georgia." From *You Have Seen Their Faces*, 1935. © *Estate of Margaret Bourke-White; licensed by VAGA, New York, NY.*

began in earnest upon Steinbeck's return from Europe and Washington in the late fall of that year.

Bristol's desire to collaborate had several motivations. A profound increase in the number of photo-books with social agendas during this period had created a receptive public. He was inspired by Taylor and Lange, and probably knew of their eventual intention to publish their work. Bristol also took inspiration from writer Erskine Caldwell and photographer Margaret Bourke-White's collaboration, *You Have Seen Their Faces*.[9] This was designed to be not a "pretty book" but an unflinching glimpse into the lives of the poor in the rural South (figure 40). Despite being criticized as exploitative, *You Have Seen Their Faces* has been called the "decade's most influential protest against farm tenancy."[10] It was also a pioneering example of the popular photo-book, featuring a synthesis between text and imagery. One reviewer commented that their work was "an indication of what the book of the future will look like."[11] By and large, the reviewer was correct. According to scholar William Stott, the release of *You Have Seen Their Faces* was the beginning of the "documentary movement" in which several photo-books were published, many featuring FSA photographs.[12] At the same time as Bourke-White and Caldwell were undertaking their project, Walker Evans, on loan from the FSA, and a brash young author named James Agee were documenting tenant farmers in Hale County, Alabama, for *Fortune* magazine. *Fortune* declined to publish their collaboration, but it was later released as *Let Us Now Praise Famous Men* in 1941. Lange and Taylor's *American Exodus*, another seminal work in this genre, was published late in 1939.

Believing that he and Steinbeck could replicate *You Have Seen Their Faces* in California, Bristol proposed the project to *Life*. The story was rejected because his editors preferred stories of scantily clad starlets to "pictures of ugly old poor people."[13] Then Bristol pitched the idea to *Life's*

sister magazine, *Fortune,* and it was quickly accepted. Over the objections of editor Wilson Hicks, *Life* editors expressed renewed interest in the project when they learned that their competitor wanted the story and that Steinbeck was on board. This was fine with Steinbeck who found *Life* more palatable than "slick" magazines like *Fortune,* which he believed catered to the wrong audience. "Fortune wanted me to do an article for them but I won't," he wrote his agent. "I don't like the audience."[14] In addition to supporting the project, *Life* also provided Bristol and Steinbeck with a carload of food, including coffee, bacon, flour, and beans, to distribute to the needy.[15] With the backing of the magazine the duo spent seven weeks from the end of 1937 to March 1938 traveling through the fields. They did most of their work on weekends, allowing Steinbeck time to write during the week and Bristol time to continue covering other stories for *Life.*

During their travels Bristol made more than two thousand images.[16] With Steinbeck interviewing the migrants and Bristol photographing their exchanges with his Rolleiflex, the duo journeyed through many of the areas in California's Central Valley hardest hit by unemployment and poverty (figure 41). Bristol remembered how the migrants opened up to Steinbeck as he asked questions, which allowed him to "move in behind with his camera."[17] This intimacy may be seen in many of the images Bristol made during his sojourns with Steinbeck—photographs of struggling farmers working with their FSA board and a young migrant mother looking off into the distance while nursing her baby (figure 42). Everyone he photographed seemed to be from Oklahoma.[18] Though the subjects are anonymous, Bristol's portraits depict people who exhibit strength and perseverance. This quality may be seen most clearly in an intimate portrait Bristol made of an Okie against a bright sky. Despite the man's weathered and worried countenance, Bristol also captured the strength in this figure as he looks beyond the camera to the distant and, he hopes, more promising horizon (figure 43).

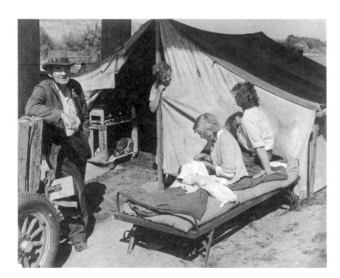

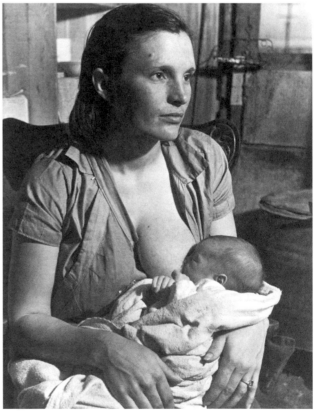

FIGURE 41. Horace Bristol, "Family Being Interviewed by John Steinbeck," 1938.
© *Horace Bristol/Corbis.*

FIGURE 42. Horace Bristol, "Rose of Sharon," 1938.
© *Horace Bristol/Corbis.*

FIGURE 43. Horace Bristol, "Tom Joad," 1938.

© Horace Bristol/Corbis.

Winter was typically a difficult time for migrants, but the winter of 1938, with its weeks of heavy rains, was especially severe.[19] Fields were flooded, migrants were stranded and destitute, and an already difficult situation was growing critical. Needing firsthand information and realizing the potential impact of the situation, Fred Soule pleaded with Steinbeck to report on the situation in the Central Valley.[20] In response Steinbeck and Bristol went to the flooded migrant camp in Visalia, Tulare County, which provided the most pressing and agonizing experience of their collaboration. Bristol remembered his horror at seeing migrants trying to cope with water several inches deep in their tents (figure 44).[21] During the flood Steinbeck, Bristol, and Collins spent two weeks "slogging through roadside camps" assisting those who were affected by the tragedy.[22] Collins later wrote of their experiences dragging starving, exhausted cotton pickers to higher ground, and of Steinbeck seething with anger, frustration, and impotence.[23] According to Robert DeMott, the deluged and desperate scene carved a "psychic wound" into Steinbeck and opened up the "floodgates of Bristol's compassion. What he saw there was the stuff of tragedy. His response couldn't simply be documentary."[24]

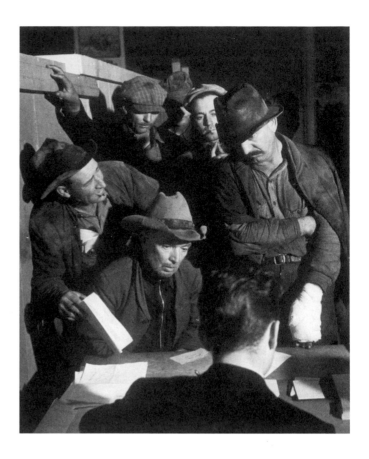

Yet Steinbeck was also profoundly affected by the migrants' fortitude even in their desperate circumstances.[25] At one point he was so exhausted he collapsed in the mud.[26] Yet he was driven to continue, as he explained to his agent and confidant, Elizabeth Otis, "I must go to Visalia. Four thousand families, drowned out of their tents are really starving to death."[27] To Soule Steinbeck confided that he was in a "white rage" over what he had seen.[28] Soule, in turn, asked him to write a report so that the FSA could deliver food and medication to the destitute families.[29] Collins's friend and assistant Sanora Babb witnessed the author and Bristol in the field and reported to her sister Steinbeck's reaction to what he saw: "By God!" he said, "I can't stand it anymore! I'm going away and blow the lid off this place."[30] Babb also wrote of Steinbeck and Bristol both pleading with a local judge to pardon the son of a sick, elderly migrant named Kirkland who was "crazy with worry" over her son. The boy had been jailed for stealing four scrapped radiators, which he sold for groceries. The judge thanked them for helping him see the boy as a human being but sentenced him to eleven years in San Quentin prison anyway.[31]

Soon after his return home in March Steinbeck sent another missive to Otis that provided insight into his anguish over working with the impoverished migrants:

> Just got back from another week in the field. The floods have aggravated the starvation and sickness. I went down for *Life* this time.... [They] sent me down with a photographer from its staff and we took a lot of pictures of the people.... I'm sorry but I simply can't make money on these people.... The suffering is too great for me to cash in on it. I hope that this doesn't sound either quixotic or martyrish to you. A short trip into the fields where water is a foot deep in the tents and the children are up on the beds and there is no food and no fire, and the county has taken off all the nurses because "the problem is so great we can't

do anything about it." So they do nothing. . . . It is the most heartbreaking thing in the world. If *Life* doesn't use the stuff there will be lots of pictures and swell ones. It will give you an idea of the kind of people they are and the kind of faces. I break myself every time I go out because the argument that one person's effort can't really do anything doesn't seem to apply when you come on a bunch of starving children and you have little money. I can't rationalize it for myself anyway. So don't get me a job for a slick [magazine]. I want to put a tag of shame on the greedy bastards who are responsible for this.[32]

The deluge and sorrow of Visalia later appeared in the final, crushing pages of *Grapes of Wrath*, as Steinbeck leaves his protagonists, the surviving members of the Joad family, trapped by rising waters with no home and no apparent future.

Steinbeck and Bristol worked quickly, and on March 16 submitted an article to *Life*.[33] Steinbeck knew it would be far too inflammatory to print but hoped that the work would still shame those who refused or were slow to help. Steinbeck also sent some of Bristol's photographs to Pare Lorentz. "Words and generalities don't mean anything anymore," Steinbeck implored Lorentz, "but I hope these pictures pin a badge of shame on the greedy sons of bitches who are causing this condition and it's definitely caused, make no mistake about it."[34] Writing to Otis he asserted, "California is most afraid of unfavorable publicity outside the state. They depend on the dimes of tourists. And if a tourist knew he might see a starving child, he might not come."[35] Ultimately he was right: *Life* considered the article too critical for its pages.

Bristol then pitched the idea of a photo-book to the author as an alternative to the article. By this point, however, Steinbeck had soured on the collaboration despite Bristol's enthusiasm: "Well, Horace," Bristol recalled Steinbeck saying, "I have bad news for you. I'm going to write it as a novel."[36] Elsewhere Bristol remembered the novelist explaining, "It's too great a story for a photographic book. I'm going to write it as a novel."[37] It seems he was not completely forthright with the young photographer; unbeknownst to Bristol, Steinbeck had been actively planning his novel for months. He probably never had any intention of pursuing a photo-book. Bristol later conceded, "I agreed with him. I mean it was too great a story and his writing could have so much more influence. Photographic books aren't terribly well-known whereas a novel can be and was."[38] The rejection did sting Bristol, however; following Steinbeck's rejection, he went on to his next assignment for *Life* and never again returned to the migrant camps.[39] In future years he also grew resentful that he was not given credit for his contributions. Whatever the reasons for the end of the collaboration, it had if nothing else allowed Steinbeck to secure another research trip subsidized by someone else.[40]

It is insightful to question why the conjoining of text and image that others employed so successfully during this period did not work for Steinbeck and Bristol. Though Steinbeck was undoubtedly influenced by photographs, that does not mean he believed they carried equal weight to words. Despite recognizing the subjective power of the camera and its ability to capture what its operator "sees, loves and hates and pities and is proud of," Steinbeck believed, it seems, that the photographic medium was limited.[41] This put him at odds with the growing documentary tradition that was based on collaborations between photographers such as Bourke-White, Evans, and Lange with writers like Caldwell, Agee, and Taylor. At the time, however, many believed that the balance was tipped toward photography. When *You Have Seen Their Faces* debuted in 1937 the case was put forward that the roles of text and photographs had been reversed. Many suggested that the text was merely illustrative of the images.[42] One year later many critics professed that Archibald MacLeish's poem in *Land of the Free* was overshadowed by the FSA photographs.

Declaring that "the pictures are the thing" and that they "speak for themselves," critics saw MacLeish's overwrought poem as taking a secondary and supportive role. MacLeish agreed, acknowledging in his text that the "power and stubborn inward livingness" of the photographs required him to relegate his poem to a mere soundtrack.[43]

James Agee called the camera "the central instrument of our time."[44] Furthermore, Agee saw Walker Evans's photography as equal, if not superior, to his own writing in its power to describe the lives of Southern sharecroppers.[45] In his text it is possible to sense his frustration at attempting to match the denotative and connotative power of the photographs. This frustration prompted Agee's famous response: "If I could do it, I'd do no writing at all here. It would be photographs; the rest would be fragments of cloth, bits of cotton, lumps of earth, records of speech, pieces of wood and iron, phials of odors, plates of food and of excrement."[46] For a writer like Steinbeck, ceding primacy to another medium probably would have caused anxiety and alarm.

As a writer Steinbeck apparently believed that nothing could match the written word.[47] In many ways he was intrigued by the visual image, but like others within his community, he probably held the notion "that literature is the older, the broader, the more regulated and the more established cultural form, while photography is . . . the newcomer, the alien, if not the troublemaker."[48] One writer in 1938 even declared that picture magazines were contributing to "adult infantilism" and that "mankind is well on the way backward to a language of pictures."[49] Although his interest in photographs would have kept him from fully agreeing with this sentiment, he was a writer and trusted his trade. This attitude was not lost on Bristol, who complained, "A photographer was a second-class citizen as far as [Steinbeck] was concerned."[50] Moreover, Steinbeck was not a collaborator at heart. In the years to come he did team up with photographer John Swope and the famed

FIGURE 45. Robert Capa, "USSR. Moscow. August–September 1947. Robert Capa and John Steinbeck." *Robert Capa* © *International Center of Photography.*

photojournalist Robert Capa, but these projects were clearly of lesser importance to him than his novels, and the photographs served as little more than illustrations to his prose (figure 45).[51]

For Steinbeck the photograph was a document that could be used, analyzed, and incorporated into a narrative but that could not create a narrative of its own; photographs depicted better than they explained.[52] Like personal interviews, direct observations, and other sources, photography was a tool from which information could be gleaned. Together these media supported the overarching themes and concepts of his books. Ultimately, his imaginative ordering of the information was what was most important. At his core Steinbeck was a storyteller. The images readers conjure in their minds through the written word were far more powerful than any photograph of a person and place. "What I see as a writer is on my mind's eye, not a photograph," wrote writer-photographer Wright Morris in words that could echo Steinbeck's beliefs. "Although a remarkable composite of impressions, the mind does not mirror a photographic likeness," Wright argued, "The mind is its own place, the visible world another."[53]

Steinbeck's "long apprenticeship" in migrant life required years of research and numerous sources. Like other authors of his day he wrote about what he knew and expanded that knowledge by means of a slow and deliberate curiosity that took him through the muddy fields and federal camps as well as to the offices of the FSA.[54] This was his process of "piling detail on detail until a picture and an experience emerge."[55] According to Joseph Henry Jackson, the literary editor for the *San Francisco Chronicle* and one of Steinbeck's most ardent apologists, Steinbeck could not turn to writing until after he collected all of his material, which he "unconsciously absorbed":

> Then he was ready. Everything added up. Steinbeck had by no means seen the whole problem, but he had seen enough to show him that there was injustice crying to be righted, that men were being hurt, that people he believed to be fundamentally decent and willing to work were being crushed by other men in the grip of a system about which nobody seemed to be able to do anything. Something had to be done. Men must not be treated like this, no matter what the reason or the excuse.[56]

To Thomsen, Steinbeck wrote, "This book is the culmination of my three years of work and notes and talking. And I do want it to do some good."[57]

With years of preparatory research completed, Steinbeck finally turned to writing. His first two attempts resulted in failed manuscripts named "L'Affaire Lettuceberg," which he destroyed, and "The Oklahomans," which ultimately provided some material for the final novel.[58] Yet the story clearly continued to haunt Steinbeck until the end of May 1938, when he began writing the final version of *The Grapes of Wrath*. With the support and patience of Carol, Steinbeck finished writing and editing the novel early in the winter of 1939. "I wrote *The Grapes of Wrath* in one hundred days," Steinbeck claimed, "but many years of preparation preceded it. I take a hell of a long time to get started. The actual writing is the last process."[59] The manuscript was soon off to his publisher, Viking Press. This was the book that he felt compelled to write and he knew that its veracity would be important to its impact. "I know what I was talking about," Steinbeck insisted after the book's publication. "I lived off and on, with those Okies for the last three years. Anyone who tried to refute me will just become ridiculous."[60]

In truth, Steinbeck integrated multiple resources to give his novel credibility, including his own experiences, the work of individuals like Tom Collins, RA/FSA field notes, and FSA photographs.[61] According to Robert DeMott, "Steinbeck's conscious and unconscious borrowings, echoes, and reverberations throughout *The Grapes of Wrath* came from a constellation of artistic, social, and intellectual sources so varied that no single reckoning can do them justice. All of these

elements—and more—entered the crucible of his imagination and allowed Steinbeck to transform the weight of his whole life into the new book."[62] Whatever their source, the multitude of details would give *The Grapes of Wrath* an air of documentary truth. As part of the constellation of sources, photographs provided a myriad of details that enriched Steinbeck's descriptions and were incorporated into his narrative.[63] The FSA's and Bristol's images were, moreover, vicariously used as proxies to create scenes and experiences that would vivify the novel.

Furthermore, their photographs carried a certain level of indexicality. Whereas a photograph is a natural signifier in the way it literally captures the light that touches its subject, Steinbeck's experiences in the fields and muddy migrant camps left a physical and psychological mark on him, which he translated into the pages of his novel. All his sources helped form what the author called a "wall of background."[64] Yet photography's interaction with the novel was far from complete. The novel's release on April 16, 1939, would mark a new chapter in the complex interaction between documentary photographs and Steinbeck's ideas—between apparent fact and factual fiction.

Post-publication

From Controversial Novel
to Dust Bowl Icon

Shooting Script

Russell Lee

The story of *The Grapes of Wrath*'s interaction with photography extends beyond the formation of Steinbeck's ideas and the background research that made his novel possible. In many ways the real story of the rich exchange between photography and *The Grapes of Wrath* begins after the book's release in 1939. Two years after Steinbeck used the Historical Section's files for part of his source material, FSA photographer Russell Lee would base his work in Oklahoma largely on what he had recently read in *The Grapes of Wrath*, though Steinbeck had done no more than drive through Oklahoma during his research. This chapter explores Lee's work in the summer of 1939. Such an investigation provides insight into the challenges and ironies of making a photographic documentation based on treating Steinbeck's realistic fiction as if it were completely factual.[1] Not surprisingly, because he believed in the general veracity of Steinbeck's novel and used it as the springboard for his investigation of Oklahoma's migrant problem, Lee would both verify Steinbeck's claims and uncover the fictional elements in the story. In so doing, he would expose the slippery interface between fiction and fact.

When *The Grapes of Wrath* hit bookstores and libraries in April 1939, it was an instant success. By the beginning of May it topped the best-seller list, selling close to ten thousand copies a week.[2] The story tells of Tom Joad, recently released from prison, and his family. Forced off their land in Sallisaw, Oklahoma, by dust, drought, and greed, the Joads travel to golden California for salvation. Along the way on Route 66, the Mother Road, they begin to experience the trials and suffering that mark their pursuit of a place to call their own. Ultimately they arrive in the fields of California only to find that the promise of a better life is unattainable. Pushed and pulled against their will, the family struggles to remain intact until forces beyond their control forever alter the family and their precarious future. In sum, Steinbeck's narrative is cathartic and heartbreaking. According to his friend Joseph Henry Jackson, Steinbeck's goal was to move the reader. The novel he wrote, "was a magnificent piece of special pleading, a novel that moved its readers—to pity, to disgust, to rage, but always moved them."[3]

In a tribute to the novel's documentary veracity its proponents scrutinized it for its accuracies just as hotly as those wishing to debunk Steinbeck searched it for errors. Critics like Frank J. Taylor recoiled at the thought that many readers would accept fiction as fact. "It is difficult to rebut fiction," he wrote, "which requires no proof, with facts, which do require proof."[4] In spite of the fact that *Grapes of Wrath* was a fictional work, those looking for faults carefully noted even the slightest deviation from what they saw as the truth. Not surprisingly many of the novel's harshest critics were in California. The Associated Farmers denounced the book as obscene, vulgar, and immoral.[5] Philip Bancroft, a former Associated Farmers official, publicly decried it as an "absolutely untrue and libelous book."[6] It was suppressed in Kern County, and in other areas of the state it was banned. In Bakersfield copies were confiscated from libraries and burned in protest.[7]

In Oklahoma the reaction was mixed. Some saw it as a realistic portrayal of the state's

predicament. Many others, however, rejected what they saw as Steinbeck's vulgar depiction of the Okie.[8] "I think the stigmatism of Steinbeck's *Grapes of Wrath* will always be with us," one Oklahoman remembered, adding, "I spent a lot of years hating him."[9] Other critics accused Steinbeck of basing his portrait of their state on hearsay.[10]

In the words of Carey McWilliams, releasing *Grapes of Wrath* at the very time when the actual migrant problem was most acute was like tossing a match into a powder keg.[11] The debate over the issue extended all the way to the floors of Congress. Although the Senate's La Follette Committee corroborated many of Steinbeck's findings, several Washington politicians took umbrage with the author.[12] Representative Alfred Elliott of California denounced Steinbeck's work as "the most damnable book that ever was permitted to be printed and put out to the public to read."[13] On January 24, 1940, fellow congressman Lyle Boren, the son of an Oklahoma tenant farmer, famously attacked the novel from the rostrum of the House. In Boren's opinion Steinbeck's book was a "dirty, lying, filthy manuscript." Not letting up, Boren called it a "lie, a black, infernal creation of a twisted, distorted mind." In sum, it was Steinbeck who was vulgar and backward, not his Oklahoma constituents. "I would to Almighty God," Boren concluded, "that all citizens of America could be as clean and noble and fine as the Oklahomans that Steinbeck labeled 'Okies.'"[14] Despite such criticism within Congress, there were many politicians, particularly among the ranks of Roosevelt's New Deal, who were sympathetic to Steinbeck and his cause. The more liberal members of the government, especially, saw the book as a landmark achievement.[15] Paul Taylor, for one, likened it to other American literary landmarks, such as *Uncle Tom's Cabin.*[16]

Within weeks of the book's publication, Steinbeck again visited Washington, DC. In the FSA offices Will Alexander was quick to acknowledge the novel's "far reaching influence" and its "immense help" in furthering the agency's work with migrant labor.[17] The FSA's Historical Section was especially supportive. Well before the publication of *Grapes of Wrath,* Stryker and his photographers were already interested in many of the themes and problems that the novel so boldly brought to the public's attention. Practically overnight in the spring of 1939, Steinbeck's book achieved the impact that Stryker's team had been working hard to attain since the Historical Section's inception in 1935.[18] By the end of April Stryker still had not read the novel all the way through but insisted, "it's damn good."[19] Determined to prove that the novel painted an accurate portrait, he acted quickly to use his agency's resources to support the embattled author. He also sought opportunities to capitalize on the success of *Grapes of Wrath* for the benefit not only of Steinbeck and the migrants, but the FSA as well. The FSA had assisted Steinbeck before and they would look for ways to do so again.

One of the individuals who would come to Steinbeck's aid was FSA photographer Russell Lee (figure 46). Lee was born in Illinois in 1903 into a prosperous family. Despite a difficult childhood that included witnessing his mother being struck and killed as she crossed the street, Lee acquired an education and graduated from Lehigh University in 1925 with a degree in chemical engineering. Two years later he married the artist Doris Emrick whose influence must have helped the buttoned-down Lee transform into an artist. In time Doris Lee became well known for her folky genre scenes of rural life.[20] After honeymooning in Europe the couple worked in Kansas City then studied in San Francisco in 1929, where their circle of friends included the Mexican muralist and political firebrand Diego Rivera.

At the suggestion of painter Arnold Blanch, the Lees relocated to the small Woodstock art community in upstate New York in 1931.[21] During the cold winter months they studied in Manhattan at the Art Students League, where Russell worked with John Sloan. While in the city Lee began to take photographs to support his work, and soon he became increasingly enamored

with the entire process of photography and abandoned painting. He also began to photograph the streets of New York and, with the encouragement of Ben Shahn, brought his portfolio to Roy Stryker. Serendipitously for him Carl Mydans was leaving the Historical Section to become a photographer for the newly formed magazine *Life*, creating a vacancy on Stryker's staff. Stryker liked what he saw and offered Lee the position. Lee quickly endeared himself to his new boss by staying out on the road for months at a time. Despite the long absences from Washington, Lee and Stryker became fast friends and enthusiastic supporters of each other's work.

Prior to 1939 Lee had already traveled across much of the United States and knew the challenges facing its rural populations. Despite being a relative newcomer to the photographic medium, he had already demonstrated an ability to create powerful and deeply sympathetic images. Early in his tenure for Stryker, Lee photographed the aged and knotted hands of Mrs. Andrew Ostermeyer, the seventy-six-year-old wife of a homesteader from Woodbury County, Iowa, who had just recently lost her farm to foreclosure (figure 47). To critic Elizabeth McCausland this image was more than a photograph; it was "a human and social document of great moment and moving quality." She continued, "In the erosion of these deformed fingers is to be seen the symbol of social distortion and deformation: waste is to be read here, as it is read in lands washed down to the sea by floods, in dust storms and in drought bowls."[22] In addition to creating such poignant social documents, Lee did not object to making the more banal images of federal programs and clients that Stryker and the FSA needed for lobbying purposes. In contrast to Walker Evans, Lee understood the mission of his agency and sought to capture images that would be politically useful to Stryker.

FIGURE 46. Unknown photographer, "Portrait of Russell Lee, FSA Photographer," c. 1942. *Library of Congress, LC-USW3-019997-C*

FIGURE 47. Russell Lee, "The hands of Mrs. Andrew Ostermeyer, wife of a homesteader, Woodbury County, Iowa." December 1936. *Library of Congress, LC-USF33-011121-M1*

The Grapes of Wrath quickly came to Lee's attention. On April 19, 1939, Lee wrote to Stryker urging him to send him copies of *Of Mice and Men* and *The Grapes of Wrath*.[23] On May 11, Roy Stryker wrote Fred Soule, "I can understand the excitement over this book. It was about the best thing I read in many a day."[24] The same day, Lee wrote his boss, "Have just finished the 'Grapes of Wrath' and rate it as one of the best books I have read. . . . The whole book is a shooting script. In fact I am going to consider it as such and attempt to pick up as many of the shots that are so graphically told. After the set is complete I think it might be a good idea to try to tip in to the book several illustrations and see what we can make of it."[25]

Previously, most "shooting scripts" had been issued from Stryker's desk and provided detailed lists of subjects he wanted his photographers to find.[26] Lee had frequently offered Stryker ideas for assignments and helped organize shooting scripts, evidence of their equity and mutual trust.[27] The script that Lee was proposing here, however, was unique. It would come neither from Washington nor from the field, but from Steinbeck's prose.

Going into the field with a work of fiction as a working map was not unprecedented. More than half a century earlier, the German archaeologist of dubious distinction Heinrich Schliemann had excavated Troy with Homer's *Iliad* as his primary guide. On the western edge of modern-day Turkey, Schliemann let visions of the glorious past cloud his actual discoveries. Yet his successes showed that "myth and history might be one."[28] In fact, others were on the road seeking fact versus fiction in rural America at the same time as Lee.[29] Like Schliemann did in Turkey, Lee went to Oklahoma with a work of fiction as his "archaeological map"; that is, his guide and primary script. Where Schliemann envisioned Achilles and Hector, Lee would see Ma, Pa, and Tom Joad. He would look for and harvest images of would-be Joads, the quintessential Okie migrants portrayed in Steinbeck's text. Like Schliemann Lee would make discoveries. Some of his images worked well as illustrative material that could easily be placed within the framework and discourse of Steinbeck's narrative. Other material excavated from the site, however, produced findings well beyond what Steinbeck had imagined.

Never one to let an opportunity pass, Stryker was determined to capitalize on the success of Steinbeck's novel. He clearly wanted to see, as his photographer had suggested, "what we can make of it." His response to Lee read,

> Very glad to get your report on the Steinbeck book. Incidentally, this thing is getting awfully popular and I think it might be advisable for you to drop everything and follow the ideas you have about shooting the material right into Oklahoma, for the next few weeks. We are going to need all the stuff we can get hold of. No shooting script will be needed since, as you say, the book could not be improved upon. It is my idea that we can sell somebody (perhaps Viking Press) on the idea of a picture-book to accompany this novel. . . . I am just bubbling over with ideas about how we can exploit the public excitement over this whole thing.[30]

Stryker issued a similar if more melodramatic proclamation to Arthur Rothstein, then in Bozeman, Montana:

> I am sending Russell to Oklahoma post haste, to start work on the additional shots for the Steinbeck book. Better keep your eye out for anything you can find. Hope to hell you have picked up some good things in route. We are going to need them. My poor old head is just bulging with ideas on how to exploit this thing. Got so bad, the doctor had to drill a hole to relieve the pressure. Most of them are screwy, however. Maybe something will come out of it.[31]

Playing to a cause was nothing new for Stryker, the attentive, publicity-savvy "shrewd promoter."[32] When authors Archibald MacLeish and Sherwood Anderson, and filmmaker Pare Lorentz, requested images not found in his ever-growing archive, Stryker gave special instructions to his photographers to find appropriate material.[33] He would now do the same for *The Grapes of Wrath*.

It was Steinbeck who took the lion's share of abuse for *Grapes of Wrath*. The novel was, after all, a work of fiction that combined his experience, knowledge, and imagination. Dismiss him and one could dismiss his book. Steinbeck clearly knew this and relied heavily on his multivalent research to ground his characters in realistic circumstances. This was a delicate balance between fact and realist fiction. In essence, Steinbeck created what William Stott called a "social document" designed to "increase our knowledge of public facts, but sharpen it with feeling; put us in touch with the perennial human spirit, but show it struggling in a particular social context at a specific historical moment. [Social documents] sensitize our intellect (or educate our emotions) about actual life." In the case of *The Grapes of Wrath* many readers knew of the actual conditions that were uprooting tens of thousands of tenant farmers and sharecroppers, but few knew their stories.[34] Writing for the *New York Times* Charles Poore recognized this. "Mr. Steinbeck did not have to create a world for the Joads," he wrote. "It is there. What he did have to do is to make you see and feel it and understand it."[35] In other words, Steinbeck created the stories and couched them in the facts as he understood them. This aspect was not lost on one contemporary critic who praised the novel for its "documentary informativeness."[36]

The term "documentary" was a favorite word of the period. To Edward Steichen the term was overused and applied to superficial images. In his estimation, however, the best FSA photographs defined the genre and were "the most remarkable human documents that were ever rendered in pictures."[37] Despite being a work of fiction, Steinbeck's novel was strongly entrenched in what has been called the "documentary decade."[38] Although not the typical "photographic-book-with-text," it was still considered to exhibit a "photographic style."[39] For instance, Hallie Flanagan, director of the Federal Theatre Project, saw *The Grapes of Wrath* as an integral part of the documentary tradition of the late 1930s. More specifically, Flanagan saw Steinbeck's novel as belonging to the same lineage as Erskine Caldwell and Margaret Bourke-White's *You Have Seen Their Faces* (1936), Dorothea Lange and Paul S. Taylor's *American Exodus* (1940), and Pare Lorentz's documentary film *The Plow That Broke the Plain* (1936).[40] The common denominator of all these works was that they presented to audiences a straightforward view of the challenges that faced rural America. The most noteworthy difference was that Steinbeck's text contained no photographic imagery.

It is important to note that *The Grapes of Wrath* was not pure fiction, just as many documentary texts were not entirely nonfiction. In *You Have Seen Their Faces* Caldwell invented the texts that accompanied Bourke-White's photographs of southern tenant farmers, in order to express "the authors' own conceptions of the sentiments of the individual portrayed; they do not pretend to reproduce the actual sentiments of these persons." Their one-sided approach caused resentment among southerners who justifiably believed that they had been manipulated.[41] In contrast, Taylor and Lange desired to "adhere to the standards of documentary photography as we have conceived them," recording only what people actually said, not what "they may or may not be thinking."[42] In the end, however, all investigations are subjective and carry the marks of their authors. As Jeff Allred put it, all documentary texts are merely "plausible fictions of the real."[43]

The publication of *The Grapes of Wrath* changed the discourse on the migrant. Thereafter everything that focused on the subject was framed by Steinbeck's novel. As David Wrobel explained, with his novel Steinbeck "created history."[44] When Paul Taylor and Dorothea Lange published *American Exodus* in 1939 they believed that they were complementing Steinbeck's

novel by presenting the actual conditions Steinbeck portrayed in his text.[45] Though he declined to endorse the text, Steinbeck admired Lange and Taylor's work and admitted to his editor, Pat Covici, "It follows very closely the *Grapes* although done independently."[46] Others saw the connection as well. One review was titled "Steinbeck in Pictures." Maynard Dixon, Lange's first husband, believed *American Exodus* was a more factual version of *The Grapes of Wrath*.[47] Lange's and Taylor's opponents, the Associated Farmers, labeled Taylor a "Grapes-of-Wrathy professor" and their collaborative effort a "grapes of wrathy" book.[48] Despite the links to Steinbeck's best seller, *American Exodus* was not a financial success. Lange's assistant Rondal Partridge remembers that she was disturbed by the publicity *The Grapes of Wrath* received and felt that it deflected attention away from her own work.[49]

The same might also be said of Carey McWilliams's book *Factories in the Field: The Story of Migratory Farm Labor in California,* which was published two months after *Grapes of Wrath.* Like Taylor, Lange, and Steinbeck, McWilliams lived and worked in California and was deeply committed to exposing the depth of the state's migrant problem. In 1935 he witnessed the migrant camps on a tour through the Central Valley. According to a close friend, "when he actually saw how migrant workers lived. . . . The sight of those people—that's what transformed Carey's life."[50] He had already left his family and a successful law practice; he now gave himself fully to the causes he championed. With his connections to various organizations like the Simon J. Lubin Society and his position as head of California's Division of Immigration and Housing under the progressive governor Culbert Olson, McWilliams was in a position to present evidence on the forces and challenges facing the state's migrants. It has been written that whereas Taylor and Lange went into the fields for their material, McWilliams went to the archives. In *Factories in the Field* McWilliams provided the statistics and data on the migrant problem in California and couched the Joads in historical and economic terms.[51] Even his presentation of facts, however, raised the ire of critics like Ross H. Gast, who accused McWilliams of an angry bias and careless documentation.[52] As important as these two texts were in their own right, they were seen as ancillaries to Steinbeck's novel.

FIGURE 48. Dorothea Lange, "Migratory family traveling across the desert in search of work in the cotton at Roswell, New Mexico. U.S. Route 70, Arizona." May 1937. *Library of Congress, LC-USF34-016725-E*

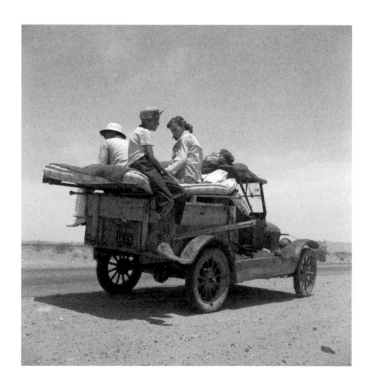

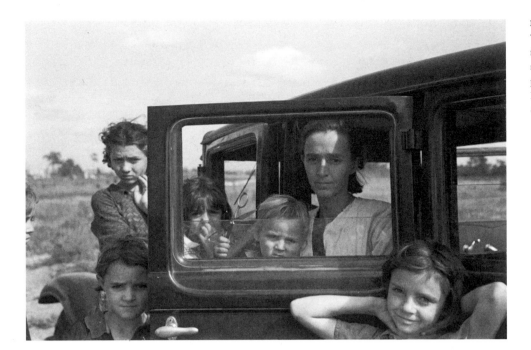

FIGURE 49. Arthur Rothstein, "The family of a migratory fruit worker from Tennessee now camped in a field near the packing house at Winter Haven, Florida." January 1937. *Library of Congress. LC-USF33-002372-M3*

The photography of the FSA was also seen through the lens of *Grapes of Wrath*. As early as April 1939 many noted the connections between Steinbeck's novel and the documentary photography of the day. In writing for the *Saturday Review*, George Stevens reminded readers of *Grapes of Wrath*: "You have seen them going West through Texas and New Mexico on Route 66, or you have seen them in the Resettlement Administration photographs: Three generations in a second hand truck, piled high with everything they own" (figure 48).[53] Whereas this subordination to Steinbeck's fame annoyed Lange, Taylor, and others, Stryker did not mind playing a subservient role if it would advance his interests.[54] Stryker could be egotistical, but when it came to the efforts of the Historical Section, he was quick to employ the photographs for what he saw as a greater cause. If ties to Steinbeck bolstered his agency's programs and alleviated suffering, he was willing to take the backseat.

Stryker was not philosophical when it came to photography. For him it was the content of the images and the use to which they were put that mattered. Photographs that did not serve a purpose could be discarded, or "killed," by Stryker's hole punch or by neglect.[55] If anything, Stryker believed that the work of the Historical Section could ground *The Grapes of Wrath* in a believable reality. Readers could doubt Steinbeck's vision, but few would question a photograph. Throughout his career Stryker relied upon the notion that photographs were seen as objective records derived by mechanical means. This belief was shared by others, including the man who hired him, Rexford Tugwell: "you could never say anything about a photograph—it was a photograph," Tugwell commented, "it was a picture. This was something that you couldn't deny. This was evident."[56] Like Stryker, Russell Lee believed photographs could support Steinbeck's novel by providing evidence that the crippling poverty and desperation of the migration were real.

Even before Steinbeck focused the nation's attention on the migrant, photographing migrants across the nation had already been a part of the Historical Section's coverage and program for several years. Leading up to the release of Steinbeck's book, Stryker's correspondence reveals his escalating interest in migrants. In letters to Lange, Lee, Rothstein, and Marion Post Wolcott he urged them to be on the lookout for migrants (figure 49). His actions suggest that he anticipated

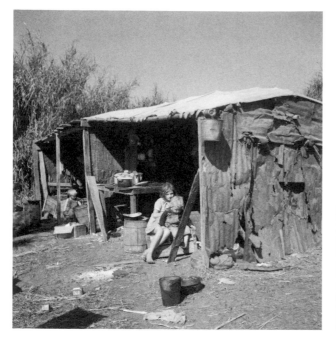

the interest Steinbeck's novel would produce. On April 11, 1939, just days before the book's official release, Stryker wrote Lange, asking her to continue working in the California migrant camps, "first, because it is part of our story and second, because there is a hell of a lot of insistence on having it."[57]

Clearly motivated by *Grapes of Wrath*'s success and anticipating requests for similar material, Stryker urged his photographers to be on the lookout for details that could tell the migrants' story. It was now "their story" too. He encouraged Wolcott to watch for migrants flooding into Florida. In and around Belle Glade she found what he was looking for (figure 50). "There's good material for me here," she wrote back, "conditions are awful at all times."[58] In August Lange photographed migrants working the hops, string bean, and peach harvests in Oregon and Washington (figure 51).[59] With *The Grapes of Wrath* on people's minds, however, the migrant coverage in the Midwest was the focus. Stryker wrote to Lee, who was then working in Texas, that he needed "pictures of labor displaced by the machine, migrants, and some tenant children pix."[60]

Lee had planned to work in Oklahoma before April 1939, but for various reasons his trip to the Sooner State had always been postponed for other, more urgent projects in the region. Everywhere he went, he had encountered farm refugees and so was already thinking about a "migrant story" months before the stir over *Grapes of Wrath*.[61] Outside the Texas towns of Edinburg and Harlingen near the Mexican border he found "rubber tramps," as they were called, living amongst mesquite trees in trailers and ramshackle homes. With the parents away working in the fields, Lee focused on the children of the migrant workers. Although they lived in difficult circumstances, these children were coping, as was a young migrant Lee photographed sitting on her cotton-picking sack outside her trailer (figure 52). To give depth to the story of the migrant Lee decided to focus his attention on three families—an idea that Stryker liked and encouraged others to emulate.[62] Focusing on these families put a human face on a problem that most Americans considered abstract or distant.

After the release of *Grapes of Wrath* in April and his proposal to Stryker to use it as a shooting script, Lee finally was compelled go to Oklahoma. The "migrant story" was now of paramount

importance. In the late spring and early summer of 1939 Lee traveled to the state, the home of the fictional Joads, to actualize Steinbeck's fiction by pursuing and photographing the real Joads. Prior to *Grapes of Wrath*'s publication, Lee had already established many of the themes and strategies he would employ in Oklahoma. With his *Grapes*-based shooting script, however, the investigation took on new layers of meaning and significance. He continued to focus on migrant families and interest himself in their lives and circumstances. With the swirling debate around Steinbeck's novel his subject matter was now *the* topic of public discussion. His work was destined for more than a government file. Lee must have envisioned it directly entering the larger discourse on the migrant issue.

By making *The Grapes of Wrath* his shooting script, Lee assumed that what he would find in Oklahoma would corroborate what Steinbeck wrote. It took Lee a couple of weeks to read the book; then, once in Oklahoma he spent months carefully and slowly dissecting it. Using Steinbeck's novel as a shooting script would, however, prove challenging. Stryker's shooting scripts typically listed three dozen or so items that he wanted his photographers to search out. With 200,000 words and more than 600 pages, *Grapes of Wrath* provided a flood of material for Lee. The novel was also more than the story of one family. Steinbeck's "interlude," or intercalary, chapters, which he used as parallels and metaphors to the larger narrative, were also worthy of illustration. Though large and complex, the novel did provide specific details and broader abstracts that Lee could look for and explore as he traveled through the land of the Joads.

In general the FSA photographers understood that shooting scripts were merely guidelines or suggestions, and that they could work within or beyond those parameters.[63] As John Collier, Jr., pointed out, 90 percent of all work done with a script was accomplished "between the lines."[64] This was certainly true of Lee's coverage in Oklahoma. A good deal of his work would come directly from Steinbeck's text, but his images suggest that he improvised a great deal. According to David Peeler, "Throughout his search, Lee was sustained by the belief that he should photograph Oklahoma not as it was, but as he and Steinbeck thought it should be."[65] Some of the material Lee excavated from the scene, however, revealed findings not contained in the novel.

FIGURE 52. Russell Lee, "Child of migrant worker near Harlingen, Texas." February 1939. *Library of Congress, LC-USF33-011999-M1*

Russell Lee entered Oklahoma from the southwest and drove through the heart of the state to the eastern side. His destination was the area around Sallisaw, located in the eastern county of Sequoyah, not only because it was the home of the fictional Joads, but also because that region was hard hit economically. In February Lee wrote to Stryker that Regional Information Advisor John H. Caulfield had informed him that the "destitute nature" of the area surpassed anything else in the region.[66] On this basis Lee traveled eastward and made the city of Muskogee his base of operation. From there he fanned out to towns such as Webbers Falls, Warner, Spiro, and eventually Sallisaw.

Even for those who knew the migrant route to California, Steinbeck's description of the Joads' travels could be convincing. Joseph Henry Jackson commented that *Grapes of Wrath* "is completely authentic. Steinbeck knows. He went back to Oklahoma and then came West with the migrants, lived in their camps, saw their pitiful brave highway communities, the life of the itinerant beside the road."[67] Florence Thompson, the "Migrant Mother," concurred: "When Steinbeck wrote *The Grapes of Wrath* about those people living under the bridge at Bakersfield—at one time we lived under that bridge. It was the same story."[68]

For Upton Sinclair Steinbeck's narrative was so convincing that reading it became a visceral experience:

> Steinbeck has been among these people, he has sat down with the men and the women, the old folks and the children; he has heard their stories, noted all the turns of their dialect, and gone home and made voluminous notes. More important yet, he has lived those stories in his own heart, he puts them before you with such vividness and tenderness that you go through the whole experience of each and every member of a large family of Oklahoma sharecroppers. You see the dust storms come and destroy your crops and you are "tractored" off your land. You sell nearly everything you own, and buy an old truck, and load your family into it, and make the long and terrifying journey to the promised land of California, where all the houses are white and you can pick oranges right off the trees and eat them. You bury old "grandpa" on the way, and find old "gramma" dead after you have crossed the California desert on a hot night.... Everything is real, everything is perfect.[69]

The irony, of course, is that Steinbeck did not fully know the geography of the migrants' pilgrimage east of California's borders. He was familiar with the migrants, their habits, and their stories, but much of his information about geography and landscape was acquired secondhand.

In *The Grapes of Wrath*, Steinbeck describes eastern Oklahoma in bleak terms. The land was red, gray, and scarred, according to the novel's first line. Throughout the narrative the region figures as a heated landscape of dried fields and starved tree clumps, blighted by the strong sun and plagued by blowing dust that covered everything like "red flour."[70] In all, the novel suggests a landscape resembling Rothstein's photographs of Cimarron County or the "sinister beauty" of painter Alexandre Hogue's contemporaneous landscapes of errant sand dunes and erosion (figure 53).[71] In truth Steinbeck's words came closer to describing the Dust Bowl of the Western panhandle of Oklahoma and Texas than the region around Sallisaw.

For critics looking to find fault with Steinbeck's narrative his questionable geography proved an easy target. One observer remarked, "Sallisaw . . . is as far away from the dust bowl as it is possible to be and still stay in Oklahoma."[72] Houston Ward, the county agent responsible for the area, ridiculed Steinbeck for suggesting that Grandpa Joad wanted to squash California grapes over his face, given that Sequoyah County was one of the largest grape-growing regions

FIGURE 53. Alexandre Hogue, *Avalanche by Wind*, 1944. Oil on canvas (original in color). *Collection of the University of Arizona Museum of Art and Archive of Visual Arts, Tucson.*

in America.[73] Even Carey McWilliams, one of Steinbeck's staunchest advocates, conceded that the author's geography was inaccurate:

> In the fall of 1940 I visited Oklahoma to discover, if possible, why thousands of American farm families had been uprooted from their homes and set adrift on the land. I had not been in Oklahoma long before I realized that "dust" and "tractors" accounted for only a small part of the migration. Sallisaw, the home of the Joad family in *The Grapes of Wrath*, is far from the dust bowl and there were probably not more than ten tractors in all of Sequoyah County in 1937. Mr. Steinbeck's slightly confused geography is merely indicative of a general failure to understand the deep-seated causes of poverty and unrest in Oklahoma's farm population.[74]

Although McWilliams conceded that Steinbeck's geography was "slightly confused," he still called it a "factual elaboration."[75] Indeed Steinbeck was not completely off the mark in situating the opening of his narrative in this part of the state. Eastern Oklahoma may not have been a dust bowl, but it was suffering from heat waves and drought. In reality only 6 percent of the so-called Dust Bowl refugees actually came from the Dust Bowl region.[76] In fact, it was estimated that more migrants originated from eastern Oklahoma than anywhere else, due to the "chronic pressure of population on resources" and other challenges there.[77]

When he visited the Sallisaw area Lee found a landscape that differed from Steinbeck's description. Located in the Ozark Hills east of the 98th meridian (considered the eastern boundary of the Dust Bowl), Sallisaw was a land of rivers, fields, and hardwood forests. In J. Russell Smith's textbook *North America*, the veritable handbook of the FSA, Lee would also have read of a complex geographical region that benefited from good rainfall, averaging between ten and thirteen inches in the summer months.[78] This was clearly not the Dust Bowl. If Lee was to prove Steinbeck's veracity, it was essential that he find the worst the area had to offer.

Before Lee entered Oklahoma Stryker provided him instructions on what he was to look for. "From now on, as you move up on the Steinbeck pictures," he wrote, "watch for photographs that

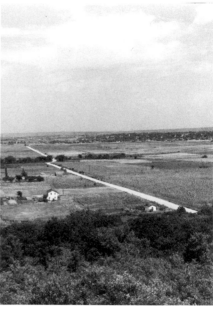

FIGURE 54. Russell Lee,
"Landscape [Panorama] near
Muskogee, Oklahoma." July 1939.
*Library of Congress, a. LC-USF34-033980-D
and b. LC-USF34-033981-D*

give a feeling of the expansiveness and dreariness of this land. They are hard to get, but are very essential.[79] Evidently Stryker suspected that finding a landscape analogous to the description in *Grapes of Wrath* might be a challenge. In eastern Oklahoma Lee may not have found the dusty landscape of Steinbeck's narrative, but he still did encounter a region in the grip of hard times and did find many residents who were struggling to survive.

Eastern Oklahoma was of great interest to the FSA. It was the site of the FSA's Eastern Oklahoma Farms Project, which was designed to curb soil erosion and to relocate farmers onto more productive land.[80] For Lee the land was to become a powerful symbol of why families in

FIGURE 55. Russell Lee,
"Landscape in Oklahoma
showing man plowing in cotton
field in background and profile of
soil showing easily erodable [sic]
structure in foreground. Near
Warner, Oklahoma." June 1939.
Library of Congress, LC-USF34-033441-D

From Controversy to Icon

eastern Oklahoma were finding life on the plains so difficult. In his notebooks he recorded how erosion and recurring floods were harming the local farmers.[81] Near Muskogee Lee created a panorama of the surrounding fields, which allowed him to capture the "expansiveness" that Stryker sought (figure 54). From a distance the fields look healthy and the farms prosperous. A closer image made farther to the south, however, reveals a different story. Here a cotton farmer is shown plowing his fields by horse and plow. In his captions Lee noted that the soil in the foreground was in decline and "easily erodible" (figure 55). Lee could find "dreariness" as well.

In this image of a cotton field, Lee chose to photograph a farmer working the land in the traditional manner, with a horse and plow rather than a motorized tractor. This was an important detail for Lee. To some the tractor was the great symbol of progress; to others it represented the end of a way of life. Mechanized farming was an easy target at the time and many, from Taylor and Lange to Steinbeck, repeatedly pointed out how it displaced thousands of farm laborers. Lee expressed similar sentiments. At one point he noted in his field book that there were only forty tractors in Frederick County, Oklahoma—a far cry from the "thunder of tractors" that spelled the end for the Joads and their peers in *Grapes of Wrath*.[82]

In *The Grapes of Wrath* the Joads left on their westward trek in the middle of the night, with little or no concern for their home or the possessions they could not affix to their automobile. Flight was of paramount importance. In Oklahoma Lee focused on abandonment as another tangible symbol in his *Grapes of Wrath* shooting script. In the novel Jim Casy, the preacher-turned-wanderer, exclaims, "Somepin's happening. I went up an' looked, an' the houses are all empty, an' the lan' is empty, an' this whole country is empty."[83] Lee evidently did not find loss and abandonment difficult to locate. By the time he photographed a small trading town named Akins outside of Sallisaw it was a ghost town. The old, abandoned schoolhouse in the town provided a telling metaphor (figure 56). Other small towns like Forgan were almost completely boarded up. In and around the countryside he photographed abandoned farms with corn and cotton crops still growing in the fields. These residents simply could not hold out for the harvest.

Working his way in closer Lee photographed small, ramshackle dwellings, former homes of tenant farmers and sharecroppers left empty and quiet (figure 57). On weathered porches he

FIGURE 56. Russell Lee, "Old school in Akins, Oklahoma. This town was formerly a cotton ginning center as well as a trading center for the surrounding farm community. There is no ginning done there now and it has assumed the status of a ghost town." June 1939. *Library of Congress, LC-USF34-033676-D*

found broken chairs, bedsteads, and canning jars. In McIntosh County he found an abandoned house similar to the one Steinbeck described in chapter 11 of his novel (figure 58). Vacant and abused it seemed to fit the author's description of houses that "swung open, and drifted back and forth with the wind."[84] The former inhabitants had presumably followed the Joads on the Mother Road to the West.

In larger centers like Muskogee, Lee also photographed the pawnshops and exchange companies where migrants jettisoned their goods for a little money. Rector's Exchange offered farming tools, and a secondhand furniture store literally overflowed with tables and washstands (figure 59). By indirect means Lee clearly wanted to express how former lives were liquidated for a chance to pursue the life of a refugee. In reality the FSA was doing all it could to keep people off the migrant trail. In 1938 the agency claimed to have paid thirty million dollars in small loans and other assistance to keep people on their lands in Oklahoma and Texas.[85] Lee's photographs showed that federal relief was not able to reach everyone in time.

Lee's emphasis on the land and its abandonment were important components of his work in Oklahoma and helped provide support for Steinbeck's text. Judging from his work, however, it seems that Lee believed the poverty he experienced in the region provided the strongest case that the destitute Joads were not imagined creatures. By focusing on the unrelenting poverty of those who were still tied to the land, Lee graphically illustrated why so many were willing to sacrifice everything for the chance of a better life in the distant West.

In his description of Oklahoma Steinbeck implied that few people stayed behind. Those that did, like the Joads' neurotic neighbor Muley, had psychological reasons or deficiencies that kept them rooted in the shifting sands. Lee was clearly interested in fleshing out the story of the farmers who remained, and he spent weeks recording the poverty around Sallisaw. Lee gave careful attention to the two groups hardest hit by the Depression—day laborers and tenant farmers.

FIGURE 57. Russell Lee, "Abandoned house, surrounded by growing corn, McIntosh Co., Oklahoma." June 1939. *Library of Congress, LC-USF33-012245-M2*

FIGURE 58. Russell Lee, "Interior of abandoned farmhouse in McIntosh County, Oklahoma." June 1939. *Library of Congress, LC-USF34-033498-D*

FIGURE 59. Russell Lee, "Man in front of secondhand store, Muskogee, Oklahoma." July 1939. *Library of Congress, LC-USF33-012333-M1*

In June Lee updated Stryker on what he was finding. "The conditions of rural poverty are very great among these Eastern Oklahomans," he explained, "probably the worst I've seen."[86] These conditions, he continued, were producing families that were beaten, frustrated, and even militant.

In the early years of the Historical Section the emphasis was on showing the desperate need for federal programs. Stryker's photographers were encouraged to document poverty while highlighting "dignity over despair."[87] By 1937, however, Stryker instructed his photographers to show a more positive side of the country by photographing everything from teenagers on Main Street to mailboxes.[88] The photographers' primary responsibility was still to record the agency's programs and activities, but increasingly they were also to take "pictures of nearly any subject that was significant as a document of American culture."[89] The new slogan for Stryker's team became introducing "America to Americans."[90] Just days before *The Grapes of Wrath*'s publication and Lee's proposal of a shooting script to align with it, Stryker wrote Lee, urging him to find images of prosperous Midwestern farms to balance out the "bad conditions" he had already documented. "Keep an eye out for them," he wrote. "Put on the syrup and white clouds and play on the sentiment."[91] Lee found what Stryker wanted in the small town of San Augustine in southeastern Texas. Lee spent weeks thoroughly documenting the town—one of the most positive visions of small-town life ever created. It was during his coverage of San Augustine and what was right in rural America that Lee wrote to Stryker requesting a copy of *The Grapes of Wrath*.[92]

Once he began investigating Steinbeck's fiction in Oklahoma, Lee confronted situations that challenged the rosy side of rural life Stryker longed to document. During his work in the summer of 1939 Lee was severely pressed to find a positive angle. Once again he reverted to recording scenes of squalor, misery, and despair. His creations were some of the most harrowing photographs of his tenure with the FSA and provided further evidence that Steinbeck's fiction was not far off the mark.

During his travels Lee worked in the counties surrounding Sallisaw. This was *the* place, Lee noted, "where Steinbeck's characters came from."[93] If he wanted to prove that the Joads were only a metaphor for numerous other families toiling under the strain of the Depression, Sallisaw

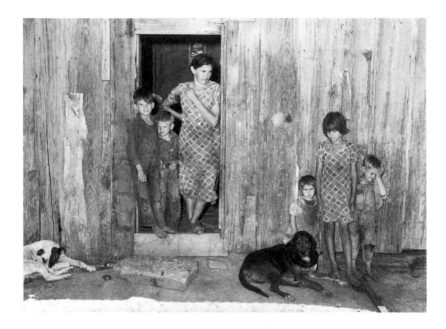

was the place to look. His objective was to find conditions similar to the ones in the text, conditions which proved that migration was inevitable (figure 60). For Lee those that stayed behind were the "forgotten men."[94] His goal was to get into their homes and expose the depths of their lives (figure 61).[95] Images of poverty and destitution were seemingly easy to find. In Sallisaw Lee documented a ragged and dirty young child in the cluttered and fly-infested kitchen of a home with chickens running around on the floor (figure 62). In another photograph he captured an elderly couple who had moved out of their home into a tent so that they could save money (figure 63). These works were clearly designed to be sympathetic documentations of how and why the Joads—or any other family for that matter—would have abandoned such circumstances and gambled everything for a better life in California.

As he worked through the region surrounding Sallisaw he found and photographed gaunt farmers and their families living in small shack houses swarming with flies. In one he documented

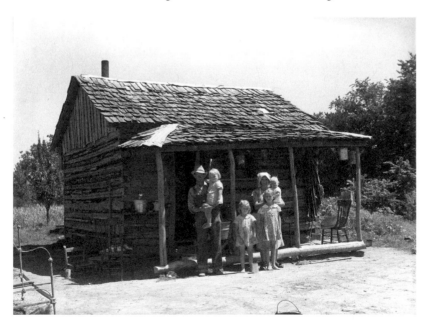

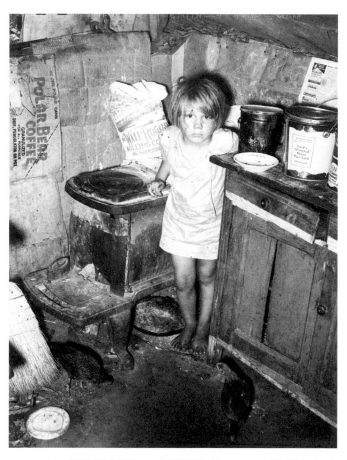

FIGURE 62. Russell Lee,
"Corner of kitchen in tent
home of family near Sallisaw,
Oklahoma. Sequoyah County."
June 1939. *Library of Congress,
LC-USF34-033699-D*

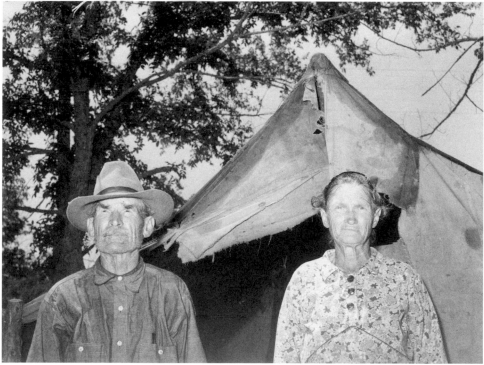

FIGURE 63. Russell Lee,
"Old couple who have moved
into tent home near Sallisaw,
Oklahoma, in order to save rent
and cost of wood in town."
June 1939. *Library of Congress,
LC-USF34-033672-D*

two small toddlers with distended bellies due to malnutrition and a diet, Lee posited, containing too many starches (figure 64).[96] He also found individuals ravaged by malaria and other diseases. Near Spiro he encountered a tubercular woman and child too weak to work or move. The mother reported that she had lost six of her eight children. Lee noted that the two survivors were "pitifully thin" (figure 65). In many of his captions he also recorded a phrase or two from his subjects. One young man reported "I get worse off every year." Another reported, "We can't make a living here. There ain't no rain, it won't grow cotton no more, we can't get enough of it to grow vittals (sic) for our wives and kids. . . . Oklahoma is hard."[97] In spite of the difficulties there was a distant glimmer that the future would be better. As one day laborer told Lee, "I hope the next time you see me you'll find me in better condition."[98]

Following a technique he developed earlier Lee narrowed his investigation to specific families who, he must have believed, were emblematic of Oklahoma's "forgotten men." In Webbers Falls, along the banks of the Arkansas River, Lee found and photographed a family of eight sitting down to dinner in their one-room home after a morning of picking cotton. Both parents and many of the children of this home worked in the fields. For the children of tenant farmers it was not uncommon at age six to begin working from dawn to dust, or "can to can't."[99] Lee's ability to gain access to people's homes is clearly on display in these images. After a morning of hard labor the family is clearly more focused on eating their meal of beans and coffee than minding what a photographer was doing in their midst (figure 66).[100]

To an outside audience the circumstances of the Webbers Falls family seem somewhat better

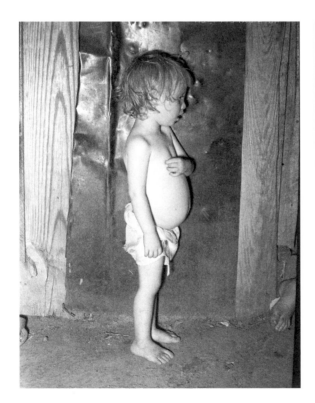

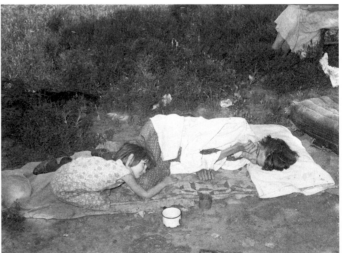

FIGURE 64. Russell Lee, "Child of agricultural day laborer living near Tullahassee, Oklahoma. Notice the distended stomach, which is indicative of malnutrition and unbalanced diet with too many starchy foods. This condition is prevalent throughout the tenant farmer and day laboring families in Oklahoma." June 1939. *Library of Congress, LC-USF34-033582-D*

FIGURE 65. Russell Lee, "Tubercular wife and daughter of agricultural day laborer. She had lost six of her eight children and the remaining two were pitifully thin. The mother said that she had tuberculosis because she had always gone back to the fields to work within two or three days after her children were born. Shack home is on Poteau Creek near Spiro, Oklahoma." June 1939. *Library of Congress, LC-USF34-033601-D*

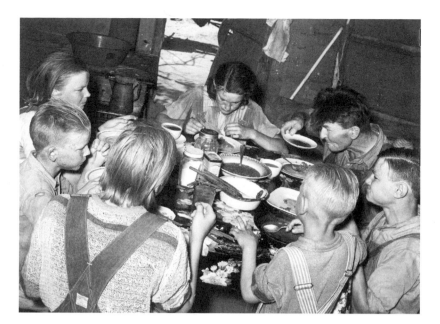

FIGURE 66. Russell Lee, "A family of agricultural day laborers eating dinner after a morning spent in chopping cotton. Though the fare of these people consists of the inexpensive and heavy starches, it is usually well prepared. This tent in which eight people lived was clean and neat. Notice the freshly combed hair of the youngsters. Near Webbers Falls, Oklahoma." June 1939. *Library of Congress, LC-USF34-033408-D*

than other families but still dismal. Like their table, the shack home is crammed. Their meal, as Lee informs us, is inexpensive and heavy on starches. Even in this scene Lee was optimistic. He noted that even though it is humble, their meal is "usually well prepared." Furthermore, "this tent in which eight people lived was clean and neat." Addressing his audience, Lee concluded, "Notice the freshly combed hair of the youngsters." Even in poverty there was dignity and hope.

Lee found another family in Webbers Falls whose lot was notably more tenuous and destitute. Lee found and took a series of photographs of the children of a day laborer living in an old and rundown home. In one image he showed the two children sitting on the bed, the arm of the older sister resting across the shoulders of her cross-eyed brother (figure 67). Evidently this teenage daughter was an example of a "little mother" who stayed at home watching her siblings so that the parents could work in the fields.[101] Domestic tasks were left to daughters while sons went out to work.[102] In his captions Lee informed his audience that the two children had never attended

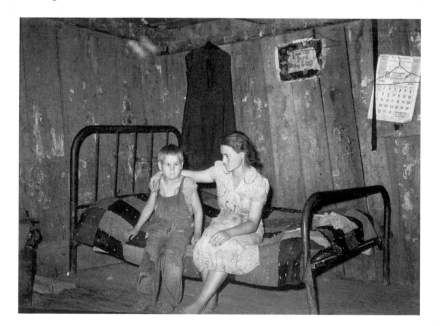

FIGURE 67. Russell Lee, "Daughter and son of agricultural day laborer living near Webbers Falls, Oklahoma. The furnishings of this shack were meager and broken and filthy. Muskogee County." June 1939. *Library of Congress, LC-USF34-033403-D*

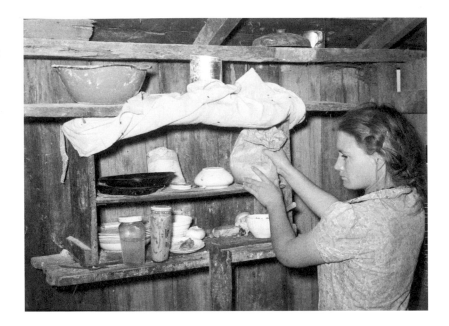

school. He also noted that the furnishings of the "shack were meager and broken and filthy" and that "the entire family was demoralized in every way." Looking at the photographs it would be difficult to argue with Lee's assessment.

Lee photographed the two children a number of times but seemed to focus his attention on the daughter. He showed her opening a cloth-covered kitchen cabinet to reveal the meager means of this family (figure 68). Throughout his work with the FSA Lee often photographed the family kitchen as a way to gauge the level of poverty or self-sufficiency of a particular family. Even in the homes of many of the poorest tenant families in Oklahoma he found some provisions. Here he found next to nothing. This photographic act was obtrusive, but it made the point Lee wanted to make. At no time did the young woman look into Lee's camera. In another image Lee photographed her standing barefoot by the humble home's window. Poignantly she stares out the opening looking forlorn and distant (figure 69). Lee's caption reveals more. "Her attitude was one of utter hopelessness," he wrote; "she was listless and completely untouched and uninterested in any living thing." Through a counterpoint of images and captions Lee put forth a strong argument that what could be seen and recorded by the camera represented only a small part of what poverty did to the individual. As witnessed in Lee's young subject, the psychological effects of hardship were often just as devastating as the physical. As Caroline Bird wrote, "The Depression hurt people and maimed them permanently because it literally depressed mind and spirit."[103]

Lee's images of played-out land, poverty, and abandonment helped capture the "source and environment" that verified Steinbeck's novel.[104] Once in Oklahoma, however, Lee must have realized that Steinbeck's narrative told only one part of the story. His photographs strongly suggest that he encountered circumstances and conditions that did not match his close reading of the novel. It was only a matter of time until he strayed from his *Grapes of Wrath* shooting script. In other words, Lee was bound to see more than Steinbeck's novel presented. This should not come as a surprise, for Steinbeck's portrait of Oklahoma was fabricated or based on secondhand accounts. Moreover, what written account could ever match the complexity of a real scene, particularly when Steinbeck was focused on telling one part of the story—the flood of refugees into California?

At times Lee's work even contradicted what Steinbeck wrote in his novel. Such was the

FIGURE 69. Russell Lee, "Daughter of agricultural day laborer looking out the unshuttered window of the desolate shack which was her home. She had never attended school. Her attitude was one of utter hopelessness; she was listless and completely untouched and uninterested in any living thing. Webbers Falls, Oklahoma." June 1939. *Library of Congress, LC-USF34-033405-D*

case when he photographed a Saturday-night square dance in a sharecropper's home in the hills above McAlester. Unlike the crestfallen Joads these sharecroppers, though poor, joyfully celebrate a respite from their daily labors. In another image Lee photographed a table set with a solid meal of "beans, cornbread, lettuce, fried potatoes, fatback and gravy, coleslaw and sweet milk" (figure 70). This meal was similar in description to the more humble meal the Joads enjoyed the night Tom Joad returned from prison.[105] Yet in Lee's photograph the recognizably southern dishes are presented in a way that seems more prosperous than the meal Steinbeck described to his readers.

To gain a full picture of the situation in eastern Oklahoma Lee also consulted regional directors, informants, and additional texts. One of his most important sources was Edwin Lanham's novel *The Stricklands*. Published one month before *The Grapes of Wrath,* Lanham's book was highly acclaimed and praised by critics, including those of the *New York Times* and *The Nation*. Oliver LaFarge, writing for the *Saturday Review of Literature*, believed it to be a "good bet" for the Pulitzer.[106] Fate, however, was not on Lanham's side. In the tempest that ignited after the publication of Steinbeck's book, *The Stricklands* was quickly forgotten.[107]

Although he began his writing career in Paris, Lanham was a product of the Midwest. Born in northern Texas in 1904, Lanham had deep roots in the land and its people, which found their way into his work. Like *Grapes of Wrath,* Lanham's novel is a realistic fictional tale rooted in Oklahoma. It tells the story of the Strickland family and its two sons, Jay, a labor organizer, and his outlaw brother, Pat. Lanham carefully details the activities of Jay Strickland as he attempts to organize the community around Muskogee for the Southern Tenant Farmers Union (STFU). In spite of his brother's misdeeds and the fall of his family, he persistently works to unite members of the local Negro communities as well as various Native American tribes. In the end Jay succeeds in creating unity, but is left with little else.

Lanham provides a more accurate description of the landscape and the complexities of eastern Oklahoma than Steinbeck does. Lanham describes the region as not a dust bowl but a land of "close green woods."[108] He also offers a much more realistic demographic portrait of Oklahoma, which was historically more diverse than any other state in the Midwest. Moreover, Lanham's

narrative was timely. It addressed the local intervention of the federal government, the workings of the FSA, and the ongoing struggles of the STFU, which was founded in 1934 by H. L. Mitchell and Isaac Shaw to organize farm labor in the South across racial lines.

In the summer of 1939 *The Grapes of Wrath* and *The Stricklands*—two fictional novels—informed Russell Lee's work in the real Oklahoma. Although Lanham's novel did not match the intensity of Steinbeck's work in Lee's opinion, it clearly helped shape his documentation in profound ways.[109] *The Stricklands* never became a shooting script for Lee, but it did influence his work and provide another window into the problems of eastern Oklahoma. Lee's use of both texts was not unusual, for they were often linked in the public consciousness at the time. It was suggested that they told two sides of the same story. In the *New York Times* on April 14, 1939, Charles Poore suggested that the two texts shaped a deeper understanding of the Okie problem. Both books, Poore believed, were "vigorously rooted in the American earth" and dealt with the same people—Oklahomans who were "dogged by disaster" and struggling to survive.[110] Furthermore, Steinbeck's novel was cast as providing the general spirit of the struggle whereas Lanham's text provided the particulars.

Lee was also assisted by Otis L. Sweeden, a labor organizer and the inspiration behind Lanham's character of Jay Strickland. A Cherokee by birth, Sweeden was fluent in three languages, including Choctaw. He was also a former member of the STFU and an ardent union activist. Though irascible and cantankerous he was a persuasive and successful organizer. Within less than a year after he had assembled his first local in 1935 he organized seventy-five other units, totaling 8,500 members and nearly 100 community councils.[111] According to H. L. Mitchell, co-founder of the STFU, Sweeden was a "fiery, imaginative person" who was able to align blacks, whites, and Native Americans in the fight for land redistribution in Oklahoma. Unfortunately, the cause of Sweeden and the STFU was hindered by the overland migration, which substantially reduced union membership in the state.[112]

Sweeden and Lee's loose partnership was based on mutual interests and like-minded institutions. Representing nearly 15,000 low-income farmers spread across six southern states, the STFU was a natural ally of the FSA. In 1937 the STFU helped arrange Dorothea Lange's trip through the Mississippi Delta, and one year later she photographed H. L. Mitchell and President J. R. Butler in the STFU headquarters (figure 71).[113] In 1938 the union helped Lee gain access to "almost anyplace" in Memphis.[114]

In 1939 Sweeden acted as Lee's guide to eastern Oklahoma. From his home in Muskogee he toured Lee around the town, the surrounding counties, and the "mountain country."[115] He also presumably took Lee to an STFU meeting and a gathering of the Worker's Alliance, which featured a speech by Stanley Clarke, "the old-time socialist" from Texas.[116] Both meetings featured a racially diverse group of farmers united in a common cause. As a former STFU union organizer, Sweeden, like his fictional counterpart Jay Strickland, had traveled extensively along the back roads of Oklahoma and knew the tenant farmers and their situation. The fact that he had been in their homes and had worked among them clearly helped Lee gain access and insight into their lives.

One of the more interesting discrepancies between Steinbeck's fiction and what Lee experienced in Oklahoma was the state's multicultural and multiracial realities. *Grapes of Wrath* focuses almost entirely on white migrants. Lanham's book, in contrast, acknowledged the presence of Native Americans as well as established African American communities. For the most part Steinbeck ignored the plight of minority groups whether in Oklahoma, where Native Americans have historically made up a large part of the population, or in California, where Mexicans and Filipinos were displaced by the cheap labor the Okies provided. Steinbeck's primary concern was telling the story of "pure American stock."[117] Lee's documentation represents an expansion of the idea of "we the people."[118]

Despite Stryker's hesitancy about photographing Native Americans, Lee made a concerted effort to document the conditions of those he found during his work in eastern Oklahoma.[119] It would have been wrong not to. In *Grapes of Wrath* the Native American is no more than a symbol of the past. As Louis Owens explained, Native Americans were used symbolically in the novel to represent what had been lost in the push toward civilization and urban life. They had "mythic dimensions but no further reality."[120] "Grampa killed Indians, Pa killed snakes for the land," an anonymous tenant cries in Steinbeck's text, "Maybe we can kill banks—they're worse than Indians and snakes."[121]

The presence of the Indian in the state was no mere symbol of the past; it was a present reality. Following the Indian Removal Act of 1830, which forced thousands of Native Americans out of the Southeast and elsewhere, Oklahoma became the home of the transplanted Five Civilized Tribes—Choctaw, Seminole, Muscogee (Creek), Chickasaw, and Cherokee. Their Trail of Tears marked one of the darker and more devastating migrations in American history. Despite setbacks and the loss of millions of acres to white settlers after their arrival, the tribes maintained a very real and widespread presence in the state. "Migrant Mother" Florence Thompson was of Cherokee descent and had purportedly been born in a tepee.[122] Steinbeck was not ignorant of this fact. In an early draft Tom Joad was described having dark eyes, which, Steinbeck wrote, "usually means Indian blood," a phrase dropped from the final work.[123]

The area of Lee's investigation was one of the most racially diverse in the state.[124] With the

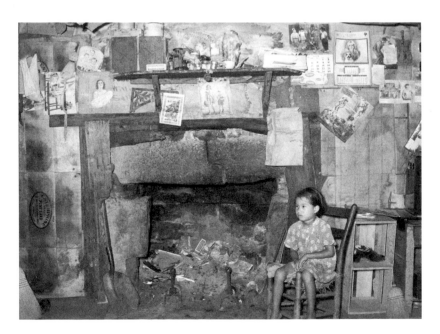

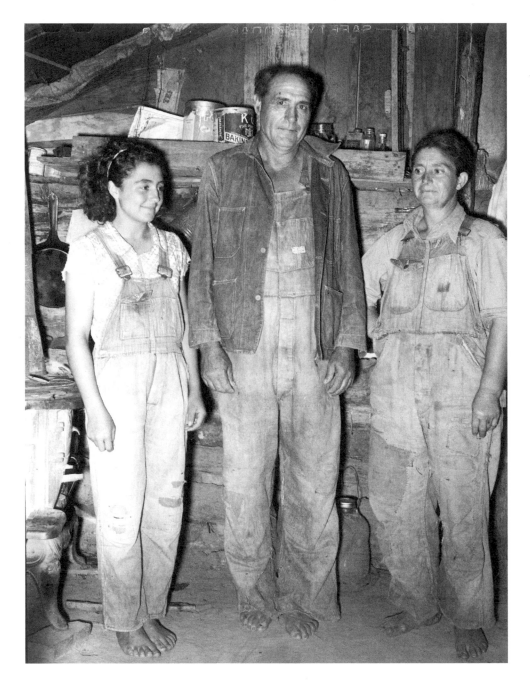

FIGURE 73. Russell Lee, "Indian agricultural workers. McIntosh County, Oklahoma." June 1939. *Library of Congress, LC-USF34-033752-D*

help of others Lee came to know this situation. Working out of Muskogee, the heart of the Creek Nation, Lee encountered many families whose roots in the area ran deep. In many ways the Native American families Lee photographed in the area suffered from the same deplorable conditions as white tenant farmers (figure 72). Their homes were just as ragged and ramshackle as their neighbors. One family of three stood barefoot before Lee's camera wearing bib overalls, what Agee called "the standard working garment" of the American farmer (figure 73).[125] In all, they did not look much different from their white neighbors. Lee's work with Oklahoma's minorities revealed a difference from the common situation of white sharecroppers and agricultural workers though. The former were not migrants or potential refugees but individuals deeply tied to a land of give and take. There was permanence in spite of their poverty.

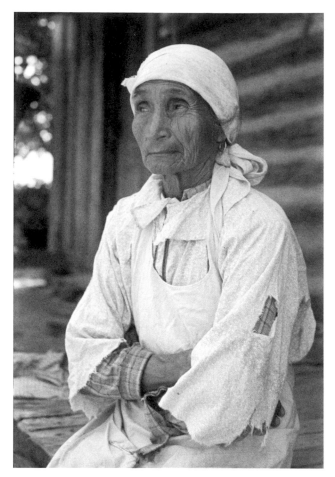

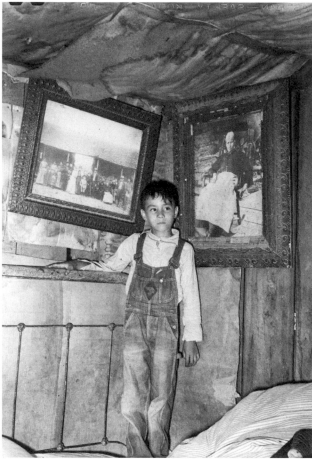

FIGURE 74. Russell Lee, "Indian woman, wife of farmer, McIntosh County, Oklahoma." June 1939. *Library of Congress, LC-USF33-012244-M5*

FIGURE 75. Russell Lee, "Indian boy between portraits of his ancestors. Near Sallisaw, Oklahoma." June 1939. *Library of Congress, LC-USF34-033721-D*

Somewhere in McIntosh County Lee created an intimate portrait of an elderly Indian farmer's wife sitting on the porch of her home (figure 74).[126] Her face is clearly worn by age and her outer clothing threadbare, but there is solidity in this Choctaw woman. Her distant gaze, folded arms, and slight smile all seem to suggest resolution and endurance. There is simply more than economics keeping this woman and other Native families tied to the land. When Lee photographed an Indian child in Sallisaw in front of a rough, worn wall bearing the neatly framed pictures of his ancestors, he followed a trope that was often used by FSA photographers and of which Lee himself was particularly fond (figure 75).[127] Photographs of the living alongside the images of ancestors stitched generations together, reflecting resilience and permanence. In 1938 John Collier, Sr., head of the Bureau of Indian Affairs, stated, "The Indian is no longer a dying race."[128] Lee's photographs corroborate Collier by showing Natives Americans as enduring and adaptable even in the face of poverty. They were, moreover, rooted to the land and a legacy that others saw as eroding and blowing away to the West.

Many of these virtues may also be seen in Lee's portrait of the African Americans who lived alongside Native American and white farmers. *Grapes of Wrath* contains no mention of blacks in Oklahoma; Steinbeck may have ignored Oklahoma's minorities but the FSA photographers did not. As Nicholas Natanson demonstrated, the percentage of African Americans in FSA photographs of Oklahoma exceeded their representation in the population.[129] Again, it seems that *The Stricklands* and Sweeden's entrée were instrumental in helping Lee gain access to communities

From Controversy to Icon

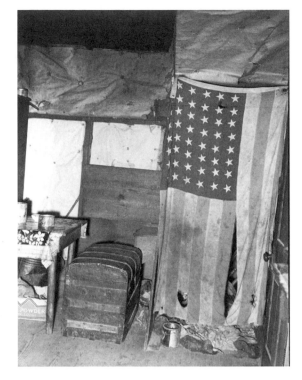

FIGURE 76. Russell Lee, "Interior of home of Negro agricultural day laborer. Wagoner County, Oklahoma." June 1939. *Library of Congress, LC-USF34-033659-D*

that might otherwise have been sealed off to outsiders making pictures for the federal government.

Oklahoma was a segregated society in the 1930s, but African Americans were seen as having higher status than Okies.[130] Eastern Oklahoma, including the region where Lee worked, boasted a large population of African Americans with deep roots in the area. Taft, a town east of Muskogee, was an "all Negro community" established by freed slaves after the Civil War.[131] During the Great Depression black families were hit at least as hard as everyone else, and Roosevelt was particularly interested in supporting them.[132] Under the leadership of Dr. Will Alexander, the FSA attempted to be as color blind as possible in helping America's rural poor. Of the estimated eight thousand families the FSA served during its tenure, nearly 20 percent were black.[133]

During the summer of 1939 Lee documented several black households in the area and created a portrait that had much in common with his representation of the region's Native American holdouts. Like everyone else blacks lived in conditions of poverty and squalor (figure 76). Their homes, in many cases, seemed to be transient—mere impermanent huts that reflected the persistent difficulties of living in a hardscrabble environment (figure 77). One image highlights a solitary black tenant farmer on the land of an absentee owner (figure 78). Concern is clearly evident on the man's face, but he also appears resilient even as his home seems to rot and collapse around him.[134]

FIGURE 77. Russell Lee, "Home of Negro agricultural day laborers in Arkansas River bottoms. Near Vian, Oklahoma, Sequoyah County." June 1939. *Library of Congress, LC-USF34-033635-D*

FIGURE 78. Russell Lee, "Tenant farmer of absentee owner. Muskogee County, Oklahoma." June 1939. *Library of Congress, LC-USF34-033735-D*

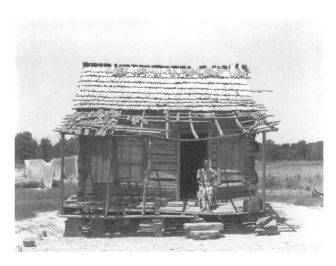

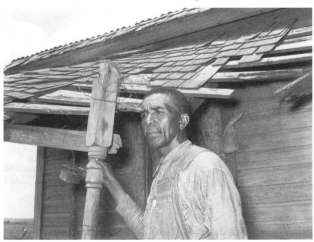

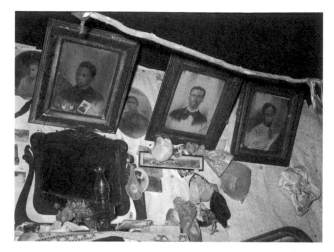 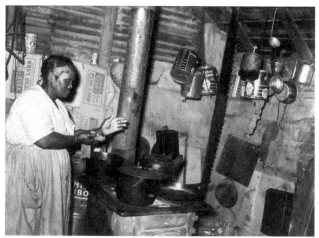

FIGURE 79. Russell Lee, "Ancestors of Negro day laborer. Wagoner County, Oklahoma." June 1939. *Library of Congress, LC-USF34-033660-D*

FIGURE 80. Russell Lee, "Negro farm owner working in kitchen. Arkansas River bottoms near Vian, Oklahoma." June 1939. *Library of Congress, LC-USF34-033628-D*

Inside the homes of his African American subjects Lee photographed ancestral portraits, just as he did in Native American households. In one day laborer's home he documented distinguished ancestors respectfully framed high on the wall (figure 79).[135] Agricultural day laborers were on the bottom rung of society but here they had place. Again Lee stressed that in spite of the dire circumstances African American laborers had deeper roots than their beleaguered white counterparts. This was particularly evident in Lee's documentation of black farmers working along the Arkansas River near Vian, just east of Sallisaw. He noted that one of these workers was a female "Negro farm owner" whose sons operated their small property. Like many others he photographed, this family's situation was humble. The walls of their home, for example, were plastered with pieces of paper scraps to keep out the wind (figure 80). But there was something different about this family: their home was meager but it was theirs. They may have been poor, but they were not tenants or sharecroppers. They were rooted to the land because it was their own.

As Lee continued to work in eastern Oklahoma, he must have understood that there was an essential element to his *Grapes of Wrath* shooting script: above all else he needed to find a family like the Joads. He needed, in other words, to find a family who was willing to cut ties with the land; he needed to look to the road.

CHAPTER 5

Finding Real Joads

Russell Lee and Elmer Thomas

Although photographing the various peoples of eastern Oklahoma was important in establishing the context of Steinbeck's novel, Lee believed that the one thing that could lend the most veracity to *Grapes of Wrath* was documentation of the overland migration. If Steinbeck's Joads were *the* symbol of displacement, he needed to find their real-life counterparts. Just as he had gained access into people's homes, Lee would now attempt to enter the lives of those on the road. To do this, he shifted his focus to the fully loaded jalopies heading west to the "promised land."

In Steinbeck's novel the Joads, a family of ten from Sallisaw, Oklahoma, represented the migrant refugee. Although fictional, the Joads became the face of the migrant problem after April 1939. Joseph Henry Jackson asked the questions that were undoubtedly on many people's minds: "Were the Joads . . . typical of the Oklahoma new poor? Were the Joads' experiences typical? Was California as a whole the callous, brutal, exploiting state that the Joads found in Steinbeck's story?"[1] Largely because Steinbeck so vividly described the Joads and the details of the family's plight, many readers identified with them. Journalists, politicians, and even President Roosevelt talked about them as real people.[2] Even Paul Taylor, who knew the situation on the ground and worked with many refugee families, connected "the displaced farmers of the Middle West and the Joads."[3] One nationally broadcast radio program even debated "What Should America Do for the Joads?"[4] For his part Steinbeck was silent on the issue. After he completed the novel, he admitted resigning from the "Matter of the Migrant."[5] Others, however, did not let the image of the Joad family fade.

Critics took great pains to paint the Joads as one of the author's exaggerations, in order to discredit them and thereby the author. Some labeled the flight of the Joads as an "imaginary pilgrimage."[6] Others attempted to show that the Joads were anything but typical. They pointed out that the Joad family was too large and too elderly. On the whole they were right. Most migrant families were younger and had fewer children than the Joads did.[7] After his own fact-finding mission along the migrant route Frank J. Taylor reported, "Along three thousand miles of highways and byways, I was unable to find a single counterpart of the Joad family."[8] Other detractors undertook similar missions hoping to challenge the author's portrayals. Pamphleteer George Miron conducted his own "first hand study."[9] Traveling incognito he picked prunes, tomatoes, and other crops in the San Joaquin and Santa Clara Valleys as part of his campaign to discredit Steinbeck.

For supporters there was just as much at stake in proving the existence of real-life Joads. So much of Steinbeck's narrative depended on the believability of their woeful odyssey (figure 81). If the real overland migration of Okies was nowhere near as harrowing, then Steinbeck's narrative would be meaningless. On the other hand, if there were Joads by the thousands then Steinbeck's text was a bellwether deserving of the attention it received. Steinbeck's supporters countered the attacks by stating that the Joads were representative of a larger population. "The Joads are alive," Joseph Henry Jackson proclaimed, "it is impossible to regard them as mere characters in a story."[10] The FSA had a vested interest in showing that real Joads lived because it stood to benefit

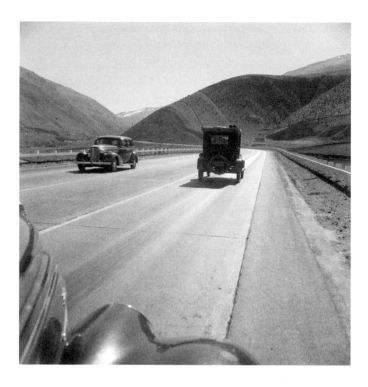

from the human face and name Steinbeck had given to the migrant problem.

Because he was in Oklahoma shortly after *Grapes of Wrath* was released, Lee was in a prime position to find actual migrants and refute Steinbeck's critics. Documenting the frequency with which he encountered migrants on the roads was an important component of Lee's work in the state. This evidence could prove that westward migration was a widespread phenomenon and that the Joads could have originated from any state in the union.[11] In 1936 Steinbeck wrote that for the "casual traveler on the great highways the movements of the migrants are mysterious if they are seen at all."[12] Much depended on Lee's ability to expose the seemingly invisible movements of the migrant. If Steinbeck had turned migrants into the Joads, then part of Lee's task was to convert the Joads back into real migrants.

As early as 1936, shortly after Arthur Rothstein made his famous images of the Dust Bowl, Roy Stryker encouraged him to look for a family "packing up, ready to leave for parts more moist."[13] In 1937 Stryker had advised Lee to be on the lookout for "families on the move with their meager goods piled on trucks or wagons."[14] A month after *Grapes of Wrath* was published Stryker was still looking for the shots he wanted. "A few good road pictures may help," he wrote Lee, "Lange has some, but they don't quite get across what we want. . . . Be sure to pick up highway signs—[Route] #66—where the roads come in from other sections, as mentioned in the Steinbeck book."[15]

Lee's foray into Oklahoma in the summer of 1939 was well timed for finding migrants: California's gravitational pull was strongest in the spring and summer, as its various picking seasons ran from March through December. Thus, Lee worked the roads that summer in search of anything and anyone that might shed further light on Steinbeck's novel. He struggled to find exactly what he was looking for, however. He did not encounter what Carey McWilliams called "Joads by the tens of thousands."[16] At the beginning of his work in the state Lee wrote Stryker, "I don't know that there is much migration at the present moment—one service man said 10 to 20 families per day along 66, but I have been unable to find more than 1 or 2 so far and they were doubtful." In the same letter he hoped that eastern Oklahoma, "where Steinbeck indicated a

source," would prove more fruitful. It was there that he hoped to find families in their "rattletrap cars" looking for a better life.[17]

In a letter to his agent in the spring of 1938 Steinbeck had stated that he was "trying to write history while it happens," which is exactly what he did in *Grapes of Wrath*.[18] A careful reading of the text indicates the Joads left Oklahoma in the early summer of 1938. In essence, therefore, Steinbeck was writing the history of the Joads in real time.[19] The year 1938 was a troubled one for much of the nation, which was struggling with the curtailing of New Deal spending that Roosevelt hoped would spur the nation's recovery. His assumption was wrong and the nation plunged deeper into the so-called Roosevelt Recession. This was also a year of massive emigration out of Oklahoma. According to one study, 275,000 people, or 28 percent of the state's farm population, were on the move that year.[20] One year later the situation was slightly better, but not for the many farmers struggling to keep their farms and way of life.

The photographic record suggests that Lee made a concerted effort to find and photograph migrant families on the road. The theme of migration, in fact, predominated his work in the summer of 1939. Of the hundreds of images that Lee made, one photograph is emblematic of his desire to expose the experience of migration and the actual existence of families like the Joads. The image clearly displays Lee's enthusiasm and curiosity, two attributes Stryker valued in a photographer.[21] Just outside of Muskogee Lee photographed a migrant family of six by opening up their car doors to his camera (figure 82). In many ways the photograph is unnatural and even puerile.

FIGURE 82. Russell Lee, "Migrants packed into their automobile near Muskogee, Oklahoma. Muskogee County." June 1939. *Library of Congress, LC-USF34-033702-D*

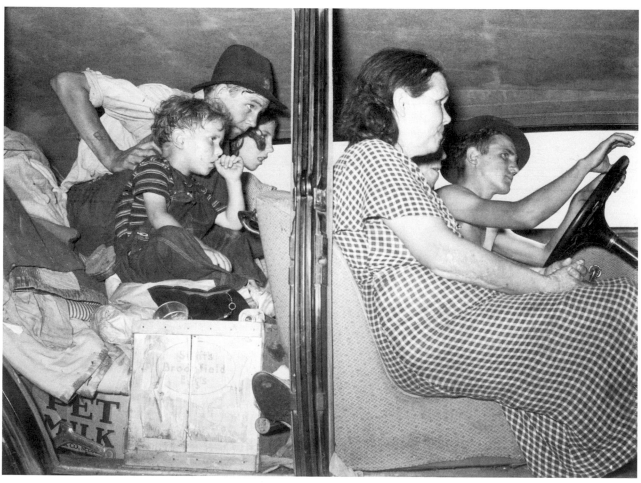

Lee watched and waited as the family packed up, then must have persuaded them to act as if they were on the road. Yet by opening the doors of their Franklin Airman Sedan, he exposed the inner workings and discomfort of those who were forced to live out of their automobiles. The image may be odd but few other photographs expose the experience of migration better. Steinbeck's analogy of a turtle carrying its home on its back is apt. The car symbolizes a home and a life that is turned inside out. Everything the family needs is packed inside this car: basins and baskets, washboards, linens, clothing, and basic staples such as salt, eggs, coffee, an old box of PET evaporated milk, and large containers of Battle Creek Lacto Dextrin—a remedy "for changing the intestinal flora."[22] The condensation of a home into a car leaves little room for the three boys who are crammed on top of the amenities of home for the long crossing.

Like Dorothea Lange, Russell Lee is known for his ability to make strongly empathetic images. It is often mentioned that Lange possessed certain attributes that made her seem unthreatening to her subjects. She was soft-spoken and short of stature and walked with a pronounced limp as a result of a childhood case of polio. Her limp, she believed, made her one of the "walking wounded" and more accessible to her subjects.[23] Lee cut a very different figure but still proved to be someone people accepted into their lives and homes. Even though he was tall and large, people remember him as a soft-spoken gentleman who was "friendly with everybody."[24] His subjects might have also sensed the deep sympathy that Szarkowski noted "appeared seamless."[25] From his own Midwestern upbringing and his marriage to Doris Lee, Lee also developed a profound understanding of and admiration for farm life. In 1941 *U.S. Camera* summed up the secret of his success with his subjects: "[Lee], tall, laconic, cigar-smoking, is the dean of the group. He handles the human problems of his job by approaching the family and explaining the whole proposition to them—how the government is making a complete record of community and family life, and that more Americans will know how the rest of the country lives. He gets along best with men."[26] These attributes proved essential in working among poor white tenants, who were known for being closed and secretive, and persuading them to allow him into their lives.

Lee was a traveler who had more in common with the migrants than one might assume. When Lee began work for the FSA, he undertook a life of nomadic circuits around the country on assignment. This peripatetic lifestyle took its toll on his marriage, and he and Doris Lee divorced in 1939, the same year Doris married her former teacher, Arnold Blanch. The road also brought a new woman into Russell's life. In 1938 he met a young journalist from Dallas named Jean Smith. From that time until Russell's service in World War II, he and Jean were always on the road together (figure 83). They were married in 1939, immediately after Lee's divorce from Doris became final.

FIGURE 83. Russell Lee, "Highway from automobile in Bexar County, Texas." March 1940. *Library of Congress, LC-USF33-012641-M2*

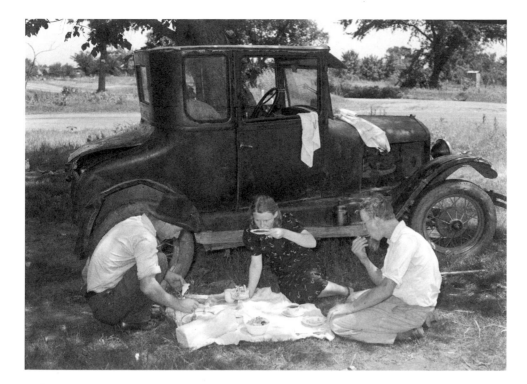

FIGURE 84. Russell Lee, "Migrant workers eating dinner by the side of their car while they are camped near Prague, Oklahoma." Lincoln County. June 1939. *Library of Congress, LC-USF34-033380-D*

Jean Lee was a vital if unheralded part of Russell's work, and together they formed an important collaborative.[27] It is difficult to gauge exactly the extent of Jean's impact, but one assumes she was a strong influence and presence during Russell's work with Oklahoma migrants in the summer of 1939 and beyond. Although the photographer is usually the one who receives the credit, many photographers associated with the FSA were part of dynamic collaborations. Taylor and Lange are the best-known team, but the list of creative partnerships should also include Jack and Irene Delano, Louise and Edwin Rosskam, and Jean and Russell Lee.[28]

Years later Russell and Jean Lee recalled their life on the road, staying in tourist cabins across the country for months at a time. At night Russell developed film in a bathroom converted into a darkroom while Jean wrote up the notes to be sent to Washington. Living a nomadic life endeared them to their subjects. Years later one former subject recalled that they were "our kind of people."[29] "[The migrants] saw *us* as migrants," Lee remembered. One farmer, feeling sorry for the rootless federal photographer, gave him a hard-won nickel.[30]

Early in his work with migrants in June 1939, Lee made one of the more recognized photographs of his career. Coming north from Texas along Route 66 and U.S. 62 Lee photographed a family of migrants on the road—possibly the first he encountered in Oklahoma. Under the peaceful shade of a large roadside tree near the town of Prague, Lee documented a young migrant man with his wife and nephew as they rested, prepared a potato dinner, and readied themselves for another day of travel (figure 84). They were wandering through Oklahoma and Texas, looking for work, and were prepared to go westward if they were unsuccessful. The young wife had already worked in the fruit groves and vegetable fields of California with her family. They returned home when her father "got sick for the sight of them red hills," she explained.[31]

Lee recorded that their possessions were meager and a guitar their only amusement. Their most prized possession was a "cut glass dish," which had belonged to the woman's mother and "represented to her the only link with her broken home and family." As the young woman was rummaging through the back of their weathered Model T, Lee photographed her dreamily gazing

FIGURE 85. Russell Lee, "Migrant woman reaching in automobile for supplies while camped near Prague, Oklahoma. Lincoln County, Oklahoma." June 1939. *Library of Congress, LC-USF34-033481-D*

through the cracked back window (figures 85 and 86). The young woman became for Lee a symbol of loss. If the inside of her family car provided details of the flight, the photograph became emblematic of loss as well.

Lee's work is often criticized as being superficial. John Szarkowski described it as "functional and blunt and free of pretension as an underwear button." Elsewhere Szarkowski argued that Lee's "subjects were often so simple that they bordered on banality."[32] Yet upon closer examination Szarkowski admitted that somehow the sum of Lee's choices was perfect. In the right situation he could, moreover, create deeply symbolic images. That was true of the woman's face gazing out the window. With their vehicle pointed toward an unknown horizon, these migrants were forced to look for a new life of challenges and hoped-for opportunities while caught in the wake of a broken past. Despite their faith and courage, they carried a tremendous sense of loss, failure, and longing for friends, family, and home. "There is agony in tearing up roots," Paul Taylor wrote, "even when these have been loosened by adversity."[33] Turned to face new hope, the migrants cast wistful and recurring backward glances at what they left behind. Theirs was a regretful departure—the common condition and psychological cost of mobility.[34]

In her 1934 story "The Dark Earth" Oklahoma native Sanora Babb described the plight of a migrant as he slowly moved west. Like Lee's photograph, her words captured the push and pull of someone caught between two worlds:

He went on not looking back. He was walking out of the unwilling level country where he belonged. Plains were cut deeply now by indistinct and smoky blue, the Rockies were rising against the edge of the sky like a dark sullen storm gathering. Even there, twenty yards to the right of him, he felt the nothingness beyond the rim of a precipice. He was coming, one step, two, three, how many a day into a disrupted earth he did not know. A quick current of fear and curiosity flowed through him for a moment and was gone, buried in weariness. He yearned back to the flat open country he understood, and he turned his feet on the road and looked for the straight far meeting of earth and space, but already the land was rising up gently, closing him in, pressing him on to the clear wide hollows. His loneliness too and his yearning fell away with all thought and feeling into weariness. Now there was only the heaviness of his body moving, under the heat that seemed to fasten parasitic upon him in terrible concentration because his was the only movement in the still hot afternoon.[35]

From Controversy to Icon

FIGURE 86. Russell Lee,
"Migrant worker looking
through back window of
automobile near Prague,
Oklahoma. Lincoln County,
Oklahoma." June 1939. *Library
of Congress, LC-USF34-033417-D*

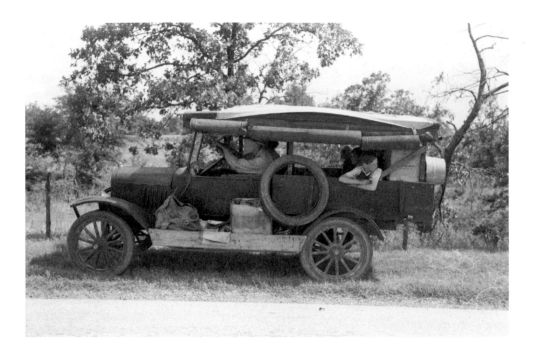

Babb's words echo Lee's visual image. In a photograph of a seemingly banal moment it is possible to see loss and the consequence and cost of migration.[36]

Several counties away Lee photographed a Texas family with five young children that he encountered eating "their noonday meal" on the roadside just east of Fort Gibson, Oklahoma (figure 87). The family was originally from West Texas, where the father had worked as a tenant farmer and restaurant cook. At some point the entire family was forced to travel through Texas, Arkansas, and Oklahoma in search of work. When Lee found them they had just come from Fayetteville, Arkansas, where they had been picking berries. The family viewed this simple job as a godsend in their time of need. They had come to Oklahoma in hopes of gaining employment in the potato and string bean fields. Lee reported however, "Their plans were most indefinite."[37]

Many people believed that migrants were dirty, inbred, immoral, and godless people. In 1939 *Fortune* published California's farmers' attitudes toward Okies. Without rebuttal, the article claimed that they were filthy, inbred failures; they were too damn independent to take orders and "easy bait for Red Organizers." The *Fortune* editor stated there was some fact to these claims, but mildly remonstrated that Okies were intelligent enough, mildly religious, of "fair" moral standards, and clean under decent conditions but filthy when they succumbed to their squalid surroundings.[38] Hence, to counter such stereotypes of Okies as dirty of body and mind, it was vital for the FSA to show the migrants as clean and orderly. "Well Okie use'ta mean you was from Oklahoma," Steinbeck wrote in *Grapes of Wrath*. "Now it means you're a dirty son-of-a-bitch. Okie means you're scum."[39] Migrants were accused of "living like hogs" and being ridden with diseases such as tuberculosis, malaria, smallpox, dysentery, pellagra, whooping cough, and typhoid.[40] They were called "road hogs" and "bums."[41]

In photographing a family near Fort Gibson, Lee constructed images and details designed to dispel the slanted picture of migrants. The family is portrayed as orderly, well mannered, and religious. Images like these were clearly aimed at "home-minded," middle-class Americans who had a specific perception of what constituted the traditional units of family and home.[42] In spite of their precarious circumstances and their location twenty feet away from the highway, this family is

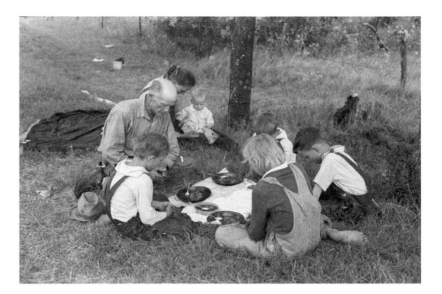

FIGURE 88. Russell Lee, "White migrant family saying grace before noonday meal by the side of the road east of Fort Gibson, Muskogee County, Oklahoma." June 1939. *Library of Congress, LC-USF33-012275-M5*

clearly trying to maintain a semblance of decorum. It was also important that Lee showed them as human and as true Americans.[43] Their appearance fits the description Paul Taylor put forth in 1936: "White Americans of old stock predominate among the emigrants. Long, lanky Oklahomans with small heads, blue eyes, an Abe Lincoln cut to the thighs, and surrounded by tow-headed children."[44] In light of the prevailing view of the Okies, Lee's choice of a family for this study is telling. Families, even those in the direst of circumstances, were perceived as more deserving than individuals.[45]

In addition to photographing the family's burdened truck overflowing with gas lamps and zinc washbasins, he calculatingly photographed them saying grace before their meal (figure 88). With the family bowing their heads to offer thanks for their blessings, Lee recorded the father's humble prayer: "God made the wild berries for the birds and I think he means them for such as us too."[46] Catching the family in the moment of saying grace for their humble meal confronted another stereotype. At the time migrants from the Bible Belt were scorned for their loose morals. One Californian stated, "There is so much unmorality among them—not immorality; they just don't know any better."[47] Lee's image portrays them not as godless human locusts lacking a

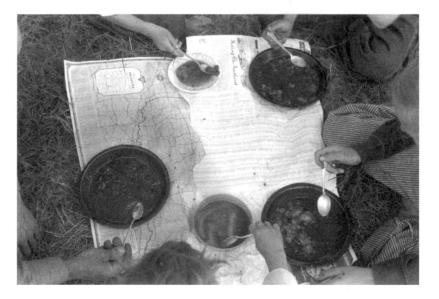

FIGURE 89. Russell Lee, "White migrant family eating lunch of blackberry pie on the highway, Muskogee County, east of Fort Gibson, Oklahoma." June 1939. *Library of Congress, LC-USF33-012275-M1*

moral compass but as part of the deserving poor. As Colleen McDannell pointed out, unlike Jim Casy, the former preacher in *Grapes of Wrath*, most migrants did not lose their faith. Rather they were often more religious than those, particularly in California, amongst whom they settled.[48] Taylor observed that even in destitute camps without ordained clergy they performed proper rites and services. Though, unsurprisingly, few critics acknowledged that the migrants were more religious than their hosts, the arrival of the Okie ultimately changed the face of religion in California.[49]

Lee also took the opportunity to document the family eating a runny blackberry pie over a map of their future travels, which they tidily used like a tablecloth (figure 89). A separate photograph revealed an empty bottle of milk, a homemade slingshot, and a bottle of "bad bowel" medicine covered in flies. In his report he noted that the children were "clean and neat in new overalls bought from the funds obtained in picking berries."[50] The children, moreover, seemed well behaved even as they sat crammed in the backseat of their truck (figures 90 and 91). The orderliness of this family testified to the fact that a migrant family could remain both physically and spiritually centered in spite of their deeply jarring situation.[51]

Like much of the population in California Steinbeck could be harsh toward the Okies. He did not attempt to hide the faults and vices that made them human. Yet he readily acknowledged that the refugees possessed many admirable traits. In 1936 he wrote, "They are not easily intimidated. They are courageous, intelligent, and resourceful. Having gone through the horrors of the drought and with immense effort having escaped from it, they cannot be herded, attacked, starved, or frightened."[52] With the escalation of the "migrant problem" and following his work in the fields Steinbeck became more vociferous in his defense of Okies. In an April 1938 article in the West Coast Communist paper *People's World,* he confronted the oft-repeated charges of dirtiness, thievery, immorality, stupidity, and laziness. The migrants were no different than anyone else in California, Steinbeck claimed, but trying times had thrust them under public scrutiny. "Of course they are dirty," Steinbeck contended. "How in the world can a people lying in the mud, having no access to hot water, living so close to starvation that soap is a luxury, keep clean? . . . These people

FIGURE 91. Russell Lee,
"White migrant children sitting
in back seat of family car east
of Fort Gibson, Muskogee
County, Oklahoma." June 1939.
Library of Congress, LC-USF33-012278-M3

are only dirty when the ability to keep clean is denied them." In spite of their ill treatment, he argued, "these people have remained a kindly, generous, honest people. But a bad name will make a bad dog in time. Men will invariably do what is expected of them." Seeing the Okies as individuals, he believed, would bring to light their virtues and the fact that these "new Californians are just like ourselves."[53] Ultimately, Steinbeck admired the migrants, claiming that they were "stronger and purer and braver" than he was.[54]

It could be argued however that despite their best intentions Steinbeck and the FSA photographers perpetuated negative stereotypes.[55] In truth, they were overly reliant on emblems of the Dust Bowl migration, including overladen cars and trucks with mattresses on top, families in tents, and barefoot children in bib overalls. Yet they were also careful to challenge what they considered false perceptions put forth by those who actively criticized the migrants and their way of life. In photographing the Fort Gibson family Lee not only attempted to dispel many of the myths of the migrant but he also came face to face with what Steinbeck called "a new technique of living." This was a family exposed and vulnerable in a new way. "The highway became their home," he wrote, "and movement their medium of expression."[56] The next family Lee encountered would exemplify this "new way of life."

Lee understood that in order to bring Steinbeck's novel to life he would need more than chance encounters with families on the road. He would need to document the entire process of migration. In other words, he would need to discover a family that was still rooted to the land, but who was also restless and had aspirations of a better life. He informed Stryker that he was always on the lookout for "potential migrants."[57] With Muskogee as his headquarters he was sure it would be only a matter of time before he came across the right situation. The region around Muskogee was a rich place for finding migrants.[58] Florence Thompson, for example, was raised in Tahlequah, not far from Muskogee.

Locating the right family was a little more difficult than Lee had expected and it took him a few weeks to find a family that resembled Steinbeck's characters. Finally, in the middle of June, he found what he was looking for. "I have a line on a family which is contemplating moving within

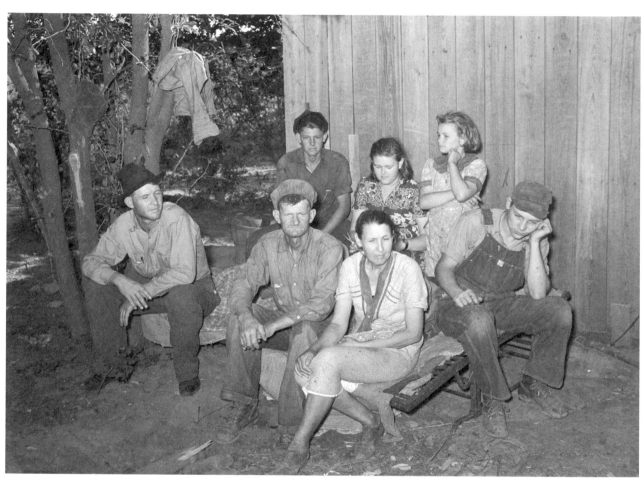

FIGURE 92. Russell Lee,
"Family of migrant workers
living near Muskogee."
June 1939. *Library of Congress,*
LC-USF34-033463-D

the next few days or a week," he wrote to Stryker. "They will let me know when they are going to start packing and shoving off—also they are going to build a trailer. I have asked every place about people leaving the county and while there are many who are "thinking of it" there are few that are actually going yet."[59] Nearly three years after Stryker's first requests to locate a migrant family, Lee had finally managed to be in the right place when one was planning to depart.

The family he found was that of Elmer and Edna Thomas, who informed him that they were saving their daily wages in order to go to California, and that they were soon to depart. In several ways the Thomas family was typical of many in the region. Elmer and Edna were originally from western Arkansas and had migrated to the Muskogee area around 1915. In the 1920 census report they were listed as tenant farmers. In 1928 they farmed 145 acres of land, of which 100 was devoted to cotton.[60] In 1929 their fortunes began to decline. When Lee photographed them in 1939, Elmer was fifty years old and Edna was forty-five. Neither could read or write, though their children could.

At the time, they were living in a small rented house in the middle of a cornfield (figure 92).[61] Their single-room, vertical-wood-plank shack was not unlike the ones James Agee and Walker Evans documented in Alabama.[62] On his initial contact with the Thomas family Lee photographed members of the family in and around their small, cluttered one-room "box house." Cardboard covered the inside walls for extra insulation and the beds were covered with clothing (figure 93). Necessities like flour, starch, clothing, oil lamps, and two boxes of Oxydol laundry detergent were stored on the floor. Like most rural homes this one did not have electricity or indoor plumbing.[63] Though cramped these living conditions were not the worst Lee had seen. In his captions Lee referred to the house as a "camp home" indicating that this was only a temporary residence.

When Lee first encountered the Thomases: Elmer; his wife, Edna; sons Amos, Frank, and Tommy; and daughter Ruby, he labeled them simply as a "migrant family." As James Curtis points out, migrants in the FSA collection were typically stripped of their identities. They were tenants, sharecroppers, agricultural day-laborers, the common but nameless "men and women whose plight the Roosevelt administration was working to improve."[64] This family was different. When Lee returned in July he gave them a name: the Thomas family. This was a significant shift that acknowledged them as individuals, not nameless migrants.

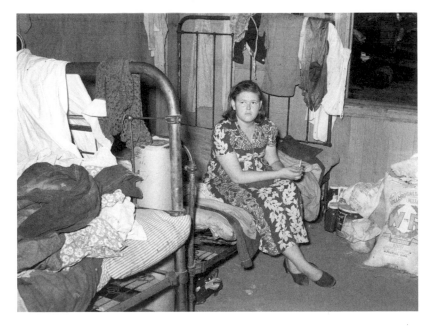

FIGURE 93. Russell Lee, "Member of migrant family group while they were camping near Muskogee, Oklahoma doing day labor to obtain funds to go to California." June 1939. *Library of Congress, LC-USF34-033442-D*

FIGURE 94. Russell Lee,
"Migrant man and wife living
near Muskogee. Muskogee
County, Oklahoma." June 1939.
Library of Congress, LC-USF34-033465-D

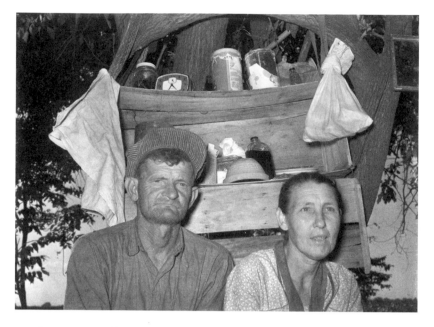

In many ways, however, the Thomas family still fit the familiar tropes. Elmer had a weather-worn, lean appearance somewhere between the descriptions of Tom and Pa Joad (figure 94). In later images he even wore overalls like Pa. Upon close examination he appears restless and nervous, yet resolute and willing to start again. At first glance Edna does not fit Steinbeck's description of Ma. The Ma that Steinbeck presented to readers was heavy "but not fat," a women who is "thick with child-bearing and work," with a face that was full but not soft.[65] Edna Thomas offers a different, wirier, and more resolute vision of the resilient Okie woman. In many ways she could be Ma—not the more rotund Ma of Jane Darwell, who would play the role in the film version of *Grapes of Wrath*, but the thinner, more harrowed "gaunt, stringy resilience" of actress Beulah Bondi, whom producer Darryl Zanuck originally wanted to cast in the part.[66] Though not having the same physical gravity as Ma, Edna could still be the "citadel" of the family, "the strong place that could not be taken."[67] The other members of the Thomas family also fit their parts well. Steinbeck was accused of creating monochromatic characters, but here in black and white, Lee demonstrates their realism.[68]

By the end of July the Thomas family was ready to leave. In what might easily be seen as a photographic illustration of the Joads' preparations in chapter 10 of Steinbeck's novel, Lee photographed the Thomas family in the final stages of readying themselves for their westward migration. Lee's work shows three distinct phases to the process: the packing up of the family's meager possessions; the loading of the truck; and the readying of the rickety old vehicle. Lee's working methods were also on display. Individually the photographs of the Thomas family are rather ordinary; their strength lies in capturing not a single defining moment but a greater, all-encompassing record of the experience.

Unlike his colleagues Arthur Rothstein and Dorothea Lange, Lee is not remembered for a single, hallmark photograph.[69] In many ways, associating Lee with one image would take away the power of his work. Easily the most prolific of the FSA photographers, Lee could go through several rolls of film in one day.[70] His modus operandi was systematic, holistic, and even plodding. Margaret Bourke-White once professed that the sum total, not the individual photograph, "is a true interpretation,"[71] and Lee clearly would have agreed that one photograph could not carry a full narrative. Just as Steinbeck's work was like sentences strung together with a particular order and clarity, so were Lee's photographs.[72]

Before becoming interested in photography, Lee trained as a chemical engineer. It is evident that he approached photography much as he would an engineering problem. In his work he took great pains to identify a given issue and to understand how the individual parts (the elements) functioned both individually and as a unified whole. As Stryker opined, "[He] was an engineer and an analyzer, a thorough, fast operator, and he turned in quality and he turned in detail, and when he hit a thing he went through it from all phases and analyzed it and took it apart for you and laid it on the table."[73] Dorothea Lange agreed with her boss:

> Russell Lee is a great cataloger of facts, and he knew how to do it.... [D]etail is valuable and Russell Lee did it and did it for months on end, indefatigable.... It never really registered, seeing a little something here or a little something there, but the bulk of his work, how solid it is. You know, it's the fact of revealing the facts, not just putting them down."[74]

Some would call Lee a "taxonomist with a camera."[75] Others, including Szarkowski, accused him of never seeing a photograph he didn't like.[76] As Lee understood it, however, making detailed visual records was simply part of his job as a government photographer. In his book *Government Publicity* (1939), a text to which Stryker contributed, James McCamy stated that the basic skills of the federal photographer combined "technical competence, a desire for accuracy, artistic good taste, and imagination enough to see the potential dramatic interest in a scene." In these respects Lee was clearly the epitome of the federal image maker "suited for informational work."[77]

At times Lee was so good at capturing the details of a story that Stryker expressed frustration that he could not take the single, encapsulating photograph like other photographers such as Jack Delano. Yet Lee's ability to dissect a story into its details and to say, "There sir, there you are in all its parts" not only endeared him to his like-minded superior but enabled him to dissect the complex process of migration.[78] As Lee acknowledged, the success of his step-by-step documentation relied on his rapport with, and the active cooperation of, his subject.[79]

Lee's documentary process connected his body of work to another important photographic tradition of the 1930s: photojournalism and the photo-magazine. Lee's reliance on multiple images was not unlike the practice of photographers for *Life* magazine, where the photographic essay replaced the single image as an accepted means of documentary reportage.[80] In spite of the similarities, Stryker did not see the FSA in the same light as photo-magazines. They may have come from the same "seedbed," but he believed their aims and techniques were very different. According to Stryker, news pictures like those found in *Life* were the "noun and verb," whereas the FSA's "kind of photography is the adjective and the adverb."[81] *Life* photographed the event, but the FSA captured the condition.[82] There were no deadlines and no editors, and his photographers enjoyed a certain amount of freedom to choose their subjects.[83] Stryker also believed in his photographers' superior skills and ability to capture more than the news picture. Yet by June 1937 Stryker was actually encouraging his crew to make "*Fortune-Life* type" photographs and began to prefer the longer photographic essay.[84]

Lee likewise perceived his work as different from and better than that of *Life*, which he denounced as "lousy, crappy stuff."[85] Without question, however, his work bore similarities to the photographs in *Life*. Richard Steven Street claims that Lee was a photo essayist who seldom if ever "snapped a single image of anything, preferring to take a series of shots that explored a story or mood, always with an opening and closing shot."[86] His rapid yet thorough approach to his work made Lee the "best storyteller in Stryker's group."[87] Not only did Lee profess to care for his subjects, but he must also have cared for his perceived audience. Whereas Evans's work was

esoteric, Lee's was didactic; he wanted his work to be clear and its meaning explicit. Telling a story via a series of images was exactly what his *Grapes of Wrath* shooting script prescribed.

As the Thomas family series demonstrates, Lee went to great lengths to circle the family and trace each step of the tedious process of migration. It was his habit to arrive early and leave late.[88] With his small 35 mm camera, he photographed the Thomas family from above and below their truck, throughout their home, and in their fields. Despite working rapidly, he revealed his presence only in a photograph of the front of his Plymouth 2 parked in front of the Thomas's vehicle. Rather, Lee became a detached witness, a floating lens that objectively recorded the visual details of the scene. Early in 1939 critic Elizabeth McCausland suggested that the invisibility of the photographer was a key aspect of the FSA. With regard to the Historical Section she wrote, "The fact is a thousand times more important than the photographer."[89] Undoubtedly, Lee would have agreed. One of Lee's subjects remembered that he stayed in the "background, close by but invisible."[90] Hanging around the scene, Lee photographed details of packing up and leaving, filling in the minutiae of transplanting a family across the United States.

The first part of the process Lee recorded was the Thomases packing up their home and possessions. Lee confirmed Steinbeck's portrayal of this as a difficult and painful task. In *Grapes of Wrath* the newcomer Jim Casy commented that "It's all work. . . . They's too much to do to split up to men's and women's work."[91] In practice, however, this was not exactly true; migration was actually a "highly gendered experience."[92] The packing stage of the process was dominated by the female head of the house, both in Steinbeck's novel and in Lee's documentation. At the time others commented on the central role of women in the migrant family. As Wendy Kozol has explained, "motherhood was loudly praised during the Depression as *the* symbol of that most fundamental of traditional institutions, the family."[93] In households suffering deprivation it was found that the mother became the primary decision maker and emotional resource. As Tom Collins observed, during periods of unemployment among the migrants "the woman steps in as 'Master of the House.'"[94] Paul Taylor made a similar observation: "As on the old frontier, women often supply the courage when the hearts of the men flag."[95]

In *The Grapes of Wrath* Ma Joad—the physical and spiritual force that kept her family together—took it upon herself to pack up the household possessions. She was the one who took

FIGURE 95. Russell Lee, "Interior of migrant's home near Muskogee, with mother removing articles of clothing preparatory for departure to California. Oklahoma." July 1939. *Library of Congress, LC-USF34-033791-D*

up the washtub, pans, kettles, frying pan, pots, and spices.[96] In Lee's photographs Edna Thomas exhibited similar matriarchal family leadership as she took charge of all domestic responsibilities. She was central to the entire operation and was pivotally placed in this drama. She packed up the family's clothes and quilts, the lamp, and the bed (figures 95–97). She was photographed packing up the kitchen spices and coffee, just like Ma Joad, as well as vegetables from their small garden. Later Mrs. Thomas and her daughter were depicted carefully packing the family's dishes, silverware, pans, and even little odds and ends such as a geometry textbook lying on the floor. Washbasins, linens, and other objects further revealed the role of the women as keepers of the home. The Thomas family carefully packed and secured all these items, unlike the Joads who were, it seems, tragically destined to start their new life with nearly nothing from their old existence.

In one of the novel's more poignant moments Ma Joad destroys many of her family's mementos and ephemeral possessions before they depart for California. In a quiet moment of fear and faith, she burns in the kitchen stove many of their private possessions, including letters, newspaper clippings, family photographs, and a watch chain of braided hair. These were deeply indexical objects of the past. Steinbeck's message was clear: the migratory act and the desire to create a new life in the promised land of California required one to sacrifice all ties to the cherished past. In the nineteenth century it was the purview of women to perform acts of mourning and remembering for their families. In this sibylline act of erasure Ma Joad conflates these roles—at once mourning the loss of their life as they knew it and destroying the objects that would have helped keep it alive.[97]

Lee presented a different view of loss and leaving. He documented the Thomas family chest—a symbol of home, tradition, and stability—being carefully loaded into the bed of the truck before any of their other possessions (figure 98). Lee was clearly looking for symbolic moments such as this to punctuate his larger narrative. The trunk's contents—presumably the prized possessions of the family—were, undoubtedly, a link to their past—a past, as Steinbeck noted, that would cry to them in the coming days as they uprooted their lives and headed westward. "How can we live without our lives?" the voice of a nameless migrant asked in the novel.[98]

Lee used a flash bulb to capture the removal of the various objects in the low light of the home. He knew that what was taking place outside told only part of the story of rural poverty

FIGURE 96. Russell Lee, "Mrs. Elmer Thomas, migrant to California, removing the spices, coffee, etc., to their car from their home which they are preparing to leave. Near Muskogee, Oklahoma." July 1939. *Library of Congress, LC-USF34-033803-D*

FIGURE 97. Russell Lee, "Packing dishes and silverware preparatory to departure for California from Muskogee, Oklahoma." July 1939. *Library of Congress, LC-USF34-033807-D*

and flight. Lee began experimenting with flash in 1935, and his use of the technology set him apart from many of his peers at the FSA. Evans used natural light and Lange employed a flash only on limited occasions. Shahn considered the use of a flash "immoral."[99] Lee felt differently. Flash photography enabled him to penetrate people's lives and capture more details and, hence, more information. Speaking of Lee's use of flash Edwin Rosskam noted the photographer's ability to capture a scene and to "eliminate all possible atmosphere, so that the picture becomes a bare, brutal kind of inventory of poverty."[100]

The Thomas family also brought along two profoundly symbolic items that represented facets of migrant life by and large ignored by Steinbeck. Only four years earlier in the popular book *Little House on the Prairie,* Laura Ingalls Wilder recorded how her family brought along a gun and a fiddle as part of their pioneer experience. The new pioneers of 1939 were much the same. One of the earliest and most conspicuous items the Thomas family loaded was a shotgun, which Lee showed Elmer lowering from the wall of their home (figure 99). This was not unique to the Thomas family, as Lee photographed other farmers proudly displaying the weapons hanging in their houses. Guns were a part of their culture. "And the rifle?" opined one migrant in Steinbeck's novel, "Wouldn't go out naked of a rifle. When shoes and clothes and food, when even hope is gone, we'll have the rifle."[101] A traditional symbol of living on the frontier, this firearm would take on a new meaning for the Argonauts of the Depression.[102] The frontier had changed and so had its challenges. In *The Grapes of Wrath* the Joads were continually tossed to and fro against their will, less like hunters than hunted animals that were always under threat and always in fear. When the Joads were being forced off their land in Oklahoma there was a real promise of violence. Their solitary neighbor Muley threatened retaliation, as did Grandpa Joad, a holdover from a different and violent age, who shot out the windows of the tractor as it was poised to tear down his house.

Beyond Oklahoma, however, the Joads' gun did not reenter the novel's narrative. What would have happened if Tom Joad had had a gun in California? An armed Joad family out West

would have made a different, probably more violent story. Where this rifle might have once offered protection from Indians or wild beasts, in the hands of an angry migrant it could be used to break strikes, threaten oppressive employers, or take the law into one's own hands. The prospect of Okies—or, in *Look* magazine's words, a "Jalopy Army of 300,000"—being able to push back would have been sobering if not horrifying for many in 1939.[103] There was an underlying militancy to the migration. As Casy claimed, "They's an army of us without no harness."[104] The image of a migrant army was cultivated in the late thirties and early forties. Carey McWilliams saw this new army as a continuation of past migrant forces. "Although the army has been made up of different races, as conditions have changed and new circumstances arisen, it has always functioned as an army," he wrote.

> It is an army that marches from crop to crop. Its equipment is negligible, a few pots and pans, and its quarters unenviable. It is supported by a vast horde of camp followers, mostly pregnant women, diseased children, and fleabitten dogs. Its transport consists of a fleet of ancient and battered Model T Fords and similar equipage. No one has ever been able to fathom the mystery of how this army supports itself or how it has continued to survive. It has had many savage encounters, with drought and floods and disease; and, occasionally, it has fought in engagements that can hardly be called sham battles, as its causalities have been heavy. Today the army has many new faces as recruits have swarmed in from the dust-bowl area eager to enlist for the duration of the crops at starvation wages. But, in substance, it is the same army that has followed the crops since 1870.[105]

In Oklahoma, Jean Lee believed she saw the seeds of revolution in the farmers' hate, a driving force that might, she noted, "be turned into a vicious, killing thing."[106] In California Sanora Babb warned, "Someday America will rumble with their voices against injustice and greed, someday they will rise up to a man and demand to live like decent human beings in a world they have made for others."[107] If they continued being pushed, Steinbeck contemplated, "someday the armies of bitterness will all be going the same way." "They can be citizens of the highest type," he wrote, " or they can be an army driven by suffering and hatred to take what they need."[108]

The second notable item the Thomas family took with them, one very different from the first, was an old Maxwell guitar that Frank Thomas, the guitar player in the family, took off the wall (figure 100). Lee's flash captured the stringless instrument resting in the boy's hands.[109] In Steinbeck's text the Okies are often painted as brooding, overburdened, and mirthless. On occasion, however, when they were huddled together, a guitar would emerge and everyone would sing songs into the night. As they sang their thoughts went inward toward their hopes and fears, and they were welded together.[110] Clearly, the situation of the Dust Bowl refugee warranted militant attitudes, but it is important to remember that these people also brought along a rich and diverse cultural life.

The FSA photographers commonly captured migrants with musical instruments, as Lee did on several occasions (figure 101). Others observed the prominent place of music in the lives of the migrants. Maynard Dixon recorded that after a full day of work the Okies still had enough spirit to get out a "cracked fiddle and battered guitar" to play the "old backwoods tunes that mean America" like "Oh, Susanna," "the Arkansas Traveler," and "Casey Jones."[111] Paul Taylor wrote of a harmonica player at one camp playing "Home, Sweet Home."[112] Another observer commented that guitars, fiddles, harmonicas, and banjoes often appeared among migrants in Hoovervilles as if "by magic."[113] The image of the Thomas boy with a guitar was another reminder that song, poetry, and music were all part of the migrants' experience. From the hardscrabble roadside

FIGURE 99. Russell Lee,
"Moving the rifle which was
placed on the wall before leaving
for California from Muskogee,
Oklahoma." July 1939. *Library
of Congress, LC-USF34-033776-D*

FIGURE 100. Russell Lee,
"Migrant boy removing guitar
before they leave for California.
At old homestead near
Muskogee, Oklahoma."
July 1939. *Library of Congress,
LC-USF34-033765-D*

FIGURE 101. Russell Lee, "Camp of migrant workers near Prague, Oklahoma. Lincoln County." June 1939. *Library of Congress, LC-USF34-033418-D*

FIGURE 102. Russell Lee, "Getting ready to leave for California. Putting the cage in place on rear of truck. Near Muskogee, Oklahoma." July 1939. *Library of Congress, LC-USF34-033804-D*

FIGURE 103. Russell Lee, "Elmer Thomas, migrant to California, standing on the body of his improvised truck before leaving for California. Near Muskogee, Oklahoma." July 1939. *Library of Congress, LC-USF34-033775-D*

shantytown along Route 66 to the FSA-supported migrant camp in California, it was a symbol of their humanity and a tonic that aided and leavened their travels.

Lee clearly centered his attention on the Thomas family's soon-to-be-overladen truck. Few tenant families in Oklahoma had cars. Like the Joads, many migrants had to sell off their possessions to obtain the means to go west.[114] The Thomases sold their cow and chickens to help buy their truck. Whereas in *The Grapes of Wrath* the Joads packed their automobile in the night, the Thomas family loaded their belongings in broad daylight, enabling Lee to document the process.

FIGURE 104. Russell Lee, Untitled (Elmer Thomas tying sack of laundry onto front lamp bracket near Muskogee, Oklahoma). July 1939. *Library of Congress, LC-USF33-012315-M1*

FIGURE 105. Russell Lee, "Loading the truck of migrant family which will take them to California from Muskogee, Oklahoma." July 1939. *Library of Congress, LC-USF34-033801-D*

FIGURE 106. Russell Lee, "Tying lantern onto the back of improvised truck which will travel to California near Muskogee, Oklahoma." July 1939. *Library of Congress, LC-USF33-012315-M2*

FIGURE 107. Russell Lee,
Untitled (Thomas family
loading their table onto the
truck). Near Muskogee,
Oklahoma. July 1939. *Library of
Congress, LC-USF33-012316-M4*

FIGURE 108. Russell Lee,
Untitled photo (Ruby Thomas
with table loaded on the bed
of the family truck). Near
Muskogee, Oklahoma. July
1939. *Library of Congress,
LC-USF33-012316-M1*

He photographed the Thomas family as they worked to piece all their earthly possessions together on their truck like a giant jigsaw puzzle. Characteristically, every surface of the vehicle—including its new, makeshift "crib-type" sides, which Lee watched being constructed—was utilized (figures 102 and 103). One of Tom Joad's first sights of his family after his release from prison was of his father constructing a similar pine crib on their adapted Hudson.[115] Converting one's home into a moving jalopy required creativity. A lantern hung from the back gate; the bedposts were tied over the back wheels; a washbasin clung to the passenger side; a sack of laundry was lashed to the right headlamp (figures 104–106). The family's table, their most difficult fit, was precariously perched over the rear of the truck and initially became the backrest for those who were not able to ride in the cab (figures 107 and 108). As was typical, the mother of the family sat in back, watching over the sum of the family's possessions.

The Thomas family was not alone in such improvisation. Steinbeck wrote of migrants headed out in "cut-down cars full a stoves an' pans an' mattresses an' kids an' chickens. Goin West."[116] Describing the migrant vehicle overburdened with piles of people and possessions was a common trope. In 1936 Paul Taylor recorded watching migrants as they made their way into California:

> The refugees travel in old automobiles and light trucks some of them home-made, and frequently with trailers behind. All their worldly possessions are piled on the car and covered with old canvas or ragged bedding, with perhaps bedsprings atop, a small iron cook-stove on the running board, a battered trunk, lantern, and galvanized iron wash-tub tied on behind. Children, aunts, grandmothers and a dog are jammed into the car, stretching its capacity incredibly.[117]

Three years later *Fortune* described a situation nearly identical to the one Lee was photographing: "They come along in wheezy old cars with the father or one of the older boys driving. The mother and the younger children sit in back; and around them, crammed inside and overflowing to the running boards, the front and rear bumpers, the top and sides, they carry along everything they own. A galvanized iron washtub is tied to the rear, a dirty, patched tent is lashed to a fender."[118] Even with the wealth of visual information that Lee collected, it is still a wonder that these families could load or hitch or tie an entire household onto a jalopy. Lee knew that the Thomas family's act of strapping everything to their truck was a potent symbol of displacement. The home they were leaving behind was far from ideal, but it was better than their new, desperately inadequate accommodations. For Lee and others these migrants were intrepid, twentieth-century pioneers setting off for better lives.

The Thomas family's final preparations for their journey involved servicing the family car. As portrayed in *The Grapes of Wrath*, migrants could go only as far as their vehicles could take them. Their truck became "the most important place" for the Joads. Steinbeck wrote, "The house was dead, and the fields were dead; but this truck was the active thing the living principle . . . this was the new hearth, the living center of the family."[119] It was therefore imperative that these automobiles run as efficiently as possible. For the migrant who needed to drive from one harvest to the next, a working automobile was essential. "The man with a family will starve if he loses his car," Steinbeck understood.[120] This was an almost insurmountable obstacle for most migrants, who usually had insufficient funds to buy reliable transportation. Most had to settle for cars of "strange vintage" like archaic de Sotos, Fords, Nashes, or anything else that resembled a car.[121] The Joads drove an old, gray Hudson Super Six sedan—the same type of car that Florence Thompson's family drove.[122] The Thomas family's vehicle was a 1928 Ford Model A Roadster Pickup.[123] Often these old jalopies were ad hoc creations held together with a lot of wire and even more ingenuity. The Lees frequently noted that the cars they recorded were "improvised."

In one of the closest parallels to the novel, Lee photographed one of the younger boys, an Al Joad type, as he examined the brakes, filled the radiator, fixed the lights, tightened a wheel, and cranked the car to life for the long road ahead (figures 109 and 110). Like Al Joad, whose mind was "one with the engine," this "young mechanic," as Lee called him, was in charge of the car, "its running, and its maintenance."[124] This boy and Al both represented a new generation with a knowledge of motors and machines. Lee noted, "The boys are now old enough to understand a car as well as their father and they take their places as drivers and repairmen."[125] Just as it seems in the twenty-first century that computer technicians get younger and younger, this boy had abilities that his elders did not possess. For this young man, his understanding of a mechanical motor was a new and marketable skill that represented opportunities and the possibility of a different life.

At some point Lee also captured the young Thomas boy concerning himself with his outward appearance as he greases back his hair, possibly for a chance encounter with a young girl (figure 111). This could easily be seen as another reference to the female-obsessed teenager Al Joad, who was frequently accused of "billy-goatin'" and "tom-cattin'" around. "He don't think of nothin' but girls and engines," Pa noted.[126] This image may be a further suggestion that this boy was looking for something beyond the family farm. What this boy learned on the road remains

FIGURE 109. Russell Lee, "Tightening the rear wheel on truck which will carry migrant family to California from Muskogee, Oklahoma." July 1939. *Library of Congress, LC-USF34-033795-D*

FIGURE 110. Russell Lee, "Migrant boy who is somewhat of a mechanic checking up the lighting wires of their improvised truck which will carry them to California. Near Muskogee, Oklahoma." July 1939. *Library of Congress, LC-USF34-033763-D*

FIGURE 111. Russell Lee, "Migrant boy combing his hair at his home near Muskogee, Oklahoma." July 1939. *Library of Congress, LC-USF34-033777-D*

unknown, but in times of economic deprivation boys often receive added independence and autonomy.[127] When the future of the Joad family is most threatened, it is a mature Al who sticks with his family and looks after the truck even when threatened by rising floods.[128]

Lee's final pictures of the family before their departure conjure another aspect of the migrant experience. When the Joads left Sallisaw they left no one except Muley, their troubled neighbor, behind. This was not the case for the Thomas family. Lee photographed them as they kissed their friends and family in Muskogee goodbye (figure 112). The Great Depression was a period of monumental rifts when people were divided not only from their lands but frequently also from their families. Steinbeck was keenly aware of this fact. When we last encounter the Joad family, they are but a skeleton of the family that left Oklahoma. Of the thirteen original members of their party,

FIGURE 112. Russell Lee, "The Elmer Thomas family at Muskogee visiting their friends to say goodbye before leaving as migrants to California." Oklahoma. July 1939. *Library of Congress, LC-USF34-033794-D*

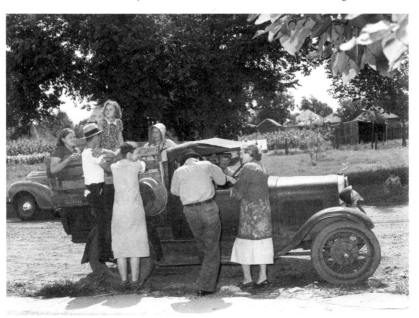

FIGURE 113. Russell Lee, "Getting ready to depart from home in Oklahoma for the trip to California. Near Muskogee, Oklahoma." July 1939. *Library of Congress, LC-USF33-012312-M1*

only six remained by the last pages of the novel. The attrition of migration had taken its toll, and the family was broken and divided.[129] Some had wandered off; others, too old to endure the trek; had died en route; and still others had been forced to flee.

At the time Lee photographed the Thomas family among their friends and family, they were still intact but had already jettisoned a number of items. After the family left their home, Lee stayed behind and photographed "doomed" dishes, jars, and other former possessions that the family was unwilling or unable to take with them. Perhaps the family left some items behind in hopes of returning to recover them.[130] In later photographs more substantial items, such as the family's table, bedpost, and dog, all visible in early photographs, were already gone (figure 113). Ditching household items is streamlining; losing precious cargo such as family members is a different story. When the Thomas family rolled out of Muskogee they were a party of seven. At that point it was uncertain whether they would be able to remain together for the long haul. The family was on the verge of an epic journey that could easily turn into a tragedy.

Cara Finnegan has pointed out that these images do not represent a mournful goodbye, but rather show the family in a cheerful moment.[131] This is definitely not the typical scene "wet with the tears and resonant with the sobs of irrevocable going."[132] As he kisses his relative, an embarrassed Elmer glares with an open eye toward Lee's now intrusive camera (figure 114). The remainder of the family also contributes to the levity of this scene, their gleeful eyes peering over the steering wheel or over the top of the truck. The reason why this departure was not more somber, as Lee noted in a letter to Stryker, was that this family had already worked as day laborers in California for ten years before returning to Oklahoma one year earlier "for a visit." In other words this was not a final farewell; this was a return migration. To quote Finnegan, "their good-byes are not good-byes forever but merely 'good-bye for now.'"[133]

Ten years earlier, in 1929, the Thomas family had made their first migration to California when hit with hardship. That year Elmer, once a successful tenant farmer in Martin Township, twenty-five miles west of Sallisaw, was able to plant and harvest only 35 acres compared to 145 acres the year before. Everything dropped off with the cotton that day, Elmer used to say, except for the mortgage. The family sold out for $65, paid their debts, and headed west to California.[134] "The plan was to get to California," Tommy Thomas remembered, "and figure her out then." Along Route 66 they experienced further hardships but eventually arrived in the small town of

McFarland just north of Bakersfield. Living in a tent on borrowed land the entire family picked up odd jobs to make ends meet. Segregated and labeled "Okie trash" they found life difficult and assimilation impossible.[135] Disillusioned the family returned to Muskogee, Oklahoma, in February 1938. When Lee found the Thomas family, Elmer was working as a truck driver hauling sand and they were preparing to return to California again. Elmer would never again farm the land. "We've packed and moved too often," Edna told the Lees, "I guess that's the reason we can't get satisfied here."[136]

The Thomas family's mobility brings to light an important aspect of the overland migration. In reality the picture of the migration was far more complicated than the exodus presented in *Grapes of Wrath*. It was not typically a one-way passage from the Great Plains to California or Arizona, as was often portrayed, but a more cyclical activity that was by no means uniform. Carey McWilliams likened it to a river with many swirls and eddies.[137] Unlike the Joads, most migrants had an intended destination, and many already had family or friends in California, which helped ease their transition and provided support.[138] Others bypassed the state altogether. Regardless of their destination, they were nearly always on the move. One study found that the average migrant moved around four or five times during his or her working life.[139] One FSA regional director likened them to tumbleweeds breaking loose across the prairie only to be lodged in one location just long enough to roll to a new locale.[140] This was true of Florence Thompson, who traveled back and forth between California and Oklahoma.[141] Many yearned to return to Oklahoma, Arkansas, Texas—dreaming of a place they knew, where they felt they belonged and would be treated humanely.[142]

Migration was a widespread and complicated issue that affected every corner of the nation in some way.[143] It was never an isolated concern. The diversity of crops across the country, with harvests at different times of the year, meant that migrants were in circulation year-round.[144] Furthermore, despite the hardships, most families who were living in the Dust Bowl decided to stick it out rather than flee.[145] The refugees on the roads did not all originate from one location. In addition to the diverse group known as the Okies, Mexican, Filipino, and Chinese workers were also searching for employment in the West, while Italians, Poles, Lithuanians, and others were doing the same in the East.[146]

For migrant advocates like Paul Taylor and Edith Lowry, the "migrant problem" was not distant or remote, but was literally on the doorstep of every American. Taylor opined that most did not realize how close to home the problem was or "how deep these forces strike." Lowry believed that America was really a nation of "stoopworkers" and "fruit tramps."[147] The FSA photographs reflected the fact that migration occurred in all directions. One experienced migrant in Oklahoma told Lee home was "all over."[148] His answer was common. Marion Post Wolcott, for example, photographed migrants in places like Belle Glade in southern Florida who ventured east not west. Jack Delano followed migrants in Delaware and Maine. Dorothea Lange found migrants moving north to Washington, and in 1940 John Vachon photographed migrants picking fruit in Michigan.[149]

The knowledge that the Thomas family were experienced migrants clearly made the stereotypical migrant narrative problematic for Lee.[150] They were not like the wide-eyed and oft-beguiled Joad family setting off on an unknown road but were seasoned migrants who knew what to expect. They were examples of what McWilliams called the "'in and out' movements" of the Oklahoma migration. The Thomas family belied the common belief that the migrants lacked the means or incentive to return to the plains, and were in California to stay.[151] Seeing this family as mobile and free to take flight when necessary would have changed, or at the very least complicated, public opinion of the migrant. Lee privately noted this aspect of the family to Stryker but assured him there was no way of discerning that fact from his photographs. As far as his audience was concerned, this was the Thomases' maiden migration. And even if this was a repeat performance, the preparations and the hardships were still real.

After the long process of preparation Lee photographed the Thomas family as they were ready to embark, accompanied by Edna's brother and his young wife. Clearly staged, the image shows the family loaded in the car, everyone looking left to the distant horizon (figure 115). They seem to fulfill MacLeish's words, "We looked west from a rise and we saw forever."[152] Shooting from a low vantage point Lee removed any direct connection to a specific landscape, making place matter less than forward progress. In his story "Leader of the People," Steinbeck claimed that "westering" died out of the people once the frontier reached the Pacific Ocean. "Westering isn't a hunger any more," he wrote, "It's all done."[153] Lee's photograph contradicts him: it is not an image of defeat, nor does it suggest that the desire for westering is exhausted. Rather, this is a family on a precipice. When the Joads reached the same pregnant moment they were numb and afraid, instinctively looking back to what they were leaving. The press resonated with similar tropes: "You notice the faces of the people in these cars. There is worry, but also something more: they are the faces of people afraid of hunger; completely dispossessed, certain only of being harried along when their immediate usefulness is over."[154] That is not true of the Thomases, who look intrepid and poised to take on a new life.

Lee's documentation of the Thomas family was merely an update of a much older trope. Many commentators viewed the Depression as a new pioneering age. "Pioneering" was not just a virtue; it was also an oft-used verb at the time. The migrants' burdened, antique flivvers became the covered wagons of 1939.[155] California was still the promised land of orchards hung with "the gold of their Eldorado."[156] During the Depression there was renewed interest in the traits of the pioneer, one of the most enduring of American archetypes. Popular periodicals such as *Look* and *Life* called attention to the "new caravan of covered wagons crossing the West."[157] Advocates of the migrants were eager to associate them with the pioneers of the past. For them the pioneer legacy was a useful past for framing and locating the current trauma. According to painter Maynard Dixon, "[The migrants'] case seems hopeless, yet in their hearts they are not defeated. . . . And

FIGURE 115. Russell Lee,
"Migrant family in car en route
to California. Near Muskogee,
Oklahoma." July 1939. *Library
of Congress, LC-USF34-033759-D*

what kind of people are they? The same kind that carried the long rifle over the Alleghenies and down the Ohio, across the Mississippi and the Plains to the Rocky Mountains; the same kind as Sam Houston and Davie Crockett, Kit Carson, Jim Bridger and California Joe."[158] Dixon was not alone in describing and depicting migrants as the new pioneers. This emphasis also appeared in the government-sponsored murals painted on post office walls and other civic buildings. Through the WPA and other agencies numerous artists painted scenes featuring covered wagons and robust settlers.[159] Even the migrants self-identified with the pioneer. Shafter camp's newsletter, for example, was entitled the "Covered Wagon News." The pioneer was thus a potent reminder of the past and a not-so-subtle reassurance of more prosperous times to come. The same trope applied to those who remained in Oklahoma, as *Oklahoma: A Guide* proclaimed: "The pioneer spirit, compounded of courage, optimism, and faith, is still strong among a people so close to the frontier of yesterday."[160]

Despite resistance from brain trusters within the New Deal who considered pioneering a "wasteful practice" of the past, the notion of the pioneer was readily embraced in the FSA.[161] A native of the West—born in Kansas and raised in western Colorado—Stryker harbored "romantic prejudices" and "American frontier spirit" that favored the pioneer past.[162] This attitude permeated his oversight of the Historical Section as well as the work of Lange and Taylor (figure 116). In articles like "Again the Covered Wagon," Taylor put forth the notion that the migrants shared qualities with the pioneers of a bygone era, qualities that were needed again.[163] Taylor and Lange tried to overcome the negative stereotypes of migrants by insisting they were in reality pioneers not an army of human locusts. In her photographs Lange emphasized the plight and pioneering zeal of the migrants entering California. One image of a camp near Bakersfield is reminiscent of a new circling of the wagons. The image captures her shadow projecting from the roof of her car as new pioneers are shown relying on each other or, as Steinbeck wrote, becoming one unit and one family out of necessity (figure 117).[164] A certain amount of hope is inherent in both Steinbeck's and Lee's portraits of the Dust Bowl migration.[165] At its core any migration is a bold, hope-filled gesture of faith, a sign of hoping and believing that life would be better elsewhere. In the Dust Bowl this hope was based on a permeating American romanticism that saw the West as a place of rebirth and renewal, and on a belief that the American dream was still

FIGURE 116. Dorothea Lange, "Near Holtville, Imperial Valley. Again the covered wagon. In migratory carrot puller's camp." February 1939. *Library of Congress, LC-USF34-019083-E*

FIGURE 117. Dorothea Lange, "Hooverville of Bakersfield, California. A rapidly growing community of people living rent-free on the edge of the town dump in whatever kind of shelter available. Approximately one thousand people now living here and raising children." April 1936. *Library of Congress, LC-USF34-001774-C*

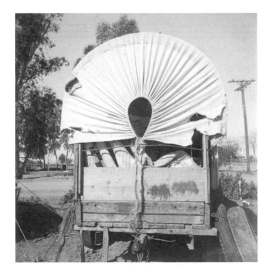

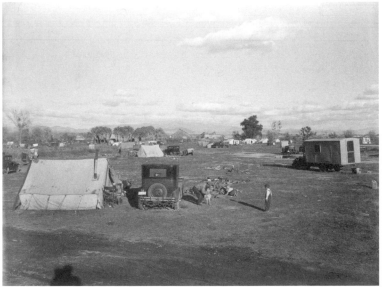

alive.[166] It was, in essence, a lingering trace of the lure of Manifest Destiny that promised a better life on the western horizon.

Steinbeck understood the social transformation from tenant farmer to migrant. Migrants were part of "the new race."[167] "They were not farm men any more, but migrant men":

> And the thought, the planning, the long staring silence that had gone out to the fields, went now to the roads, to the distance, to the West. That man whose mind had been bound with acres lived with narrow concrete miles. And his thought and his worry were not any more with rainfall, with wind and dust, with the thrust of the crops. Eyes watched the tires, ears listened to the clattering motors, and minds struggled with oil, with gasoline, with the thinning rubber between air and road. Then a broken gear was tragedy. Then water in the evening was the yearning, and food over the fire. Then health to go on was the need and strength to go on, and spirit to go on. The wills thrust westward ahead of them, and fears that had once apprehended drought or flood now lingered with anything that might stop the westward crawling.[168]

Lee captured the Thomas family on the verge of this transition. Figure 115 was not the last shot he made of the family, but it could be viewed as the closing shot of his work with the farmers, tenants, and sharecroppers of Oklahoma.[169] It was the end of one chapter, with a new one about to begin: the Thomases were no longer tied down to the land; they were migrants—part of the nameless, faceless flood of refugees bound for the West.

Lee was anxious to continue recording the family's exodus, the beginning of their "westering." "Am going to carry them on to Henryetta tomorrow morning," he excitedly informed Stryker, "getting pictures of them stopping at filling stations, eating lunch, camping for the night, breaking camp the next morning."[170] *Grapes of Wrath* still provided his script of what he still needed to photograph. Beginning in chapter 13 Steinbeck tracked the overland migration of the Joads along Route 66, the Mother Road, "the path of people in flight," through towns in Oklahoma, New Mexico, and Arizona.[171] The Thomas family started down a similar route, starting along U.S. 62. Shooting out his car window, Lee photographed them in real time as they entered the town of Muskogee, driving westward down Okmulgee Avenue past the Safeway Grocery Store, the Ritz Café, and the Jefferson Hotel (figure 118). Their burdened Model A stood out against the city's buildings and beautiful homes, just as the Joads' car had stood out in Oklahoma City. Although the Thomases undoubtedly had been down this road before, they too may have been embarrassed by the "bigness and strangeness" of the place.[172]

Along the way Lee documented the process that Steinbeck called "camp-making": unpacking the essentials from the truck, gathering firewood, starting a cooking fire, and preparing a humble meal.[173] Lee carefully documented the specific duties of each member of the family (figures 119–121). Elmer started the fire with kerosene from their lamp and helped prepare the pans for cooking. Others helped by gathering wood for the fire and doing other chores. Edna again took the lead in preparing their roadside lunch of fatback (inexpensive strips of fat from the back of a hog), diced potatoes, and coffee. Like Ma Joad, she might have been more focused on what she was going to prepare for dinner than on where the family was going.[174] The challenge for Edna and other migrant families was that domesticity became a public spectacle. As Max Horkheimer pointed out in 1937, unemployment blurred "the boundaries between the private and the social."[175] Whether on the road or in Hoovervilles across the United States, home life was literally turned inside out for thousands of families and "a woman's work" was fully exposed, as when Edna is photographed peeling potatoes onto the ground. In a nation where home was sacrosanct

FIGURE 118. Russell Lee,
"Main street of Muskogee,
Oklahoma, with migrants' car
passing down the middle of it."
July 1939. *Library of Congress,*
LC-USF33-012310-M4

FIGURE 119. Russell Lee, "Removing victuals and groceries from the improvised truck at campfire near Henrietta, Oklahoma. This is a migrant family en route to California." July 1939. *Library of Congress, LC-USF33-012321-M3*

FIGURE 120. Russell Lee, "Elmer Thomas putting lard into the frying pan. At roadside camps each person in a migrant camp has his own duties. In this case, Mr. Thomas is attending the fire. There are a certain number of assignments which have been given him, of which this is one. Near Henrietta [sic, Henryetta], Oklahoma." July 1939. *Library of Congress, LC-USF33-012318-M3*

in the public imagination, to maintain stability and decency on the western trek was a daunting challenge. How could one remain the "angels of the house" when the house was no longer there and the hearth was a campfire or a makeshift stove?[176] Later Lee photographed the family at their meal. Again Lee provided an important contrast for his audience (figure 122). Seated around their meal genially and with an air of civility, the family seems tragically out of place on the dirt of the roadside. The gathering of family around the dinner table has long been a symbol of home and prosperity. Here, Lee illustrated the fundamental challenge migrants faced in remaining civil, clean, intact, and human.

As the migration continued, Lee photographed Elmer as he purchased bread and a few potatoes for his family at a roadside market no more than fifty miles from their point of origin (figure 123). This hardly seems a necessary stop. Lee's photographs of the family packing fresh provisions and eating their recent roadside meal indicated that they were supplied for their journey. Both Elmer and the store clerk seem wooden and frozen in stereotypical gestures amongst ads for chewing tobacco and Dr. Pepper. It seems likely then that this scene was fabricated in order to pay homage to one of the most visceral scenes in *Grapes of Wrath*.

FIGURE 121. Russell Lee, "Cutting up the fatback and nursing along the fire. Migrant family bound for California. Henrietta, Oklahoma." July 1939. *Library of Congress, LC-USF33-012317-M3*

FIGURE 122. Russell Lee, "Migrant family encamped along roadside eating meal. Near Henryetta, Oklahoma." July 1939. *Library of Congress, LC-USF34-033792-D*

FIGURE 123. Russell Lee, "Head of migrant family buying loaf of bread in grocery store of small town near Henryetta, Oklahoma." July 1939. *Library of Congress, C-USF34-033797-D*

In chapter 15, Steinbeck describes a similar stop. He wrote of a hungry and wayworn migrant family stopping at a roadside station. Over the objections of the proprietors, the family fills their radiator and begs to buy a loaf of bread. Turned away, the poor migrant father, honest and humble, enters a nearby diner filled with well-off truck drivers and travelers, seeking to buy bread for his family. Originally not able to afford the entire loaf he is finally able to get what his family needs, including two relatively expensive pieces of hard candy for his youngest children, through the reluctant altruism of Mae, the waitress. This is an emotional and dramatic scene that made even Pare Lorentz cry when he read it. In this chapter Steinbeck brings the migrant off the road and into the sphere of the average American in a direct encounter, a collision of two worlds. With a strong biblical undertone, it sends a clear message: Would you turn away the hungry, the sick, or the poor?[177]

Separately Lee's store images fail to convey the power of Steinbeck's prose. They are vapid and stiff. As illustrations of this well-known chapter, however, they make perfect sense in the larger narrative and are not out of character for FSA documentary photography. "Dramatizing" a photograph by arranging a model was often necessary in Stryker's eyes.[178] Staging, as opposed to posing, a photograph was permissible in his view, as long as the photographer had the subjects perform tasks true to their everyday lives.[179] As Ulrich Keller pointed out, Stryker valued explicitness more than spontaneity."[180] The same was true of many of his photographers, who were not opposed to staging photographs for the right effect.[181] As FSA photographer Jack Delano explained, "[To] me, a photograph is not reality. It is only an *interpretation* of reality. I do not believe that photographs do not lie. They lie all the time—though not intentionally, of course. In my view a photograph should not pretend to represent reality. The best it can do is *interpret* reality. It cannot tell the complete truth, but it can try to get at the *essence* of the truth."[182] In order to capture the essence of Steinbeck's writing Lee obviously did not object to interpreting reality.

James Gregory has pointed out that, barring complications, most migrants could make the trip to California in three to four days. The Joads believed that the trek would take around ten days. It is not clear how long the Thomas family expected to be on the road, but they estimated the journey would cost $20.[183] From Lee's photographs, it already seemed doubtful that they would be so lucky. Like Steinbeck's characters, they soon encountered misadventures.[184] Even before they

hit the road, a terrible thunderstorm delayed their departure and produced mud so thick that Lee's new Plymouth 2 became stuck and he punctured his gas tank.[185] In a small town near Henryetta (possibly Okmulgee), less than fifty miles from their point of origin, their car stalled on Main Street, and steam leaked ominously from the radiator. Ultimately, they needed to be pushed to a service station where they received needed fuel, air in the tires, and water for the radiator (figures 124–127).[186] Lee photographed each painful detail.

The photographs in the filling station were some of the last Lee made of the Thomas family, and he never knew whether they fared better on the remaining 1,400 miles of their trek or once they reached California. Lee headed out to a new assignment while the Thomases continued toward California, again. It was, as they all knew, a known path but with an unknown outcome. Although Lee did not follow the family to their final destination, he had a general picture of what was in store for them and for other migrants. From experience he knew of the migrants' hardships and restlessness, and was not altogether optimistic about their future. "As you know," he informed Stryker, "the cycle of migrant from tenant farmers is roughly this—after leaving the tenant farm

FIGURE 126. Russell Lee, "Pushing a truck of migrant family en route to California in order to get it started, near Henrietta [*sic*], Oklahoma." July 1939. *Library of Congress, LC-USF33-012322-M4*

FIGURE 127. Russell Lee, "Filling radiator of migrant car with water. This is done frequently, as these radiators usually leak. Near Henrietta [*sic*], Oklahoma." July 1939. *Library of Congress, LC-USF33-012323-M3*

they become agricultural day laborers or work on W.P.A. and then gradually become disgusted and turn to the road."[187]

In 1989, on the fiftieth anniversary of the publication of *The Grapes of Wrath,* Jack Fischer, a reporter for the *San Jose Mercury News,* tracked down the two surviving members of the Thomas family—Tommy, then age sixty-six, and his younger sister, Ruby, both still living in Bakersfield— and pieced together their story. He learned that upon their arrival in California in 1939 Elmer and his family settled in a Hooverville in Bakersfield, California. Elmer found work for the Southern Pacific Railroad while Edna became the cook for the crew. Amos, the jack-of-all-trades, headed out on his own and Frank joined the Civilian Conservation Corps. Their stories were filled with struggle, sorrow, and hope. Edna and Elmer divorced in 1950. When Elmer died in 1963 at the age of seventy-three he was alone and buried in an unmarked grave. His son Frank died in 1971 of a kidney ailment in Oklahoma. Edna died in 1981, and Amos was never heard from again after he went out on his own.[188]

With the Dust Bowl buried in their past, the surviving Thomases—who were now great-grandparents—would call themselves Californians. In 1935 Paul S. Taylor contemplated the future of the young migrant: "will these children of distress who creep west unheralded have no share in California history and tradition?"[189] At the time the answer was anything but clear. Although the question took decades to answer and by some accounts the result was not spectacular, the migrants' story ultimately was one of progress and pride. One reporter noted, "The pariahs, outcasts and social lepers of yesterday have become . . . worthy and respected members of the communities in which they settled. They are honest and industrious. They have better homes, better jobs, and greater economic security than ever before. They have regained their self-esteem; and they walk, talk, work and vote as equals among equals."[190]

For decades the term "Okie" was a slur from which many fought to disassociate themselves. Being an Okie meant being dirty, dislocated, and a "depression drifter."[191] Florence Thompson,

for example, resented that Lange's image stereotyped her as an Okie and a *Grapes of Wrath* character.[192] One of the few exceptions was Woody Guthrie, a self-proclaimed "Okie full blood," who insisted that should be his only epitaph.[193] Most of the children of the Depression preferred the label "Dust Bowler."[194] By the 1970s, however, many "came from behind the pea patch" and proudly accepted being an Okie.[195] In his 1969 counter-counterculture hit song Merle Haggard, the son of a migrant, unashamedly proclaimed: "I'm proud to be an Okie from Muskogee." Several decades after their arrival in California the surviving family of Elmer Thomas would probably say the same.

In covering the Thomas family as they packed up their home, loaded their Model A, and began their westward trek, Lee covered a large portion of *Grapes of Wrath*. Steinbeck dedicated more than three hundred pages to the Joads' experiences in Oklahoma and on Route 66.[196] Even after he documented the Thomas family, however, Lee's work related to *The Grapes of Wrath* was still not complete. For much of the summer he continued to document Midwesterners who stayed behind by choice and others who were hopelessly trapped on the land in Oklahoma. Later, he recorded the select few who made it to a place disarmingly called Pie Town.

Hope and Despair along the Migrant Trail

Russell Lee

In August 1939 Roy Stryker (figure 128) made a rare field visit to Russell Lee to observe and help him in his coverage. Together Stryker and the Lees traveled more than three thousand miles through Oklahoma, New Mexico, Texas, Colorado, and Arizona.[1] In contrast to his earlier ten-day field visit with Lee in Minnesota, Stryker did not take photographs on this visit.[2] From Lee's images it is possible to see that Stryker was part field operative and part tourist.[3] Years later Stryker recounted some of his experiences in the field with the Lees. The most poignant occurred somewhere along the migrant trail. Stryker recalled coming over a small hill and encountering two migrants along the road with two baby strollers. The strollers contained the couple's four children of various ages. The two carriers represented the sum of their possessions. When Stryker inquired about their destination, their response was, "We're going to try to make it to California." Impressed and humbled, Stryker gave them his address and asked them to write once they arrived. The family did later send Stryker notice that they had succeeded in reaching California. "That thing had a terrific effect on me," he remembered. During their conversation Lee reached for his camera to take the couple's picture, but Stryker stopped him, saying, "No, you can't. You just put that camera back." Stryker later recounted, "There was something about that situation I saw, that I couldn't stand the thought of a photograph of those two people and their two baby carriages. I didn't want it photographed. It was crazy but I couldn't help it. It was a strange quirk in me not to have that photograph. I was so touched, so involved— it went so deep into me."[4]

FIGURE 128. Russell Lee, Untitled photograph of Roy E. Stryker, ca. August 1938. *Library of Congress, LC-USF33-011585-M5*

Comfortably ensconced in Washington, Stryker experienced the plight of America's poor through photographs, and he cherished being able to go "into every home in America" from his office.[5] His was a virtual experience that depended on the photographers who were working on the front lines. Writing to Lange about his trip, Stryker reported, "That country is rich with material for our cameras."[6] Yet in this instance he objected and let some of the richest material remain a part of his own private memories and understanding. In person the experience was too real and uncomfortably close. For his part, Lee had, after all, captured the likenesses of hundreds of other migrants in dire straits. He was used to understanding the world through the lens of his camera.

Stryker always saw his role as different from that of his photographers. For all of his involvement in maintaining and protecting the FSA photography file, Stryker remained distant and detached from the Historical Section images. His experience in the West suggests that he was more than the administrator of the Historical Section, more than the gatekeeper of the photography file.

In his role as editor of the files, Stryker's worldview was predicated more on the photographs he viewed than the world his photographers were engaging with. He was the surrogate for the viewer and saw himself as such. Not only was he the defender of his photographers, their "watchdog" as Lange put it, he was also an advocate for the subjects they photographed.[7] After looking at a batch of images from Lee's work in Oklahoma, Stryker reported,

> Every so often I am brought to the realization of the ruthlessness of the camera, particularly the way we have been using it. A lot of people whose pictures you took do not realize how they are going to look to smug, smart city people when the pictures are reproduced. Of course, we could turn right around and put the camera on the smug, smart city people and make them ridiculous too.[8]

Out on the front lines, Stryker's reaction was starkly different from that of his employees. He had not inured himself to the suffering they witnessed on a regular basis.

After surveying the land and the situation on the ground, Stryker decided to send Lee to Kansas, the home of the Wilson family, who became the Joads' friends and allies in *The Grapes of Wrath*.[9] In Kansas Lee did make pictures of Dust Bowl devastation, but much of his work involved making official images of jaunty client-farmers who were benefiting from FSA programs, such as William Rall of Sheridan County, Kansas (figure 129).[10] Along with taking portraits of the farmer's family of thirteen, Lee photographed Rall in his cornfields and with his wife holding samples of their diverse crop. Similarly, Mrs. Shoenfeldt, another Kansan recipient of FSA funds, was shown smiling among the fruits of her labors (figure 130). Lee's images were not unlike John Steuart Curry's contemporaneous images of a pastoral and prosperous Kansas painted on the walls of the Kansas State House.[11]

Lee did not seem to have any difficulty persuading these farmers to pose for his camera. As Marion Post Wolcott noted to Stryker, most of the poor "don't object too strenuously or too long to a photographer or picture. They believe it may help them, or they may get something out of it—a little money, or better houses, or a gov. loan."[12] This was clearly the case with these individuals, who were benefiting from the largess of the FSA and were proof that its efforts were producing positive results. The FSA called these farmers clients or borrowers; agency head Will Alexander referred to them as "our people."[13]

FIGURE 130. Russell Lee, "Mrs. Shoenfeldt, wife of FSA (Farm Security Administration) client, Sheridan County, Kansas. Chickens are an important part of live at home program for this family." August 1939. *Library of Congress, LC-USF33-012357-M3*

These images provided Stryker with the "cheery side" of the Dust Bowl.[14] At Stryker's request Lee also photographed happy times such as a 4-H Fair in hard-hit Cimarron County in August, one month after his work with the Thomas family. These sunnier images of the region may however have been the exception—there was still a muckraking edge to the FSA.[15] In places like the migrant camp that Lee called Mays Avenue, along present May Avenue in what was then the outskirts of Oklahoma City, the photographer created shocking images of suffering. The smiling faces of FSA client-farmers were replaced with images of poverty and misery unmatched in *The Grapes of Wrath*. Located right off Route 66 and near the Elm Grove camp both Lange and Lee had photographed earlier (see figures 19–21), the migrant camp was a location Steinbeck would have passed during his travels in 1937. In the camp Lee found migrants trapped in a liminal space—a no-man's-land—between the place they had once called home and a destination—California or otherwise—that remained elusively out of reach.

Only three years earlier Oklahoma City had boasted that it "scarcely knew that there was a depression" and had portrayed itself as "a white spot upon the map of the nation's business, to the astonishment of the country."[16] Yet the nearby camps and shantytowns along the banks of the Canadian River painted a very different portrait. Located near the meatpacking district and the city dump, the camps of Elm Grove and Mays Avenue were nearly ten years old by the time Lee arrived in 1939. In 1935 less than half of the inhabitants were former farmers or tenants who had left the land (figures 131 and 132).[17] Four years later Lee noted that the camps had roughly three thousand inhabitants, most of them migrants who were trapped. He photographed piles of useless plows and tires—symbols of futility, stagnation, and desperation (figure 133). Always looking for the good, he noted the ingenuity and resourcefulness of the inhabitants as well as their intense religiosity.[18] It must, however, have been difficult to put a positive spin on what he witnessed.

FIGURE 131. Russell Lee,
"Part of Mays [*sic*; May]
Avenue camp under the bridge.
Oklahoma City, Oklahoma."
July 1939. *Library of Congress,*
LC-USF34-033941-D

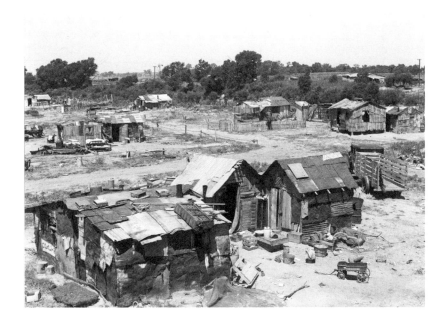

When actress Helen Gahagan Douglas visited the camps as part of her own fact-finding mission in support of Steinbeck, she reported that the scene was so bad she gagged until she could get out of the camp."[19] At about the same time writer Henry Hill Collins described the situation:

> In Oklahoma City a 1941 visitor would have seen thousands of migrants and stranded migrants in a state of deep degradation and squalor. Many of the inhabitants of this camp, a rent-free shack-town fashioned over and out of a former dump, were drought and tractor refugees from farms elsewhere in the State, who, unable to progress further, had had to put up in this vast transient hut-town.... The 'Housing' ... was almost entirely pieced together out of junk-yard materials by the unfortunates whose destitution compelled them to dwell there.

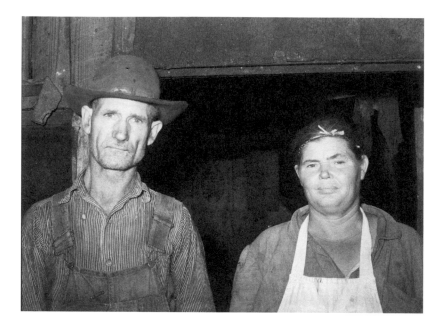

In Collins's account, as with others, it was the children who were the focus of pity in the "stench, filth and general debased living" of the camp. Collins continued his vivid description: "children, looking like savages, played in the dumps, wandered along the neighboring, muddy banks of the half-stagnant Canadian River or aimlessly roamed the twisting, dusty alleys between the shacks and lean-tos." "Indeed," he concluded, "so foul were these human habitations and so vast their extent that some authorities reluctantly expressed the belief that Oklahoma City contained the largest and the worst congregation of migrant hovels between the Mississippi River and the Sierras."[20]

The Lees labeled both the Elm Grove and Mays Avenue camps deplorable, but in their opinion Mays Avenue was by far the worse camp. In the extended caption Jean reported, "There are no streets, little attempt at beautification, and there has not yet arisen any pride of possession. The

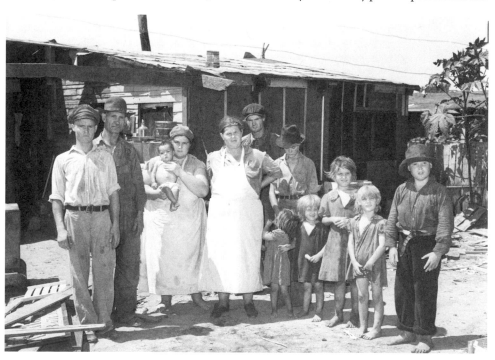

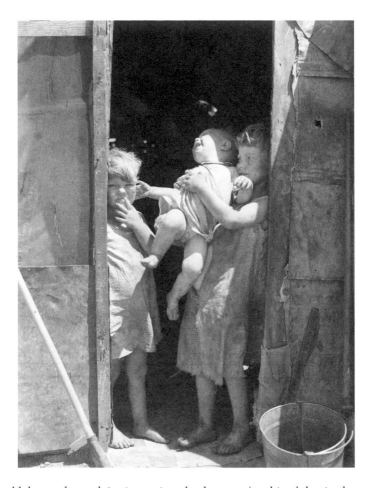

FIGURE 136. Russell Lee, "Children of Mays Avenue camp dressed in old sacks. Their father is a "trasher." Oklahoma City, Oklahoma." July 1939.

Library of Congress, LC-USF34-033949-D

camp is built on top of an old dump, the trash jutting up in ugly ulcers. . . . 'trashing,' that is, the gathering from the dump heaps of any salable articles such as metal, bottles and rags, is the best represented occupation."[21]

In his investigation of Mays Avenue Russell Lee made a different portrait of those most vulnerable to the suffering of the Depression. In this town of "dirty rags and scrap iron," Lee photographed the poor "trashers" and other adults who were forced to scavenge for expired vegetables for their food (figure 134).[22] Yet his focus was clearly on the children (figures 135 and 136). As James Guimond has suggested, rarely if ever did FSA photographers focus on the grotesque.[23] But in the shack homes of Mays Avenue such a focus could not be avoided. Many of the images he made were too disturbing to appear in newspapers, and even now they are rarely printed in the largely nostalgic books on FSA photography that are regularly published.[24]

In Mays Avenue Lee focused much of his attention on families, and particularly on the children. As a reliable barometer of social change children reflect and magnify their parents' condition.[25] In *Grapes of Wrath*, however, Steinbeck elected to keep the children largely above the turmoil. He did not ignore their suffering, but for the youngest members of the Joad family, Ruthie (age 12) and Winfield (age 10), the migration was primarily an experience of wonder and adventure.[26] Although profoundly affected by external pressures, they remained relatively aloof from the pain and worry the other members of their party experienced. Their innocence and naïveté often enabled them to rise above hardship. The same quality was often captured in FSA photographs as well.[27] Stryker's team captured hundreds of images of children playing games, often in the street or on the porches of their homes, running around in packs, or simply following

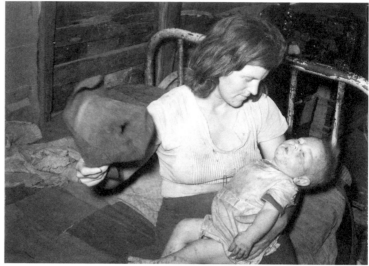

FIGURE 137. Russell Lee, "Mother bandaging toe of her son, which was cut in debris of Mays Avenue camp. Oklahoma City, Oklahoma." July 1939. *Library of Congress, LC-USF34-033929-D*

FIGURE 138. Russell Lee, "Mother fanning child with old hat to keep off flies. Mays Avenue camp, Oklahoma City, Oklahoma. See general caption 21." July 1939. *Library of Congress, LC-USF34-033953-D*

the photographer. In other words, they generally captured children behaving like children. Given the right circumstances, however, they did show children looking pitiful and helpless.

Migrant camps were particularly hard on children. As Lange did in photographing the "Damaged Child" at Elm Grove (figure 21), in Mays Avenue Lee focused on the children of the camp to expose the crushing poverty he witnessed. Ansel Adams once claimed that the FSA photographers were "sociologists with cameras,"[28] and in this camp there was no way of avoiding the gritty subjects in order to give Stryker photographs of what was right with America. Lee documented an environment that was filthy, degrading, and even crippling. He recorded bare-footed children who had been injured by the ubiquitous trash and debris (figure 137). In one photograph that showed the utter squalor both inside and outside people's homes, Lee captured a young boy trying to eat an overripe cantaloupe in the midst of an infestation of flies. Years earlier in *Their Blood Is Strong*, Steinbeck had described a similar situation: "The tent is full of flies clinging to the apple box that is the dinner table, buzzing about the foul clothes of the children, particularly the baby, who has not been bathed nor cleaned for several days."[29] In another image a young mother futilely tries to swat the flying insects off her limp, inert child with an old hat. This is a truly pitiful pieta that is arguably unmatched in the FSA collection (figure 138). Another shows two young boys in a similarly sad situation. The youngest child, defeated by the onslaught, does not even try to keep the flies off his face (figure 139).[30] Stuck and abandoned in places like Mays Avenue, these migrants were worse off than the Joad or Thomas families. With little chance of escape they lacked even a reason to hope for an opportunity at a better life over some distant horizon.

Perhaps Mays Avenue culminated Lee's view of Oklahoma through the lens of his *Grapes of Wrath* shooting script. When the Lees returned to eastern Oklahoma seven months later, in the fall of 1940, they sought out a starkly different portrait of those who had stayed behind. This time Russell and Jean Lee found "rural folk" and small farming communities or knit together by "a close identity of interests." In Muskogee County Russell documented a "pie supper," a pie

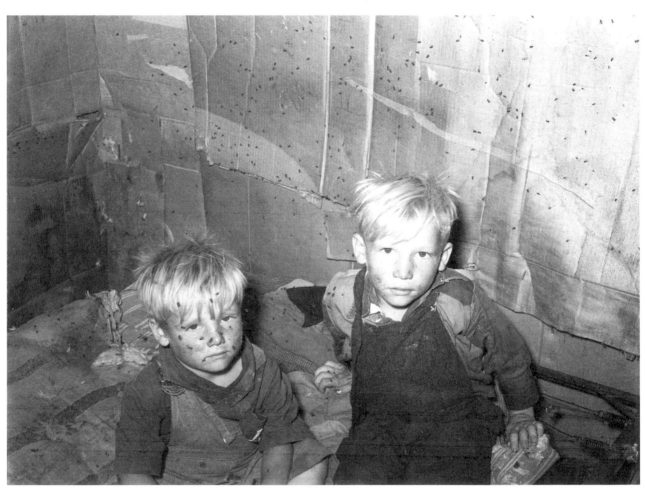

FIGURE 139. Russell Lee,
"Children of Mays Avenue camp
family in small shack used as
sleeping quarters. Oklahoma
City, Oklahoma. Refer to
general caption no. 21."
July 1939. *Library of Congress,*
LC-USF34-033883-D

FIGURE 140. Russell Lee,
"Young couple dancing at Jaycee
buffet supper and party. Eufaula,
Oklahoma." February 1940.
Library of Congress, LC-USF34-035410-D

auction and fundraiser for the community. Despite the fact that the men "bemoan[ed] the lack of rain" and the women discussed the "housekeeping difficulties when the dust storm starts," there was singing and the farmers were well fed and satisfied. In nearby Eufaula, the county seat of McIntosh County, he found similar happy events in spite of the cold temperatures and roads impassable due to mud and ice.[31] Where only months earlier he recorded unflinching poverty, he now documented the lives of local farmers enjoying "play parties," boy scouts, 4-H club activities, a basketball game, and a buffet dinner and dance held by the Jaycees (a nonsectarian youth service organization) (figure 140).[32] Not all the events he recorded were recreational. That winter he also recorded meetings related to soil conservation, the AAA (Agricultural Adjustment Agency), and the FSA. As his extended portrait of a "Negro tenant farmer" from Creek County named Pomp Hall indicates, the promise of a higher standard of living and the renewed sense of optimism were not limited to the white residents of the state.[33] In all, Lee's photographic follow-up presented a much different and more balanced picture of life in the state. It showed that there was a brighter outlook and a broader foundation for a different future in eastern Oklahoma.

Actually, it was in a neighboring state that Lee found what seemed to be the clearest foil to the poverty he documented in Oklahoma during the summer of 1939. His detailed portrayal of Pie Town, a village located in the remote highlands of New Mexico, offered a sharp contrast to the destitution around Muskogee and Sallisaw and the filth and flies of the Oklahoma City camps (figures 141 and 142). Recall that in the spring of 1939, Stryker had commissioned Lee to document small-town life as fully as possible. The town he selected and documented then was the small East Texas town of San Augustine.[34] One year later, in what must be seen as part of his work with the migrant and Steinbeck's novel, he documented the small, pioneering community of Pie

Town. This was arguably the most important body of work in Lee's career and one that took full advantage of his abilities to catalog and record a place in full detail.

The choice of Pie Town was serendipitous. The Lees saw the tiny town on the map and thought that it sounded like a good place to investigate the American small town.[35] It did, after all, have an inviting name and even today boasts of being "America's Friendliest Little Town."[36] Founded in the early 1920s on the Continental Divide in western New Mexico, it was removed from the busier thoroughfares to the West. A small town of only 250 families, it grew during the Great Depression due to an influx of migrants principally from Oklahoma and Texas. If Mays Avenue exemplified migrants beaten down and sullied by their situation, Pie Town showed them as hardy pioneers who were able to "stay off the highways and the relief rolls" and turn a challenging, high-mountain, frontier landscape into a prosperous community.[37] Lee saw it as a "place that had unalterably molded the American character."[38] Pie Town represented a positive ending of the migrant trail.

Many migrants came to Pie Town directly from the Dust Bowl. When the Lees chose the town it was already known as the halfway point of the migration from Oklahoma, Texas, and Arkansas to California.[39] Those arriving in town were typical migrants. Lee noted that they came

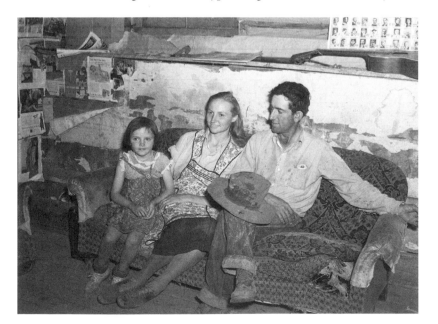

FIGURE 144. Russell Lee, "Detail of homesteader on horseback returning home after trip to town. There is no R.F.D. service so farmers must make a trip into town for mail. Pie Town, New Mexico." June 1940.

Library of Congress, LC-USF33-012709-M4

with very little: "Usually they brought their kids, their personal belongings, some furniture, and some family heirlooms, in cars that barely made the grade," he observed.[40] The Keele family, originally from the Texas Panhandle town of Demmet, stopped in town in 1933 to buy nails. They ended up staying. The Besson and Caudill families had come from Oklahoma (figure 143). "After the Dust Bowl," one resident recalled, Pie Town "looked like heaven to us."[41]

In sharp contrast to the residents of the crowded Hoovervilles in California or the derelict camps in Oklahoma, when migrants arrived in Pie Town they were transformed into homesteaders. In Oklahoma Lee had labeled everyone a "migrant" in his captions; in Pie Town his subjects were "pioneers" or "homesteaders." He elaborated that the residents of the town were like "pioneers who have pushed westward . . . doggedly, ingeniously, humbly and yet heroically, conquering a continent, making it fruitful for generations to come."[42] The "rugged individualism" that brain-truster critics saw as partly to blame for the migrants' downfall in Oklahoma was now an asset on the frontier (figure 144).

In his work Lee emphasized both individualism and cooperation, resilience and self-reliance.[43] In an article published in *U.S. Camera* Lee insisted that Pie Town was a "frontier town

very much after the pattern of frontier towns a hundred years ago."[44] He photographed the log dugout dwellings migrants built on their arrival and the better homes they constructed once they were established. Among the small-town traditions they maintained, he photographed canning, quilting, religion, and a sense of community (figures 145 and 146). In contrast to images of farmers being "tractored" off their land, Lee showed Pie Town residents using technology to better their circumstances. Most importantly he recorded how they had preserved their humanity and vitality.[45] Altogether, this was a very different portrait of the migrant than the one he constructed earlier in other parts of the Midwest.

In addition to photographing the general scene in Pie Town, Lee spent an entire day photographing the family of George Hutton, a homesteader originally from Oklahoma. In many ways the Hutton family presented a strong foil to that of Elmer Thomas. In far better circumstances, the Huttons were depicted as well-to-do farmers not destitute Okies. Among the first to homestead in Pie Town in 1931, they claimed more than six hundred acres.[46] They were industrious, inventive, and successful. In fact, the family had prospered in New Mexico and were better off than most Pie Town residents.[47] They owned their own tractor and even had an electric washing machine. Lee photographed Mr. Hutton working in the fields and in his tool shop while his wife and children were busy in their orderly home and garden. As James Curtis pointed out, the photographs of Mrs. Hutton represented a concentration of hard work, family values, and deeply rooted beliefs.[48]

There were certain elements of his former life that George Hutton did not miss. According to one caption Mr. Hutton told Lee, "There is nothing I'd rather see less than a cotton field" (figure 147). Yet even in their favorable circumstances they were still tied to their past and longed for their home in Oklahoma. Lee cued into this by photographing two of the family's cherished heirlooms among the few items that they brought with them—two framed photographs. As he had done in Oklahoma, Lee used personal photographs as a means of getting to know the

FIGURE 147. Russell Lee, "Mr. and Mrs. George Hutton, Sr., homesteaders from Oklahoma. Mr. Hutton says, 'There is nothing I'd rather see less than a cotton field.' Pie Town, New Mexico." June 1940. *Library of Congress, LC-USF34-036727-D*

From Controversy to Icon

FIGURE 148. Russell Lee, "Picture of the Hutton family taken about fifteen years ago in Oklahoma. Pie Town, New Mexico." June 1940. *Library of Congress, LC-USF33-012729-M4*

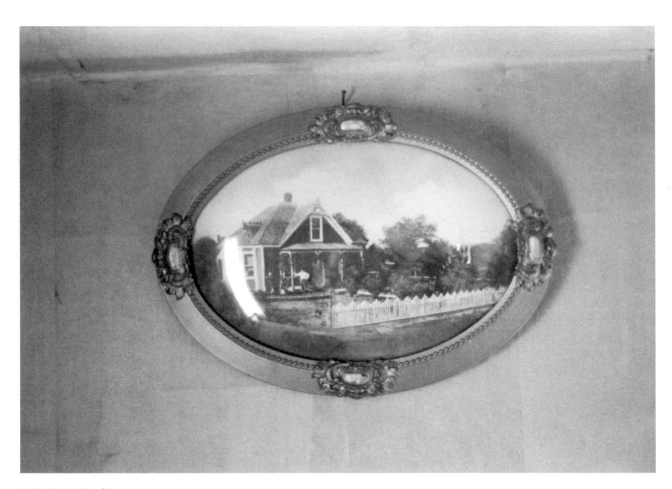

FIGURE 149. Russell Lee, "Picture of their farm home in Oklahoma. Hanging in living room of the George Huttons, Pie Town, New Mexico." June 1940. *Library of Congress, LC-USF33-012728-M5*

family and their aspirations.[49] The nicely framed family portrait, which Lee photographed in the bright New Mexico sun against the rough unpainted wooden boards of the home, had been taken fifteen years earlier and showed the Huttons as composed, well off, and strong (figure 148). In their new life on the frontier this portrait must have acted as an aide-mémoire of a more stable past.

The second photograph, which hung in the living room near or alongside the various religious images that adorned their home, also showed prosperity lost (figure 149). It was a photograph of their former farm home, which sat on eighty acres in Maud in central Oklahoma.[50] This image represented more than what they left behind. The family could see through the photograph to a place that once existed and was assuredly still longed for.[51] In *The Grapes of Wrath* Ma Joad dreamed of a "little white house."[52] In many ways the Huttons were dreaming of the same thing. The difference was that for Ma this house was a hope for the future; for the Huttons it was what they had lost in the past. In the novel, Ma Joad burned similar images as an act of cutting her ties with the past. "How will we know it's us without our past?" is a lingering question for all migrants.[53] For the Huttons these active mementos served as a foundation for their new lives in New Mexico. All of their hard work in Pie Town was an attempt to recover what was once theirs and to re-create what they had lost.

Ultimately, many of Pie Town's pioneers failed to make a go of it in the highlands of New Mexico and were forced to move elsewhere in search of a better life.[54] This outcome was not obvious from Lee's photographic coverage, which implied a foundation that would last. Years later Jean Lee admitted that she and Russell had serious doubts at the time about whether the families would make it. They also felt that their rosy work created a false impression of the town.[55] At the time however Lee's images served to reassure viewers that the American dream and the zeal of the pioneer would persevere. When Lee arrived in Pie Town he was told it was the "last frontier." This image was especially important in an age of migration when it seemed the past had been swept away like the sands of the Dust Bowl. If these people could dream and make a living in these conditions, perhaps the American myth of converting wilderness into farms was not dead. With rather more realism, Stryker was leery of this phrase, believing that there never would be a "last frontier."[56] Those who stayed and those who moved on both faced other frontiers to overcome.

Through their continuing travels Russell and Jean Lee witnessed firsthand the epic nature of the American migration, personally experiencing and recording the process. In many ways what Lee saw corroborated what he had read in Steinbeck's *Grapes of Wrath*. In Sallisaw and along the highways and byways of Oklahoma he saw desperation, poverty, and decay. This gave him a perspective that few had. Jean Lee commented that they observed, "Okies in the fruit, Okies in the vegetables, Okies in the stoop crops, Okies picking cotton; migrants on the roads, bums in the towns—everyone is excited over these thousands." She continued, "California is worried over the problem of excess farm labor. How to get work for them, how to give them a living wage without ruining the grower, how to keep their children in school. It is assuming the place of Public Problem Number One." The Lees knew the depth of this problem, yet also realized that at its heart were the farmers who were trapped on their depleted land in Oklahoma. "There is another group of farmers that can rightfully claim the title, Forgotten Men," Jean Lee continued, "They are the farmers who have remained in Oklahoma. The farmers who are trying to force a living for their large families from that soil these thousands in California have left, saying, "We can't make a living here.""[57]

Through traveling with migrants, Lee saw how their experiences matched the Joads'. He also saw, however, that no matter how encompassing the novel, Steinbeck could tell only a small part

of what was actually happening on the ground. Lee attempted to explore the various aspects of this greater story. He tried to tie it to names and places; he tried to show the triumphs and failures of the migrants. In all, he showed their humanity. Lange's coverage in California and Lee's in the Midwest created a more complete portrait of the migrant than Steinbeck could have put into words. From Muskogee to Mays Avenue, Lee recorded the conditions that forced families to flee and what happened to those whose flight was unsuccessful. In Pie Town he created an image of hope. With his camera as a tool, Lee showed the nation the complexity of the "migrant problem." He also showed the challenges and strength and resilience of these American refugees. "Strangely enough these are not beaten people," Jean Lee proffered. "They are fighting people. They have had a struggle and they expect to always have a struggle to keep their families together and alive."[58]

Displaying Grapes and Wrath

FSA Exhibitions

In May 1939, while Russell Lee was working throughout Oklahoma, Roy Stryker was still "bubbling over with ideas" about how he could exploit the public excitement around *The Grapes of Wrath*.[1] As many scholars have suggested, Stryker had energy and drive but was not an idea man. According to Michael Lesy, for example, he was much better at identifying important ideas than having his own. Once Stryker recognized a big idea, however, he was fiercely single-minded in making it happen.[2] This is exactly what would happen with his plans for *Grapes of Wrath*, though not all of his schemes came to fruition.

Early on Stryker hoped that the photographs of his Historical Section, especially Russell Lee's, could illustrate Steinbeck's novel. In his mind the pairing seemed a natural fit.[3] In the spring and early summer of 1939 and in the face of increasing hostility toward his agency, both from the public and within the Roosevelt administration, he made several trips to New York in attempts to sell the idea to a publisher.[4] Stryker approached Viking Press, the publisher of *Grapes of Wrath*, about a "picture-book" that could accompany the novel.[5] His idea was turned down. Like Steinbeck himself, Viking was apparently not interested in transforming the successful novel into a documentary text. At the end of June Stryker was still "putting all the steam we can on the Oklahoma pictures" but was not enjoying any success in marketing them.[6]

Others beyond Stryker and Lee recognized the connection between the FSA's images and Steinbeck's text. For many, Steinbeck's characters resonated with the images they already knew. In April Edwin Locke informed Stryker, his former boss, "I am reading Steinbeck's great book, and it's great. When you read it, notice how like the pictures of D[orothea] Lange it is."[7] Others in the media also saw the connection. Writing for the *Saturday Review*, George Stevens pointed out to readers of *The Grapes of Wrath*, "You have seen them going West through Texas and New Mexico on Route 66, or you have seen them in the Resettlement Administration photographs."[8] Thus, from the beginning the two bodies of work were linked in the public's mind. Yet despite this fact and all of Lee's and Stryker's efforts in Oklahoma and Washington, FSA photographs would not be used to illustrate *The Grapes of Wrath* until decades later.

Following the book's release many migrant advocates proposed tie-ins to Steinbeck's novel in a belief that buttressing it with empirical evidence would make it difficult to dismiss as mere fiction. In 1939, Leon Whipple suggested in *Survey Graphic* that Steinbeck's "bitter story" be accompanied by the report on unemployment and relief that Paul Taylor had submitted to Congress, along with Lange' photographs illustrating it and other pertinent information to help readers realize the truth behind the novel.[9] Some saw *Factories in the Fields,* Carey McWilliams's exposé of California's agricultural industry, as the novel's factual counterpart. As the critic Robert A. Brady pointed out, "Here is the data that gives the terrible migration of the Joad family historical and economic meaning not only for the immediate present, but also for the larger canvas of American rural life at the end of a long, rich cycle."[10] Others saw Lange and Taylor's *American*

FIGURE 150. Title page to
M. V. Hartranft's *Grapes of
Gladness*, illustrated by Kathryn
Bone, 1939.

Exodus as a necessary ancillary to Steinbeck's work. Stryker saw the strong similarities between the photo-book and the novel, while Maynard Dixon believed that Lange and Taylor's collaboration was a factual version of *The Grapes of Wrath*.[11]

Those who wished to corroborate Steinbeck's novel are better remembered today, but at the time there were many writers who used their skills to undermine the story. Among the novels published in the wake of *Grapes of Wrath* were M. V. Hartranft's *Grapes of Gladness* (1939), a sappy story of the Hoag family from Oklahoma who find prosperity in California, and Ruth Comfort Mitchell's *Of Human Kindness* (1940), which attempted to put forth a different narrative of the nature of California and the migrant experience.[12] Mitchell professed to admire Steinbeck and claimed the goal of her novel was to show the "farmer's side" of the situation.[13] Neither work was successful in solidifying a rosier picture of the migration or of California's picking fields. Steinbeck's opposition was not able to put forth a documentary counterpart that matched McWilliams's or Taylor's empirical data. Likewise, few used realistic imagery in their effort to debunk Steinbeck (figure 150). Hartranft's text contained cheery cartoons of migrants, and Frank Taylor's critical article "California's Grapes of Wrath" featured woodblock illustrations by the English-born artist Clare Leighton. Few readers were likely to mistake Leighton's idealized images of the English countryside for central California (figures 151 and 152).[14] The Sunkist Corporation and the Associated Farmers created their own photographic campaigns to counter Lange's potent photographs. Not much is known of their efforts, which had little impact and quickly slipped from view.[15]

FIGURE 151. Clare Leighton,
"August, Harvesting."
Woodblock print. 1933.

Estate of Clare Leighton.

FIGURE 152. Clare Leighton,
"September, Apple Picking."
Woodblock print. 1933.

Estate of Clare Leighton.

The only illustration accompanying *The Grapes of Wrath* on its first publication in 1939 was the dust jacket illustration by Elmer Hader, an academically trained painter who became an award-winning illustrator (figure 153). Hader was a logical choice for the jacket art. One year earlier he had provided, at Steinbeck's request, the pastoral illustration for *The Long Valley*. Later he provided illustrations for two other books by Steinbeck: *East of Eden* and *The Winter of Our Discontent*. Milton Glick, Viking's artistic director, requested that Hader's painting emphasize hope instead of dejection but still have an "additional feeling of dustiness in the air and dryness in the land."[16] Hader's illustration featured a small and unshod migrant family seen from behind as they watch a long line of heavily laden jalopies rumbling down a rural road. Working from a brief abstract of the novel and probably from photographs, Hader successfully conveyed the spirit of the book if not its grim plot.[17] The cover's primary figures, rendered with a minimum of identifying details, become "everyman" proxies for the thousands of migrants on America's roads. Furthermore, the portrayal from behind also makes the image a *rückenfigure* that allows viewers to project themselves into the work and see the world through the eyes of the figures represented. It was an effective cover, but it lacked the realism needed to support the cause of the migrant and remove the association of artistic fabrication and license.

In April 1939, the same month *The Grapes of Wrath* hit bookstores, *Fortune* magazine published a lengthy investigation of the "Okie problem," entitled "I Wonder Where We Can Go Now," by an unnamed *Fortune* writer that some have speculated was Archibald MacLeish.[18] Many of Horace Bristol's previously rejected photographs from the camps, along with FSA photographs by Dorothea Lange, were published as an appendix to the article. Yet despite the reporter's suggestions that "it is worth while to study these people closely" and "photographs tell better than words . . . what the effects have on [migrants] as humans," the article itself was primarily illustrated with deft watercolor sketches by Public Works of Art Project artist Millard Sheets (figure 154).[19] At the same time as he was reading *Grapes of Wrath*, Lee also read this article and judged that it "missed an awful lot of the story."[20]

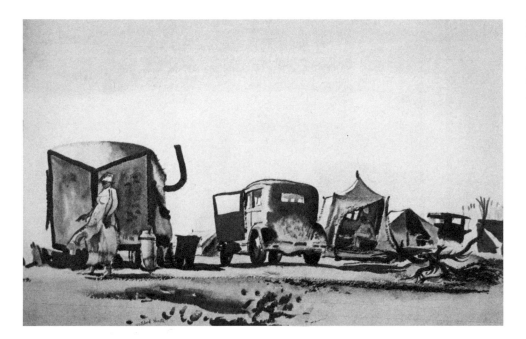

FIGURE 154. Millard Sheets, "Near Brawley," illustration (original in color) for *Fortune* article "I Wonder Where We Can Go Now." 1939. *Estate of Millard Sheets.*

The publication of "I Wonder Where We Can Go Now" set off a chain reaction throughout the photographic press. Not to be outdone by its sister magazine, *Life* finally published Bristol's work in its June 5 edition. What was once a forgotten story now became a way for *Life* to enter the migrant debate. The text touted Bristol's photographs as "not simply types which resemble those described in *The Grape of Wrath*. They are the people of whom John Steinbeck wrote." It continued, "Before starting his book, he [Steinbeck] lived in California's migratory labor camps. *Life* photographer Horace Bristol accompanied him."[21] Albeit belatedly Bristol finally saw his work hitched to Steinbeck's star. Ultimately, the photographs he took during the weeks he spent with Steinbeck would become one of his most recognized bodies of work.

Quick to jump on the migrant bandwagon *Look* magazine rushed to produce its own story and contacted Stryker about providing imagery. Stryker must have been pleased to oblige: FSA images had been published in magazines and periodicals before, but large photo magazines like *Look* offered exposure to a mass audience.[22] In August 1939 the magazine devoted an eight-page article, "The Story behind 'The Grapes of Wrath': America's Own Refugees," to the migrant problem. The purpose of *Look*'s article was to show the nation why Steinbeck wrote his novel and that more assistance, particularly in the form of federal aid, was direly needed to solve it.[23] To do so it matched FSA images and photographs by its staff photographer Earl Theisen directly with Steinbeck's prose. The first pairing linked an image by Arthur Rothstein of a young boy looking over the eroded fields of his Midwestern home with the words "God knows the lan' ain't no good . . . but it's our land." (The first part is a quotation from *Grapes of Wrath*, p. 264, the latter is apparently the editors' addition.) The article concluded with a far more optimistic image of young children receiving a bath in an FSA-run camp. Overall, the article followed the basic arc of Steinbeck's narrative of erosion, flight, and governmental assistance.

Shortly after *Grapes of Wrath*'s publication, Viking Press agreed to an illustrated edition, but much to Stryker's chagrin decided not to use photographs. Regionalist painter Thomas Hart Benton was instead commissioned to illustrate a two-volume limited edition published in 1940

(figure 155). According to the foreword by critic Thomas Craven, Benton's supporter and friend, it was inevitable—even foreordained—that Benton illustrate Steinbeck's novel. Craven argued that Benton's career-long predilection for capturing plain people full of courage and fight helped him portray the Joads in a straightforward and realistic fashion, and he even boasted that the illustrations were more realistic than Steinbeck's novel.[24] The subject also resonated with Benton, who believed that migration was an ongoing saga that was ingrained in the American character. "We Americans are restless," he wrote in 1937 after his own wanderings around the United States. "We cannot stay put. Our history is mainly one of migrations.... There seems to have existed since earliest times in this country an adventurous foot itch which made it difficult for men to plant themselves and settle for all time."[25]

Steinbeck was evidently pleased with Benton's illustrations, stating that they added a "visual dimension" to his book.[26] Yet the illustrations are lacking the realism that photographs could have produced. Like Sheets's drawings in *Fortune* or Hader's dust jacket for the original edition, Benton's lithograph illustrations may be seen as "a cross between post-office mural . . . and grainy documentary."[27] Once paired in the edition Benton's illustrations simply failed to equal Steinbeck's prose. The images did not give faces to the suffering, but merely provided their essence and types. Benton's illustrations must have irked Stryker, who wrote to Lange that a photograph "made on the ground" was more important than a painting could ever be.[28]

Yet it is probable that in many ways the artistic representations of Hader and Benton were closer to what Steinbeck intended as the role of illustrations. Despite all of his field research, his characters were not real. At the most elemental level Steinbeck's characters were designed to be

FIGURE 155. Thomas Hart Benton: "Tom Joad," and "Hooverville." Illustrations for the limited edition of John Steinbeck's *The Grapes of Wrath*. 1940. © *Estate of Thomas Hart Benton, licensed by VAGA, New York*

From Controversy to Icon

"larger than life," and the "over essence of people."[29] When looking for an artist to illustrate *Of Mice and Men* Steinbeck reportedly contacted Ben Shahn, who turned down the offer, claiming that his "illustrations would tend to vitiate the impact of the text."[30] Tellingly Steinbeck was interested in Shahn's talents as an artist not a photographer. Moreover, even if he employed some camera tactics and photographic terms to create a mental picture for his audience, Steinbeck's vision was not photographic, as critic Donald Adams has pointed out.[31] As Eleanor Roosevelt's initial reaction to the book illustrates, Steinbeck's scenes and story created their own picture.[32] Steinbeck may have been obsessive in his accuracy and details, but in the end everything was subservient to his art, and he did not believe photographs should compete with it. "I still think that most 'realistic' writing is farther from the real than the most honest fantasy," Steinbeck wrote a friend in 1936.[33]

For his part, Stryker remained adamant that the primary reason for all of the Historical Section's efforts was to help those in distress. Steinbeck's work made waves but some questioned whether it would actually improve the migrants' condition. Stryker wrote to Lee shortly after the publication of *Grapes of Wrath:* "Incidentally, and somewhat beside the point, I am fearful that all this furore over the book and later over the movie may not lead to very serious consideration of the problem. It will be another one of America's big excitements soon forgotten. We should make all possible capital of it and solidify our position as far as we can."[34] Beyond the popular press and books, there were other ways of using Steinbeck's name and work to broadcast the needs of the migrants and the FSA's accomplishments.

Even though Stryker was unable to persuade publishers to bring out Lee's photographs in book format, there were other means by which he could take advantage of the interest in Steinbeck's book. To make "all possible capital" of the moment, Stryker turned to an outlet that was increasing in importance for the Historical Section at that time: traveling photography exhibitions.[35]

The Historical Section mounted its first exhibitions in 1936, and traveling exhibitions soon became an important and highly effective tool by which the FSA reached the American public.[36] "Canned" exhibits, consisting of photographic prints mounted on mat boards, were constantly in circulation and were displayed in a wide variety of venues, including county fairs, women's clubs, colleges and universities, church conventions, public libraries, and public gatherings.[37] FSA exhibitions also visited loftier venues, including the Museum of Modern Art and the Cleveland Museum of Art.[38] Given the flexibility of the FSA and the low cost of materials, exhibitions could also be made to order.[39] In time, however, Stryker was inundated with requests and unable to keep up with demand. In 1938 he hired Edwin Rosskam to facilitate the use of FSA images in books, magazines, and exhibitions. Earlier in his life Rosskam had trained to be a painter in Paris and had become enamored with photography through his friend Man Ray.[40] At this time he developed an interest in modernist ideas and design that continued throughout his career. Upon his return to the States he married and worked closely with his wife, the photographer Louise Rosskam. The underlying theme of their employment, as Edwin Rosskam understood it, was to help "make a dent in the world."[41]

In organizing books and other materials for the FSA, Rosskam relied on what he viewed as the power and separate nature of text and image. "The ideal," he insisted, "is that they never overlap, but running parallel, should add up by saying what is to be said in the most direct way."[42] Rosskam admitted that for the most part putting together exhibitions was boring "bread and butter" work, but there were times when he was able to make "combinations of pictures and words" that really excited him.[43] He believed that books were ultimately the most effective means of reaching the

public: exhibitions could be packed away, magazines discarded, but books lasted.[44] Yet once in Stryker's employ he clearly spent much of his time producing exhibitions of various sizes.

Regional FSA managers particularly favored small exhibitions and saw them as effective propaganda.[45] Such exhibitions were not only effective but strategic as well. On the one hand they represented an effective means of getting the FSA's message to Main Street. On the other, they were typically small enough that they did not provoke the ire of critics or local congressman who might be upset at the use of tax dollars.[46] As Lee's photographs of an FSA exhibition at a state fair in Dallas indicate, these exhibitions were highly didactic productions in which photographs were only one component of a complex program (figure 156). Accompanying the photographs were text panels, charts, and statistics, as well as applied arts like models of canning pantries and even a tractor juxtaposed next to an old plow. Pare Lorentz's documentary films *The Plow That Broke the Plains* and *The River* might also be shown.

Stryker admitted that even the most important of the FSA exhibitions did not receive the attention or documentation they deserved, and most have faded into history.[47] Still, many of the most popular and important were those connected to *The Grapes of Wrath,* whose publication unfurled a new banner under which exhibitions on the migrant problem could be presented. By the fall of 1939 the FSA had a number of different productions on the road, including one titled *Migrant Exhibit* and multiple sets of a *Grapes of Wrath* exhibition.[48]

A 1941 photograph of the *Migrant Exhibit,* or at least part of it, revealed the nature of FSA exhibitions as well as the strong connections to Steinbeck's novel (figure 157). This exhibit, reportedly one of the FSA's most popular, was requested more than eighty times in a three-year period, though no requests ever came from Oklahoma, Arkansas, or Texas.[49] Titled "Small Farms Are Going Out," the display in figure 157 followed the basic arc of the novel, beginning with images of useless soil and an equally useless, tractored-out farm. These images represented the causes of migration. The effects came next via images of overworked pea pickers and Dust Bowl

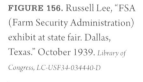

FIGURE 156. Russell Lee, "FSA (Farm Security Administration) exhibit at state fair. Dallas, Texas." October 1939. *Library of Congress, LC-USF34-034440-D*

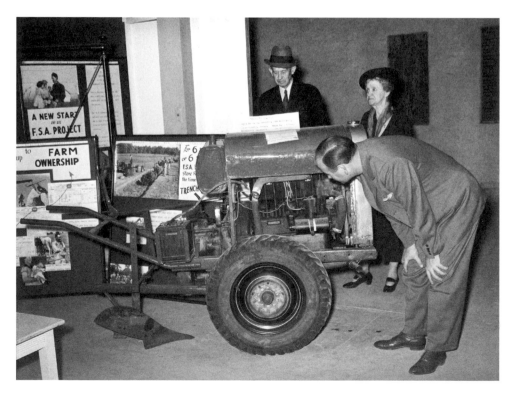

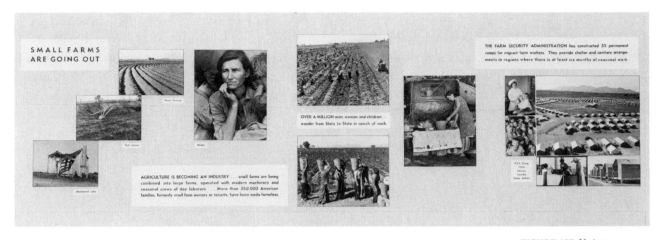

FIGURE 157. Various photographers, display from *Migrant Exhibition*. 1941. *Library of Congress, LC-USF345-007656-ZA*

refugees alongside statistical data declaring that 350,000 American families were homeless. The final images highlighted the orderliness and amenities of the FSA migrant camps, which were portrayed as a solution. Photographs by Arthur Rothstein, Marion Post Wolcott, Dorothea Lange, and John Vachon were represented in this small, portable exhibit.[50]

More closely aligned with the novel, the *Grapes of Wrath Picture Exhibit* featured panels of FSA photographs interspersed with quotations from Steinbeck. From surviving material it seems that the exhibition was malleable and could be customized for particular venues. Edwin Rosskam recalled using many of Lange's images in this exhibit. In the fall of 1939 he wrote to Lange seeking more material on migrants in FSA camps for use in it. "How do they cook, sleep, dress, and visa-versa, pray, visit, take care of their sick, their children, etc.?" he asked.[51] Like the *Migrant Exhibit* the *Grapes of Wrath Picture Exhibit* followed the general chronology of the book, ending with images of the FSA migrant camps in California.[52] According to Charlotte Aiken, Stryker's office assistant, the photographs in the exhibit were perfect for bringing the book's characters to life. This point was not lost on one reviewer, who claimed that "the exhibit pictorially tells much of the same story."[53]

From surviving information, it seems that the target audience for the *Grapes of Wrath* exhibition was residents of California and Oklahoma. Given the attention and scrutiny that both states received in the book, this emphasis seems logical. One of the most active producers of exhibitions was Regional Office IX in San Francisco under Jonathan Garst and Fred Soule. As early as 1936 Garst organized an exhibition on the migrant problem that featured graphs and charts organized by Paul Taylor and photographs provided and arranged by Lange.[54] A month before the publication of *Grapes of Wrath* Soule requested prints for exhibitions on the "cause, effect, and solution of the migration problem" in anticipation of the novel's release.[55] Soule felt that an exhibition was necessary because most people in California believed migration was a local problem rather than a national concern.

Later, Soule was eager to show a *Grapes of Wrath* exhibition, but feared that its message might be more effective outside California, where opinions were not yet crystalized. "You have to make up your mind on Steinbeck in California on a strict partisan basis," he wrote Stryker, "either you're for him and his novel or you're [against] him and all his works."[56] Even so Soule still actively looked for venues within the state. Understandably he wanted to send the exhibit to fairs in the Central Valley, the heart of Steinbeck's novel. He also sent materials to the Steinbeck Committee in southern California, who used them for lectures and showed them at "Grapes of Wrath" parties.[57] One of the leading voices in favor of the migrant and *Grapes of Wrath* was the actress-politician Helen

Gahagan Douglas, a friend of Paul Taylor's. According to Soule, Douglas was "indefatigable in her work to better the condition of the migrant" and used *Grapes of Wrath* and her own "considerable promotional value" in fund-raising and other activities.[58] Under the auspices of the Steinbeck Committee, and with the author's direct approval, she toured California, presenting exhibition materials to various groups.

The Department of Anthropology and Sociology at the University of Oklahoma mounted another *Grapes of Wrath* exhibition in March 1940. Displayed in the university's Union Lounge, it featured forty-eight images from Lee, Lange, Rothstein, and Shahn. The exhibition was made possible through the efforts of Willard Z. Park, a professor of anthropology and friend of Paul S. Taylor's and Roy Stryker's. Park was clear that his intention was to bring "home to our people the actual conditions of the state."[59] A promotional article in the *Oklahoma Daily* never directly stated the title of the exhibition but noted that it offered "an actual pictorial record" of *The Grapes of Wrath*. Although the exhibition matched quotations from the novel with FSA photographs, it was stated that Steinbeck's "shocking rhetoric cannot do the job as effectively as do the photographs now on exhibit."[60] Stryker described the exhibition as necessarily "ruthless," which was fine with Park, who stated, "A sugar-coated pill would not do the job, and certainly the situation demands that the public . . . realize the seriousness of our rural problems."[61] "These photos," one reviewer wrote, "bring home their messages with a bang that leaves a lasting echo. . . . It's harder to escape from the truth when it is not hidden in paragraphs of laboriously read words."[62] It must have worked. The university exhibition kicked off a lively debate in the heart of Okie country. Responding to an attack on Steinbeck, reviewer Jack Brumm protested:

> Every one of those pictures was like a living page from Steinbeck's novel. They depicted the real Joads in our state as pictured by ordinary file [photos] but they tell a powerful story. As long as such conditions exist at all in Oklahoma, there are too many Joad families here. Granted that Steinbeck did use strong language in painting the scenes in his book. It takes strong language to do justice to the squalor and filth that exist in some sections of our state. "The Grapes of Wrath" should serve as a powerful stimulus toward arousing us Sooners from our apathy and as added incentive to lift the Joads out of their present abyss of poverty.[63]

Aroused from their apathy, several OU students made trips to Tower Town, a local migrant colony in Norman, to see the migrants' plight for themselves.[64] Beyond Oklahoma, several other colleges and universities around the United States hosted the FSA exhibition, including Harvard University, Swarthmore College, and the University of Southern California.[65]

Stryker and his team were evidently willing to experiment with materials and presentation in order to get their message across more poignantly.[66] One variant of the *Grapes of Wrath* exhibition was a large book with folio pages featuring photographs and words, which the viewer was to turn.[67] Due to its interactive nature Soule believed that the exhibit book would work better in a library or social forum where people would have more time to engage with it. When Helen Gahagan Douglas traveled throughout California with exhibition panels she also presented "stereooptican glass slides" of FSA images; viewed through a viewing apparatus these slides appeared three-dimensional. These slides were apparently designed to make the migrant experience more visceral. Unfortunately, no examples have surfaced.

The experiment that does survive in the FSA/OWI archive is a series of panels that were likely designed by Rosskam. Produced in 1940, the photomontages—photographs made from more than one negative—employ highly sophisticated imagery that depend on the viewer's

FIGURE 159. Various photographers, Dust Bowl–themed photo montage. 1940. *Library of Congress, LC-USF.344-007547-ZB*

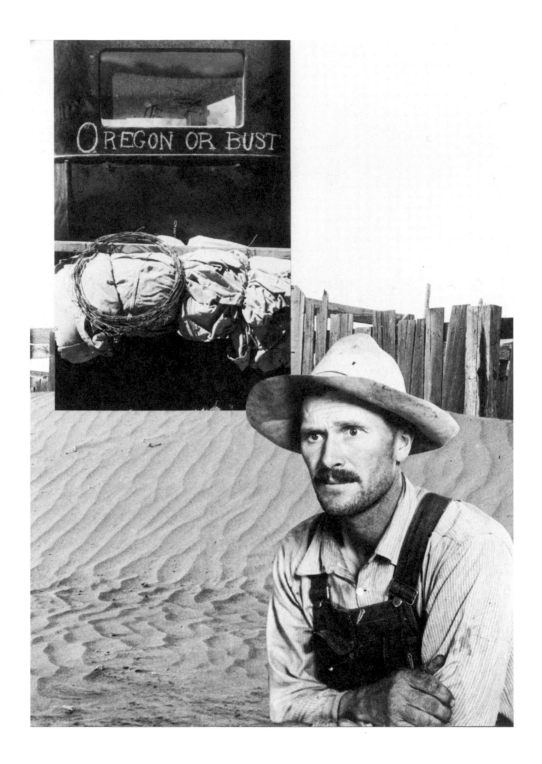

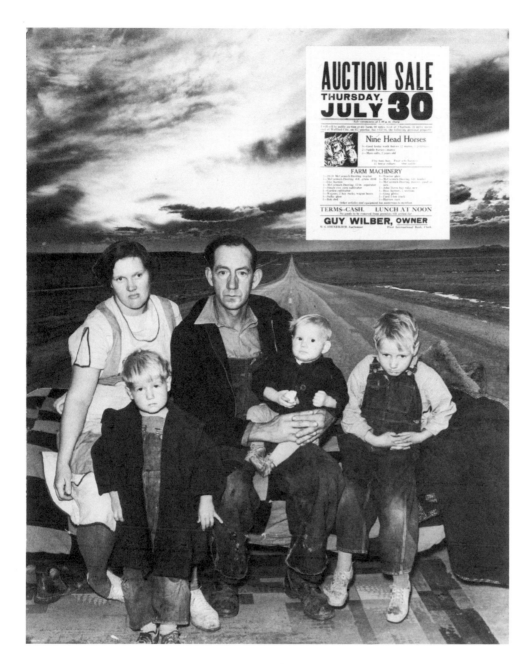

FIGURE 160. Various photographers, relocation-themed photo montage. 1940. *Library of Congress, LC-USF344-007546-ZB*

ability to read juxtaposed images and relate them to Steinbeck's novel and current events.[68] The panels display the work of various FSA photographers, including Rothstein, Lee, and Lange, and emphasize the plight of the migrant. In one example, an image of a row of tractors, which Lee photographed in Oklahoma City in 1940, is placed above Lange's potent image of a "tractored out" farmhouse (figure 158). The message is clear and parallels Steinbeck's emphasis on the ways mechanization forced farmers off their land.

Another panel juxtaposes a rather shell-shocked farmer in the sand dunes of western Oklahoma with a detail of Rothstein's photograph of a migrant car with the pioneering phrase "Oregon or Bust" in chalk below the rear window (figure 159). Another panel displays a grim-looking migrant family of five superimposed before an image of the open road and a handbill for a South Dakota farm auction (figure 160). The family appears overwhelmed and

FIGURE 161. Various photographers, irony of travel photo montage. 1940. *Library of Congress, LC-USF344-007545-ZB*

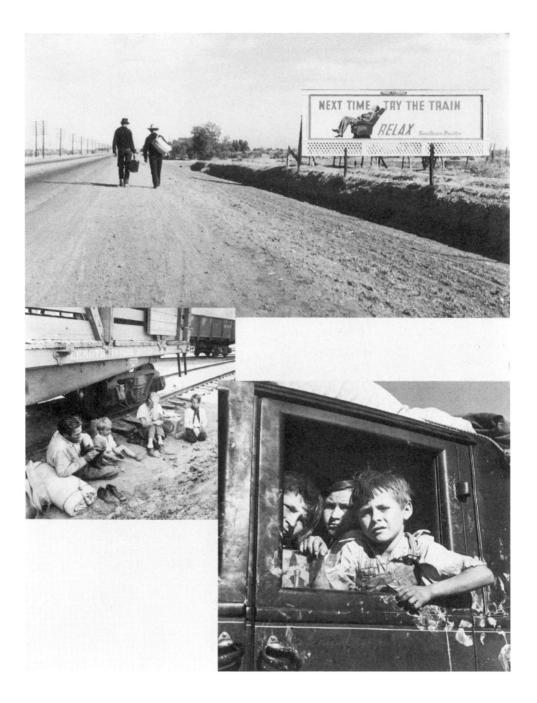

worn down.[69] Again the message is anything but covert. In linking the specter of economic uncertainty and removal, the impoverished family, and the open road Rosskam captured the essence of much of Steinbeck's narrative of the Joad family being forcibly removed from their home and flung toward California.

The remaining "experimental photo panels" visualize other themes of Steinbeck's novel. To emphasize the plight of refugees on the open road, the next panel links Lange's wonderfully ironic image of migrants walking down a road next to a billboard advertising the relaxing nature of train travel, an image of a migrant family finding shelter under a boxcar, and migrant children peering out of their jalopy (figure 161). The remaining two panels contrast the life of migrants in squatter Hoovervilles with the cleanliness, order, and safety of the federal camp system and the

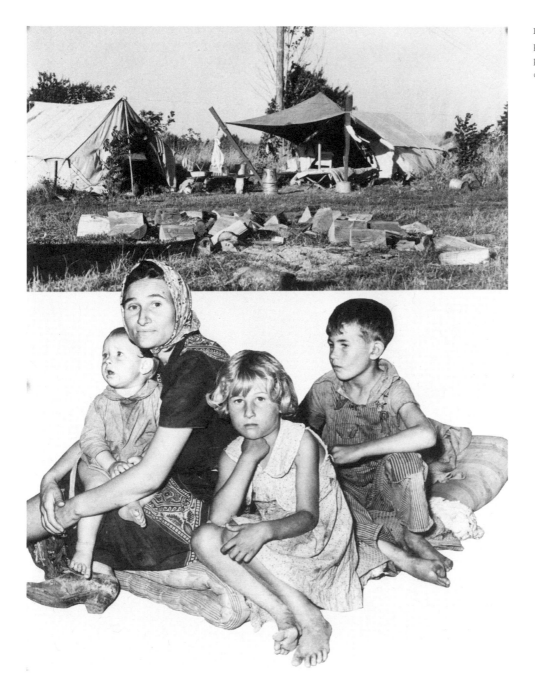

FIGURE 162. Various photographers, Hooverville photo montage. 1940. *Library of Congress, LC-USF344-007543-ZB*

emblematic FSA mobile trailer clinic, which brought basic health care to the camps (figures 162 and 163). Thus, in six panels and without using one word, the FSA was able to tell a story similar to the seemingly organic narrative of Steinbeck's novel but with a positive ending of hope due to the FSA's efforts.

These photographs represent a profound contrast to the straightforward aesthetic and practice of Stryker and his photographers. They represent new avenues that could have been more fully explored. Looking at Rosskam's panels it is hard to believe that Stryker was upset at Lange's decision to remove, by means of dodging in the darkroom, the errant thumb from her "Migrant Mother" photograph.[70] The composite images do not represent the typical "hands off" approach of documentary photography. Instead they create deeply layered and dynamic visual

readings that testify to Rosskam's interest in using "visual material as a language."[71]

From various accounts it seems that very little of Russell Lee's attempt to follow a *Grapes of Wrath* shooting script in the summer of 1939 appeared in the subsequent exhibitions inspired by Steinbeck's novel. Individual works by Lee were included but his series never appeared in its entirety. In many ways this was not surprising. In 1939 Steichen encouraged viewers to look at the work of the FSA in order to "listen to the stories they tell."[72] The images from Lee's shooting script did not tell their own story but leaned on the *Grapes of Wrath* narrative. Even *Look, Life,* or *Survey Graphic,* which frequently printed series of photographs, could not have accommodated so many images. The FSA, too, was not in the practice of printing many images. It has been estimated that during the agency's tenure around three hundred images were regularly printed. The paucity of use from such a vast collection strongly suggests that Lee's "Oklahoma

Story" could not be brought to light by any means other than as a photo-book, which despite Stryker's best efforts, never came to fruition.[73] Very few images from this series have in fact been published.

Yet despite its lack of circulation, Lee's work in Oklahoma continued to resonate. In October 1942, as he was traveling the same route through Sallisaw that the Lees had driven a couple of years earlier, John Vachon thought of Lee and Steinbeck. He clearly knew both the photographs and the novel. In 1940 he wrote to his wife, Penny, from Benton Harbor, Michigan, "Tell all your friends that the new book *Grapes of Wrath* isn't exaggeration at all. I mean the situation is worse than you could believe. And the people, the folks, are so damn nice, good, heart warming." Passing through eastern Oklahoma, the actual landscape of the book's opening, he again wrote Penny that he was seeing "real grapes of wrath stuff, shacks and tin houses, all those starved faces out of Russell Lee's pictures."[74]

John Vachon was hired by Roy Stryker in 1936 as an "assistant messenger" and shortly thereafter became responsible for organizing the burgeoning files. This put him in close connection with the work of all the FSA photographers. By 1937 Stryker eventually allowed him to pick up a camera and begin making photographs for the file. Having worked in the files longer than anyone else, Vachon not only knew and emulated the styles of many of the more established FSA photographers, but also developed an understanding of the places they visited. In 1938, for example, Vachon tracked down and photographed the same twin houses in Atlanta, Georgia, that Walker Evans—his most important influence—had documented two years earlier. For Vachon there was something magical about locating this site; it was like "a historic find" he reported.[75] "I found the very place," he wrote to his wife, "and it was like finding a first folio Shakespeare."[76]

In Oklahoma Vachon followed in Lee's footsteps, but he found a remarkably different situation. Large industry had replaced small-scale agriculture as the United States built up for war. Even the streets of Muskogee, where Lee once followed the Thomas family, were filled with servicemen, like the ones Vachon captured strolling past the Roxy Theater (figure 164). Vachon also revisited the Mays Avenue slum where Lee made his penetrating images of trapped, suffering migrants. "It's a very strange sight," Vachon wrote, "obviously much thinned out since Lee

FIGURE 164. John Vachon, "Muskogee, Oklahoma." November 1942. *Library of Congress, LC-USW33-000729-C*

made his pictures, still huge and sprawling, with many cleaned up, that is torn down sections." He continued,

> It looks like the remains of some horrible monstrous picnic—lived in shacks, knocked down shacks, old cars, garbage, scrap, sewing machines. It's quite a sight and I stood and considered it, thinking of all the people I knew who had been there—children who had grown 3 years since Lee took his pictures, the old man with the Bible. These were really the most gruesome and stricken with pure poverty of any picture we'd ever had you know. This place caught the Okie on their way to California. Something like the Appalachian hollow took in the weaker of the pioneers moving west, maybe. Now it looks like 75% of the people have moved on to somewhere. It would be interesting to go in and talk with some of those still living there, see why, who they are, etc. But that ain't my line this season.[77]

Vachon's "line" was very different from Lee's. He was charged with documenting not migration and its ills but refineries, gasoline plants, oil tankers, rail lines, and anything else that was integral to the ongoing industry of war (figure 165).

Years later Jean Lee remembered her husband's work with the migrants in Oklahoma as the most important, complex, and poignant of his FSA career.[78] It was an important moment in the history of the FSA and one of the last engagements in its battle against rural poverty. In all, Russell Lee had succeeded in illustrating an important portion of Steinbeck's novel. He had documented the conditions of the Okies and participated in their migration. His extensive portrait of their situation, however, was far more varied and complex than what appears in Steinbeck text. Lee's Okies—both migrants and those who chose to endure in their homes—were more sophisticated, more religious, culturally richer, more multiracial, and of a greater psychological depth than the types found in *The Grapes of Wrath* or in the press. Above all, Lee had succeeded in putting a human face on the problems of migration and the Dust Bowl. Lee's photographic portrait of migration was much more difficult to dismiss than Steinbeck's work of fiction. The product of an arguably objective device—the camera—his images ostensibly offered photographic proof that the problems of migration and crippling rural poverty were real. For most of the public this evidence was much harder to deny.

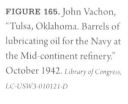

FIGURE 165. John Vachon, "Tulsa, Oklahoma. Barrels of lubricating oil for the Navy at the Mid-continent refinery." October 1942. *Library of Congress, LC-USW3-010121-D*

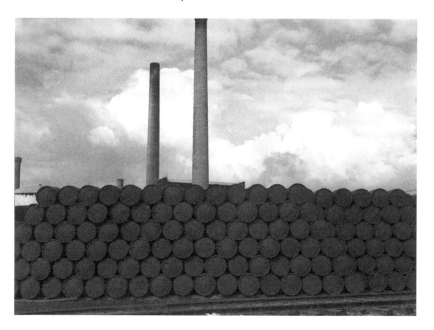

From Controversy to Icon

A Straight Picture

Darryl Zanuck and Arthur Rothstein

For more than a year following its release in April 1939, *The Grapes of Wrath* continued to garner public attention. From its supporters it received accolades, from its critics scorn—but it always generated headlines. As Steinbeck withdrew, others rushed in to carry on the cause. Well-known public figures like Mother Sue Sanders hurried to the camps to see conditions for themselves.[1] In April 1940 First Lady Eleanor Roosevelt, long a champion of immigrants, toured the Central Valley to see for herself the situation that the embattled author described. Accompanied by Helen Gahagan and Melvin Douglas, she traveled through both pitiful ditch-bank hovels and FSA camps. The latter she praised "for their attempts to rehabilitate the Dust Bowl refugees." She similarly complimented the FSA staff for their wisdom, tact, and love. "Above everything else," she wrote, "I carried away from my day in the migratory camps, a feeling of pride in our people and an admiration for the indomitable courage which can continue to have faith in the future when present conditions seem almost unbearable."[2]

In May 1939, only weeks after the release of *The Grapes of Wrath*, Hollywood mogul Darryl Zanuck purchased the movie rights from Steinbeck for a record $75,000.[3] The transition to the silver screen was a logical progression for the novel. In the late thirties Steinbeck was increasingly lured by Hollywood. Some have argued that he wrote his novels and stories with potential conversion into a film script in mind.[4] Regardless, Steinbeck was deeply suspicious of Zanuck's intentions, and insisted that he would retain the money he received in his bank account in order

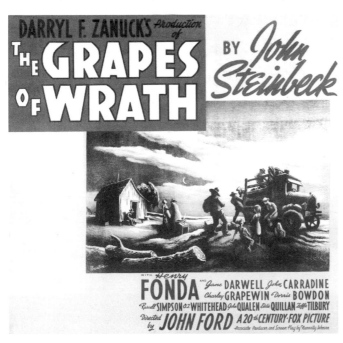

FIGURE 166. *The Grapes of Wrath* film poster (original in color), featuring Thomas Hart Benton's lithograph "The Departure of the Joads" (from *The Grapes of Wrath* series). 1939.

to sue the movie mogul if he strayed from the fealty of novel's original message.[5] Zanuck, too, had reservations about the novel and hired a private investigator to corroborate that what Steinbeck wrote reflected the facts.[6] Zanuck later reported that the conditions his investigator found were worse than what Steinbeck had portrayed. Although Zanuck's decision to produce the movie was controversial, he felt it was the right thing to do. Ultimately, he did everything he could to ensure the film's fidelity and success. He selected John Ford to direct the film; brought in his best scriptwriter, Nunally Johnson; acquired the talented cinematographer Gregg Toland; and cast Henry Fonda to play Tom Joad, the lead role.[7] Ford, in turn, wanted a "Benton-look" for the film, and Thomas Hart Benton was commissioned to produce lithographs for the film's poster and promotional materials (figure 166).[8] In sum, no detail was overlooked in the film's production.

Whereas Steinbeck believed that the written word was the only medium capable of carrying his message of suffering and protest, in Zanuck's mind the power of film unquestionably topped all other media. "A written eyewitness account of a slum or of a queue of starving children makes a limited emotional impact on the reader," he wrote. "But at best the literary account seems second-hand, as compared with the motion picture, which provides the facts for the audience at first hand, making the beholder the witness himself, who is socially implicated in all that he sees."[9]

From the beginning Zanuck intended that the film mimic the look of a documentary. Shot in black in white, in an era when color was an option, it resembled both documentary photographs and Lorentz's films.[10] Not only did Lorentz's films influence Steinbeck, but scriptwriter Nunally Johnson contacted Lorentz for further insight into Steinbeck's style.[11]

To enhance the documentary feel of the film, Zanuck's crew went to great lengths to make everything look and feel authentic. Henry Fonda, for example, traveled to Oklahoma to visit Okies.[12] Moreover, the production crew acquired used clothing from Goodwill stores, and the music for the barn dance scene was provided by the King family, residents of the Arvin migrant camp, who returned to picking fruit after filming was over.[13] Assistant Director Otto Brower and

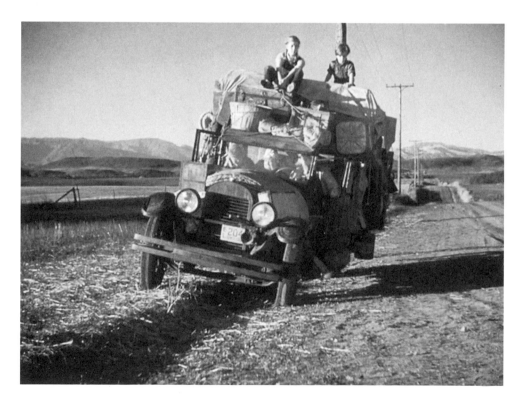

FIGURE 167. *The Grapes of Wrath* film. 1939. *20th Century Fox Productions.*

Zanuck's second unit shot many of the film's scenes on location, in the environs of Sallisaw; Route 66 through Oklahoma, Texas, and Arizona; at roadside Hoovervilles; and in the FSA Camp at Weedpatch.[14] When Brower's crews arrived in Sallisaw in September 1939, local residents—who were told the film was a comedy entitled "Highway 66"—were recruited as extras. Though not fooled, they were impressed by the film crew's attention to detail (figure 167). Knowing that their town and the surrounding region were far different from what Steinbeck described, they still commented that it "looks like *The Grapes of Wrath*."[15] Brower also attempted to film actual migrants as they drove westward. He paid them five dollars for a shot of their car, and another five dollars for each occupant. Despite the payoff for only twenty minutes of their time, Brower was usually turned down. To get the feel he wanted, he purchased twenty-four used jalopies and loaded them with extras to re-create Okie caravans.[16]

The realism was based on more than mere location and authentic costume, however; it was also dependent on many of the same sources that Steinbeck used when writing his book. At Steinbeck's recommendation, Tom Collins, still an FSA camp manager, was hired as a consultant for the film and paid $15,000. To aid in casting the studio also borrowed the photographs Horace Bristol had taken while accompanying Steinbeck.[17] The result might be most obvious in the casting of Ma Joad. Though Zanuck initially wished to cast Beulah Bondi, the role ultimately went to Jane Darwell, who clearly resembled the woman Bristol called "Ma" in his photographs. This may also explain why the film's Ma is, according to Susan Shillinglaw, a little "squishier and more sentimental" than her counterpart in Steinbeck's book.[18]

Moreover, just as Steinbeck had done three years earlier, Zanuck relied on FSA photographs for the look and feel of his film. The 20th Century Fox studio solicited five hundred photographs from the FSA files.[19] According to Grace Mayer, Ford particularly sought out the work of Dorothea Lange, and her influence was evident.[20] Stryker was amazed at the fidelity of the film and Ben Shahn remembered, "You know, when they did the picture of the Okies, the movie, Steinbeck's picture, *Grapes of Wrath*, our photographs were used, you know, for setting up all sorts of scenes. When I saw it, I recognized it immediately."[21]

Even the film stills on location and in the Fox studio support Shahn's assertion. Many have the look and feel of specific FSA photographs. One of the film's most famous stills, a photograph of Henry Fonda (Tom Joad) at the wheel of the family automobile with Jane Darwell (Ma) by his side, closely resembles images by Lange (figures 168 and 169).[22] In all, the details from the FSA and Bristol's photographs, as well as the assistance of Collins, provided an important foundation for director John Ford. Years later the famed director admitted that he never read Steinbeck's book and, therefore, needed to rely heavily on the documentary evidence presented to him by other sources.[23]

Even with the plethora of source material, Ford was, first and foremost, a filmmaker. Like Steinbeck, he desired to tell a story more than provide documentary evidence of contemporary events. "It isn't elaborate realism that counts," he maintained, "but the plain, homey touches for which a director must try." Indeed, Ford dispelled any doubt that he might be making a documentary rather than a movie: "I was not interested in *Grapes* as a social study," he insisted.[24]

With all of the hype surrounding the book and Zanuck's purchase of the movie rights, a great deal of anticipation surrounded the film's release. In January 1940 *Look* magazine previewed the forthcoming film. Arching over the article's mix of text and images was an illustrated map that traced the Joads' travels from Sallisaw, Oklahoma, across the western United States to California. The endpoint, however, was different. Rather than ending in the fields of the Imperial Valley, the route now, ironically, led to Beverly Hills.[25]

Many migrants were also eager to see the film, which they believed would tell their story and validate their plight to a broader audience. Working in Marysville, Lange recorded the thoughts of one migrant from Oklahoma who was fed up with being called a bum: "Abraham Lincoln lived in a little shack too, . . . When they gone to turn that pitcher loose, the *Grapes of Wrath*. I'm look[ing] to take it in."[26] Residents of the nearby camp were encouraged to see it and to write down their reactions.[27] Evidently, *The Grapes of Wrath* increasingly became part of the migrant experience.

Upon its release on February 27, 1940, Zanuck's film was praised for its documentary realism, thanks to the attention to details of Ford, Johnson, Brower, and Collins. Steinbeck shared his thoughts with his agent: "Zanuck has more than kept his word. He has a hard, straight picture in which the actors are submerged so completely that it looks and feels like a documentary film and certainly has a hard, truthful ring. No punches were pulled—in fact with descriptive matter removed, it is a harsher thing than the book, by far. It seems unbelievable but it is true."[28]

Like Steinbeck's novel had been, Zanuck's film was held up for praise by some and beaten down with scorn by others. Groups on both sides of the political spectrum even proposed boycotts.[29] Despite their initial reservations, both Steinbeck and Zanuck were satisfied with the final results. In fact, Steinbeck was even content with the different ending, which left the Joads defiant and resolute rather than utterly destitute.[30] Defying the predictions of critics who believed that a socially charged film would not garner box office revenues, the movie was both a critical and financial success.[31] It did well at the box office and received several accolades, including seven Academy Award nominations and Oscars for best director for John Ford and supporting actress for Jane Darwell (Ma).

Pare Lorentz was one of those who praised Zanuck for his "fidelity to the original spirit" of the book. In his review for *U.S. Camera,* he noted that John Ford "enhanced this brutal, uncompromising saga of the migrant by giving the California sequences a fast newsreel tempo and verisimilitude."[32] Striking back at the critics who cried that Zanuck's film was propaganda, Archibald MacLeish suggested that the typical, illusory Hollywood film with "forests of pretty legs and acres of gaudy faces" were more propagandistic than *The Grapes of Wrath*.[33] In the end the attention to detail granted the film an air of authenticity. One resident of a California FSA camp asserted that book and movie were both "true—every word of it."[34]

For many the film represented a milestone in social documentation. Indeed, it broadcast the plight of the migrant to a national audience, reaching more people than Steinbeck's text did. One of those influenced by the film was Woody Guthrie, the folk singer and "real Dust Bowl Refugee" from Okemah, Oklahoma. Guthrie knew the situation of the migrant well: he claimed to have been in every one of the towns mentioned in the novel.[35] James Forester of the *Hollywood Tribune* noted, "For Woody is really one of them [Okies] and at the same time he's a poet and a singer. He's the troubadour of those who are condemned to the other side of the fence."[36] Guthrie insisted that he did not read Steinbeck's novel. His education, he claimed, came not from books but from picture shows.[37] After seeing the film he wrote, "Seen the pitcher [*sic*] last night "Grapes of Wrath," best cussed pitcher I ever seen. "The Grapes of Wrath" you know is about us a pullin' out of Oklahoma and Arkansas, and down south and out, and driftin' around over the state of California, busted, disgusted, down and out, and lookin' for work."[38] After seeing the film he allegedly stayed up with a half-gallon jug of wine and a typewriter and composed his "Ballad of Tom Joad."[39] He would see the film "a couple or three times in a row" and write other songs on the theme, which he released on his 1940 album *Dust Bowl Ballads*.[40] Steinbeck originally envisioned his novel as a theme for a symphony; Guthrie's work proved that ballads of an Okie troubadour were a better fit.[41]

Following the movie's release, *Life* magazine published two articles about it. The first,

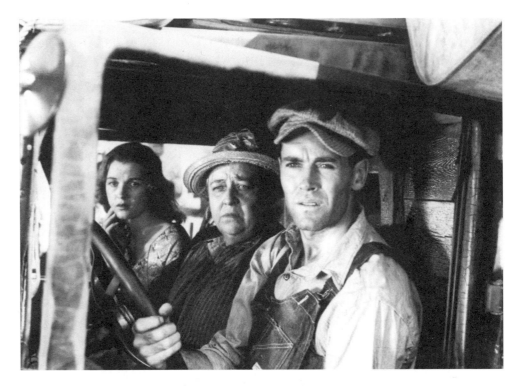

FIGURE 168. Film still from
The Grapes of Wrath. 1939.
20th Century Fox Productions.

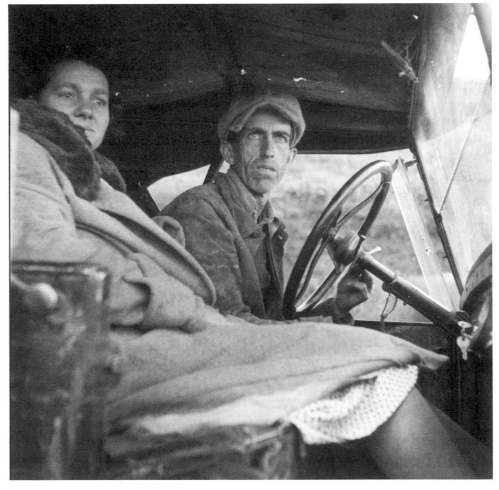

FIGURE 169. Dorothea Lange,
"Once a Missouri farmer, now
a migratory farm laborer on
the Pacific Coast. California."
February 1936. *Library of Congress,
LC-USF34-002470-E*

released in the January 22, 1940, edition, was illustrated with publicity shots and film stills. Less than a month later *Life* published a second, shorter article that matched "picture for picture" Steinbeck's prose with the photographs that Horace Bristol had made almost two years earlier. Titled "Speaking of Pictures" the article claimed these photographs "by *Life* prove facts in 'Grapes of Wrath.'"[42] The editors placed six of Bristol's photographs alongside the movie stills released one month earlier, labeled, respectively, "Life" and "Movie." The photograph of Henry Fonda as Tom Joad was juxtaposed to a photograph identified as the "real Tom Joad"; Darwell was placed alongside a real-life Ma; a roadside camp created by set designers was placed alongside a real camp, and so on. This strategy rendered the boundary between the real Okie and the illusion more tangled and complex.[43] Compounding this blurring of the line between fact and fiction were the names Bristol subsequently gave his photographs—names that remain today. Thus, Ma Joad, Pa, Rose of Sharon (figure 42), and Winfield serve as living illustrations of Steinbeck's fiction (figure 170).

Due in part to the success of the film and the continuing controversy surrounding the book, the novel stayed on the best-seller list through 1940. The prolonged interest bode well for the FSA and its programs. FSA administrator C. B. Baldwin believed that the *Grapes of Wrath* film marked a "highpoint in effective propaganda" for his agency.[44] The FSA program that benefited most from

FIGURE 170. Horace Bristol, "Ma Joad," 1938. © *Horace Bristol/ Corbis*

From Controversy to Icon

the film was the migrant labor camp system. In both book and film the FSA camps were painted as refuges in a sea of mistrust, corporate greed, and ignorance. In the camps Steinbeck exhibited his belief in human fellowship and courage, a quality which carried over into the film.[45] Nearly a fifth of Zanuck's production, in fact, was shot in and around the Weedpatch federal facility. In his review of the film Edwin Locke wrote that "the picture will undoubtedly make more converts to the idea of government owned and operated camps for the dispossessed."[46]

Again Stryker was quick to take advantage of the opportunity. When he released Dorothea Lange on January 1, 1940, he needed to assign another member of his staff to cover her area in the West. In March 1940 Stryker sent Arthur Rothstein across the country to document two California camps.[47] Rothstein was instructed to focus his attention on the Tulare migrant camp in Visalia and the Shafter camp in Kern County, just weeks before first lady Eleanor Roosevelt toured the area. This was one of Rothstein's final assignments for the FSA; one month later he resigned his post to join the staff of *Look*.[48]

The public demand for images of the camps remained high: "I still want you to get to California and get us a series of detailed pictures on the camps," Stryker wrote to Rothstein, "so we can quit being harassed so much by people around Washington for this particular type of photo."[49] Meanwhile, Fred Soule in the Region IX office also requested copies of Rothstein's work to help garner public support for the program.[50] In conjunction with Lange's extensive and touching documentation of California's migrant population and Lee's photographs from Oklahoma, Rothstein's work in California helped complete the *Grapes of Wrath* "shooting script" Stryker wished to assemble. Rothstein's overarching purpose was to put a human face on the California camps and to demonstrate that the salvation they offered justified the sizable FSA expenditure.

At the time of Rothstein's assignment, the FSA camps were well established throughout the West but still faced serious public resistance. In 1940 the FSA reported twenty-six permanent camps were in operation or under construction, providing shelter for around seven thousand migrant families.[51] These camps were the front lines in the battle against the problems that plagued migrants most: insecurity, poverty, inadequate housing, violence, and disease.[52] Due to Steinbeck's glowing account, the camps in California were clearly the best known, though they were also broadly considered the most unpopular federal program in the state.[53] Migrants who made it to the camps received better treatment but were sardonically labeled the "star boarders" of California.[54] Many saw the camp system as meddling, unfair, and even communist.[55] California Republican State Senator William Rich warned, "If [migrants] come to this state, let them starve or stay away."[56] Supporters of the migrants and their cause portrayed the camps as a "ray of hope."[57] According to the FSA official Lawrence Hewes, the migrant camps provided the chance "to live as good a life as decent, hard-working American citizens should be able to live."[58]

Even before sending Rothstein to California, Stryker already possessed a number of salutary images of the FSA camps from Dorothea Lange, who had a long history of working in them. In 1938, for example, she visited the Shafter camp, highlighting happy and poignant moments like a baseball game and a Halloween party. Through aerial shots she emphasized the orderliness of the camps, even during a cotton strike. Her work portrayed the FSA camps in general as saviors that restored the spirits and democratic values of their inhabitants. Rondal Partridge, who as a young man traveled to the camps as Lange's assistant, remembered, "When families came to Arvin, they came to a place where survival wasn't such a struggle. There was a school, and kids could learn and play instead of just working in the fields."[59] No one embodied this spirit of caring more than a white-clad, angelic nurse whom Lange followed on duty in the Farmersville camp in 1939. She

documented the nurse mending a boy's injured wrist, visiting young children, and administering to bedridden migrants (figure 171). Not surprisingly, before he traveled to the camps Rothstein met with Lange at her home in Berkeley to learn from her experiences.[60]

At Stryker's behest Rothstein followed Lange's lead in documenting what was right about the camps, in order to satiate the need in Washington for material showing their "positive side."[61] Rothstein came to California with a mandate from Stryker: "Remember, your emphasis here is to see how people conduct themselves in and around the camp."[62] On his arrival Rothstein, followed his instructions, photographing various positive features corroborated in Steinbeck's novel. Later that summer Charles Todd and Robert Sonkin, graduate students at the City College of New York, came to the camps to make field recordings of the migrants' ballads and folksongs for Alan Lomax and the Archive of American Folk Song. Margaret Bourke-White also reportedly made a visit.[63] Indeed, as Todd noted, it seemed the camps were "full of Ph.D. scholars and do-gooders studying the real people."[64]

At the time of Rothstein's visit the Tulare migrant camp in Visalia and Shafter migrant camp in Kern County were undergoing important changes. Tulare was originally established as temporary housing but transitioned to a more permanent migrant settlement.[65] By 1940 it was a large and impressive camp, and Rothstein spent most of his time there, documenting its various aspects. By 1941 it had 448 homes accommodating more than 1,500 migrants.[66] The Shafter camp, opened on November 11, 1937, was one of the newer and larger camps in California, housing 240 families.[67]

When Rothstein arrived at Tulare he focused on the general layout of the camp. Presumably at the suggestion of camp manager Robert Hardie he photographed the camp's entrance with its high-flying American flag. He also shot a handful of general views of the camp's layout. He paid particular attention to the various types of camp housing, from the "Sanitary Steel Cabins" to the larger, and undoubtedly cooler, labor homes with vegetable gardens for longer-term residents. In all, the impression was a clean, orderly, hospitable and, ultimately, pleasant settlement (figure

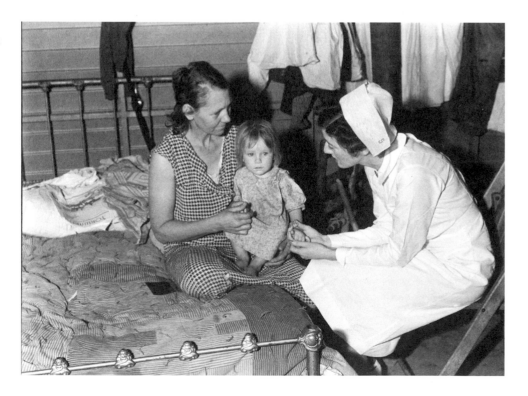

FIGURE 171. Dorothea Lange, "Tulare County, California. Farm Security Administration (FSA) camp for migratory agricultural workers at Farmersville. Nurse of Agricultural Workers' Health and Medical Association (FSA) is assigned to the camp. Photo shows her attending sick baby." May 1939. *Library of Congress, LC-USF34-019657-D*

FIGURE 172. Arthur Rothstein, "Tulare migrant camp. Visalia, California." March 1940. *Library of Congress, LC-USF34-024313-D*

172). If there was a stigma attached to living in a government camp, there was no sign of it in Rothstein's images.[68] More importantly, his portrait revealed that the sizable federal expenditure was a suitable and appropriate investment of taxpayers' money.

Rothstein took few photographs of the camp and its architecture in comparison to the number of images he captured of the camp's inhabitants. He clearly set out to create a human portrait of camp life: what campers did, what they needed, and who they were. More specifically, it was important for him and the FSA to show that the migrants were clean, healthy, and all-American. During his visit Rothstein paid particularly close attention to the camp's women and children— in part because the men were working at jobs outside the camp. But Stryker had also instructed Rothstein that images of mothers and children were particularly important: "Get nurses treating children, mothers coming in for post natal instruction," he wrote, "anything that will demonstrate child welfare work."[69]

Children became living symbols of the camps, because people across the nation were interested in this estimated one-third—and particularly vulnerable—component of the migrant population.[70] Children were also disproportionately expensive. Opponents of the camp system consistently cited as failures of the camp system either the incursion of communist/leftist influence or the ballooning expenditures for day care, schooling, and other child care (figure 173).[71] On the other side, supporters of the camps advocated for keeping children safe and free from fieldwork.[72] Contemplating the migrants' fate Sanora Babb wrote, "Must their children grow up like this, hungry, ragged, unhealthy, half-schooled and scorned as *Okies*?"[73]

According to the FSA, the agency's goal was to give children an understanding of "the meaning of home and community life." Paul Taylor reported that being continually on the move was bad for children: "Some parents are beginning to complain that their children cannot write as good English as they can themselves," he wrote. "There is a growing feeling that the future carries no hope of progress, but that their children will be worse off than they are."[74] First Lady Eleanor Roosevelt pleaded with the nation, "You may think that it does not matter what happens to the migratory laborers in the Southwest and on the West Coast, but it does. It matters a great deal. Those children who cannot get schooling, who grow up in unhealthy conditions—they are going

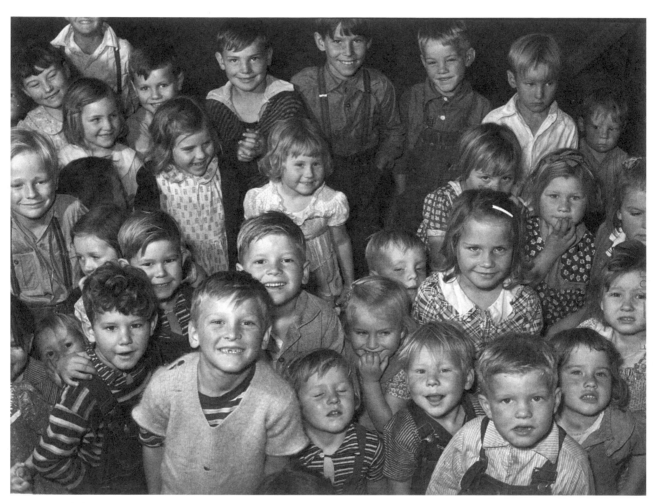

FIGURE 173. Arthur
Rothstein, "Children in nursery.
Tulare migrant camp. Visalia,
California." March 1940. *Library
of Congress, LC-USF346-024267-D-B*

to be citizens some day, and how do you suppose they are going to become intelligent citizens in a democracy?"[75]

Lange agreed. Many of her images of young migrants were captioned "Children in a Democracy." Rothstein's visual account reassured the nation that the children were well cared for and were given the chance to grow both physically and intellectually.

For the younger members of the Joad family, Ruthie and Winfield, the Weedpatch camp was an enchanted place filled with amenities like flushing toilets, which they had never experienced before. When they arrived Ruthie even interrupted a civilized game of croquet. Rothstein's images indeed reinforced that children were the greatest benefactors of the camps' largess.[76] Freed from working in the fields, they were able to play, learn, and rest as children should (figure 174). Rothstein documented them playing in front of their houses as well as taking naps in nurseries, playing games, making handicrafts, and reading in the camp's library.[77] In many ways these children lived as other young American children did. By focusing on these activities Rothstein implied that they were not privileges but basic necessities for a child.

Rothstein also focused his attention on the children's general health. Health care and clinics were vital parts of the FSA efforts, but at the time of Rothstein's visit they were encountering considerable scrutiny.[78] His documentation was designed not only to assuage local fears but also, on a national scale, to garner public support for a costly and controversial program. Providing aid to sick and needy children was difficult to criticize, especially when treatment might be as simple as decent food and a clean environment.

In 1936 it was estimated that 80 percent of the ailments afflicting migrant children were caused by malnutrition and poor hygiene.[79] Common conditions included dysentery, pneumonia,

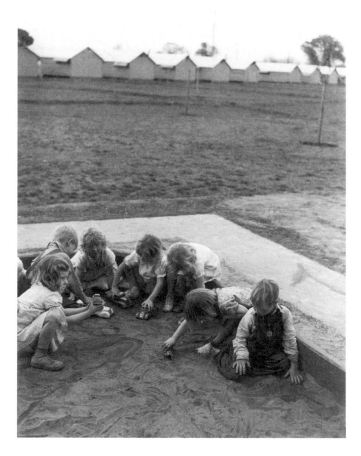

FIGURE 174. Arthur Rothstein, "Children playing in sandbox. Tulare migrant camp. Visalia, California." March 1940. *Library of Congress, LC-USF34-024142-D*

FIGURE 175. Arthur Rothstein, "Child being treated in health clinic. Tulare migrant camp. Visalia, California." March 1940.
Library of Congress, LC-USF34-024166-D

and hookworm.[80] The infant mortality rate in the San Joaquin Valley was two and a half times the national average. For this reason camp medical staff paid special attention to pregnant mothers, a fact that appeared in Steinbeck's text when Rose of Sharon was promised prenatal care at the Weedpatch camp.[81] In his documentation Rothstein photographed young children receiving medical checkups. In model camp clinics young white-clad nurses bandaged arms, provided postnatal care, and provided simple preventive care like checking for lice (figure 175). For many children these visits were the first time they had ever received health care. The nurses not only attended to children's immediate health needs but also formed the front line in efforts to educate migrant parents on how to better care for their children.[82]

In addition to focusing on the children, Rothstein paid close attention to the recreational component of camp life. If the children were symbols of the need for these camps, the photographs of migrants engaged in various recreational activities showed that the adults were also deserving humans.[83] Three years earlier in his Second Inaugural Address, President Roosevelt had proclaimed that education and recreation were crucial ingredients in bettering the lives of migrants and their children. As a New Deal agency, the FSA felt a responsibility to provide recreational, cultural, and self-help opportunities for the "enrichment of the life of the campers."[84] Images of leisure have always been powerful signifiers of culture and status. By showing migrants engaged in wholesome activities that others enjoyed, or longed to enjoy, Rothstein not only humanized the migrants but reaffirmed their status as Americans.

From the beginning of the camp system Tom Collins realized that the migrants' talents and interests could be used to help "civilize" them through wholesome recreation. Steinbeck was

FIGURE 176. Arthur Rothstein,
"Saturday night dance.
Tulare migrant camp. Visalia,
California." March 1940. *Library
of Congress, LC-USF34-024159-D*

cognizant of this. When the Joads entered the Weedpatch camp the prospects of personal safety and of dance nights helped them feel like they were finally "treated decent."[85] As director of the Marysville and Arvin camps, Collins supported a variety of activities that eventually became part of the larger camp system, such as evening concerts; biweekly dances and community sing-ins; campfires; and horseshoes, cribbage, chess, volleyball, and softball contests. In an effort to improve relations with the surrounding communities, neighbors of the camps were invited to the dances and sports contests (figures 176 and 177).[86] Residents also participated in amateur nights, "literary evenings," poetry readings, performances, and plays.[87] S. C. Loop, a resident of the Tulare camp, brought eighteen years of experience on the stage and became the leader of the camp's social

FIGURE 177. Arthur Rothstein,
"Baseball game. Tulare migrant
camp. Visalia, California."
March 1940. *Library of Congress,
LC-USF34-024143-D*

FIGURE 178. Arthur Rothstein, "Bingo game. Tulare migrant camp. Visalia, California." March 1940. *Library of Congress, LC-USF34-024188-D*

FIGURE 179. Arthur Rothstein, "Children playing in nursery. Tulare migrant camp. Visalia, California." March 1940. *Library of Congress, LC-USF346-024173-D*

and recreational activities. Reading was also encouraged: Mildred Dykeman, the WPA librarian at Shafter, reported that *Gone with the Wind* and sundry Westerns were popular among the migrants.[88] There was also instruction in handicrafts: woodworking for men, and sewing, quilting, or painting for women. In all of these activities the Okies and Arkies proved to be talented.

During his work in the camp Rothstein also photographed the women's committee, men playing checkers, and a civilized bingo night (figure 178). He photographed everything from a play put on by a traveling troupe from the Arvin migrant camp to children engaged in activities like boxing and wrestling, which encouraged group activity as well as strength and toughness (figure 179).[89] Steinbeck reported that there were "no pansies" in the camps or fields.[90] Rothstein's images suggest that toughness was an important aspect of the persona of migrants, who faced a host of challenges and threats.

As the Thomas family illustrated, many migrants enjoyed playing music and brought their instruments with them on the road. Rothstein carefully photographed a guitar, fiddle, and banjo ensemble providing music for a Saturday-evening dance, complete with a shrieking kitty to hold tips (figure 180). Facing displacement, the migrants turned the songs and tunes from home into an important part of their identity. As John Steinbeck observed years later, songs were *the* statement of a people, of their "hopes and hurt, the angers, the wants and aspirations." He observed, "A few years ago when I sat in the camps of the people from the dustbowl when hunger was everywhere, I heard the singing and I knew that this was a great race, for, while there was loneliness and trouble in their singing, there was also a fierceness and the will to fight."[91] Traveling from camp to camp in California, Charles Todd and Robert Sonkin mentioned a plethora of guitars, recorded folk songs, and found migrants with tremendous talent.[92] One visitor to Arvin noted "the Campers sing[ing] in their churches and their dances, and pie suppers and speakins."[93] Music was a tonic to

the migrants' situation, and in groups large and small they sang a rich ensemble of ballads and folk songs about home, love, hardship, and loss. One young migrant from Arkansas sang:

> Sometimes I wonder why I have to roam
> My thoughts still linger in the way back home
> How I miss the old folks and my little sister Lu
> Wonder if she misses me too.[94]

Songs with such titles as "Cotton Fever," "Texas Girl," "Pea Picking Blues," and "No Depression in Heaven" filled the air in Shafter, Tulare, and other camps. Bands such as the Arkansas Playboys quickly formed. Meanwhile, the young balladeer from Okemah, Woody Guthrie, "harsh voiced and nasal," could be heard on radio airwaves.[95] It did not take long for these songs and singers to leave their mark on California. Migrants changed the music industry in the state and made Bakersfield, California, well removed from the U.S. heartland, the second great center of country music.[96]

One of the persistent themes in Steinbeck's novel was the palpable enmity between the established local populations and their unwelcome visitors, the migrants. This hatred nearly boiled over when the Joads were harassed by local toughs while enjoying a Saturday-night dance. There were ample reasons for conflict between these two worlds, and the Tulare camp, in particular, saw its share of tension.[97] Yet in Rothstein's images it is also possible to see how cultural activities at the camps brought new energy to surrounding communities. Charles Todd noted that the "ordinary citizen has discovered that his town has been made a livelier place in which to live, with three or four hundred healthy Midwesterners within shouting distance." He continued, "In Brawley, for instance, the camp puts on an old fashioned square dance every Saturday night. The camp orchestra from Indio [camp] took first prize at the Imperial County Fair. There are Friday night boxing matches in which the town boys often participate. The migrants' baseball teams are included in various sectional leagues. Famous people—movie actors and actresses—often visit the camp. As one Brawley lad put it: 'Them Okies has sure pepped things up around here!'"[98]

Such activities were not universally popular among the displaced migrants, however. As Tom Collins observed when he was manager of the Thornton camp, some migrants, especially the more

FIGURE 180. Arthur Rothstein, "Band playing at Saturday night dance. Tulare migrant camp. Visalia, California." March 1940.
Library of Congress, LC-USF34-024258-D

religious residents of the camp, wanted "less education, less recreation, more salvation." In *Grapes of Wrath*, Mrs. Sandry, a fellow migrant who zealously believed that the camp's theatrical and dance opportunities were sinful, represented this attitude.[99] For her, wickedness was everywhere, even in the camps.

In general, religion played an important role in migrants' lives. In *Grapes of Wrath*, as in reality, religious beliefs are palpably present yet complicated. Certain figures like Ma continued to cling to their faith in the face of turmoil and change, while others, represented by the former preacher Jim Casy, fell away. The novel did not endorse religion. Salvation, Steinbeck seemed to suggest, was never simple, an ambiguous stance that caused some readers to label the book "anti-religious." First Lady Eleanor Roosevelt disagreed, calling the novel a "profoundly religious, spiritual, and ethically urgent book."[100]

Although in Steinbeck's novel salvation may not have been a straightforward matter of religious belief, the Weedpatch camp clearly provided succor for the Joads, and its manager was one of the most saintly characters in the text. In reality, however, camp managers shared a pragmatic view of religion that differed in many ways from that of the migrants they served. Urban, secular, and educated, many camp managers and administrators were leery of the migrants' religious activities. Though respectful of migrants' beliefs, they viewed them as folksy and backward—an attitude also common among resident Californians.[101] Speaking of his local congregation, the pastor of the Presbyterian church in Visalia professed, "None of them are of the migrant class, they are far from it. . . . It is a white collar crowd. I am not used to speaking to people of the Dust Bowl."[102]

Particularly difficult to accept for administrators and average Californians alike was the emotive, evangelical forms of worship.[103] Employees of the Historical Section were no exception. Like Steinbeck, Stryker was interested in religion but was not a churchgoer. Rothstein was Jewish, but not particularly religious.[104] In *Grapes of Wrath*, camp manager Jim Rawley clearly saw the "wailin' an' moanin'" as a distraction. One month before Rothstein's visit, Robert Hardie, director at Tulare, commented, "The migrants, being largely rural southwesterners, are historically addicted to 'shouting' religion. Whatever value this sort of worship may have as an outlet for starved emotions or as a compensatory mechanism for the exploited, it is productive of fanaticisms and irrationalities which can seriously disturb the general social equilibrium." "While the management does not wish to banish God from the camp," Hardie continued, "I believe that it would be heartily glad if it could keep out the Churches, letting the people attend the ones of their choice in town."[105] Finding themselves ostracized from local parishes, however, migrants in the camps preferred to initiate their own services, including Sunday schools. Thus, camp managers were left to walk a careful line of controlling the "shouting" religions in an effort to maintain order, without trampling on freedom of worship. At Marysville Collins initiated a nondenominational service, and a similar practice occurred at Tulare. It was a "working compromise," according to Hardie, that allowed the camp manager to maintain control and also helped downplay evangelical tendencies that might hinder migrants' assimilation into local communities.[106] Rothstein's images corroborate this approach. His photographs of the camp Sunday school show calm participants engaging in composed worship and appearing no different than a mainstream Protestant service (figure 181). In all, it seems clear from Rothstein's work that recreation and culture were as important as religion. In fact, he took as many images of bingo night as of religious services. Per the will of the FSA, devotion to the New Deal came first; individual faith second.

Most migrants partook of the camp's cultural offerings willingly and thankfully. Such activities provided them with means of cultural expression and a far better life than what their brethren

FIGURE 181. Arthur Rothstein, "Sunday school. Tulare migrant camp. Visalia, California." March 1940. *Library of Congress, LC-USF34-024312-D*

living in Hoovervilles or typical fruit tramp housing were experiencing. Commenting on life in the camps Woody Guthrie wisely observed:

> You need U.S. Government Camps for the Workin' Folks, with a nice clean place to live and cook and do your washin' and ironin' and cookin,' and good bed to rest on, and so nobody couldn't herd you around like whiteface cattle, and deputies beat you up, and run you out of town, and stuff like that.... You could pay a dime a day for your place to live, and you could do work around the Camp to pay your bill, and you could have a nice buildin' with a good dance floor in it, and you could have church there, too, and go to Sunday School, . . . and have all kinds of meetings and talk about crops and weather and wages, and no cops would make you scatter out.... You could meet there and have Singings and Pie Suppers, and Raffles, and Banquets, and Eats . . . and have your own Peace Officers to keep down fist fights, and your own women to keep care of the kids, and they could have games and baths and good toilets and clean showers and—the governor of the state could find out where the jobs was, and keep you hired out all the time, building Oklahoma, and the whole Dust Bowl over again.[107]

The interventions the camps provided were designed to have lasting consequences. As Lawrence W. Levine succinctly pointed out, "The only culture the poor are supposed to have is the culture of poverty: worn faces and torn clothing, dirty skin and dead eyes, ramshackle shelters and disorganized lives. Any forms of contentment or self-respect, even cleanliness itself, have no place in this totality."[108] By downplaying images of want and poverty and accentuating the positive aspects of the camps, Rothstein's images portray the migrants as having escaped the culture of poverty and as enjoying a new and vibrant culture.

Rothstein's photographs of migrants holding council meetings or women's committees and participating in elections for camp officials had another purpose (figures 182 and 183). These were viewed as experiments in self-governance that helped migrants feel they were part of a working

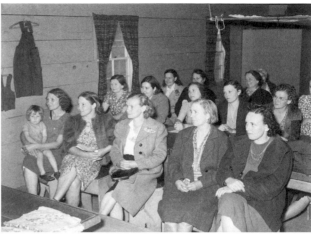

FIGURE 182. Arthur Rothstein, "Election for sheriff and councilman. Tulare migrant camp. Visalia, California." March 1940. *Library of Congress, LC-USF34-024253-D*

FIGURE 183. Arthur Rothstein, "Ladies club meeting. Tulare migrant camp. Visalia, California." March 1940. *Library of Congress, LC-USF34-024179-D*

democracy.[109] Tom Collins set up a system of self-governance and order he referred to as "functional democracy." Though the managers maintained ultimate authority, the camps had written constitutions based on the American Constitution and elected council members to manage the affairs of the facility.[110]

Despite the fact that these activities would seem to be hallmarks of democracy, local residents could easily have viewed them with suspicion. One of the primary fears in the local communities, particularly among those who had the most to lose, was that the migrants would become easy prey for communist agitators and their camps hotbeds of leftist ideas. Hugh Osborn, a supervisor for the Associated Farmers, feared that "the whole proposition is Communist through and through! It stinks of Russia!" Furthermore, he agitated, "The Reds are burrowing from within ... you know how they work!"[111] Those within the system, however, disagreed. Tom Collins noted that migrants were entrenched "individuals" who had trouble working on collaborative farms.[112] Despite unionizers' best efforts, which had support from camp managers, unions had difficulty organizing migrants, who tended to be rugged individualists. As historian Brian Cannon pointed out, numerous forces created divisions among the migrant tenants.[113] According to Jean Lee, "They have lived isolated lives, they are individualistic by temperament. But they are beginning to listen to the other fellow. Give them a chance, they'll learn. They are almost pitifully eager for any hint which will help."[114] Charles Todd, who in 1942 became the assistant manager at the Tulare migrant camp, insisted that the council meetings and other camp organizations were introducing the migrants to democracy: "For many 'Okies' this government camp is the first taste of real democracy," he argued. "Theirs is a collective life, with plenty of outlets for individualism."[115] After visiting the camps Eleanor Roosevelt concurred, "Above all, [the camps] are run by the people themselves so that democracy may be seen in action."[116]

There was a need for the public to see the constant flood of migrants coming into California as being composed of individuals. Author and migrant activist Sanora Babb remarked, "It is hard to distinguish in my mind the several thousand faces I have seen, but the composite of them all could be the small lean face of the Midwesterner, marked sharply with honesty and hunger, the last almost concealed by a stern and independent pride."[117] Seeing virtue in the individual is exactly what the migrants' antagonists were unable to do—often considering them as less than human. In *The Grapes of Wrath* Steinbeck penned a conversation between gas station attendants watching the flow of migrants coming into California. Their callousness undoubtedly echoed

what many Californians were thinking: "Them goddamn Okies got no sense and no feeling. They ain't human. A human being wouldn't live like they do. A human being couldn't stand it to be so dirty and miserable. They ain't a hell of a lot better than gorillas."[118] Critics, in effect, were not able to see the migrants' faces. In *The Grapes of Wrath* the Weedpatch camp was the only place where the Joads were treated like individuals and not a faceless, locust-like mob deserving of suspicion and contempt.[119]

Emphasis on the individual found particular resonance in Rothstein's work in Visalia. His most powerful images from this assignment in 1940 are a collection of more than thirty portraits. Tightly cropped and isolated against a blank sky or the wall of the FSA administrative building, these portraits captured the faces of migrant field workers, their wives, and their children (figure 184). According to McWilliams, migrants were widely stereotyped and seen as a "racial minority." Here, though, they are represented as "American people."[120]

Although stylistically similar to Walker Evans's famous portraits of Allie Mae Burroughs from Hale County, Alabama, Rothstein's images were designed to carry a very different message. Evans's image is cool and detached (figure 185). As Anne Tucker suggested, Evans gave Allie Mae the look of art. And that look extends to the clapboard of her house, which James Agee described as patterned like a "wild fugue and floods of grain."[121] Susan Sontag has argued that such images supported the FSA photographers' "own notions about poverty, light, dignity, texture, exploitation, and geometry."[122] Granted, Rothstein was imposing his own ideas on his subjects, but he was less interested in artifice than the individual. One of the lessons Rothstein said he learned through his travels across the United States was that "each man was an individual" and that there was "no

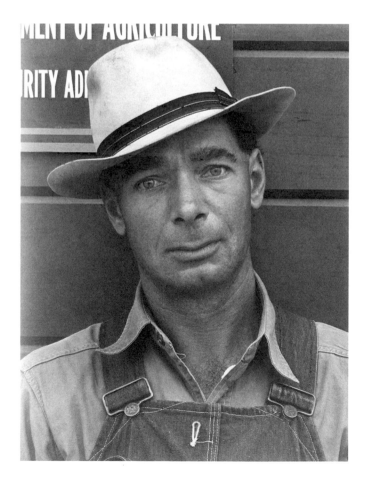

FIGURE 184. Arthur Rothstein, "Migrant field worker. Tulare migrant camp. Visalia, California." March 1940. *Library of Congress, LC-USF34-024118-D*

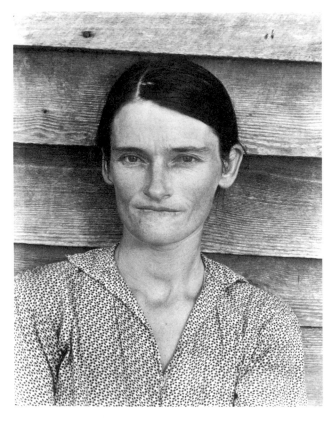
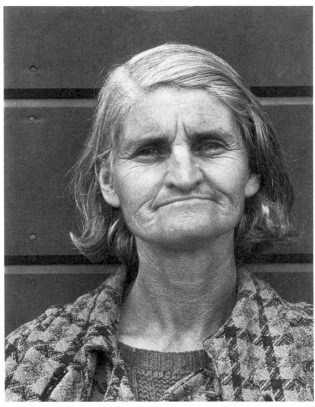

FIGURE 185. Walker Evans, "Allie Mae Burroughs, wife of cotton sharecropper. Hale County, Alabama." 1936. *Library of Congress, LC-USF342-008139-A*

FIGURE 186. Arthur Rothstein, "Wife of migrant. Tulare migrant camp. Visalia, California." March 1940. *Library of Congress, LC-USF34-024204-D*

FIGURE 187. Arthur Rothstein, "Migrant field worker. Tulare migrant camp. Visalia, California." March 1940. *Library of Congress, LC-USF34-024300-D*

FIGURE 188. Arthur Rothstein, "Migrant girl. Tulare migrant camp. Visalia, California." March 1940. *Library of Congress, LC-USF34-024205-D*

FIGURE 189. Arthur Rothstein, "Migrant boy. Tulare migrant camp. Visalia, California." March 1940. *Library of Congress, LC-USF34-024196-D*

FIGURE 190. Arthur Rothstein, "Wife of migrant. Tulare migrant camp. Visalia, California." March 1940. *Library of Congress, LC-USF34-024212-D*

homogeneous quality about Americans."[123] Rothstein's portraits represent a broad variety of men and women, demonstrating that there was no one look among the migrants. Though he portrayed a wide variety of ages, overall he also showed that migration was a youthful phenomenon (figures 186–194).[124] In these photographs it is possible to see what John Steinbeck meant when he wrote: "The sullen and frightened expression that is the rule among the migrants has disappeared from the faces of the Federal camp inhabitants. Instead there is a steadiness of gaze and a self-confidence that can only come of restored dignity."[125]

These portraits have also come to the attention of later historians. John Raeburn sees Rothstein's images as being a counteraction against stereotypes of the Okies and Arkies and an affirmation of their worthiness to receive taxpayer-funded assistance.[126] For Kevin Starr Rothstein captured "full human beings, embattled but coping, each face with a separate story to tell." He continued, "Far from seeming like poor white trash, the men and women depicted in Rothstein's images seem more like the beginnings of a new California people, direct descendants of one of North America's most venerable stocks."[127] Richard Steven Street elucidated further: "Camp residents appear as well-scrubbed citizens, indistinguishable from other Americans. All are nicely dressed in clean clothes. Most smile. . . . No one looks discouraged or malnourished.[128] In the final line of Zanuck's movie Ma Joad proclaims, "They can't wipe us out; they can't lick us. We'll go on forever . . . cause we're the people." Rothstein's portraits convey the same message.

The presentation of American faces was integral to Stryker's larger goals. In 1939 he encouraged Rothstein to be on the lookout for "a good many pictures" for a traveling exhibition entitled *Faces of America*. He asked for portraits of farmers and farm families engaged in their daily duties.[129] Rothstein's work in 1940 was an important variant on this theme. Rather than settled farmers he photographed displaced farmers. Instead of a farm or town in the background, the backdrop for these photographs was usually the side of the FSA office. With the rise of overt racism and persecution in fascist Europe the notion of "American faces" was topical.[130] They are what Steinbeck, in *The Harvest Gypsies* article series, called "the new race" of the American people—products of a democracy transformed by necessity and hardship.[131] Stryker too asserted, "The faces to me were the most significant part of the file":

> When a man is down and they have taken from him his job and his land and his home—everything he spent his life working for—he's going to have the expression of tragedy permanently on his face. But I have always believed that the American people have the ability to endure. And that is in those faces, too. Remember Steinbeck's famous lines—"We ain't gonna die out. People is goin' on"? That's the feeling which comes through in those pictures.[132]

Rothstein's sampling of migrants has important omissions. African American, Mexican, and Filipino migrant workers had access to the camps but were segregated from white migrants, and Rothstein did not photograph them at all.[133] Perhaps within the context of his time, it would have been counterproductive to his propagandistic purposes for him to do so. Yet despite the narrowness of Rothstein's series, he did reveal the human side of the migrant problem.

Arguably the best known photograph in this series is that of a gruff field worker (figure 195). In subsequent years this portrait was mislabeled as a farmer from Nebraska and a cattle rancher from Wyoming or Montana.[134] In reality—and regardless of whatever his former occupation was—at this stage in his life the man was a migrant. Rothstein may or may not have been responsible for the misidentification of this image, but the fact it was mislabeled is telling. One might

FIGURE 191. Arthur Rothstein, "Migrant field worker. Tulare migrant camp. Visalia, California." March 1940. *Library of Congress, LC-USF34-024203-D*

FIGURE 192. Arthur Rothstein, "Migrant girl. Tulare migrant camp. Visalia, California." March 1940. *Library of Congress, LC-USF34-024226-D*

FIGURE 193. Arthur Rothstein, "Migrant field worker. Tulare migrant camp. Visalia, California." March 1940. *Library of Congress, LC-USF34-024305-D*

FIGURE 194. Arthur Rothstein, "Migrant field worker. Tulare migrant camp. Visalia, California." March 1940. *Library of Congress, LC-USF34-024257-D*

FIGURE 195. Arthur Rothstein, "Migrant field worker. Tulare migrant camp. Visalia, California." March 1940. *Library of Congress, LC-USF34-024211-D*

prefer to envision this proud and strong man working on the range, rather than as an unskilled picker in a field alongside children. Such, however, was the nature of the Great Depression: anyone could have ended up in the fields of California. Interpreted in the context of this uncertainty, the message behind Rothstein's migrant portraits becomes clear. Not only do they represent the diversity of the nation but they also say: Here are the faces of the migrants, they look like you and, if circumstances dictated, they could be you.

In general, Stryker was well pleased with Rothstein's work in California. Once the negatives were received and processed, Stryker viewed them and wrote to Fred Soule, informing him of their quality. He also proposed the possibility of an exhibition "on the welfare side of the camps" that Helen Gahagan Douglas and the John Steinbeck Committee could use in their talks. He even bet the show would be "a honey."[135] Unfortunately, it seems no such exhibition was ever organized.

Nearly a month after the release of *The Grapes of Wrath* film and Rothstein's visit to California, Lange photographed a large billboard along Route 33 in the San Joaquin Valley, advertising the showing of the movie at the Princess Theater in Modesto (figure 196).[136] In her notes she scribbled, "More of the Grapes of Wrath?"[137] By the time Lange took this photograph she was no longer on Stryker's payroll, but was still going into the field regardless. With intentional irony, Lange captured a pea pickers' settlement in the background—using the surroundings to give new

FIGURE 196. Dorothea Lange, *"Grapes of Wrath* Billboard," 1940. *© Dorothea Lange Collection, Oakland Museum of California, City of Oakland. Gift of Paul S. Taylor.*

meaning to the billboard, as she had done on other occasions.[138] She undoubtedly loved playing on commercial messages misplaced against harsh realities of actual scenes. This is certainly true here. Her camera recorded a derelict house and a yard filled with migrant tents and trailers in the shadow of the large billboard.

Within a year after this image was taken, Pare Lorentz proudly exclaimed that Steinbeck and Lange "had done more for these tragic nomads than all the politicians in the country."[139] For Lange, however, it must have been difficult to gauge whether her efforts—or those of Steinbeck, Zanuck, the FSA, and others—had made much of an impact. Despite their advocacy, many migrants still faced poverty and deprivation. The misery described in the novel and on the glittering silver screen was still playing out across the disparate landscapes of California. Huddled beneath the *Grapes of Wrath* billboard, which served as protection against the wind and sun, were more migrant families forced to live alongside the road. Lange's image was yet another plea to help, but she must have known that the world was changing and growing progressively deafer to their cause. The day she made this photograph, April 9, 1940, was the same day Nazi Germany invaded Norway and Denmark.

Icons of the Great Depression

Looking Back on History

The December 7, 1941, attack on Pearl Harbor was a turning point for the migrant issue. With the United States waging war in two theaters, the migrant problem and the plight of the poor quickly faded from the minds of the American public. World War II made the United States less insular. Once-pressing domestic issues dropped from the front pages, which were increasingly filled with grim news from abroad.

By 1942 the issue that had dominated an entire decade slipped into history. According to Paul Taylor, "People began very quickly turning their eyes away from Depression into what we called the Defense Period."[1] Few listened or cared when the Tolan and La Follette Committees published their comprehensive reports on interstate migration.[2] Lange and Taylor quickly found their book *American Exodus* remaindered, and very few read Evans and Agee's masterwork, *Let Us Now Praise Famous Men,* when it was published in 1941. The world had changed. When the BBC reporter Alistair Cooke first traveled to the Dust Bowl in 1939, he found houses covered in sand. When he returned during World War II, he encountered a landscape covered with grass and cattle. The Dust Bowl, he noted, had become the "Beef Bowl."[3]

When America entered the war, the migrants' situation changed as well. In 1939 Lange and Taylor forecast that "industrial expansion" would offer hope for displaced workers.[4] It is unlikely that they foresaw their prediction coming to pass so soon. Across the nation the burgeoning war industry employed tens of thousands, including many who once called themselves tenant farmers, sharecroppers, or migrants. Consequently, relief rolls shrank and crop prices rose. People

FIGURE 197. Russell Lee, "Sign at entrance of FSA (Farm Security Administration) defense housing dormitories at Vallejo, California." February 1942. *Library of Congress, LC-USF34-071556-D*

continued to flow into California, but not as pickers. Rather, they supplied labor for the war industry, including the shipyards near Oakland and the aircraft plants near Los Angeles.[5] It was reported that the number of migrants during this time exceeded the flow during the heart of the Depression.[6] Across California migrants gained a new title: "defense Okies."[7] During the war the FSA facilitated housing for defense workers while continuing to actively assist rural populations, albeit that the urgency of their rural efforts was no longer as evident (figure 197).[8] The FSA motto became "Farm Security Is National Security."[9] In this light, the faces Rothstein had recorded in 1940 no longer represented the needy but a needed human surplus.

The shift in the nation's focus was welcome news for John Steinbeck. Despite having been awarded a Pulitzer Prize in 1940 for *The Grapes of Wrath*, the author was eager to slip away from public scrutiny. When *Grapes of Wrath* dropped from the top of the best-seller list it gave him a longed-for respite from fame. "One nice thing to think of is the speed of obscurity," he wrote, "*Grapes* is not first now. In a month it will be off the list and in six months I'll be forgotten."[10] Steinbeck's prediction proved overly optimistic. He never slipped into obscurity, and *Grapes of Wrath*, his most famous novel, continued to be widely read throughout the 1940s, which proved to be one of the more difficult decades of his career. Moreover, fame continued to dog him until his death in 1968. Yet he was at least able to move on to new projects, including a documentary film titled *The Forgotten Village*, shot in rural Mexico in 1941.[11]

In this changing world FSA photography shifted as well, away from documenting America and toward recording the nation's preparations for war. In 1942 Roy Stryker's Historical Section was transferred from the Farm Security Administration to the Office of War Information. By the time Stryker left his position in the federal government in September 1943 his photographers had amassed more than 130,000 images (figure 198). Despite obvious and notable holes, this collection still stands as one of the most important and expansive documentations of the nation ever assembled.

During his tenure Stryker's project was little known outside of Washington. Moreover, the Historical Section faced constant pressures and enemies both "real and imagined," and Stryker was repeatedly forced to stave off attempts to discontinue his beloved archive.[12] Critics saw the Historical Section's activities as wasteful, superfluous, and propagandistic. As late as 1948 Senator Homer Capehart (R-Indiana) claimed that the FSA squandered $750,000 of the government's money on silly, ridiculous, and foolish pictures. Many of the FSA images, in Capehart's estimation, were a waste of "perfectly good film."[13] At this point, however, Capehart's tirade was pointless. In one of his final acts of service in 1943, Stryker secured the transfer of his prized files to the Library of Congress. His friend and supporter Archibald MacLeish, now the librarian of Congress, facilitated the transfer and helped ensure the preservation and availability of the FSA photographic files for future generations.

In the aftermath of World War II many of the "greatest generation" did not want to look back and relive the tumultuous past of the Depression. Furthermore, America's unprecedented economic growth allowed them to forget about the suffering of the 1930s. "Americans forgot the Depression as abruptly as Germans forgot Hitler," Caroline Bird commented at the time. "Nobody talks, glowingly or otherwise, about 'the good old days' before World War II," she observed. "It is a curious fact that the Great Depression is in danger of disappearing altogether from the collective consciousness. Already it seems unreal, even for those who lived through it."[14] In a culture and climate of prosperity it was easy to relegate *The Grapes of Wrath* and the FSA photographs to the past.

Better times also lured many to fields far from migrant hovels and poverty. Steinbeck moved from California to New York City to continue his career. When he wrote of his 1960 journey through California's Central Valley in *Travels with Charley,* he made no mention of the former poverty-ridden roadside camps where he sat with dusty and downtrodden migrants. Rather, he traveled in ease and comfort on a high-speed road in a "comfortable and dependable car" with the "old days of the 1930s" well behind him.[15] Stryker was hired by Standard Oil of New Jersey to create a photo archive, for which he employed many of his former photographers, including Russell Lee, John Vachon, and Edwin and Louise Rosskam.[16] Walker Evans went on to a position with *Fortune* magazine. It is no small irony that Stryker and his photographers, who once worked diligently on behalf of the rural poor were now employed by titans of industry.

By the 1960s a new, socially conscious generation returned to Steinbeck's novel and the photography of the FSA. A generation or two removed from the turmoil of the 1930s, baby boomers looked at the work with new eyes and engaged with it in a more critical way. They were not distraught by the images because they had not personally lived through this time. Even for many of those who had lived through the Depression, the 1930s were lost in a "fog of nostalgia" that took off the rougher edges.[17] Jack Delano, one of Stryker's photographers, referred to the Depression era of hardship as an "exciting time."[18] With the passage of time, it was possible to look back on the photographs and Steinbeck's book as more than social documents of a tumultuous era in history. Many now considered them art that carried trappings of timelessness, beauty, and universality.

Prior to the 1960s many considered *The Grapes of Wrath* to be merely a "proletariat novel" and a "social document with only marginal literary status."[19] This assessment was about to change. In a controversial choice, Steinbeck received the Nobel Prize for literature in 1962, with *Grapes of Wrath* being an important factor in the decision.[20] Steinbeck's most famous work subsequently grew in reputation, with many acclaiming it as a great American novel, an "achievement of artistic vision," and a "work of literary genius."[21] In an appraisal written the day after

Steinbeck's death, *New York Times* columnist Charles Poore suggested that *Grapes of Wrath* was the author's first great book and his last great work. "But Good Lord," Poore exclaimed, "what a book that was and is."[22]

Since its original publication the novel has sold more than fifteen million copies worldwide and has been translated into nearly thirty languages.[23] Despite an occasional ban, *Grapes of Wrath* is a standard on high school reading lists. More importantly, decades after its debut it is still seen as a work that made a difference, not only for the migrants whose plight Steinbeck wrote about, but on a more universal and lasting level as well. As Robert DeMott exclaimed, it "still speaks to the larger experience of human disenfranchisement, still looks toward an authentic human ecology, still anticipates an ethos of individual and communal conversion."[24]

The FSA received a similar reappraisal. At the end of the 1930s the public reaction to the photograph archive was mixed, some viewing the photographs as slanted and propagandistic, others calling them touching, "true and sad and tragic."[25] In 1939 James McCamy, writing on government publicity, remarked that the photography of Stryker's team has "been an unquestionable influence on the use of the camera for documentation of social conditions."[26] Yet this fame was tied to a declining reputation of and interest in documentary photography.[27] By and large, photojournalism, the purview of *Life* and *Look*, famously ignored the tragic. As Raeburn correctly pointed out, the FSA would become more famous in later decades than it was in its own time. Stryker predicted this might happen. Writing to Lange he mused, "I feel certain that some day it will be a more important record than it now seems at the moment."[28] He was right. As the FSA photographs started to lose their direct tie to the past they became burnished by history and the art world.

The enhanced recognition of the FSA archive paralleled an important change in the culture of photography. Beginning in the 1960s photography became increasingly visible as an art form, finding its way into galleries and museums. Though art critics might sneer, the public increasingly perceived photographs as a legitimate form of art.[29] In 1940 Stryker envisioned that the files would ultimately benefit historians and social scientists. He could not have predicted the "long and circuitous journey from government archive to art museum," or that many, including Rexford Tugwell, would begin calling the photographs works of art.[30] Others called the FSA photographers "poets with cameras."[31]

This transformation was troubling for some former FSA employees, including Russell Lee and Jack Delano, who did not see their work as collector's items or museum pieces.[32] Later in life many of the photographers insisted that their work was to be used as part of a living archive. They were adamant that FSA photographs were not "cult objects" and were never intended for a museum wall.[33] Yet a growing market for vintage prints challenged the perceptions of the project and the opinions of its photographers. By the end of the 1970s photographs that Stryker's office had once given out for free or later sold for a few dollars were selling for more than a thousand dollars.[34] The prices only escalated as the images became the purview of the collector and curator.

In truth FSA photographs had been mounted on museum walls for nearly four decades. In 1938 Walker Evans's influential exhibition *American Photographs* was shown at the Museum of Modern Art (MoMA). In the same year Stryker's crew mounted a large show at the International Photography Exhibition at Grand Central Palace, New York. Shortly thereafter MoMA acquired a print of Lange's "Migrant Mother." During his tenure as the curator of photography for MoMA Edward Steichen incorporated several works from FSA photographers in exhibitions including *Road to Victory* (1942), and his seminal 1955 exhibition *The Family of Man*.[35] The most important

FSA exhibition occurred seven years later when Steichen organized a traveling retrospective and catalog known as *The Bitter Years,* the last exhibition he curated for MoMA.

In the catalog of *The Bitter Years* Steichen referred to the FSA as "one of the proudest achievements in the history of photography."[36] Featuring more than two hundred images, the exhibition was an impressive showcase for the FSA and its photographers. In Steichen's estimation it was the right time to exhibit the work. "In 1962," he later recalled, "the time seemed ripe for a reminder of those 'bitter years' and for bringing them into the consciousness of a new generation that had problems of its own but was largely unaware of the endurance and fortitude that had made the emergence from the Great Depression one of America's victorious hours."[37] Lange received particular attention, with eighty-four works on display. The exhibition also included several of Lee's images.[38]

While Stryker questioned Steichen's choices for the exhibition on the grounds that they highlighted the bitter, concentrating on images of defeated sharecroppers and migrants, he was pleased that the show helped cement the FSA's legacy.[39] A reviewer for *U.S. Camera* called the FSA "one of the most memorable and effective visual documentations ever undertaken by any Government in the world."[40] Another critic, Nat Herz, felt that the exhibition not only reminded viewers that terrible conditions continued to be found in the American countryside but also established the legacy and importance of the FSA file. "Among these 270,000 pictures," he wrote, "there are some photographic works of art that will last for all time."[41] *The Bitter Years* was the "revival exhibition" of the FSA and an important event in the afterlife of Stryker's Historical Section, which was disproportionately reassessed as one of the most important contributions of the New Deal. *The Bitter Years* also reestablished the Historical Section's tie to *The Grapes of Wrath.* One review paired two chapters from the novel with FSA images.[42]

Interest in the FSA photographs was enhanced by their accessibility. As part of the Library

FIGURE 199. John Collier, Jr., "Picture selection from FSA (Farm Security Administration) files for war bonds mural in Grand Central Terminal in New York City." December 1941.
Library of Congress, LC-USF34-081770-C

of Congress's holdings, the FSA archive is open to the public and scholars in a remarkable way (figure 199). Photographic prints, many from the original negatives, can also be obtained at nominal cost.[43] As was true of Steinbeck's oeuvre, the accessibility and growing notoriety of the FSA attracted young scholars and curators like Therese Thau Heyman, F. Jack Hurley, William Stott, and Robert Doherty. The Historical Section's efforts reached new heights of recognition, becoming the subject of theses, films, and numerous publications.[44] By 1973 Stryker called his project "perhaps the greatest [collection of photographs] ever assembled in the history of America."[45] His younger admirers, however, went even further. Arthur Siegel professed that Stryker was a prophet and hoped his "tribe" might increase. Doherty called the FSA photographers' work "timeless" and praised their "high level of aesthetic quality." Gene Thornton, the photo critic for the *New York Times,* predicted that in a century the FSA images would be more important than the art of much of the twentieth century.[46]

In 1964 Paul Vanderbilt predicted that the FSA's influence on other photographers would be more important than the file itself.[47] Vanderbilt was probably correct, and the reputation of the Historical Section benefited greatly from the growing notoriety of its photographers, in particular the two most famous FSA members—Walker Evans and Dorothea Lange.[48] In many ways Lange and Evans represent the two poles of FSA photography.[49] Both struggled with Stryker's directions but the reasons behind their resistance were very different. Evans cared very little for the kinds of images Stryker needed. His work was critical, cool, and calculated, and he took equal care whether photographing the lines of a parish church or the facial features of a sharecropper. Lange, on the other hand, focused on the individual. Her lens was sympathetic and caring, and her expertise was in documenting human dramas told through a subject's face, body, or hands. In all, her passion and intensity outpaced Stryker's vision and made it difficult for her to stay in his employ. Together these two different personalities represented the wide spectrum of what FSA photography was and their work attracted a variety of young photographers.

Although Walker Evans bristled under Stryker's authority and constantly bickered with his boss, the photographs he took for the RA/FSA became his most important and distinctive body of work. Szarkowski's claim that Evans had few acolytes is short-sighted; there were many who looked to him for inspiration.[50] Through his book *American Photographs* and his teaching position at Yale later in his life Evans became one of the most influential photographers of the twentieth century. It has been suggested, in fact, that his work formed the bedrock of one of the most vibrant traditions in American photography: following his lead generations of younger photographers, including Robert Frank, Lee Friedlander, Garry Winogrand, and Diane Arbus, explored the complexity and visual ironies of the social landscape.[51]

Painful stomach ulcers and a series of surgeries sidelined Dorothea Lange for much of the 1940s. When she recovered her strength in the early 1950s she turned her focus to photographing "the familiar." "It is the nature of the camera to deal with what *is,*" she wrote, "we urge those who use the camera to retire from what *might be.*"[52] Despite her years of relative inactivity, Steichen claimed that Lange was "without doubt our greatest documentary photographer" and "one of the truly great photographers of all time."[53] Just prior to her death John Szarkowski, Steichen's successor at MoMA, worked with Lange on organizing a major retrospective. Lange would not live to see the exhibition open in 1965, but she continued to be an important influence on younger photographers like Homer Page, who worked with her directly, and others like Ken Light and Roger Minick who followed the "humanist tradition" she helped establish.[54] Indeed, the conditions surrounding many of these younger photographers were not unlike the difficult years of the Depression. Migrants were still found on the roadways all across the

United States (figure 200). Lange's legacy is also tied to the growing fame of her work. This is particularly true of "Migrant Mother," which, according to Sally Stein, has been "reproduced so often that many consider it the most widely reproduced photograph in the entire history of photographic image-making."[55]

Lange and Evans were not the only ones who left their mark on younger photographers. Through his long career as the director of photography for *Look,* Arthur Rothstein continued to be an advocate for documentary photography and photojournalism. As a defender of the FSA photography file, he praised its achievements and bemoaned its misrepresentation. He particularly resented the fact that Walker Evans was seen as the leading member of the project.[56] Although Russell Lee chose to stay out of the spotlight, his quiet presence and "human documents" influenced many younger photographers, including Bill Owens, Judy Bankhead, and Chauncey Hare (figure 201).[57] Better known in photographic circles than by the public, Lee was seen as a photographer's photographer.[58] Later in their lives Marion Post Wolcott, John Vachon, and Jack Delano were also recognized for their contributions to the FSA photography file. Speaking for his generation James Alinder claimed that the FSA photographers were the "heroes of the history of photography."[59]

One photographer with more limited influence was Horace Bristol. After serving in Edward Steichen's photo corps during World War II, Horace Bristol was sent to Asia by *Fortune* magazine, where he stayed for the next twenty-five years. Eventually, he gave up photography and burned the prints and negatives that were in his possession.[60] Yet Bristol's work from the 1930s was not completely forgotten. In the 1964 edition of his *History of Photography* photo-historian Beaumont Newhall claimed that *The Grapes of Wrath* grew out of Bristol's work with Steinbeck in the early spring of 1938, a lofty but erroneous claim. Newhall later retracted his assertion and

edited references to Bristol out of his subsequent edition, but the photographs Bristol completed alongside Steinbeck remain his best-known work.[61] Years later, Bristol's son, while working on a school project, asked his father whether he had ever read *The Grapes of Wrath*. The question inspired him to bring out his surviving work and look anew on the faces from the camps and the images of poverty. Later, when he watched a rerun of *The Grapes of Wrath* film, he said he felt like he was greeting old friends.[62]

As the FSA photo file and *The Grapes of Wrath* became better known, they also became increasingly welded together as cultural symbols of the Great Depression. In subsequent years FSA administrators, FSA photographers, and even Stryker were quick to acknowledge the connections in interviews. By the early 1960s the FSA images were already considered the public consciousness of the Depression and enduring symbols of poverty.[63] Writing in *U.S. Camera* in 1962 Roger Hammarlund claimed the work of the FSA was so thorough and extensive that when average citizens thought of the Depression they would envision those images.[64] The same might be said about Steinbeck's novel, which still had pull. For many readers no work better captured the essence of the Depression experience.[65] Increasingly, the FSA photo file and *The Grapes of Wrath* together became shorthand references for the 1930s and "the collective symbols of the period."[66]

While the FSA collection is commonly associated with *The Grapes of Wrath*, there has always been an especially strong connection between Steinbeck's work and the imagery of Dorothea

Lange. Lange and Steinbeck were the products of a particular place and time. They worked the same roads and valleys in California alongside destitute migrants and were united in a similar cause. Later in life Lange's husband, Paul S. Taylor, endorsed the connections between the FSA and *Grapes of Wrath*.[67] The connections were recognized as well by peers like Pare Lorentz and by subsequent historians. More than anyone else it was through Lange and Steinbeck that "ideas and images" met.[68] Indeed Lange's "Migrant Mother" and Steinbeck's *Grapes of Wrath* seem to have a natural allegiance. When asked near the end of her life about the photograph Lange made of her, Florence Thompson stated it "stamped a permanent *Grapes of Wrath* stereotype" on her.[69] According to Jackson Benson, Lange's "pictures of Dust Bowl landscapes and victims, of migrants in transit and in California, have become classics, as closely connected to the Okies and the suffering of farm laborers as *The Grapes of Wrath*."[70]

Despite earlier ill feelings toward Steinbeck, Lange respected the author and believed that their work jointly did more for American migrant labor than anyone else prior to César Chávez.[71] Near the end of her life she reportedly sent Steinbeck one of her photographs. Which one is not known, but one can assume it related to the great migration—the shared subject matter that helped define both their careers.[72] Lange's simple gesture was an acknowledgment of respect and admiration. It also left an impression on the aging author, who wrote a note of thanks to the ailing photographer on July 3, 1965. Like veterans of a distant struggle he talked of the past and present. "Nothing was ever taken that so illustrated that time," he wrote, "a strange time but surely no more paradoxical than the present. . . . If the question were asked, if you could choose out of all time, when would you elect to have lived. I would surely say—the Present. Of course we don't know how it comes out. No one ever does. The story ends only in fiction and I have made sure that it never ends in my fiction." Thirty years after their interests and energies initially crossed, he too had direct praise for Lange. "There have been great ones in my time and I have been privileged to know some of them and surely you are among the giants." He ended his brief note with the humble statement, "How I wish I may do it as gallantly as you."[73] After a long battle Lange succumbed to cancer on October 11, 1965. Steinbeck died of heart failure three years later on December 20, 1968. Yet despite their deaths, their joint story was not over.

The recession of the 1970s marked a decade of increased visibility for both the FSA and Steinbeck's novel. The U.S. economy did not slip to the depths it had during the Great Depression, but many Americans experienced significant economic hardships due to high unemployment, record inflation, recession, and an energy crisis that humbled a headstrong nation. Dust storms even returned to plague the Midwest.[74] These hardships encouraged many to look to the past. In 1974 *U.S. News & World Report* brought together FSA imagery and eyewitness accounts in an article aptly titled, "What a Depression Is Really Like."[75] Steinbeck's novel received renewed scrutiny and a "second wind" from a host of younger scholars like Robert DeMott, Richard Astro, Jackson Benson, and many others.[76] By 1975 there were more than two million copies of *Grapes of Wrath* in circulation.[77] The FSA photographs also received renewed interest. As one writer commented, "as we embark on a depression of our own, there is a temptation to compare and to learn what we can from these earlier photographs."[78] Senator Walter Mondale (D-Minnesota) even proposed a new, FSA-like documentation of the nation to correspond with the upcoming bicentennial.[79] While the proposal had backers in Congress and among former members of the FSA like Arthur Rothstein, it did not garner enough support in Washington to come to fruition.

Having experienced the Great Depression the FSA photographers must have known that the troubles of the 1970s were nowhere near as severe. But as the stature of the FSA grew and praise for the photography file mounted, the surviving photographers waxed nostalgic about the past

and their time with Stryker.[80] With the notable exception of Walker Evans, they became a "little starry-eyed" about the nobility of the project.[81] Increasingly their work was shown in galleries and museums, including at a well-received 1973 exhibit at the Victoria and Albert Museum in London. Titled *The Compassionate Camera: The Dust Bowl Pictures,* the exhibition also featured screenings of Pare Lorentz's documentary *The Plow That Broke the Plains* and tapes of Woody Guthrie's "Dust Bowl Ballads" playing in the background.[82]

Yet even as the FSA images received praise and collectors eyed them, the photographers themselves became something of an enigma and a challenge for younger admirers. In the age of Vietnam and Watergate many could not understand the dedication and devotion these photographers had possessed for the federal government. They criticized their dedication to Stryker and attacked Stryker's shooting scripts as "bureaucratic interference with photographic freedom and expression."[83] Critics like Martha Rosler wrote of the "gigantic State-propagandist Farm Security Administration corpus."[84] The questioning and second-guessing caught many of the surviving FSA photographers off guard. Yet they reiterated that their commitment was to "the file" and a government agency set on social change rather than to their own artistic aims.[85] In this new age Steinbeck, too, came under fire. Decades earlier he was viewed as a champion of liberal causes; by the 1960s his reputation had soured due to his vocal support of the Vietnam War and his close friendship with President Lyndon B. Johnson. As one scholar surmised, "Those who believed he was a champion a generation before now shunned him. He was too old, too simple, too blind."[86]

If the 1970s had a brush with depression, the end of the 2000s witnessed the closest that the United States has come to returning to and understanding the depths of the Great Depression. With the subprime mortgage crisis and the subsequent collapse of America's housing market, the 1930s seem not far distant. Years after the dramatic fall of Lehman Brothers, the phrase "It has not been this bad *since the Great Depression*" is still heard in daily discussion, on TV news shows, and even in political debates.[87] In many ways Steinbeck's novel has proven prophetic in forecasting the environmental and economic realities of the present.[88] In November 2008 the *New York Times* film critic A. O. Scott queried, "What decade are we in? I have to be honest I never thought *The Grapes of Wrath* would be the most topical movie for right now. But here we are. People are losing their jobs, losing their homes, losing everything and nobody knows exactly who to blame."[89] The works of the FSA photographers and Steinbeck's *Grapes of Wrath* are helping Americans understand the nation's nadir, reminding the nation what difficult times look, sound, and feel like.

In the turmoil and uncertainty of the twenty-first century, there are activists for whom *The Grapes of Wrath* and the Farm Security Administration are very much alive. A case in point is the thirty-year collaboration of writer-journalist Dale Maharidge and photographer Michael S. Williamson. The influences of the FSA and Steinbeck are palpable in their work. Fifty years after Agee and Evans collaborated in Hales County on the project that culminated in *Let Us Now Praise Famous Men,* Maharidge and Williams followed them to Alabama. According to Carl Mydans, who was one of Stryker's original photographers, Williamson's work was so aligned with FSA photographs, conveying "the same eye and feeling," that Stryker would surely have welcomed him "aboard." Maharidge and Williams also knew Steinbeck's work and found themselves in pursuit of the "ghost of Tom Joad."[90] In 2010 they sought out the faces and stories of the "New Great Depression," traveling down "forgotten backwaters where people who evoke the Joads still walk lonely roads flanked by orange, peach, and prune." Following a new wave of America's poor across the United States they uncovered scenes reminiscent of the FSA images and scenes that they knew well from *The Grapes of Wrath* (figures 202–203). Although the recent economic downturn did not reach the depths of the Great Depression, it affected the lives of countless individuals

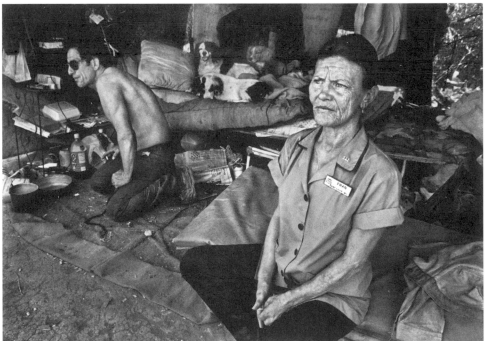

FIGURE 202. Michael S. Williamson, "Alexander Camp, Houston." 1983. Michael S. Williamson, *Someplace Like America: Tales from the New Great Depression.*

FIGURE 203. Michael S. Williamson, "Francis and Frank, Bullhead City, Arizona." 1995. Michael S. Williamson, *Someplace Like America: Tales from the New Great Depression.*

across the country. "The Great Recession can be a Great Depression for those who lost their jobs," Maharidge succinctly reasoned.[91]

In a digital age and a moment when class distinctions in America are a matter of intense debate, other ways of broadcasting the plight of the poor have emerged. It is possible to see the echoes of the FSA, and of Steinbeck, on websites such as americanpoverty.org. Organized by photographers Steve Liss and John Lowenstein, the organization sought to raise awareness of poverty in the United States, remove destructive stereotypes of the poor, and encourage action to alleviate poverty.[92] The use of visual media was a key component of their pursuits. Thus, their efforts did not differ substantially from those of Roy Stryker, Paul Taylor, and Dorothea Lange. The organization's mission statement read:

> During the Great Depression, photographers created riveting images chronicling the desperation of those times. Pictures helped mold the nation's collective memory and conscience. Seventy years later, the plight and potential of the least fortunate members of our communities is mostly unseen and ignored, and photographers are once again poised to jump-start a national conversation about the issue of poverty.[93]

Thus, while the visual details may change, the effects of poverty remain the same. In many ways FSA photographs appear dated but they continue to signify poverty decades after they were created. "We are the children of Lange and company," Liss acknowledged.[94]

For the past seventy-five years the Great Depression has been the baseline of economic despair and hardship. In times of economic downturn we turn to that decade for reassurance that the present is not that bad. We look to the 1930s to learn what a real economic depression looks like. In reality, few images of poverty have been elevated since the 1930s. Despite all the work that writers and photographers are doing today, few if any icons have emerged from the present economic turmoil.[95] In reality it is hard to imagine what the icon of the Great Recession would be. To date no novel has galvanized, or angered, the public like *The Grapes of Wrath* did in the midst of difficult times. Moreover, no photograph has thus far emerged as an emblem of the age. Indeed, it is unlikely that any image will emerge. Florence Thompson was still living a migratory life when Lange's image began being praised and circulated in the 1930s. If Dorothea Lange were to make a similar image today, her subject would be on the talk show circuit by the end of the week and have her own reality show by the end of the year. While not a scientific sampling, a Google image search under "the Great Recession" simply yields a number of graphs, a handful of pithy political cartoons, and more images of the 1930s than of 2008. Googling "The Great Depression," on the other hand, produces photographs of hard times, including a host of FSA images and several examples of "Migrant Mother."[96] In this age, a far different time, it seems easier to ignore current challenges or to become immersed in the confusing mire of complicated banking tricks than to confront poverty in America.

While the reputations of the Farm Security Administration, Horace Bristol, and *The Grapes of Wrath* have recovered and thrived, the conditions they described decades ago are still present. Indeed, migrations have never ceased. Out of sheer necessity there are thousands of migrants working in the United States today, and they remain among the poorest laborers in the West.[97] Worldwide, millions of migrants live in poverty. Unlike Steinbeck and Lange, whose histories are well documented, the story of most migrants will always remain concealed. But what is known of Florence Thompson and Elmer Thomas evinces that everyone has a story. Ultimately, in what they do and where they go, the nameless migrant will always be an important figure in American history.

Coda

In spite of earlier hopes and plans, it was several decades until FSA images would be physically conjoined with *The Grapes of Wrath*. Despite their strong connections, the photographs of the FSA were not used to illustrate the novel until the fiftieth anniversary of its release in 1989. On that occasion Erskine Caldwell provided an introduction to a new edition and chose, without great care, fifteen works from Lange, Rothstein, and Lee that formed a special insert in the leather-bound edition.[1] The images were not selected from Lee's work in Oklahoma in 1939 but from a veritable "greatest hits" of the Historical Section. This is not exactly what Stryker or Lee originally intended when they set out to create a literal illustration of the novel. It is probably not what Steinbeck would have wanted either. Three years later Penguin Books reprinted the novel with Horace Bristol's photograph of "Tom Joad" on the cover (figure 205). This was redemption of sorts for the once-jilted photographer. A young man when he accompanied Steinbeck to the destitute migrant camps, Bristol was eighty-four at the time of the book's publication.

FIGURE 205. Horace Bristol, "Tom Joad." Cover of *The Grapes of Wrath* (1992 edition). *Used with permission of Viking Press and Penguin Books.*

JOHN STEINBECK

The Grapes of Wrath

A half-century after the debut of *The Grapes of Wrath* no one questioned the pairing of the novel with FSA photographs. In numerous ways they were already knit together—tied by images of migrants, a common cause, and distance. Discussions of Steinbeck often include images of Lange, just as books on the FSA always include a reference to *Grapes of Wrath*. Over time though they have become more than historical reference points or cultural symbols. They have become the interlocking icons of the Great Depression through time, rediscovery, and their universality. According to Robert DeMott, Steinbeck's novel has entered "both the American consciousness and the American conscience," and has become "a persistent presence, a cultural icon."[2] The same could be said of the FSA. Additionally what Paula Rabinowitz has written about Lange's "Migrant Mother" is equally true of the Historical Section's photographs and of *Grapes of Wrath*. They have been "composed, revised, circulated, and reissued in various venues until whatever reality [their] subject first possessed has been drained away" and they have become icons.[3] They contained what Taylor called "the seeds of enduring life."[4] Indeed, few icons in American history have the malleability, universality, and longevity of *The Grapes of Wrath*, the imagery of the FSA, Lange's "Migrant Mother," and Steinbeck's Tom Joad.[5] Now, seventy-five years later, they are *the* preeminent icons of the Dust Bowl era.[6]

In all, *The Grapes of Wrath* and the photographs of the Farm Security Administration provide parallel descriptions of America's Great Depression. Born of a similar climate and zeal to assist the one-third of Americans who could not help themselves—America's own refugees—these two works were profoundly influenced by each other. Steinbeck was influenced by the work of the FSA, and Lange's work in particular, just as Stryker's team of photographers found validation and inspiration from what they discovered in *The Grapes of Wrath*. Together sought to illustrate the lives of and challenges facing rural American in an age of uncertainty and change. One did not supplement the other but together they bore similar witness to the trying times that many endured in the 1930s. Moreover, the aura of each is strengthened by the presence and power of the other. Over time they became the living reminders of the Great Depression and what it came to symbolize. Few creative endeavors have had similar endurance or potency. As icons they have shaped the national memory and have come to represent a defining period of American history. They are, simply put, the images that come to mind when we think of the Great Depression.

Notes

Book epigraph (p. vii): Roy Stryker, "The Lean Thirties," *Harvester World,* February–March 1960, 9.

Introduction

1. Vicki Goldberg has called Lange's "Migrant Mother" the "canonical image of the Depression." Wendy Kozol likewise wrote that it was "the major iconic symbol of 1930s Depression families struggling to survive." Goldberg, *The Power of Photography: How Photographs Changed Our Lives* (New York: Abbeville Press, 1991), 136; Wendy Kozol, "Madonnas of the Fields: Photography, Gender, and 1930s Farm Relief," *Genders* 2 (Summer 1988): 19.

2. Alan Trachtenberg, "From Image to Story," in *Documenting America, 1935–1943,* ed. Carl Fleischhauer and Beverly W. Brannan (Berkeley: University of California Press, 1988), 45.

3. See Charles Shindo, *Dust Bowl Migrants in the American Imagination* (Lawrence: University Press of Kansas, 1997), 5–9.

4. Robert J. Doherty, *Social Documentary Photography in the USA* (Garden City, NY: AMPHOTO, 1976), 80.

5. Michael Carlebach, "Documentary and Propaganda: The Photographs of the Farm Security Administration," *Journal of Decorative and Propaganda Arts* (Spring 1988): 6.

6. See Nicolaus Milis, "John Steinbeck's Hurricane Katrina Lesson," *Dissent* 53, no. 4 (Fall 2006): 97–98.

7. See Linda Gordon, *Dorothea Lange: A Life beyond Limits* (London and New York: W. W. Norton, 2009), xv.

8. Katharine Q. Seelye, "Survivor of Dust Bowl Now Battles a Fiercer Drought," *New York Times,* May 3, 2011.

9. Ben S. Bernanke, *Essays on the Great Depression* (Princeton, NJ: Princeton University Press, 2000), vii.

10. Errol Morris, "The Case of the Inappropriate Alarm Clock (Part 1)," *New York Times,* October 18, 2009; reprinted in Morris, *Believing Is Seeing (Observations on the Mysteries of Photography)* (New York: Penguin Press, 2011).

11. See F. Jack Hurley, *Portrait of a Decade: Roy Stryker and the Development of Documentary Photography in the Thirties* (Baton Rouge: Louisiana State University Press, 1972).

12. This abbreviated list could also include other members of Stryker's staff, such as Carl Mydans, Esther Bubley, and Louise Rosskam. For an updated listing of FSA scholarship on specific photographers visit the Farm Security Administration/Office of War Information (FSA/OWI) "Selected Bibliography and Related Resources," Library of Congress, at www.loc.gov/pictures/collection/fsa/bibliography.html#st (accessed July 29, 2013).

13. The omission is all the more surprising considering Rothstein's long career and extensive writings on photography. During his time with *Look* magazine Rothstein published many books on photography, photojournalism, and his work with the FSA through Dover Publications and other presses.

14. F. Jack Hurley, "The Farm Security Administration File: In and Out of Focus," *History of Photography* 17, no. 3 (Autumn 1993): 244; see also Martha Rosler, "In, Around, and Afterthoughts (On Documentary Photography)," in *The Contest of Meaning: Critical Histories of Photography,* ed. Richard Bolton (Cambridge, MA: MIT Press, 1989), 308.

15. Martha Rosler, "Lookers, Buyers, Dealers, and Makers: Thoughts on Audience," in *Decoys and Disruptions: Selected Writings, 1975–2001,* ed. Martha Rosler (Cambridge, MA: MIT Press, 2004), 27. See also Rosalind Krauss, "Photography's Discursive Spaces," in Bolton, *Contest of Meaning,* 293–99; Abigail Solomon-Godeau, *Photography at the Dock: Essays on Photographic History, Institutions, and Practices* (Minneapolis: University of Minnesota Press, 1991), xxii, 17; Colleen McDannell, "Religious History and Visual Culture," *Journal of American History* 94 (June 2007): 112–13.

16. For a listing of FSA scholarship on particular states visit the FSA/OWI "Selected Bibliography and Related Resources."

17. Abigail Solomon-Godeau, "Who Is Speaking Thus," in Solomon-Godeau, *Photography at the Dock,* 174.

18. Edward Steichen, "The F.S.A. Photographers," in T. J. Maloney, *U.S. Camera, 1939* (New York: William Morrow, 1939), 45; Hurley, "Farm Security Administration File," 250.

19. Sara Blair and Eric Rosenberg, *Trauma and Documentary Photography of the FSA* (Berkeley: University of California Press, 2012), 89.

20. On Shahn see John Raeburn, *Ben Shahn's American Scene: Photographs, 1938* (Urbana: University of Illinois Press, 2010).

21. There is a rather small but established tradition of giving voice to the subjects of FSA/OWI photographs. The 2013 publication *Migrant Mother,* a biography of Florence Thompson, clearly adds to this growing field of research even though the book was issued in incomplete form due to the death of Roger Sprague, the book's co-author and Thompson's grandson. See Oleta Kay Sprague Ham and Roger Sprague, Sr., *Migrant Mother: The Untold Story, A Family Memoir* (Mustang, OK: Tate, 2013). For other examples see Bill Ganzel, *Dust Bowl Descent* (Lincoln: University of Nebraska Press, 1984); Joan Myers, *Pie Town Woman: The Hard Life and Good Times of a New Mexico Homesteader* (Albuquerque: University of New Mexico Press, 2001); and John Gruber, ed.,

Railroaders: Jack Delano's Homefront Photography (Madison, WI: Center for Railroad Photography, 2014). This list also includes Marissa Silver's book *Mary Coin* (New York: Blue Rider Press, 2013). The novel presents a fictionalized retelling of Lange and Thompson's encounter and their interwoven histories.

22. Hurley, "Farm Security Administration File," 248.

Chapter 1

1. James N. Gregory, *American Exodus: The Dust Bowl Migration and Okie Culture in California* (New York: Oxford University Press, 1989), xiv; Karal Ann Marling, *Wall-to-Wall America: A Cultural History of Post-Office Murals in the Great Depression* (Minneapolis: University of Minnesota Press, 1982), 133.

2. Benson, *The True Adventures of John Steinbeck, Writer* (New York: Viking Press, 1984), 386–87.

3. Paul Taylor quoted in Carey McWilliams, *Ill Fares the Land: Migrants and Migratory Labor in the United States* (Boston: Little, Brown, 1942), 12.

4. Walter J. Stein, *California and the Dust Bowl Migration* (Westport, CT: Greenwood Press, 1973), 72.

5. Dr. William Alexander, "How the Farm Security Administration Is Helping Needy Farm Families (May 24, 1939)," Robert W. Hollenberg Collection of Materials Relating to the Farm Security Administration, Region IX, 1924–41, Bancroft Library, University of California, Berkeley (hereafter Hollenberg Collection).

6. "Migrant Workers in Agriculture (May 11, 1940)," in *Miscellaneous Material on Migratory Farm Labor and Related Subjects,* call number HD1525.M5 (FSA), Library of Congress (hereafter LOC), c. 1940, 3–6.

7. Carey McWilliams, *Education of Carey McWilliams* (New York: Simon and Schuster, 1978), 75; Paul S. Taylor, "Migratory Farm Labor in the United States [1937]," in Taylor, *Labor on the Land: Collected Writings, 1930–1970* (New York: Arno Press, 1981), 100. Sidney Baldwin put the number of unemployed migratory farmworkers who arrived in California between July 1, 1935, and March 31, 1938, at 250,000. Baldwin, *Poverty and Politics: The Rise and Decline of the Farm Security Administration* (Chapel Hill: University of North Carolina Press, 1968), 221–22.

8. Lawrence Hewes, "Report before the Sub-committee on Education and Labor," September 25, 1940, Hollenberg Collection.

9. Carey McWilliams, *Factories in the Field: The Story of Migratory Farm Labor in California* (Boston: Little, Brown, 1939), 308.

10. Writers' Program of the Work Projects Administration in the State of Oklahoma, *Oklahoma: A Guide to the Sooner State* (Norman: University of Oklahoma Press, 1941), 6; W. Richard Fossey, "'Talkin' Dust Bowl Blues': A Study of Oklahoma's Cultural Identity during the Great Depression," *Chronicles of Oklahoma* 55 (Spring 1977): 21–22.

11. McWilliams, *Ill Fares the Land,* 196.

12. Farm Security Administration, *Migrant Farm Labor: The Problem and Some Efforts to Meet It* (Washington, DC: Government Printing Office, 1940), 5. See also Frank J. Taylor, "California's Grapes of Wrath," *The Forum,* November 1939: 235.

13. Dorothea Lange and Paul S. Taylor, *American Exodus: A Record of Human Erosion* (1939; Reprint, New York: Arno Press, 1975), 67; McWilliams, *Ill Fares the Land,* 194.

14. Lange and Taylor, *American Exodus,* 67.

15. Ulrich Keller, *The Highway as Habitat: A Roy Stryker Documentation, 1943–1955* (Santa Barbara, CA: University Art Museum, 1986), 13.

16. Michael R. Grey, *New Deal Medicine: The Rural Health Programs of the Farm Security Administration* (Baltimore, MD: Johns Hopkins University Press, 1999), 27.

17. For a deeper examination of the makeup of the California migrant see W. Stein, *California and the Dust Bowl Migration;* and "I Wonder Where We Can Go Now," *Fortune* 19, no. 4 (April 1939): 112–14.

18. Louis Adamic, *My America, 1928–1938* (New York: Harper and Brothers, 1938), 381; see also Derva Weber, *Dark Sweat, White Gold: California Farm Workers, Cotton, and the New Deal* (Berkeley: University of California Press, 1996).

19. Susan Shillinglaw, *On Reading* The Grapes of Wrath (New York: Penguin Books, 2014), 172–73.

20. Omer Mills, "Health Problems among Migratory Workers," Hollenberg Collection.

21. Charles L. Todd, "The Okies Search for a Lost Frontier," *New York Times Magazine,* August 27, 1939, 10.

22. Brian St. Pierre, *John Steinbeck: The California Years* (San Francisco: Chronicle Books, 1983), 92; Gregory, *American Exodus,* 86, 93–97, 152–53. The election of progressive Democrat Culbert Olson as California governor in 1938 confirmed that this new constituency did indeed have political power. See Weber, *Dark Sweat, White Gold,* 176; "Flow of Migrants to Coast Spurts," newspaper clipping, in "Scrapbook," *Voices from the Dust Bowl: The Charles L. Todd and Robert Sonkin Migrant Worker Collection, 1940–1941,* American Memory, LOC website: http://memory.loc.gov/ammem/afctshtml/tshome.html (accessed August 22, 2013) (hereafter *Todd and Sonkin, Voices from the Dust Bowl,* LOC).

23. W. Stein, *California and the Dust Bowl Migration,* 46, 54.

24. Rick Wartzman, *Obscene in the Extreme: The Burning and Banning of John Steinbeck's* The Grapes of Wrath (New York: Public Affairs, 2008), 4; Benson, *True Adventures of John Steinbeck,* 337.

25. For more on the life of Dorothea Lange, see Milton Meltzer, *Dorothea Lange: A Photographer's Life* (New York: Farrar, Straus, and Giroux, 1978); and Gordon, *Dorothea Lange: Life beyond Limits.* For more on Maynard Dixon, see Donald J. Hagerty, *Desert Dreams: The Art and Life of Maynard Dixon* (Salt Lake City, UT: Gibbs Smith, 1998).

26. Quoted in Gordon, *Dorothea Lange: Life beyond Limits,* 115.

27. Jan Goggans, *California on the Breadlines: Dorothea Lange, Paul Taylor, and the Making of a New Deal Narrative* (Berkeley: University of California Press, 2010), 12.

28. Richard Steven Street, "Lange's Antecedents: The Emergence of Social Documentary Photography of California's Farmworkers," *Pacific Historical Review* 75, no. 3 (August 2006): 402.

29. For more on Taylor's use of the camera see Richard Steven Street, "Paul S. Taylor and the Origins of Documentary Photography in California," *History of Photography* 7, no. 4 (October–December 1983): 293–308; and Eugenia Parry Janis and Wendy MacNeil, *Photography within the Humanities* (Danbury, NH: Addison House, 1977), 27.

30. See Meltzer, *Dorothea Lange: Photographer's Life,* 86.

31. Gordon, *Dorothea Lange: Life beyond Limits,* 157.

32. For more on the remarkable collaboration of Lange and Taylor consult Goggans, *California on the Breadlines;* Therese Thau Heyman et al., *Celebrating the Collection: The Work of Dorothea Lange* (Oakland, CA: Oakland Museum, 1978), 55–57; John Szarkowski, "Dorothea Lange and Paul Taylor," in Therese Thau Heyman, Sandra Phillips, and John Szarkowski, *Dorothea Lange: American Photographs* (San Francisco: Chronicle Books and the San Francisco Museum of Art, 1994), 42–53.

33. Meltzer, *Dorothea Lange: Photographer's Life,* 94.

34. Quoted in Heyman et al., *Celebrating the Collection,* 56.

35. Quoted in Richard Steven Street, *Everyone Had Cameras: Photography and Farmworkers in California, 1850–2000* (Minneapolis: University of Minnesota Press, 2008), 189.

36. Lange recounted, "That Sunday in April of 1935 was a Sunday that I well remember because no one noticed what was happening, no one recognized it. A month later they were trying to close the border. There were so many that they were talking about it, but they never did really close the border, though they stopped everybody. That was the big agitation then. Should they, or should they not let them in?" Dorothea Lange, "The Making of a Documentary Photographer," interview by Suzanne B. Reiss, 1968, Regional Oral History Office, Bancroft Library, University of California, Berkeley 74–75 (hereafter Lange-Reiss interview).

37. Dorothea Lange, oral history interview, May 22, 1964, Archives of American Art, Smithsonian Institution.

38. Paul S. Taylor quoted in Peter Cowan, "Revisiting Dorothea Lange's Legacy," newspaper clipping, Paul Schuster Taylor Papers, Bancroft Library, University of California, Berkeley.

39. Paul S. Taylor, "Again the Covered Wagon," *Survey Graphic,* July 1935, 348.

40. Lange, oral history interview; See also Anne Whiston Spirn, *Daring to Look: Dorothea Lange's Photographs and Reports from the Field* (Chicago: University of Chicago Press, 2008), 3–4; Lange-Reiss interview, 145; Meltzer, *Dorothea Lange: Photographer's Life,* 96.

41. For more on the Lange-Taylor reports, see Spirn, *Daring to Look,* 18–20; and Meltzer, *Dorothea Lange: Photographer's Life,* 100.

42. Clifton C. Edom, "Documentary Photography," *PSA Journal,* April 1946, 142–43. Richard Street noted that one of the Lange-Taylor reports was fifty-four pages in length. It contained fifteen pages of text by Taylor and fifty-seven photographs by Lange. Street, *Everyone Had Cameras,* 184. See also Spirn, *Daring to Look,* 18–20.

43. Paul S. Taylor et al., *Paul Schuster Taylor: California Social Scientist* (Berkeley: Bancroft Library, University of California, Regional Oral History Office, Earl Warren Oral History Project, 1973), 138–39.

44. Spirn, *Daring to Look,* 20; Goggans, *California on the Breadlines,* 116–17. Before working for Tugwell in the RA, Hewes worked alongside Taylor in the California State Emergency Relief Administration. It was Hewes who hired Lange as Taylor's "clerk-stenographer." Meltzer, *Dorothea Lange: Photographer's Life,* 93–94.

45. Spirn, *Daring to Look,* 20.

46. Linda Gordon reports that it was Taylor who showed the reports to Stryker in the late summer of 1935. Gordon, *Dorothea Lange: Life beyond Limits,* 171.

47. Stryker quoted in Zoe Brown, "Dorothea Lange: Field Notes and Photographs" (MA thesis, John F. Kennedy University, Pleasant Hill, CA, 1979), 28.

48. James L. McCamy, *Government Publicity: Its Practice in Federal Administration* (Chicago: University of Chicago Press, 1939), 23.

49. Ben Shahn, oral history interview, April 14, 1964, Archives of American Art, Smithsonian Institution; Szarkowski claimed that the Taylor-Lange reports might be seen as "inventing the Historical Section." Walker Evans made a similar claim about his own work. Szarkowski, "Dorothea Lange and Paul Taylor," 48; Gordon, *Dorothea Lange: Life beyond Limits,* 171.

50. Quoted in Meltzer, *Dorothea Lange: Photographer's Life,* 128.

51. Roy E. Stryker and Nancy Wood, *In This Proud Land: America, 1935–1943, as Seen in the FSA Photographs* (Greenwich, CT: New York Graphic Society, 1973), 19.

52. See Spirn, *Daring to Look,* 28–29.

53. Roy Emerson Stryker, oral history interviews, 1963–65, Archives of American Art, Smithsonian Institution.

54. Miles Orvell, *The Real Thing: Imitation and Authenticity in American Culture, 1880–1940* (Chapel Hill: University of North Carolina Press, 1989), 309.

55. Zoe Brown, "Dorothea Lange: Field Notes and Photographs," 4.

56. Ibid., 154.

57. Lange and Taylor, *American Exodus,* 148.

58. Lange, notes on photograph LC-USF34-009749-E, LOC.

59. Dorothea Lange, "The Assignment I'll Never Forget: Migrant Mother, *Popular Photography* 46, no. 2 (February 1960)," 42–43.

60. Janis and MacNeil, *Photography within the Humanities,* 41.

61. See Stryker and Wood, *In This Proud Land,* 19; Janis and MacNeil, *Photography within the Humanities,* 38.

62. Street, *Everyone Had Cameras,* 214; Lange, "Assignment I'll Never Forget," 42–43.

63. The best account of Thompson's life is found in Geoffrey Dunn's article "Photographic License: The Story of Florence Owens Thompson—Dorothea Lange's 'Migrant Mother'—and How Her Famous Portrait Haunted Her for a Lifetime," *Metro* (San Jose, CA), January 19–25, 1995, 20–25. However, the various accounts of Thompson's life contain minor discrepancies. In later interviews Florence Thompson recalled that her first emigration from Oklahoma occurred in 1925. In a separate account by her grandson, Roger Sprague, he gives the date as 1921; Roger Sprague, "Migrant Mother," www.weedpatchcamp.com/Migrant%20 Mother/MMother.htm (accessed September 11, 2013); see also Ganzel, *Dust Bowl Descent,* 30.

64. For more on Lange's recollections, see Lange, "Assignment I'll Never Forget," 42–43, 128; Paul S. Taylor, "Migrant Mother: 1936," in *Photography in Print: Writings from 1816 to the Present,* edited by Vicki Goldberg (Albuquerque: University of New Mexico Press, 1981), 355–57. Thompson's view of the encounter may be found in Dunn, "Photographic License," 22; Ham and Sprague, *Migrant Mother,* 368–79.

65. Stryker and Wood, *In This Proud Land,* 19.

66. Dorothea Lange to Roy Stryker, March 13, 1939, Roy Stryker Papers, University of Louisville Photographic Archives, Louisville, Kentucky (hereafter Stryker Papers); see also Paul S. Taylor, "What Shall We Do With Them," April 15, 1938(?) in file Miscellaneous Material on Migratory Farm Labor and Related Subjects, ca. 1940, LOC.

67. These two visits with Taylor occurred in February and August 1936. Lange returned to Oklahoma for the FSA in June 1937 and again in June 1938. While not on the FSA payroll, she did additional work with Taylor that appeared in their collaboration *American Exodus.*

68. Zoe Brown, "Dorothea Lange: Field Notes and Photographs," 90.

69. Lange, notes on photograph LC-USF34-009724-C, LOC.

70. Jim Mayo, *Sallisaw Historical Highlights: 1888–1993* (Sallisaw, OK: Cookson Hills, 1993), 51.

71. Lange and Taylor visited Sallisaw on August 4, 1936, on their return journey from Washington, DC, via U.S. 64 through the American South. Lange and Taylor returned briefly to the region again during the summer of 1938. Arthur Krim, *Route 66: Iconography of the American Highway,* edited by Denis Wood (Santa Fe, NM: Center for American Places, 2005), 86–89.

72. The conditions plaguing the residents of Elk Grove included pneumonia, typhus, syphilis, epilepsy, tuberculosis, pellagra, gonorrhea, and "insanity." McWilliams, *Ill Fares the Land,* 206, 205; quotation on 206.

73. Photographer and publisher Ralph Gibson remembers Lange weeping while discussing this young girl, who was abused and ostracized because she was different. In 1955 this photograph appeared in Steichen's *Family of Man* exhibition, presenting a different angle on childhood than the one most often associated with the sometimes saccharine exhibition. Sandra S. Phillips, "Dorothea Lange: An American Photographer," in Heyman, Phillips, and Szarkowski, *Dorothea Lange: American Photographs,* 25; Heyman et al., *Celebrating the Collection,* 46.

74. In her field notes Lange first mentions the idea of a book in 1938. In one entry she recorded, "A Book on the conditions of US." One year later Taylor and Lange traveled to New York City in hope of enticing a publisher to take on their project. Zoe Brown, "Dorothea Lange: Field Notes and Photographs," 87, 344. Roy Stryker to Marion Post Wolcott, June 22, 1939, Stryker Papers. Quotation from Lange and Taylor, *American Exodus,* 6, 148.

75. Frederick Lewis Allen, *Since Yesterday: The Nineteen-Thirties in America, September 3, 1929–September 3, 1939* (New York: Harper and Row, 1940), 264.

Chapter 2

1. John Steinbeck, *Working Days: The Journals of* The Grapes of Wrath, edited and with an introduction by Robert DeMott (New York: Penguin Books, 1990), 149.

2. See McWilliams, *Ill Fares the Land,* 14–15.

3. Jackson J. Benson, To Tom, Who Lived It: John Steinbeck and the Man from Weedpatch," *Journal of Modern Literature* 5, no. 2 (April 1976): 173.

4. For a deeper investigation of the ways in which the novel

failed to accomplish what Steinbeck had hoped, see Carol Shloss, *In Visible Light: Photography and the American Writer, 1840–1940* (Oxford: Oxford University Press, 1987), 217–22. Years later, however, *In Dubious Battle* influenced photographer Gordon Parks, who would go on to work with Stryker and *Life* magazine. See Michael Lesy, *Long Time Coming: A Photographic Portrait of America, 1935–1943* (New York: W. W. Norton, 2002), 116.

5. See David Wrobel, "Regionalism and Social Protest during John Steinbeck's 'Years of Greatness,' 1936–1939," in Michael Steiner, ed., *Regionalists on the Left: Radical Voices from the American West* (Norman: University of Oklahoma Press, 2013), 333–34.

6. Steinbeck quoted in Benson and Loftis, "John Steinbeck and Farm Labor Unionization," 196–97.

7. Pare Lorentz, "Dorothea Lange: Camera with a Purpose," *U.S. Camera* 1 (1941): 94.

8. Jackson J. Benson, "An Afterword and an Introduction," *Journal of Modern Literature* 5, no. 2 (April 1976): 207.

9. Jackson J. Benson and Anne Loftis, "John Steinbeck and Farm Labor Unionization: The Background of 'In Dubious Battle,'" *American Literature* 25, no. 2 (May 1980): 196.

10. Ibid.

11. Wilbur L. Schramm, "Careers at Crossroads," in John Ditsky, ed., *Critical Essays on Steinbeck's* Grapes of Wrath (Boston: G. K. Hall, 1989), 42.

12. Benson, "To Tom," 181.

13. For more on the FSA Region IX office see Anne Loftis, *Witness to the Struggle: Imaging the 1930s California Labor Movement* (Reno: University of Nevada Press, 1998), 145–46.

14. Jackson J. Benson, "Background to the Composition of *The Grapes of Wrath,*" in *Critical Essays on Steinbeck's* The Grapes of Wrath, edited by John Ditsky (Boston: G. K. Hall, 1989), 54. Regional directors were crucial for the success of the RA and, after September 1937, of the FSA, which inherited many of the RA's programs along with Roy Stryker's Historical Section. By 1939 there were around three thousand regional offices across the United States employing 94 percent of the total FSA workforce. Baldwin, *Poverty and Politics,* 103, 239, 248–55; Stuart Kidd, *Farm Security Administration Photography, the Rural South, and the Dynamics of Image-Making,* Studies in American History No. 52 (Lewiston, UK: Edwin Mellen Press, 2004), 5.

15. Shillinglaw, *On Reading* The Grapes of Wrath, 60–61.

16. Jackson J. Benson, *Looking for Steinbeck's Ghost* (Norman: University of Oklahoma Press, 1988), 79–81; Wartzman, *Obscene in the Extreme,* 78–79; Loftis, *Witness to the Struggle,* 145. When Garst became regional director of the Food Stamp Plan at the end of 1939, Lawrence Hewes, Jr., replaced him. Helen Horn Hosmer later became the director of the Simon J. Lubin Society, an organization dedicated to helping poor rural migrants. See Helen Hosmer, *A Radical Critic of California Agribusiness in the 1930s* (Santa Cruz: University of California, Santa Cruz, University Library Digital Collection, 1992), 42, 57.

17. Before working for the FSA, Jonathan Garst received a Ph.D. from the University of Edinburgh and taught geography at the University of California. He also farmed in Scotland and in Manitoba, as well as working in California's garden-seed industry.

See Jonathan Garst, *No Need for Hunger* (New York: Random House, 1963), 183.

18. Wilma Dykeman and James Stokely, *Seeds of Southern Change: The Life of Will Alexander* (Chicago: University of Chicago Press, 1962), 228–31.

19. John Steinbeck, *The Harvest Gypsies: On the Road to the Grapes of Wrath,* introduction by Charles Wollenberg (Berkeley: Heyday Books, 1988), 58.

20. Lange worked closely with Garst, and he is repeatedly mentioned in her field notes. Working with regional offices presented a challenge for Stryker and the Historical Section. Soule was apparently leery of the RA/FSA photographers making "arty pictures"—a criticism that offended Stryker. For her part Lange had reservations about the abilities of "news-paper trained men." Stu Cohen, *The Like of Us: America in the Eyes of the Farm Security Administration,* edited and with a foreword by Peter Bacon Hales (Boston: David R. Godine, 2009), 20; Meltzer, *Dorothea Lange: Photographer's Life,* 180; Zoe Brown, "Dorothea Lange: Field Notes and Photographs," 145, 255. See also McCamy, *Government Publicity,* 82–83.

21. Lorentz, "Dorothea Lange: Camera with a Purpose," 94.

22. Benson, *Looking for Steinbeck's Ghost,* 81; Benson, *True Adventures of John Steinbeck,* 332. For more on Steinbeck's relationship with Thomsen, see Alice Barnard Thomsen, "Erich H. Thomsen and John Steinbeck" *Steinbeck Newsletter* (Summer 1990), 1–3; Loftis, *Witness to the Struggle,* 145–46.

23. Lowry Nelson, *In the Direction of His Dreams: Memoirs* (New York: Philosophical Library, 1985), 265–67; Cara A. Finnegan, "Documentary as Art in 'U.S. Camera,'" *Rhetoric Society Quarterly* 31, no. 2 (Spring 2001): 37; Goggans, *California on the Breadlines,* 145–46; Gordon, *Dorothea Lange: Life beyond Limits,* 170.

24. Spirn, *Daring to Look,* 18.

25. This number does not include the various mobile camps that were also built and maintained by the FSA. See Goggans, *California on the Breadlines,* 470 n. 50.

26. For more on Tom Collins see Benson, *Looking for Steinbeck's Ghost,* 79–94.

27. On the qualifications of FSA camp managers see Walter J. Stein, "A New Deal Experiment with Guided Democracy: The FSA Migrant Camps in California," *Historical Papers* 5, no. 1 (1970): 133–34. See also Kelly R. O'Reilly, "'Oklatopia': The Cultural Mission of California's Migratory Labor Camps" (senior thesis, Columbia University, New York, 2012), 14–16.

28. Benson, *Looking for Steinbeck's Ghost,* 93.

29. Quoted in Benson, *True Adventures of John Steinbeck,* 339. Collins was clearly the model for the camp manager Ed Rawley in *The Grapes of Wrath.* In describing Rawley Steinbeck wrote he was a "little man dressed all in white . . . with a thin brown, lined, face with merry eyes . . . lean as a picket [in] white clean clothes [frayed] at the seams." John Steinbeck, *The Grapes of Wrath and Other Writings, 1936–1941,* edited by Robert DeMott (New York: Library of America, 1996), 533. (All quotations are from this edition.)

30. Sanora Babb, a friend and assistant to Collins, described him as "a sincere, self-sacrificing hard working friend of these people [the migrants], and many of them, never having found anyone else willing to help them since they came to California, believe him to be their only friend. They are suspicious of others, but they trust him to the utmost. He does not attempt to be a 'power' among them; he sincerely tries to help them to help themselves, and they know this." In her novel *Whose Names Are Unknown* Babb clearly based "Mr. Woody," manager of the FSA camp in the Imperial Valley, on Collins. Mr. Woody was small, thin, and deeply tanned. Sanora Babb, "Migratory Farm Workers (1938)," in Douglas Wixson, ed., *On the Dirty Plate Trail: Remembering the Dust Bowl Refugee Camps* (Austin: University of Texas Press, 2007), 102, 129, 144; Loftis, *Witness to the Struggle,* 147; Sanora Babb, *Whose Names Are Unknown* (Norman: University of Oklahoma Press, 2004), 136, 140.

31. Martha Heasley Cox, "Fact into Fiction in *The Grapes of Wrath:* The Weedpatch and Arvin Camps," in *John Steinbeck: East and West: Proceedings of the First International Steinbeck Congress,* edited by Tetsumaro Hayashi (Millwood, NY: Kraus, 1980), 17.

32. Charles Wollenberg, introduction to Steinbeck, *Harvest Gypsies,* vii, 77.

33. Thomas A. Collins [Windsor Drake], "Bringing in the Sheaves," introduction by John Steinbeck, *Journal of Modern Literature* 5, no. 2 (April 1976): 213.

34. Benson, *Looking for Steinbeck's Ghost,* 81; St. Pierre, *Steinbeck: California Years,* 77.

35. The "Big Book" contained similar information as the camp and manager reports Collins issued and of which Steinbeck had copies. See Robert DeMott, "This Book Is My Life," in *Steinbeck's Typewriter: Essays on His Art* (Troy, NY: Whitston, 1996), 161. In 1938 W. W. Norton pursued publishing Collins's book but this project never came to fruition. See DeMott, introduction to Steinbeck, *Working Days,* xxviii–xxix.

36. Benson, "To Tom," 179–80; quotation from St. Pierre, *Steinbeck: California Years,* 77.

37. It unknown whether this was Collins's Big Book or another notebook in which Steinbeck was gathering information. Phil Tobin, "Meeting Steinbeck," *The Story,* Radio Program 943, aired October 6, 2010.

38. Benson, "Background to the Composition of *The Grapes of Wrath,*" 51–56; See also Cox, "Fact into Fiction," 12–21; Wartzman, *Obscene in the Extreme,* 82.

39. Benson, "To Tom," 181.

40. John Steinbeck, "Dubious Battle in California," *The Nation,* September 12, 1936, 303.

41. Samantha Baskind, "The 'True' Story: *Life* Magazine, Horace Bristol, and John Steinbeck's *The Grapes of Wrath,*" *Steinbeck Studies* 15, no. 2 (Winter 2004): 48.

42. See Susan Shillinglaw, *Carol and John Steinbeck: Portrait of a Marriage* (Reno: University of Nevada Press, 2013), 183. Many but not all of the published images match up with images in the FSA collection, including Lange's photograph of a Texas tenant farmer in Marysville (LC-USF34-009066-E), Oklahoma Dust Bowl refugees in San Fernando (LC-USF34-002613-C; see figure 9), and the migrant pea workers' camp in Nipomo (LC-USF34-001817-C).

43. Steinbeck, *Harvest Gypsies,* 19, 46–48.

44. Ibid., 46, 39.

45. M. Steiner, *Regionalists on the Left*, 278; Shillinglaw, *On Reading* The Grapes of Wrath, 73–74.

46. See Lorentz, "Dorothea Lange: Camera with a Purpose," 94.

47. Meltzer, *Dorothea Lange: Photographer's Life*, 155.

48. Benson, *True Adventures of John Steinbeck*, 332, 380; Lorentz, "Dorothea Lange: Camera with a Purpose," 94.

49. According to Zoe Brown, who knew and worked with Lange late in her life, Steinbeck examined FSA photographs at the regional office. See Brown, "Dorothea Lange: Field Notes and Photographs," 92.

50. See "U.S. Dust Bowl," *Life* 2, no. 25 (June 21, 1937): 62–65. For more on the connections between Stryker's unit and the popular press, consult Cara A. Finnegan, *Picturing Poverty: Print Culture and FSA Photography* (Washington, DC: Smithsonian Institution Press, 2003).

51. See William Stott, *Documentary Expression and Thirties America* (New York: Oxford University Press, 1973), 59; Heyman et al., *Celebrating the Collection*, 77.

52. *Their Blood Is Strong* was well received and went through four printings. One of the readers inspired by the pamphlet was Charles L. Todd, a Columbia University graduate student. After reading it he decided to go to California to see the situation for himself. Later, at age twenty-seven he became assistant manager of the Tulare camp in Visalia. McWilliams, *Factories in the Field*, 281; Meltzer, *Dorothea Lange: Photographer's Life*, 182; Charles L. Todd, interview with Margaret and Gerald Parsons (1985), *Todd and Sonkin, Voices from the Dust Bowl*, LOC.

53. The aims of the John Steinbeck Committee were to raise public consciousness of the migrants' plight; protect their civil rights; support legislation that would benefit agricultural workers; work to assimilate workers into their committees; and organize co-ops among the migrants. Steinbeck lent his name to the committee in hopes of garnering support and publicity as well as raising money and collecting food and clothing for the displaced. See James R. Swensen, "Focusing on the Migrant: The Contextualization of Dorothea Lange's Photographs of the John Steinbeck Committee, 1938," in *Ambivalent American: The Political Companion to John Steinbeck*, edited by Simon Stow and Cyrus Ernesto Zirakzadeh (Lexington: University Press of Kentucky, 2013).

54. Cox, "Fact into Fiction," 14, italics added.

55. Wartzman, *Obscene in the Extreme*, 90.

56. Hurley (*Portrait of a Decade*, 140) and Lesy (*Long Time Coming*, 318) place Steinbeck's visit in 1938, whereas Benson (*True Adventures of John Steinbeck*, 359), dates it in 1937. It is possible that Lesy and Hurley might be conflating another trip Steinbeck made to Washington in April 1939.

57. See Steinbeck, *Harvest Gypsies*, 59.

58. Baldwin, *Poverty and Politics*, 260.

59. Rexford Tugwell et al., "What Should America Do for the Joads?" *Town Meeting: Bulletin of America's Town Meeting of the Air*, March 11, 1940, 3–30. Audio file available online at Internet Archive: https://archive.org/details/ATMOTA12.

60. The final cost for Lorentz's film was $19,260 and it premiered in New York City on May 10, 1936. See Robert L. Snyder, *Pare Lorentz and the Documentary Film* (Norman: University of Oklahoma Press, 1968), 30–31, 37–40. For more see Ralph Steiner, *Ralph Steiner: A Point of View* (Middletown, CT: Wesleyan University Press, 1978), xi, 13–14; William Alexander, "Paul Strand as Filmmaker, 1933–1942," in *Paul Strand: Essays on His Life and* Work, edited by Maren Stange (New York: Aperture Foundation, 1990), 153–54.

61. Snyder, *Pare Lorentz and the Documentary Film*, 28, 32; Krim, *Route 66*, 84; Meltzer, *Dorothea Lange: Photographer's Life*, 104–105.

62. On Lorentz's influence on Steinbeck and the FSA, see Benson, *True Adventures of John Steinbeck*, 399–400; James Curtis, *Mind's Eye, Mind's Truth: FSA Photography Reconsidered* (Philadelphia: Temple University Press, 1989), 76–78.

63. Studs Terkel, *Hard Times: An Oral History of the Great Depression* (New York: Pantheon Books, 1970), 259.

64. Benson, "To Tom," 183; Baskind, "'True' Story," 48.

65. John Tagg, *The Disciplinary Frame: Photographic Truths and the Capture of Meaning* (Minneapolis: University of Minnesota Press, 2009), 71, 87.

66. In an oral history interview with Richard Doud, C. B. (Calvin Benham) Baldwin recalled, "Steinbeck grew a long beard and wore the same clothes that other migrants wore and he actually worked in the fields." "That comes out in the realism of the book. Really a great book, a great movie, too." See also Patricia Sullivan, *Days of Hope: Race and Democracy in the New Deal Era* (Chapel Hill: University of North Carolina Press, 1996), 126.

67. Quoted in Benson, *True Adventures of John Steinbeck*, 359.

68. Terkel, *Hard Times*, 259.

69. See Benson, *True Adventures of John Steinbeck*, 361–63.

70. Benson, "To Tom," 184.

71. Steinbeck's visit coincided with the RA's demise and the Historical Section's transfer to the FSA. Hurley, *Portrait of a Decade*, 140.

72. See Street, *Everyone Had Cameras*, 260.

73. The Associated Farmers was formed in 1934 with the blessing of the California Farm Bureau Federation and given the mandate of combating unionization. Roy Stryker to Dorothea Lange, February 2, 1939, Stryker Papers; Steinbeck, *Harvest Gypsies*, 33–34. For more on Associated Farmers see Auerbach, *Labor and Liberty*, 186–87; Gregory, *American Exodus*, 89; Steinbeck, *Grapes of Wrath and Other Writings*, 532–33.

74. Stryker and Wood, *In This Proud Land*, 14.

75. This assertion is based on the impressions of Phyllis S. Wilson, Stryker's daughter. D. G. Kehl, "Steinbeck's 'String of Pictures,' in *The Grapes of Wrath*," *Image* 17, no. 1 (March 1974): 2.

76. Curtis, *Mind's Eye*, 10. See Hartley Howe, "You Have Seen Their Pictures," *Survey Graphic* 29, no. 4 (April 1940): 237; Roy E. Stryker and Paul H. Johnstone, "Documentary Photographs," in *The Cultural Approach to History*, edited by Caroline F. Ware (New York: Columbia University Press, 1940), 326.

77. Archibald MacLeish, *Land of the Free* (New York: Harcourt, Brace, 1938), 89.

78. Historian James Guimond cites several works describing contemporary conditions in the United States, including the FSA photographs, Steinbeck's *Grapes of Wrath*, English writer A. Fenner Brockway's account of his travels in the United States in 1933, journalist Edmund Wilson's articles in the *New Republic*, and

writings of Lorena Hickok. Guimond, *American Photography and the American Dream* (Chapel Hill and London: University of North Carolina Press, 1991), 103–104.

79. Maren Stange, "The Record Itself: Farm Security Administration Photography and the Transformation of Rural Life," in Pete Daniel et al., eds., *Official Images: New Deal Photography* (Washington, DC: Smithsonian Institution Press, 1987), 1.

80. Goldberg, *Power of Photography,* 141.

81. Arthur Krim, "Right near Sallisaw," *Steinbeck Newsletter* 12, no. 1 (Spring 1999): 2.

82. Hurley, *Portrait of a Decade,* 140.

83. Kehl, "Steinbeck's 'String of Pictures,'" 1–8.

84. Steinbeck, *Grapes of Wrath and Other Writings,* 461, 515; Kehl, "Steinbeck's 'String of Pictures,'" 4. In 1939 the Cleveland Museum of Art mounted an exhibition of nearly eighty FSA images. During the negotiations they indicated their interest in procuring images with "art values," not the grittier pictures such as "Legionnaires and the rear ends of cops." This suggests that Steinbeck was not the only one to notice Shahn's image, and also that he was clearly not afraid of pushing prevailing standards of decency. See John Raeburn, *A Staggering Revolution: A Cultural History of Thirties Photography* (Urbana and Chicago: University of Illinois Press, 2006), 186.

85. Kehl, "Steinbeck's 'String of Pictures,'" 8; Hank O'Neal, *A Vision Shared: A Classic Portrait of America and Its People, 1935–1943* (New York: St. Martin's Press, 1976), 24, 26.

86. Kehl believed that Steinbeck based his writing on two sources: MacLeish's *Land of the Free* and Taylor and Lange's *American Exodus.* Carol Shloss rightly points out that *American Exodus* was published after the release of the novel. She also questioned whether Steinbeck was influenced by *Land of the Free,* which was published in 1938. Shloss, *In Visible Light,* 212. Today the images of the FSA/OWI archive are estimated at around 270,000. In 1940 there were 40,000 negatives; by 1942, the estimate was more than 80,000. Steinbeck could not possibly have viewed an archive of this size in its entirety. Therefore, Kehl's assertion that MacLeish's *Land of the Free* was a valuable visual resource for Steinbeck is likely correct. Kehl, "Steinbeck's 'String of Pictures,'" 2.

87. Steinbeck owned James Agee and Walker Evans's 1941 investigation *Let Us Now Praise Famous Men.* Furthermore, he owned, and praised, all the Federal Writer's Project state guides, which were replete with FSA imagery. Steinbeck's first wife, Carol, worked on the state guide for California. See Robert J. DeMott, *Steinbeck's Reading: A Catalogue of Books Owned and Borrowed* (New York: Garland, 1984); John Steinbeck, *Travels with Charley: In Search of America* (New York: Viking Press, 1963), 120–22; Shillinglaw, *On Reading* The Grapes of Wrath, 77. See also Jerrold Hirsch, *Portrait of America: A Cultural History of the Federal Writer's Project* (Chapel Hill: University of North Carolina Press, 2003).

88. George Stevens, "Steinbeck's Uncovered Wagon," *Saturday Review* 19 (April 15, 1939); and Peter Monro Jack, "John Steinbeck's New Novel Brims with Anger and Pity," *New York Times Book Review* 88 (April 16, 1939); both reprinted in Joseph R. McElrath, Jr., Jesse S. Crisler, and Susan Shillinglaw, eds., *John Steinbeck: The Contemporary Reviews* (Cambridge: Cambridge

University Press, 1996), 158, 160. Later in his life MacLeish claimed Steinbeck "obviously" took impressions from *Land of the Free.* Kehl, "Steinbeck's 'String of Pictures,'" 2.

89. Lorentz, "Dorothea Lange: Camera with a Purpose," 97.

90. Edwin Rosskam, "Not Intended for Framing the FSA Archive," *Afterimage* 8, no. 8 (March 1981): 10.

91. For an excellent example of Lange's images becoming the visual voice of the Depression in California, examine the photographs in Gregory's *American Exodus.* William H. Goetzmann and William N. Goetzmann, *The West of the Imagination* (Norman: University of Oklahoma Press, 2009), 446, also suggest that Lange's work is the visual basis of Steinbeck's novel. Among the scholars who assert that Steinbeck was influenced by Lange but do not provide supporting evidence are William Stott, "Introduction to a Never-Published Book of Dorothea Lange's Best Photographs of Depression America," *Exposure* 22, no. 3 (Fall 1984): 25; Robert J. Doherty, "USA/FSA, Farm Security Administration Photographs of the Depression," *Camera,* October 1962, 11; and Jhan Robbins and June Robbins, "The Man Behind the Man Behind the Lens, Roy Stryker," *Minicam Photography* 11 (November 1947): 52–61, 146–47. See also Meltzer, *Dorothea Lange: Photographer's Life,* 203; St. Pierre, *Steinbeck: California Years,* 104.

92. MacLeish acknowledged that Dorothea Lange's photography "started the poem working in my head" and constituted one of his primary sources (accounting for thirty-three of the eighty-eight illustrations in *Land of the Free*). Meltzer, *Dorothea Lange: Photographer's Life,* 171. See also Penelope Dixon, *Photographs of the Farm Security Administration: An Annotated Bibliography, 1930–1950* (New York: Garland, 1983), 194–95.

93. Street, *Everyone Had Cameras,* 298.

94. Sally Stein, "On Location: The Placement (and Replacement) of California in 1930s Photography," in *Reading California: Art, Image, and Identity, 1900–2000,* edited by Stephanie Barron, Sheri Bernstein, and Ilene Susan Fort (Berkeley: University of California Press, 2000), 192. Stein writes that Lange's imagery was the impetus for Steinbeck pursuing the "harvest gypsies" stories for the San Francisco *News.*

95. Shloss, *In Visible Light,* 213–14, 211.

96. See Loftis, *Witness to the Struggle,* 157.

97. See Lorentz, "Dorothea Lange: Camera with a Purpose," 96.

98. Steinbeck, *Grapes of Wrath and Other Writings,* 370. See also Kehl, "Steinbeck's 'String of Pictures,'" 4; Krim, *Route 66,* 99. Paul S. Taylor used the same motif in 1936 in describing migrants squatting on roadsides, river bottoms, and garbage dumps. See Taylor, "From the Ground Up," *Survey Graphic,* September 1936, 526.

99. Kehl commented that a deeper investigation could link many of the statements in Steinbeck's novel to those recorded by Lange and other FSA photographers. Kehl, "Steinbeck's 'String of Pictures,'" 10 n. 11.

100. Shillinglaw, *On Reading* The Grapes of Wrath, 15–16.

101. The nadir of the infamous dust storms was "Black Sunday," April 14, 1935. R. Douglas Hurt, *The Dust Bowl: An Agricultural and Social History* (Chicago: Nelson-Hall, 1981), 30. See also Michael Parfit, "The Dust Bowl," *Smithsonian,* June 1989: 44–57; and Babb, *Whose Names Are Unknown,* 90–95.

102. Hurt, *Dust Bowl*, 54, 95–97.

103. Brad D. Lookingbill, *Dust Bowl USA: Depression America and the Ecological Imagination, 1929–1941* (Athens: Ohio University Press, 2001), 26.

104. Curtis, *Mind's Eye*, 77–78; quotations from Lookingbill, *Dust Bowl USA*, 53; see also Timothy Egan, *The Worst Hard Time: The Untold Story of Those Who Survived the Great American Dust Bowl* (Boston: Houghton Mifflin, 2006), 136–37, 254.

105. Alice Lent Covert, *Return to Dust* (New York: H. C. Kinsey, 1939), v. See also Babb, *Whose Names Are Unknown*, 79–80.

106. Grey, *New Deal Medicine*, 25.

107. O'Neal, *Vision Shared*, 21–22.

108. When Steinbeck introduces the family car in chapter 10 of *Grapes of Wrath*, he carefully notes the continual buildup of sand on the hood and roof and in back. The old Hudson Super Six's lights, he writes, were covered with dust, dark and fine like "red flour" (310).

109. These words were spoken by Muley, the Joads' neighbor, when informing Tom of his family's predicament. Steinbeck, *Grapes of Wrath and Other Writings*, 258.

110. Lewis Gannett, *John Steinbeck: Personal and Bibliographical Notes* (Brooklyn, NY: Haskell House, 1977), 14.

111. Benson, *Looking for Steinbeck's Ghost*, 79. See Warren French, *A Companion to* The Grapes of Wrath (New York: Viking Press, 1963), 52. Krim insightfully calls this trip "a legend wrapped in its own myth." *Route 66*, 97.

112. Benson, *Looking for Steinbeck's Ghost*, 79.

113. Benson, *True Adventures of John Steinbeck*, 362–63; Benson, "Background to the Composition of *The Grapes of Wrath*," 56, 65.

114. Benson speculates that Steinbeck's ostensible "Oklahoma trip" was a jaunt to the Central Valley or to Needles and Blythe on the California border with Tom Collins in the fall of 1937. Benson, *True Adventures of John Steinbeck*, 362; and *Looking for Steinbeck's Ghost*, 83.

115. St. Pierre, *Steinbeck: California Years*, 86; see also Krim, *Route 66*, 97–98.

116. Benson, *True Adventures of John Steinbeck*, 360.

117. The text contains few specifics of the Joads' westward course. One exception occurs when Steinbeck describes how the Colorado River follows the road. During his travels leading up to *Grapes of Wrath*'s publication Steinbeck traveled as far as the California border and Needles. Steinbeck, *Grapes of Wrath and Other Writings*, 424–25; and *Working Days*, 45; Krim, *Route 66*, 99.

118. For an example of how Steinbeck assimilated many forms of information, including photography, in the construction of his narrative, see Krim, "Right near Sallisaw," 1–4.

Chapter 3

1. Street questioned the relationship between Bristol and the Taylors based on the simple fact that neither Lange nor Taylor mentioned his involvement. Bristol, however, insisted that he traveled with them and studied the migration issue alongside them. Given that the connection clearly benefited his reputation more than theirs, it behooved him to mention it frequently in his recollections—and he did. Moreover, Lange and Taylor worked with several young photographers—such as Otto Hagel, Hansel Mieth, John Collier, Jr., Rondal Partridge, Christina Page, and Homer Page—and did not commonly mention them in their notes or published works. Horace Bristol, "Documenting *The Grapes of Wrath*," *The Californians* (January–February 1988): 40–47.

2. Patricia Berman, "Horace Bristol's Photojournalism: Art, the Mass Media, and the Contingent Career," in *Stories from Life: The Photography of Horace Bristol*, edited by Horace Bristol (Athens: Georgia Museum of Art, University of Georgia, 1995), 55.

3. Photographers Otto Hagel and his partner-wife, Hansel Mieth, immigrated to the San Francisco area in the 1920s. There they participated in the social unrest and even worked as field laborers for about three years. They began documenting Hoovervilles around 1931, producing a book called *The Great Hunger* and a film on the 1934 cotton strike in the Central Valley. They lived with Taylor and Lange off and on during these years. For more on Hagel and Mieth see Mieth, "The Depression and the Early Days of *Life*," in Ken Light, *Witness in Our Time: Working Lives of Documentary Photographers* (Washington, DC: Smithsonian Institution Press, 2000), 15–23; John Loengard, "Hansel Mieth," in *LIFE Photographers: What They Saw* (Boston: Little, Brown, 1998), 75–81; Street, *Everyone Had Cameras*, 134–43. On Bristol see Loengard, *LIFE Photographers*, 67; and William Eiland, "Tales of Fortune, Time, and Life: Horace Bristol's Odyssey," in Horace Bristol, *Stories from Life: The Photography of Horace Bristol* (Athens: Georgia Museum of Art, University of Georgia, 1995), 19–20; Baskind, "'True' Story," 47.

4. Bristol worked alongside Taylor and Lange at the time they were collecting material for *American Exodus*. Bristol contributed one image to this text, which serves as evidence of their collaboration. David Roberts, "Travels with Steinbeck," *American Photographer* 22 (March 1989), 45; Eiland, "Tales of Fortune, Time, and Life," 21; Lange and Taylor, *American Exodus*, 6, 138.

5. Bristol quoted in Baskind, "'True' Story," 47.

6. Eiland, "Tales of Fortune, Time, and Life," 18; quotation from Berman, "Horace Bristol's Photojournalism," 54.

7. See St. Pierre, *Steinbeck: California Years*, 74.

8. Loengard, *LIFE Photographers*, 68.

9. Street, *Everyone Had Cameras*, 276.

10. Stott, *Documentary Expression and Thirties America*, 216.

11. Quoted in Lesy, *Long Time Coming*, 318.

12. Stott, *Documentary Expression and Thirties America*, ix. Examples of other photo-books include H. C. Nixon's *Forty Acres and Steel Mules*, Richard Wright's *12 Million Black Voices* (1941), and Sherwood Anderson's *Home Town* (1941).

13. Bristol's original proposal was rejected, as the editors noted, because "we don't want pictures of ugly, old people. We make 25% of our street sales showing pictures of Hollywood starlets with as little on as the law allows." See Bristol, *Stories from Life*, 21, 56. Roberts, "Travels with Steinbeck," 46; Berman, "Horace Bristol's Photojournalism," 56.

14. John Steinbeck to Elizabeth Otis, March 17, 1938, in Steinbeck, *Steinbeck: A Life in Letters*, edited by Elaine Steinbeck and Robert Wallsten (New York: Viking Press, 1975), 161; Bristol, *Stories from Life*, 40.

15. Bristol, *Stories from Life*, 47.

16. Street, *Everyone Had Cameras*, 276.

17. Roberts, "Travels with Steinbeck," 45; quotation from Ken Conner and Debra Heimerclinger, *Horace Bristol: An American View* (San Francisco: Chronicle Books, 1996), 56.

18. Loengard, *LIFE Photographers*, 68.

19. See Gregory, *American Exodus*, 64–65.

20. Benson, *True Adventures of John Steinbeck*, 368.

21. Roberts, "Travels with Steinbeck," 50.

22. Quotation from Bristol, *Stories from Life*, 47; see also Benson, "Afterword and an Introduction," 204; Benson, *True Adventures of John Steinbeck*, 368–71.

23. Collins, "Bringing in the Sheaves," 211–14, 225.

24. DeMott, "This Book Is My Life," 148.

25. Conner and Heimerclinger, *Horace Bristol*, 56.

26. DeMott, introduction to Steinbeck, *Working Days*, xiii.

27. John Steinbeck to Elizabeth Otis, February 14, 1938, quoted in Benson, *True Adventures of John Steinbeck*, 368.

28. Shillinglaw, *On Reading* The Grapes of Wrath, 60.

29. Benson, *True Adventures of John Steinbeck*, 368.

30. In a letter to her sister Babb reported, "When Steinbeck first came, he had to stop seeing [the migrants] before the day was out. Tom Collins said he said: 'By god! I can't stand it anymore! I'm going away and blow the lid off this place." She continued, "I think he got the man out for the pictures." Wixson, *On the Dirty Plate Trail*, 130.

31. Babb included the incident in her novel *Whose Names Are Unknown*, 213. Based on the wealth of details she provided, I infer that she must have recorded this experience in the notes she kept while working in the camps in the San Joaquin Valley.

32. Steinbeck, *Steinbeck: Life in Letters*, 161–62.

33. John Steinbeck to Elizabeth Otis, March 23, 1938, John Steinbeck Collection, Stanford University Special Collections and University Archives, Palo Alto, CA.

34. Shillinglaw, *On Reading* The Grapes of Wrath, 76.

35. Steinbeck to Otis, March 23, 1938, Steinbeck Collection.

36. Roberts, "Travels with Steinbeck," 45.

37. Loengard, *LIFE Photographers*, 68.

38. Bristol quoted in Baskind, "'True' Story," 49. Although he acknowledged Steinbeck's success, Bristol held an understandable animosity toward the author. In a 1990 interview he asserted, "Steinbeck was a very secretive individual. He was, for lack of another term, a user.... I have to think about my words because it's not too easy. He got rid of Carol by divorce ultimately. He never saw Tom Collins again.... The problem was Horace Bristol. What does [Steinbeck] do about him?" In the same interview he also asserted, "Steinbeck didn't really want them [the photographs] to be competitive with his book.... I don't think he wanted them." See Baskind, "'True' Story," 66, 69.

39. Street, *Everyone Had Cameras*, 277–78.

40. In addition to paying for travel expenses, *Life* also gave the duo money to distribute food and needed supplies to the hungry migrants. This was Steinbeck's justification for working for the magazine. From his archives it is clear that he and Bristol did submit something to *Life*, but as yet no evidence of this article has surfaced.

41. John Steinbeck, *America and Americans* (New York: Viking Press, 1966), 7. Over the past 150 years there have been many examples of authors who were inspired by photography. One of the more important was Stephen Crane, who employed Civil War photographs as aids in writing *The Red Badge of Courage*. Alan Trachtenberg, *Reading American Photographs: Images as History: Mathew Brady to Walker Evans* (New York: Hill and Wang, 1989), 78.

During the furor over *The Grapes of Wrath* Steinbeck became even leerier of photography and did not like to have his photograph taken. One reporter for *Collier's* noted, "No photos. He doesn't care for photography, doesn't like to see his picture in the morning paper and doesn't want people calling on him at his ranch, which is surrounded by wire fence, not electrified." Steinbeck was not ignorant of photography and its potential, however. In *Travels with Charley* he admitted, "I would rather see a good Brady photograph than Mount Rushmore." It seems that he did like the casual portrait that west coast photographer and former member of the f64 group Sonya Noskowiak took of him in her San Francisco studio around 1935. A cropped version of this image appeared in *Life* in 1939 ("The Grapes of Wrath," *Life*, June 5, 1939). See Frank Condon, "The Grapes of Raps," *Collier's*, January 27, 1940, 64; Steinbeck, *Travels with Charley*, 145.

42. Vicki Goldberg, *Margaret Bourke-White: A Biography* (New York: Harper and Row, 1986), 194; see Erskine Caldwell and Margaret Bourke-White, *You Have Seen Their Faces*, foreword by Alan Trachtenberg (1939; reprint, Athens: University of Georgia Press, 1995), v.

43. Critics quoted in Raeburn, *Staggering Revolution*, 174–76. MacLeish rather expected the critics' response. In the book he wrote, "The original purpose had been to write some sort of text to which these photographs might serve as commentary. But so great was the power and stubborn inward livingness of these vivid American documents that the result was a reversal of that plan." MacLeish, *Land of the Free*, 89.

44. James Agee and Walker Evans, *Let Us Now Praise Famous Men: The American Classic, in Words and Photographs, of Three Tenant Families in the Deep South* (1941; reprint, New York: Mariner Books, 2001), 11.

45. See Shloss, *In Visible Light*, 191–97. Although not a critical or commercial success when it was released in 1941, Agee and Evans's *Let Us Now Praise Famous Men* has received considerable attention since its reprinting in 1962. Reflecting what Miles Orvell calls a "reflexive ethnography," Agee was extremely critical, if not pessimistic, about whether it was possible to capture accurate, unbiased information in his writing or even in a photograph. This questioning of the basic tenets of the documentary project was something other writers in that tradition failed to do. Orvell, "Walker Evans and James Agee: The Legacy," *History of Photography* 17 (June 1993): 170. For more see Alex Hughes and Andrea Noble, *Phototextualities: Intersections of Photography and Narrative* (Albuquerque: University of New Mexico Press, 2003), 14. Stuart Burrows has questioned Agee's proclamations of the camera's superiority, arguing that Agee's extensive use of text proves that he clearly believed in the power and utility of the written word. See Stuart Burrows, "The Power of What Is Not There: James Agee's *Let Us Now Praise Famous Men*," in *On Writing with Photography*, edited by Karen Beckman and Liliane Weissberg (Minneapolis: University of Minnesota Press, 2013), 118.

46. Agee and Evans, *Let Us Now Praise Famous Men,* 10.

47. See Baskind, "'True' Story," 69; Orvell, *Real Thing,* 127; Trachtenberg, *Reading American Photographs,* 78.

48. François Brunet, *Photography and Literature* (London: Reaktion Books, 2009), 5–8. Also Finnegan, *Picturing Poverty,* 168–69. I would like to thank Dr. Susan Shillinglaw for her assistance on this topic.

49. The author, J. L. Brown, concluded his article: "We may not be as far as we think from the Stone Age of human intelligence." Brown, "Picture Magazines and Morons," *American Mercury* 45, no. 180 (December 1938): 408; Erika Doss, "Looking at *Life*: Rethinking America's Favorite Magazine, 1936–1972," in *Looking at* Life *Magazine* (Washington, DC: Smithsonian Institution Press, 2001), 14. Certain elitist attitudes within the literary world could also have added to the disdain for photography. Like a comic book, photography was easily readable and widely accessible. As Susan Sontag claimed, "Photography is designed potentially for all. All can read it." This is exactly what made it so threatening. Sontag, *Regarding the Pain of Others* (New York: Picador, 2003), 20.

50. Loengard, *LIFE Photographers,* 68–69.

51. DeMott, introduction to Steinbeck, *Working Days,* xxx. Benson (*True Adventures of John Steinbeck,* 347, 505) noted that Steinbeck detested collaboration even though he was involved in several collaborative efforts throughout his life. He was not above working with photographers when it suited his ends. In the buildup to World War II Steinbeck collaborated with photographer John Swope on an investigation of the Air Force and its preparations. Steinbeck and Swope *Bombs Away: The Story of a Bomber Team* (New York: Viking Press, 1942). Several years later he teamed up with photographer Robert Capa on what would become his *Russian Journal.* Buoyed by his daring successes in the Spanish Civil War and World War II, Capa, unlike Bristol, was a well-known and important figure whose images had the potential of matching the power of Steinbeck's diaristic prose. When Soviet consular officials in New York City suggested that he use a Soviet photographer Steinbeck responded, "But you have no Capas. If the thing is to be done at all, it must be done as a whole, as a collaboration" (Roberts, "Travels with Steinbeck," 50). In appraising their effort, however, it is apparent that Steinbeck's words are still preeminent to Capa's images, which are relegated to illustrating the text. Yet in his 1977 introduction to MacLeish's *Land of the Free,* photo critic A. D. Coleman ranked Steinbeck's work with Swope and Capa among the most noteworthy photo-text collaborations of the era.

52. See Jeff Allred, *American Modernism and Depression Documentary* (New York: Oxford University Press, 2010), 11.

53. Wright Morris, "The Romantic Realist," in *Time Pieces: Photographs, Writing, and Memory* (New York: Aperture Foundation, 1999), 26.

54. Benson, "Background to the Composition of *The Grapes of Wrath,*" 51; Alfred Kazin, *On Native Grounds: An Interpretation of Modern American Prose Literature* (New York: Reynal and Hitchcock, 1942), 396. See also Amy Godine, "Notes Toward a Reappraisal of Depression Literature," *Prospects* 5 (1980): 197–239.

55. Steinbeck, *Working Days,* 25.

56. Joseph Henry Jackson, *Why Steinbeck Wrote* The Grapes of Wrath (New York: Limited Editions Club, 1940), 8–9.

57. See Loftis, *Witness to the Struggle,* 145–46.

58. Shillinglaw, *On Reading* The Grapes of Wrath, 63.

59. Quoted in DeMott, introduction to Steinbeck, *Working Days,* xxxvii.

60. Tom Cameron, "*The Grapes of Wrath* Author Guards Self from Threats at Moody Gulch, *Los Angeles Times,* July 9, 1939, 1–2; reprinted in Thomas Fensch, ed., *Conversations with John Steinbeck* (Jackson: University of Mississippi Press, 1988), 19.

61. DeMott, "This Book Is My Life," 173.

62. DeMott, introduction to Steinbeck, *Working Days,* xlv.

63. For more on the importance of details in the writing of *Grapes of Wrath,* see DeMott, "This Book Is My Life," 172, 176.

64. Shillinglaw, *On Reading* The Grapes of Wrath, 108.

Chapter 4

1. In *Picturing Poverty* (215), Finnegan has pointed out that a "fascinating irony" was at play when Steinbeck used fiction to investigate real conditions.

2. French, *Companion to* The Grapes of Wrath, 106.

3. Joseph Henry Jackson, "John Steinbeck and The Grapes of Wrath," in John Steinbeck, *The Grapes of Wrath,* lithographs by Thomas Hart Benton (New York: Limited Editions Club, 1940), 9.

4. F. Taylor, "California's Grapes of Wrath," 232.

5. Ibid, 43.

6. Tugwell et al., "What Should America Do for the Joads?" 22. Bancroft was the president of Associated Farmers of Contra Costa County.

7. French, *Companion to* The Grapes of Wrath, 106. For a compelling investigation of the novel's banning in Kern County and other reactions to it see Wartzman, *Obscene in the Extreme.*

8. Near the close of the novel, Rose of Sharon, who has had a stillborn child, nurses an elderly man near death from starvation. This scene, in particular, drew the wrath of those who demonized Steinbeck as amoral, and even of those who supported the author and his cause, such as Horace Bristol. Before the book was published his agent, Elizabeth Otis, and his Viking Press editor encouraged him to rewrite this scene. In response he protested, "I cannot change that ending. It is casual—there is no fruity climax, it is not more important than any other part of the book—if there is a symbol, it is a survival symbol not a love symbol, it must be an accident, it must be a stranger, it must be quick. . . . The fact that the Joads don't know him, don't care about him, have no ties to him—that is the emphasis. The giving of the breast has no more sentiment than the giving of a piece of bread." Metaphors of nursing are found throughout Steinbeck's writing on the migrants, including in *Harvest Gypsies,* 50. It is also a theme in many FSA images. See St. Pierre, *Steinbeck: California Years,* 96–97; Curtis, *Mind's Eye,* 55; Berman, "Horace Bristol's Photojournalism," 56. For a different view of Steinbeck's use of vulgarity, see Upton Sinclair, "Sinclair Salutes Steinbeck," *Common Sense* 8, no. 5 (May 1939): 22.

9. Quoted in Gregory, *American Exodus,* 111.

10. W. Richard Fossey, "The End of the Western Dream: *The Grapes of Wrath* and Oklahoma," *Cimarron Review* 22 (1973): 27.

11. McWilliams, *Ill Fares the Land,* 42.

12. The La Follette Civil Liberties Committee, or the Committee on Education and Labor, Subcommittee Investigating

Violations of Free Speech and the Rights of Labor, was chaired by Senators Robert M. La Follette, Jr. (R-Wisconsin) and Elbert D. Thomas (R-Utah). Formed in 1936, its purpose was to investigate infractions of civil liberties during labor disputes. In addition to looking at migratory labor, the committee also investigated other industries, including private police systems and strikebreaking services. At the request of the National Labor Relations Board and propelled by Steinbeck's novel and Carey McWilliams's *Factories in the Fields,* the committee members came to California in 1939 to investigate allegations of wrongdoing within the agricultural industry. In December 1939 and January 1940, twenty-eight days of hearings were held in San Francisco and Los Angeles, with more than four thousand witnesses being called, including Paul S. Taylor and officials from Associated Farmers. As historian Jerold Auerbach noted, the findings of the La Follette Committee gave the tacit approval of the federal government to the work of Steinbeck and McWilliams. Auerbach, *Labor and Liberty: The La Follette Committee and the New Deal* (Indianapolis, IN: Bobbs-Merrill, 1966), 191. Stryker was also aware of the La Follette Committee and was eager to provide assistance. Roy Stryker to Dorothea Lange, September 9, 1939, Stryker Papers.

13. Quoted in McWilliams, *Ill Fares the Land,* 47.

14. Quoted in French, *Companion to* The Grapes of Wrath, 125–26.

15. Linda Gordon has written that the "FSA was at the left edge of the Department of Agriculture, and its photography project was at the left edge of the FSA." Gordon, "Dorothea Lange: The Photographer as Agricultural Sociologist," *Journal of American History* 93, no. 3 (December 2006): 698; see also Gordon, *Dorothea Lange: Life beyond Limits,* 274.

16. Paul S. Taylor, "Adrift on the Land," Public Affairs Pamphlet No. 42 (New York: Public Affairs Committee, 1940), 1.

17. Kidd, *Farm Security Administration Photography,* 211.

18. Not only did *The Grapes of Wrath* do more to publicize the plight of the migrants to the general public, but it also, according to Walter Stein, "performed the task that no amount of legislative oratory could achieve." Stein, *California and the Dust Bowl Migration,* 201.

19. Roy Stryker to Ed Locke, April 25, 1939, Stryker Papers.

20. For more on the career of Doris Lee see *Doris Lee,* Monograph No. 16 (New York: American Artists Group, 1946). Historians seldom mention Lee's first wife. Doris Lee is remembered for her interest in rural America and for creating charming genre scenes of rural life, including murals for the Post Office Department in Washington, DC, executed through the Treasury Department's Section of Fine Art; on the latter see Marling, *Wall-to-Wall America,* 59–61. Further investigation is needed into how Doris Lee influenced Russell and his eye. Russell and Doris divorced in 1939.

21. For more on the Woodstock Art Community that greeted the Lees see Karal Ann Marling, *Woodstock: An American Art Colony, 1902–1977* (Poughkeepsie, NY: Vassar College Art Gallery, 1977).

22. Elizabeth McCausland, "Documentary Photography," *Photo Notes,* January 1939, http://newdeal.feri.org/pn/pn139.htm (accessed September 30, 2013).

23. Russell Lee to Roy Stryker, April 19, 1939, Stryker Papers.

24. Roy Stryker to Fred Soule, May 11, 1939, FSA/OWI Written Records, 1935–46 [microfilm], Print and Photograph Reading Room, LOC (hereafter FSA/OWI Written Records).

25. Russell Lee to Roy Stryker May 11, 1939, Stryker Papers.

26. For more on Stryker's shooting scripts see Lesy, *Long Time Coming,* 226. For an example of Stryker's scripts see Thomas Garver, *Just before the War* (Balboa, CA: Newport Harbor Museum; October House, 1968).

27. O'Neal, *Vision Shared,* 136; Cohen, *The Like of Us,* 169–70.

28. Claire L. Lyons, *Archeology and Photography: Early Views of Ancient Mediterranean Sites* (Los Angeles: J. Paul Getty Museum, 2005), 44.

29. In 1937 Thomas Hart Benton traveled through the American South with an Italian newspaper correspondent who wanted to see if Erskine Caldwell's controversial play *Tobacco Road* was close to reality. Benton did not recount what he found. Benton, *An Artist in America* (Columbia: University of Missouri Press, 1983), 102, 301. See also David P. Peeler, *Hope among Us Yet: Social Criticism and Social Solace in Depression America* (Athens: University of Georgia Press, 1987), 68.

30. Roy Stryker to Russell Lee, May 17, 1939, Stryker Papers.

31. Roy Stryker to Arthur Rothstein, May 19, 1939, Stryker Papers.

32. See Raeburn, *Staggering Revolution,* 146; Edwin and Louise Rosskam, oral history interview, August 3, 1965, Archives of American Art, Smithsonian Institution.

33. For Stryker the illustration of MacLeish's project was a "very important job" and he specifically encouraged his photographers to be on the lookout for "stranded peoples left behind after the empire builders have found new areas for their exploitation." Jefferson Hunter, *Image and Word: The Interaction of Twentieth-Century Photographers and Texts* (Cambridge, MA: Harvard University Press, 1987), 89. As part of this assignment John Vachon remembers Stryker sending him to the countryside to find a picture of "a rough pioneer cabin, a clearing in the wood, with limitless ranges of mountains dissolving into the West," which MacLeish could not find in the files. Miles Orvell, ed., *John Vachon's America: Photographs and Letters from the Depression to World War II* (Berkeley: University of California Press, 2003), 310–11. Stryker subsequently sent MacLeish five hundred images from which to choose. Sherwood Anderson also sent Stryker a long list of "shots" for *Home Town,* his ode to the American small town, but for unknown reasons, Stryker gave Anderson's requests less urgency than other projects. Stryker also assigned his photographers to assist with other projects. Examples include Jack Delano's work with Arthur F. Raper on tenant farming in Greene County, Georgia; Lange's assistance of Lorentz during the filming of *The Plow That Broke the Plain,* Rothstein's assistance of Lorentz on his Pittsburgh project; and Russell Lee's and Edwin Rosskam's work with Richard Wright in Chicago for his *12 Million Black Voices.* See Lesy, *Long Time Coming,* 318–23; Arthur F. Raper, *Tenants of the Almighty* (New York: Macmillan, 1943), ix; Jack Delano, *Photographic Memories* (Washington, DC, and London: Smithsonian Institution Press, 1997), 37–39; Lorentz, "Dorothea Lange: Camera with a Purpose," 94; Arthur Rothstein, oral history

interview, May 25, 1964, Archives of American Art, Smithsonian Institution; Kim Townsend, *Sherwood Anderson* (Boston: Houghton Mifflin, 1987), 314–15.

34. "I Wonder Where We Can Go Now," 93–94ff.

35. Charles Poore, "Books of the Times," *New York Times,* April 14, 1939, 27.

36. Kate O'Brien, book review in the *Spectator,* September 15, 1939, quoted in McElrath, Crisler, and Shillinglaw, *John Steinbeck: Contemporary Reviews,* 179.

37. Edward Steichen, "The F.S.A. Photographers," in Maloney, *U.S. Camera, 1939,* 43, 44. Eventually many grew weary of the term's meaning and promise. By 1941 Lorentz noted that "documentary" had become a "dread word." Lorentz, "Dorothea Lange: Camera with a Purpose," 97.

38. Finnegan, *Picturing Poverty,* xiii. For a comparison of Agee and Steinbeck see Linda Ray Pratt, "Imagining Existence: Form and History in Steinbeck and Agee," *Southern Review* 11 (January 1975): 84–98.

39. John Rogers Puckett, *Five Photo-Textual Documentaries from the Great Depression* (Ann Arbor, MI: UMI Research Press, 1984), 12. Other contemporary critics of the medium, including Robert Taft, also noted this trend. See Taft, *Photography and the American Scene* (Reprint, New York: Dover, 1938, 317. Grisèle Freund believed that the work of Upton Sinclair and Ernest Hemingway also exhibited a "photographic style." Freund, *Photography and Society* (Boston: David R. Godine, 1980), 193.

40. Stott, *Documentary Expression and Thirties America,* 121–22, 3. Lorentz saw his work as related to that of Lange and Steinbeck but was quick to point out that their contributions were made independently of each other. See Arthur Krim, "Steinbeck, Lorentz and Lange in 1941," *Steinbeck Newsletter* 6 (Summer 1993): 9.

41. Caldwell and Bourke-White, *You Have Seen Their Faces,* x. See also Edward K. Thompson, *A Love Affair with* Life *and* Smithsonian (Columbia: University of Missouri Press, 1995), 52–53. FSA photographer Marion Post Wolcott recalled that Bourke-White created a lot of trouble for her in the South: "Many plantation owners, operators and managers who thoroughly disapproved of her book *You Have Seen Their Faces* mistrusted any other girl photographer and had to be convinced I was not Bourke-White and had no intention of making similar photographic documents." O'Neal, *Vision Shared,* 176. Agee and Evans also responded to Bourke-White and Caldwell's work and tactics. Their scorn is palpable in *Let Us Now Praise Famous Men* through their choice of articles describing the successful photographer in her red coat "bribing, cajoling, and sometimes browbeating her way in to photograph Negroes, share-croppers and tenant farmers in their own environments" (pp. 398–401, quotation p. 399).

42. Lange and Taylor, *American Exodus,* 6.

43. Allred, *American Modernism and Depression Documentary,* 10, 14–15.

44. David Wrobel, "Regionalism and Social Protest during John Steinbeck's 'Years of Greatness,' 1936–1939," in M. Steiner, *Regionalists on the Left,* 346. For a good example of ways in which *The Grapes of Wrath* framed the national discussion of interstate migration see "Testimony of Hon. Caroline O'Day, Representative of Congress from the State of New York," in U.S. Congress,

Hearings before the Select Committee to Investigate the Interstate Migration of Destitute Citizens, Seventy-sixth Congress . . . pursuant to H. Res. 63 and H. Res. 491 (Washington, DC: Government Printing Office, 1940–41), 319–22.

45. P. Taylor et al., *Paul Schuster Taylor, California Social Scientist,* 219. See also Meltzer, *Dorothea Lange: Photographer's Life,* 193–94.

46. In his reply Covici suggested that Steinbeck might provide "running comments" for the book if Viking picked it up. Viking turned the book down and, despite Taylor and Lange seeking his assistance, Steinbeck did not support their project. Shillinglaw, *On Reading* The Grapes of Wrath, 74–75.

47. Spirn, *Daring to Look,* 38. To Herald R. Clark Maynard Dixon wrote, "You have no doubt seen Am[erican] Exodus by Dorothea Lange and Paul Taylor—it is the *factual* Grapes of Wrath." Quoted in Philip Hone Clark, comp., *The Heart of Maynard Dixon: Conversations with Herald R. Clark and Other Related Correspondence, 1937–1946* (Provo, UT: Excel Graphics, 2001), 141. See also Nelson, *In the Direction of His Dreams,* 265.

48. Meltzer, *Dorothea Lange: Photographer's Life,* 234; Street, *Everyone Had Cameras,* 312. Street, "The Documentary Eye: How Economist Paul S. Taylor Pioneered the Use of Photography as a Social Documentary," http://alumni.berkeley.edu/news/california-magazine/may-june-2009-go-bare/documentary-eye (accessed March 27, 2012).

49. Rondal Partridge, conversation with the author, June 23, 2010.

50. Quoted in Michael C. Steiner, "Carey McWilliams, California, and the Education of a Radical Regionalist," in Steiner, *Regionalists on the Left,* 367.

51. Kevin Starr, *Endangered Dreams: The Great Depression in California* (New York: Oxford University Press, 1996), 266, 263–64.

52. Ross H. Gast, "Grapes of Wrath," newspaper clipping, *Todd and Sonkin, Voices from the Dust Bowl,* LOC.

53. George Stevens, "Steinbeck's Uncovered Wagon," *Saturday Review,* April 15, 1939, 19, reprinted in McElrath, Crisler, and Shillinglaw, *John Steinbeck: Contemporary Reviews,* 158.

54. Steinbeck's meteoric rise angered many, including Erskine Caldwell. See Harvey L. Klevar, *Erskine Caldwell: A Biography* (Knoxville: University of Tennessee Press, 1993), 218–19.

55. Robert Girvin, "Photography as Social Documentation," *Journalism Quarterly* 24, no. 3 (September 1947): 219. For an interesting if uneven examination of Stryker's "killed" images, see William E. Jones, *"Killed": Rejected Images of the Farm Security Administration* (New York: Andrew Roth, 2010).

56. Rexford Tugwell, oral history interview, January 21, 1965, Archives of American Art, Smithsonian Institution.

57. Roy Stryker to Dorothea Lange, April 11, 1939, Stryker Papers. Stryker's interest in migrants might also have been piqued by his having lunch with John N. Webb, who was in the process of compiling his own investigation of migration. See Roy Stryker to Russell Lee, April 21, 1939, Stryker Papers; John N. Webb and Malcolm Brown, *Migrant Families,* Works Progress Administration, Division of Social Research, Research Monograph 18, 1938 (New York: Da Capo Press, 1971).

58. Quoted in Paul Hendrickson, *Looking for the Light: The Hidden Life and Art of Marion Post Wolcott* (New York: Alfred A. Knopf, 1992), 140. See also Michael Carlebach and Eugene F. Provenzo, Jr., *Farm Security Administration Photographs of Florida* (Gainesville: University Press of Florida, 1993), 5.

59. For more on Lange's work in the Northwest, see Spirn, *Daring to Look*, 143–67ff.

60. Stryker to Lee, quoted in Robert L. Reid, *Picturing Texas: The FSA-OWI Photographers in the Lone Star State, 1935–1943* (Austin: Texas State Historical Association, 1994), 151.

61. See Roy Stryker to Russell Lee, April 7, 1939, and April 21, 1939; Stryker to Ed Locke, February 4, 1939; Lee to Stryker, February 8, 1939; all in Stryker Papers.

62. In March 1939 Stryker encouraged Marion Post Wolcott, then working in Alabama, to "get a couple of good families with complete stories." Stryker to Wolcott, March 16, 1939; see also Stryker to Russell Lee, February 21, 1939, both in Stryker Papers.

63. Rosskam, "Not Intended for Framing," 10.

64. Quotation from Gordon, *Dorothea Lange: Life beyond Limits*, 202; Karin Becker Ohrn, *Dorothea Lange and the Documentary Tradition* (Baton Rouge: Louisiana State University Press, 1980): 54.

65. Peeler, *Hope among Us Yet*, 92.

66. Stationed in Amarillo, Texas, John H. Caulfield was the regional information specialist for Region XII, which encompassed the plains states (parts of Texas, New Mexico, Colorado, Kansas, and Oklahoma). Like Stryker and Lee, he was interested in procuring images of "mechanization, migrants, pickers, etc." Russell Lee to Roy Stryker, February 1(?), 1939; Stryker to Marion Post Wolcott, February 1, 1939; and Lee to Stryker, March 24, 1939; all in Stryker Papers.

67. Jackson, "The Finest Book John Steinbeck Has Written," *New York Herald Tribune*, April 16, 1939, 3. Reprinted in McElrath, Crisler, and Shillinglaw, *John Steinbeck: Contemporary Reviews*, 162.

68. Ganzel, *Dust Bowl Descent*, 30.

69. Sinclair, "Sinclair Salutes Steinbeck," 22–23. It is in this article that Sinclair passes on the proverbial muckraking mantle to Steinbeck, whom he sees as being of the same lineage as himself and Zola.

70. Steinbeck, *Grapes of Wrath and Other Writings*, 219, 301.

71. In 1937 *Life* magazine called Alexandre Hogue "The Artist of the U.S. Dust Bowl." Raised in the Texas Panhandle, Hogue returned there during the Dust Bowl and recorded former grazing land destroyed "first by the fence, then by overplowing, now by drought." All three of these themes became important in his work. "U.S. Dust Bowl: Its Artist Is a Texan Portraying 'Man's Mistakes,'" *Life*, June 21, 1937, 60–61; Martin Staples Schockley, "The Reception of the *Grapes of Wrath* in Oklahoma," *American Literature* 15, no. 4 (January 1944): 353. See also Lea Rosson DeLong, *Nature's Forms/Nature's Forces: The Art of Alexandre Hogue* (Norman: University of Oklahoma Press, 1984), 3, 19–20.

72. Schockley, "Reception of the *Grapes of Wrath*," 353; quotation in George Thomas Miron, *The Truth about John Steinbeck and the Migrants* (Los Angeles: Haynes, 1939), 6.

73. Schockley, "Reception of the *Grapes of Wrath*," 353; French, *Companion to* The Grapes of Wrath, 120.

74. McWilliams, *Ill Fares the Land*, 187. Steinbeck's friends Fred Whitaker and Ed Ricketts frequently chided the author on his penchant for making up railway lines, valleys, mountain ranges, and highways in his writing. See Benson, *True Adventures of John Steinbeck*, 299. Journalist Bill Steigerwald's more recent analysis of the accuracy of Steinbeck's cross-country travelogue, *Travels with Charley*, also sheds light on the author's ability to fabricate realistic places and scenes. As Steigerwald explains in his introduction, "Though it was a nonfiction book filled with real places, real people and real events, it was often vague and confusing about where Steinbeck really was on any given date. It was not a travelogue, not a serious work of journalism and, as I soon realized, it was not an accurate, full or reliable account of his actual road trip." Steigerwald, *Dogging Steinbeck: How I Went in Search of John Steinbeck's America, Found My Own America, and Exposed the Truth about* Travels with Charley (Pittsburgh, PA: Fourth River Access, 2012), 8.

75. McWilliams, *Ill Fares the Land*, 15.

76. See Krim, *Route 66*, 87.

77. Gregory, *American Exodus*, 11; Douglas Cazaux Sackman, *Orange Empire: California and the Fruits of Eden* (Berkeley: University of California Press, 2005), 234; "Statement of Frank Lorimer, Professor of Population Studies, American University; Consultant, National Resources Planning Board," in U.S. Congress, *Hearings*, 12, 22.

78. Walter Prescott Webb, *The Great Plains* (New York: Grosset and Dunlap, 1931), 5–8, 310. According to Smith, the average rainfall is greater in eastern Oklahoma, with an annual rainfall of 40 inches per year, than in the western panhandle, which receives up to 20 inches annually. J. Russell Smith, *North America: Its People and the Resources, Development, and Prospects of the Continent as Home of Man* (New York: Harcourt, Brace, 1925), 279–394. For Stryker's reliance on Smith's text see Lesy, *Long Time Coming*, 114.

79. Roy Stryker to Russell Lee, May 22, 1939, Stryker Papers.

80. The Eastern Oklahoma Farms Project began in 1937 when the federal government purchased a large tract of badly eroded land near Muskogee. The land was retired and the seventy-one families were offered loans of $975 to help them secure better land outside of the Cookson Hills. This became known as the Cookson Hills Project. Having visited the project in the fall of 1940, McWilliams praised it as a success in 1942. McWilliams, *Ill Fares the Land*, 203.

81. Russell Lee, "Field notebook #3," Russell Lee Collection, Wittliff Collections, Albert B. Alkek Library, Texas State University, San Marcos.

82. Ibid.; Lee, caption to photograph LC-USF34-033665-D; Steinbeck, *Grapes of Wrath and Other Writings*, 334. See also McWilliams, *Ill Fares the Land*, 187; French, *Companion to* The Grapes of Wrath, 120.

83. Steinbeck, *Grapes of Wrath and Other Writings*, 309.

84. Ibid., 333.

85. FSA small loans were made possible through the Bankhead-Jones Farm Tenant Act, which helped thousands of tenants, sharecroppers, and farm laborers buy their own land. According to some reports, the FSA gave loans to 395,000 families in Dust Bowl states. Transcript of "Your Government at Your Service," Radio Broadcast, October 21, 1938; Transcript and [Press] Release for All

Papers, March 23, 1939, both in Hollenberg Collection. See FSA, *Migrant Farm Labor,* 13–14.

86. Russell Lee to Roy Stryker, June 12, 1939, Stryker Papers.

87. An emphasis on attributes like dignity and fortitude was not unique to Stryker's Historical Section; it was broader FSA policy. Stryker and Wood, *In This Proud Land,* 14; C. B. Baldwin, "Doors to Rural Democracy," October 22, 1941, Hollenberg Collection. See also Frank Crowninshield, foreword to Maloney, *U.S. Camera, 1939,* 12.

88. Howe, "You Have Seen Their Pictures," 237–38.

89. James McCamy, interview with Roy Stryker, in McCamy, *Government Publicity,* 119–20.

90. Stryker and Wood, *In This Proud Land,* 9. See also David F. Burg, *The Great Depression: An Eyewitness History* (New York: Facts on File, 1996), 175.

91. Roy Stryker to Russell Lee, April 7, 1939, Stryker Papers.

92. Russell Lee to Roy Stryker, April 19, 1939, Stryker Papers. For more on Lee's activities in the Lone Star State see Reid, *Picturing Texas,* 38–39.

93. Russell Lee to Roy Stryker, May 19, 1939, Stryker Papers. For a discussion of the possible connections between Sallisaw and Steinbeck see Krim, "Right near Sallisaw," 1–4.

94. Jean Lee, "Tenant Farmers in Oklahoma" and "Ancillary to General Caption no. 20," FSA Archives, LOC. According to F. Jack Hurley, Jean Lee wrote the general captions at the end of an assignment. Hurley, *Russell Lee: Photographer* (New York: Morgan and Morgan, 1978), 19. On Lange's use of general captions see Spirn, *Daring to Look,* 12–13.

95. Russell Lee to Roy Stryker, May 27, 1939, Stryker Papers.

96. Compare Steinbeck, *Harvest Gypsies,* 29, 31.

97. From, respectively, Russell Lee, caption to photograph LC-USF34- 033425-D; and Jean Lee, "Tenant Farmers in Oklahoma," "Ancillary to General Caption no. 20," LOC.

98. Russell Lee, caption to photograph LC-USF34-033508-D.

99. David Eugene Conrad, *The Forgotten Farmers: The Story of Sharecroppers in the New Deal* (Westport, CT: Greenwood Press, 1965), 15.

100. For another illustration of Lee's ability to enter people's homes and lives, see Mary Murphy, "Picture/Story: Representing Gender in Montana Farm Security Administration Photographs, *Frontiers: A Journal of Women Studies* 22, no. 3 (2001): 108–10.

101. Edith E. Lowry, *They Starve That We May Eat* (New York: Council of Women for Home Missions and Missionary Education Movement, 1938), 23. Caring for children was a major purpose of the Council of Woman for Home Missions ("Testimony of Edith Lowry," in U.S. Congress, *Hearings,* 298–302). Edith Elizabeth Lowry (1887–1970) was executive secretary of this council and later led the Home Missions Council of North America. She was firmly committed to the general welfare of migrants in her home state of New Jersey and across the United States. She authored books and pamphlets on the topic, including *They Starve That We May Eat* (1938), *Migrants of the Crops* (1938), and *Tales of Americans on Trek* (1940), and testified before the Tolan Committee on interstate migration. Her public ministry to migrants lasted until 1961, and upon her death in 1970 Wellesley College established the Edith E. Lowry Memorial Scholarship Fund for Migrant Children.

102. Glen H. Elder, *Children of the Great Depression: Social Change in Life Experience* (Chicago: University of Chicago Press, 1974), 278.

103. Caroline Bird, *The Invisible Scar* (New York: David McKay, 1966), 59. See also Caldwell and Bourke-White, *You Have Seen Their Faces,* 31–32.

104. Russell Lee to Roy Stryker, May 27, 1939, Stryker Papers.

105. On that occasion the Joads enjoyed a meal of pork, biscuits and gravy, and coffee. Steinbeck, *Grapes of Wrath and Other Writings,* 293.

106. Oliver LaFarge, "Men Alone and Men Together," *Saturday Review of Literature,* March 4, 1939, 19. See also Stanley Young, "Edwin Lanham's Vigorous Western Saga," *New York Times,* March 5, 1939, 7.

107. Lanham's book was not the only novel of consequence forgotten in the wake of *The Grapes of Wrath.* Determined to write about the people of Oklahoma's high plains, in 1938 Sanora Babb, a native of the Sooner State and assistant to Tom Collins, completed a novel on the plight of the migrant entitled *Whose Names Are Unknown.* Random House agreed to publish it but shelved it in the wake of *The Grapes of Wrath.* The novel remained unpublished until 2004. At the time of its publication Lawrence R. Rodgers called Babb's novel "perhaps the most famous unpublished novel of the thirties" and likened it to Rothstein's work in Cimarron County.

108. Even in the opening line of the novel Lanham reveals his understanding of eastern Oklahoma's actual topography. See Edwin Lanham, *The Stricklands: A Novel,* introduction by Lawrence R. Rodgers (Norman: University of Oklahoma Press, 2002), 3.

109. Russell Lee to Roy Stryker, May 11, 1939, Stryker Papers.

110. Poore, "Books of the Times."

111. Donald H. Grubbs, *Cry from the Cotton: The Southern Tenant Farmers Union and the New Deal* (Chapel Hill: University of North Carolina Press, 1971), 180–84, 80; H. L. Mitchell, *Mean Things Happening in This Land: The Life and Times of H. L. Mitchell Co-Founder of the Southern Tenant Farmers Union* (Montclair, NJ: Allanheld, Osum, 1979), 77–79, 141; Orville Vernon Burton, *Roll the Union On: As Told by Its Co-founder H. L. Mitchell* (Chicago: Charles H. Kerr, 1987), 42–43. The first STFU local was organized in Sweeden's hometown of Muskogee, Oklahoma, in September 1935. For more see U.S. Department of Labor, *Labor Unionism in American Agriculture,* Bulletin No. 836 (1945; reprint, New York: Arno Press, 1975), 268–70. By the time Lee worked with Sweeden, the STFU was in disarray despite having been absorbed by the United Cannery, Agricultural, Packing and Allied Workers of America and the Congress of Industrial Organizations (CIO) in 1937. Sweeden left the STFU in the fall of 1938 and worked as a migrant farm laborer in Arizona. When he returned to Oklahoma he tried unsuccessfully to reenter the STFU's ranks. Eventually he joined the CIO.

112. Sweeden also had some radical ideas, such as when he proposed to the STFU executive council to blow up the Mississippi River levees in order to flood eastern Arkansas plantations in retaliation for the mistreatment of union members. H. L. Mitchell, *Mean Things Happening,* 77. For more on challenges facing the STFU see H. L. Mitchell, *The Disinherited Speak* (New York:

Workers Defense League, 1937). On union membership losses due to migration, see Conrad, *Forgotten Farmers,* 173.

113. Lange's tour was arranged by Prentice Thomas, an STFU organizer who at one time organized an exhibition of RA images at Howard University. In 1936 Lange had photographed evicted Arkansas sharecroppers and members of the STFU, both white and black, who joined Sherwood Eddy's cooperative experiment in Hill House, Mississippi. Meltzer, *Dorothea Lange: Photographer's Life,* 147, 178. For more on the STFU and its connections to the FSA see Baldwin, *Poverty and Politics,* 298–99; Gordon, *Dorothea Lange: Life beyond Limits,* 274–75; U.S. Congress, *Hearings,* 624–28.

114. Hurley, "Farm Security Administration File," 250.

115. See Russell Lee to Roy Stryker, June 1, 1939, and June 12, 1939, in Stryker Papers.

116. Quotation from Lee, caption to photograph LC-USF34-033837-D.

117. Christina Sheehan Gold, "Changing Perceptions of Homelessness: John Steinbeck, Carey McWilliams, and California during the 1930s," in *Beyond Boundaries: Rereading John Steinbeck,* edited by Susan Shillinglaw and Kevin Hearle (Tuscaloosa: University of Alabama Press, 2002), 59.

118. See Allred, *American Modernism and Depression Documentary,* 135–40.

119. Nancy Wood, *Heartland, New Mexico: Photographs from the Farm Security Administration, 1935–1943* (Albuquerque: University of New Mexico Press, 1989), 7.

120. Louis Owens, *The Grapes of Wrath: Trouble in the Promised Land* (Boston: Twayne, 1989), 60.

121. Steinbeck, *Grapes of Wrath and Other Writings,* 245, 556. On Native Americans in *The Grapes of Wrath* see Owens, *Grapes of Wrath: Trouble in the Promised Land,* 58–64.

122. It has been written that Florence Owens Thompson was part Choctaw as well, though her family asserts that she was "pure" Cherokee. Ham and Sprague, *Migrant Mother,* 14–15. See Sally Stein, "Passing Likeness: Dorothea Lange's 'Migrant Mother' and the Paradox of Iconicity," in *Only Skin Deep: Changing Visions of the American Self,* edited by Coco Fusco and Brian Wallis (New York: Harry N. Abrams, 2003), 348; Dunn, "Photographic License," 22; Gordon, *Dorothea Lange: Life beyond Limits,* 235.

123. Shillinglaw, *On Reading* The Grapes of Wrath, 109.

124. Writers' Program of the WPA, *Oklahoma,* 256–57.

125. Agee and Evans, *Let Us Now Praise Famous Men,* 232, 234–35. See also Gregory, *American Exodus,* 81–82.

126. In the WPA *Oklahoma* guide, this portrait of Lee's is featured in the photography section titled "Land of the Indians," with the caption "Choctaw Indian Farm Woman" (82–83).

127. Margaret Bourke-White also repeatedly employed this device in *You Have Seen Their Faces.*

128. See Erika Doss, "Between Modernity and 'The Real Thing': Maynard Dixon's Mural for the Bureau of Indian Affairs," *American Art* 18, no. 3 (Fall 2004): 27; "Unusual Indian Murals Completed by Maynard Dixon," *Indian at Work* 6, no. 11 (July 1939): 22.

129. According to Nicholas Natanson, African Americans made up 7.4 percent of Oklahoma's population during the 1930s but featured as subjects in 17.1 percent of the FSA photographs of the state. Natanson, *The Black Image in the New Deal: The Politics of FSA*

Photography (Knoxville: University of Tennessee Press, 1992), 70.

130. Gregory, *American Exodus,* 104. Apparently "white" referred not just to the color of one's skin but also to the level of one's status and solvency. In 1937 one migrant reported to Lange, "we are not tramps. We hold ourselves to be white folks." Another reported of life back home, "we *did* live like white people." Zoe Brown, "Dorothea Lange: Field Notes and Photographs," 164–66. According to Sanora Babb, the term "Okie" was also used in connection with another pejorative, "white nigger." Babb, *Whose Names Are Unknown,* 154, 185.

131. Writers' Program of the WPA, *Oklahoma,* 152, 237.

132. David Bradley, introduction to Richard Wright and Edwin Rosskam, *12 Million Black Voices* (New York: Thunder's Mouth, 2002), xiii–xix.

133. Sullivan, *Days of Hope,* 125.

134. Edwin Rosskam used a variant of this photograph in *12 Million Black Voices.* Lee's photograph was accompanied by Wright's words: "Days come and days go, but our lives upon the land remain without hope. We do not care if the barns rot down; they do not belong to us, anyway" (Wright and Rosskam, *12 Million Black Voices,* 57). See also Caldwell and Bourke-White, *You Have Seen Their Faces,* 10–13.

135. For discussion of a similar image see Allred, *American Modernism and Depression Documentary,* 142.

Chapter 5

1. Jackson, "John Steinbeck and The Grapes of Wrath," xii.

2. Robert S. McElvaine, *The Great Depression: America, 1929–1941* (New York: Times Books, 1993), 342; Starr, *Endangered Dreams,* 258–59.

3. Quoted in McWilliams, *Ill Fares the Land,* 4.

4. Tugwell et al., "What Should America Do for the Joads?"

5. According to Robert DeMott, Steinbeck's resignation from *Grapes of Wrath* occurred in October 1939. DeMott, "This Book Is My Life," 149, 154.

6. Tugwell et al., "What Should America Do for the Joads?" 10.

7. The average migrant family had three to four children—a fact that Steinbeck knew. See W. Webb, *Great Plains,* xxvii–xxx; F. Taylor, "California's Grapes of Wrath," 233; John Steinbeck, "Starvation under the Orange Tree," in Steinbeck, *Grapes of Wrath and Other Writings,* 1024. See also Farm Security Administration Region IX, "[Press] Release to Morning Papers, April 20, 1939," Hollenberg Collection; "Testimony of Edith Lowry," in U.S. Congress, *Hearings.*

8. Frank Taylor, a staunch opponent of Steinbeck's text and an advocate for California's large growers, made two "reportorial tours of the agricultural valleys" in 1937–38 and 1939. Steinbeck labeled Taylor the "propaganda front of the Associated Farmers," and McWilliams asserted that he was one of "Associated Farmers' many henchmen." F. Taylor, "California's Grapes of Wrath," 232; Wartzman, *Obscene in the Extreme,* 199; Carey McWilliams, "Letter to Editor," *The Forum,* December 1939, vi.

9. See Miron, *Truth about John Steinbeck,* 19–26.

10. Jackson, *Why Steinbeck Wrote* The Grapes of Wrath, 13.

11. Schockley, "Reception of the *Grapes of Wrath,*" 356.

12. Steinbeck, *Harvest Gypsies,* 19.

13. Quoted in Ganzel, *Dust Bowl Descent*, 7.

14. Stryker to Lee, April 17, 1937, quoted in Carlebach and Provenzo, *Farm Security Administration Photographs of Florida*, 32.

15. Roy Stryker to Russell Lee, May 22, 1939, Stryker Papers.

16. McWilliams, *Ill Fares the Land*, 10–11.

17. Russell Lee to Roy Stryker, May 27, 1939, Stryker Papers.

18. John Steinbeck to Elizabeth Otis, ca. March 1938, in Steinbeck, *Steinbeck: Life in Letters*, 162.

19. During their westward trek Tom Joad remarked that the Wilsons's 1925 Dodge had been on the road for thirteen years, implying a date of 1938. Steinbeck, *Grapes of Wrath and Other Writings*, 392–93. According to his journals, Steinbeck began writing *Grapes of Wrath* in May 1938; five months later, on October 26, 1938, he wrote, "Finished this day—I hope to God it's good." Steinbeck, *Working Days*, 93.

20. See McWilliams, *Ill Fares the Land*, 195.

21. Todd Webb, *Looking Back: Memoirs and Photographs*, foreword by Michael Rowell (Albuquerque: University of New Mexico Press, 1991), 90.

22. William Howarth, "The Okies: Beyond the Dust Bowl," *National Geographic* 166, no. 3 (September 1984): 324.

23. For more see Meltzer, *Dorothea Lange: Photographer's Life*, 6–8.

24. Quotation from Murphy, "Picture/Story," 110. From their first meeting Stryker was impressed with Russell Lee and particularly admired his forthrightness. "There's my man.... Frank, healthy, open, whatever you'd want." Another of Lee's subjects, Minnie Harshbarger Richardson, remembered him as "a nice person, not forceful, considerate and polite." *Today, Tomorrow's History: Photographer Russell Lee*, VHS directed by Ann Mundy (1986; Museum of Fine Arts, Santa Fe); "Roy Stryker on FSA, SONJ, J & L (1972), An Interview Conducted by Robert J. Doherty, F. Jack Hurley, Jay M. Kloner, and Carl G. Ryant," in *The Camera Viewed: Writings on Twentieth-Century Photography*, vol. 2, edited by Peninah R. Petruck (New York: E. P. Dutton, 1979), 144–46.

25. John Szarkowski, foreword to Lee, *Russell Lee: Photographs*, xi.

26. "The Home Front: U.S. Mobilizes the First Line of Defense," *U.S. Camera*, September 1941.

27. Joan Myers states that Russell and Jean met in 1937. Their first meeting, however, must have been in September 1938. For more on the "unsung hero" Jean Lee and the vital role she played on the road with her husband see Myers, *Pie Town Woman*, 114; Hurley, *Russell Lee, Photographer*, 18–19, 25. According to divorce and marriage records in the Russell Lee Collection, Lee's divorce from Doris was final on December 7, 1939, and his marriage to Jean took place eight days later, on December 15.

28. In writing about the Rosskams, Laura Katzman and Beverly W. Brannan note that the idea of a husband and wife working as a "photo-reporter team" was a radical idea at the time and some looked down upon it. Katzman and Brannan, *Reviewing Documentary: The Photographic Life of Louise Rosskam* (Washington, DC: American University Museum, 2011), 12–17; Hurley insisted that collaboration was a key aspect of the FSA, whereas Rothstein believed that in general the products of the Historical Section would have been improved with more "writer-photographer teams." Hurley, "Farm Security Administration File," 251; Arthur Rothstein, oral history interview; Delano, *Photographic Memories*, 35–36; Jack and Irene Delano, oral history interview, June 12, 1965, Archives of American Art, Smithsonian Institution.

29. Myers, *Pie Town Woman*, 113.

30. Peeler, *Hope among Us Yet*, 76.

31. Information on the "Prague family" comes from Jean Lee, "General Caption no. 18," FSA Archives, LOC.

32. Quotations from, respectively, Szarkowski, foreword to Lee, *Russell Lee: Photographs*, ix; and Szarkowski, *Looking at Photographs: 100 Pictures from the Collection of the Museum of Modern Art* (New York: Museum of Modern Art, 1973), 134.

33. P. Taylor, "Again the Covered Wagon," 351.

34. See Christopher L. Salter, "John Steinbeck's *The Grapes of Wrath* as a Primer for Cultural Geography," in Ditsky, *Critical Essays*, 142–44.

35. Wixson, *On the Dirty Plate Trail*, 134. Babb knew about loss from personal experience; see Sanora Babb, *An Owl on Every Post* (New York: McCall, 1970). Babb was born in Red Rock, an Otoe Indian community in Oklahoma Territory, in 1907. After living in eastern Colorado for a time her family returned to the panhandle of Oklahoma, where Babb finished high school. During the Depression she was active in the Communist Party and volunteered for the FSA in the San Joaquin and Imperial Valleys under the direction of Tom Collins. Babb set up tents and helped migrants by day while writing at night. Collins also asked Babb to take notes, which he later gave Steinbeck a copy of. After receiving a death threat, she left Collins's service and relocated to the Weedpatch migrant camp. She went on to a long career as an author, editor, and activist. For more see Wixson, *On the Dirty Plate Trail*, 4–7ff; Lawrence G. Rodgers, foreword to Babb, *Whose Names Are Unknown*, ix–x. See also Wixson, "Radical by Nature: Sanora Babb and Ecological Disaster on the High Plains, 1900–1940," in M. Steiner, *Regionalists on the Left*, 111–33.

36. Gregory, *American Exodus*, 117; Salter, "John Steinbeck's *Grapes of Wrath*," 142.

37. Jean Lee, "General Caption no. 20," LOC.

38. "I Wonder Where We Can Go Now," 119. On attitudes toward migrants see Wartzman, *Obscene in the Extreme*, 154–56; Steinbeck, *Grapes of Wrath and Other Writings*, 512.

39. Steinbeck, *Grapes of Wrath and Other Writings*, 429; Gregory, *American Exodus*, 100.

40. Gregory, *American Exodus*, 87. As Michael Grey pointed out, many of these fears were warranted. The rate of tuberculosis among migrants, for example, was eight times higher than among average Americans at that time. Grey, *New Deal Medicine*, 27–28; E. Lowry, *They Starve That We May Eat*, 8; F. Taylor, "California's Grapes of Wrath," 234ff; Steinbeck, *Harvest Gypsies*, 31.

41. Dorothea Lange, caption to photograph LC-USF34-009925-E.

42. Kozol, "Madonnas of the Fields," 9–10.

43. See Gregory, *American Exodus*, 102; Ethel Prince Miller, "The Genesis of the Exodus," in *Uprooted Americans: How Can the Churches Serve Shifting Populations* (pamphlet), edited by Benson Y. Landis, Hollenberg Collection.

44. Taylor, "Again the Covered Wagon," 348–49.

45. Kozol, "Madonnas of the Fields," 9–12.

46. Jean Lee, "General Caption no. 20," LOC.

47. Quoted in Wartzman, *Obscene in the Extreme*, 155. On migrants' morals see Benson, *True Adventures of John Steinbeck*, 335.

48. Colleen McDannell, *Picturing Faith: Photography and the Great Depression* (New Haven, CT: Yale University Press, 2004), 33; Elizabeth Partridge and Sally Stein, *Quizzical Eye: The Photography of Rondal Partridge* (San Francisco: California Historical Society Press, 2003), 132.

49. See Paul S. Taylor [Lucretia Penny], "Pea-Pickers' Child," *Survey Graphic*, July 1935, 352–53; Gregory, *American Exodus*, 108, 191–222, esp. 217.

50. Jean Lee, "General Caption no. 20," LOC.

51. For a discussion of the religious hardships faced by the migrants see Gregory, *American Exodus*, 193–99; also Lange and Taylor, *American Exodus*, 148.

52. Steinbeck, "Dubious Battle in California," 303.

53. John Steinbeck, "Rich Growers' Fostering of Prejudice Backed by Common Bond," *People's World*, April 1938, newspaper clipping in Carey McWilliams Papers, Charles E. Young Research Library, Department of Special Collections, University of California, Los Angeles.

54. Steinbeck quoted in Shillinglaw, *On Reading* The Grapes of Wrath, 51.

55. Gregory, *American Exodus*, 108–13.

56. Steinbeck, *Grapes of Wrath and Other Writings*, 383.

57. Russell Lee to Roy Stryker, June 1, 1939, Stryker Papers.

58. Muskogee was one of four counties that produced the largest number of migrants from 1935 to 1940. The other three were Oklahoma, Caddo, and Tulsa. McWilliams, *Ill Fares the Land*, 197.

59. Russell Lee to Roy Stryker, June 14, 1939, Stryker Papers. See also Peeler, *Hope among Us Yet*, 92.

60. Jean Lee, "General Caption no. 19," LOC.

61. Russell Lee to Roy Stryker, May 27, 1939, Stryker Papers. In Lee's photographs it appears that the Thomas family had three boys and two girls. In actuality, there were only four children: Amos (age 26), Frank (21), Tommy (16), and Ruby (14), the youngest. The identity of the second girl is not known, nor was it revealed years later when the surviving members of the Thomas family were tracked down in Bakersfield, California. The Elmer Thomas that Lee photographed should not be confused with Senator Elmer Thomas, who served Oklahoma as a member of Congress from 1922 to 1950. Thomas was a staunch supporter of the New Deal and the rights of Oklahoma's farmers, an association that might have made Lee's find even more serendipitous. See Jack Fischer, "Hardship Trail," *Fort Worth Star-Telegram*, April 14, 1989, 1, 7.

62. Agee and Evans, *Let Us Now Praise Famous Men*, 180; See also Lanham, *The Stricklands*, 4.

63. On the rural "box house" see Max R. White, "Rich Land—Poor People," Farm Security Administration Region III, January 1938, p. 5, Hollenberg Collection. At the time four of five farmers had no electricity and nine of ten did not have an indoor toilet. Lesy, *Long Time Coming*, 10.

64. Curtis, *Mind's Eye*, 49. In contrast, in *Harvest Gypsies*

Steinbeck deliberately cites the migrants' European surnames as a way of creating affinities with his Anglo-Saxon readers. Like "Munns, Holbrooks, Hansens, Schmidts," "Thomas" was a solid, old English name that did not suggest a recent immigrant (23). See also Steinbeck, *Grapes of Wrath and Other Writings*, 458.

65. For Steinbeck's description of Pa Joad, see *Grapes of Wrath and Other Writings*, 533; for Ma, see 287.

66. Believing that she already had the part of Ma, Beulah Bondi acquired an old jalopy and clothes and lived among Okies in Bakersfield. "I visited five different camps as an unknown," she remembered, "I was an Okie. I lived with them . . . to get the feeling of the role." Rudy Behlmer, *America's Favorite Movies: Behind the Scenes* (New York: Frederick Ungar, 1982), 126–27. See also Mimi Reisel Gladstein, "From Heroine to Supporting Player: The Diminution of Ma Joad," in Ditsky, *Critical Essays*, 127, 136.

67. Steinbeck, *Grapes of Wrath and Other Writings*, 288.

68. Kazin, *On Native Grounds*, 396–98.

69. Arthur Rothstein's "Fleeing the Dust Storm, Cimarron County" and Dorothea Lange's "Migrant Mother," both from 1936, have not only become icons of the FSA but in many ways have defined the legacies of the photographers as well. This is especially true of Rothstein, who is known for this image more than any other part of his inadequately documented career. Given her productive career, Dorothea Lange bristled at the notion that she was a "one-photograph-photographer." Lange, "Assignment I'll Never Forget," 42; See also Mary Jane Appel, "Russell Lee: The Man Who Made America's Portrait," in Lee, *Russell Lee: Photographs*, 3.

70. The volume of Lee's work in the FSA/OWI collection in the LOC attests to his prodigious output. Over the course of his work with the federal government he produced 19,000 images, nearly 30 percent of the total. See Mary Jan Appel, *Russell Lee: A Centenary Exhibition* (San Marcos: Wittliff Gallery of Southwestern and Mexican Photography, Texas State University, 2003), 4.

71. Bourke-White quoted in Agee and Evans, *Let Us Now Praise Famous Men*, 410.

72. See John Szarkowski, "Photographing Architecture," in Thomas Barrow, Shelley Armitage, and William E. Tydeman, eds., *Reading into Photography: Selected Essays, 1950–1989* (Albuquerque: University of New Mexico Press, 1982), 16–17.

73. Quoted in Beverly W. Brannan and Gilles Mora, *FSA: The American Vision* (New York: Abrams, 2006), 234.

74. Quoted in O'Neal, *Vision Shared*, 183. See also Lange, oral history interview.

75. Street, *Everyone Had Cameras*, 315.

76. Szarkowski, foreword to Lee, *Russell Lee: Photographs*, vii.

77. McCamy, *Government Publicity*, 52–53.

78. Stryker, oral history interviews. Stryker was also frustrated that Delano could not make serial photographs like Russell Lee's. An ideal photographer, in Stryker's mind, might have been somewhere in between. A closer examination of Lee and Delano's careers, however, reveals that they were not as polarized as Stryker portrayed them. Brannan and Mora, *FSA*, 17.

79. Ohrn, *Dorothea Lange and the Documentary Tradition*, 61.

80. In 1939 James McCamy noted that "narrative use of pictures in a sequence" was a device used by picture magazines and government photographers, and predicted it would probably spread

to newspapers and magazines. McCamy, *Government Publicity*, 83; Curtis, *Mind's Eye*, 48.

81. Stryker also believed that *Life*'s photographs did not have guts. Stryker and Wood, *In This Proud Land*, 8; Finnegan, *Picturing Poverty*, 196.

82. Rosskam, "Not Intended for Framing," 10; Myers, *Pie Town Woman*, 108.

83. Marion Post Wolcott, oral history interview, January 18, 1965, Archives of American Art, Smithsonian Institution; Werner J. Severin, "Photographic Documentation by the Farm Security Administration, 1935–1942" (MA thesis, University of Missouri, Columbia, 1959), 41.

84. Pressure for change might also have come from above. John Fischer, one of Stryker's superiors, encouraged picture sequences like those in *Life* and *Look*, rather than "single, isolated shots." Finnegan, *Picturing Poverty*, 195; Ohrn, *Dorothea Lange and the Documentary Tradition*, 65; Maren Stange, ed., *Symbols of Ideal Life: Social Documentary Photography in America, 1890–1950* (New York: Cambridge University Press, 1989), 128.

85. Raeburn, *Staggering Revolution*, 144.

86. Street, *Everyone Had Cameras*, 315.

87. "Home Front: U.S. Mobilizes the First Line of Defense."

88. See Myers, *Pie Town Woman*, 113.

89. McCausland continued, "[The photographer's] personality can be intruded only by the worst taste of exhibitionism; this at last is reality.... First of all, there is no room for exhibitionism or opportunism or exploitation in the equipment of the documentary photographer. His purpose must be clear and unified, and his mood simple and modest. Montage of his personality over his subject will only defeat the serious aims of documentary photography." Elizabeth McCausland, "Documentary Photography," *Photo Notes*, January 1939.

90. Myers, *Pie Town Woman*, 112.

91. Steinbeck, *Grapes of Wrath and Other Writings*, 324. For a discussion of Ma Joad and of Steinbeck's use of gender roles see Nellie Y. McKay, "Happy [?]-Wife-and-Motherdom: The Portrayal of Ma in John Steinbeck's *The Grapes of Wrath*," in David Wyatt, ed., *New Essays on* The Grapes of Wrath (Cambridge: Cambridge University Press, 1990), 47–69.

92. Goggans, *California on the Breadlines*, 231.

93. Kozol, "Madonnas of the Fields," 340–41.

94. Quoted in Cox, "Fact into Fiction," 20; Elder, *Children of the Great Depression*, 278.

95. P. Taylor, "From the Ground Up," 526–27.

96. Steinbeck, *Grapes of Wrath and Other Writings*, 324.

97. Ibid., 325. On acts of remembrance, see Geoffrey Batchen, *Forget Me Not: Photography and Remembrance* (New York: Princeton Architectural Press, 2004), 78.

98. Steinbeck, *Grapes of Wrath and Other Writings*, 304. Steinbeck wrote that the past would cry particularly to the women—the keepers of the home (301).

99. Ben Shahn, oral history interview, April 14, 1964, Archives of American Art, Smithsonian Institution.

100. Speaking of Lee and the "vroom" of his camera's flash, Louise Rosskam commented, "And all of a sudden a little shack opened up with every little piece of grime on the wall, radio cords mixed up with the electrical cords, and what-not, was absolutely a complete blank, before he put it down, and everybody could see it." Edwin and Louise Rosskam, oral history interview, August 3, 1965, Archives of American Art, Smithsonian Institution.

101. Steinbeck, *Grapes of Wrath and Other Writings*, 303.

102. See Lee's images LC-USF-34–335441 and LC-USF34–33510-D, LOC. The WPA Writers' Program *Guide to Oklahoma* featured a similar photograph with the caption "Behind the ebb of the frontier" (114). This guide also argued that the gun was an important part of the state's folklore and folkways (374–75).

103. Though *Look* used this term to connote the immensity of the migrant masses, it is also possible to see how this group of displaced and disgruntled Americans could, given the appropriate circumstances, become a veritable army willing to take their rights by force. See "The Story behind 'The Grapes of Wrath': America's Own Refugees," *Look*, August 29, 1939, 18. See also Gregory, *American Exodus*, 162; McWilliams (*Ill Fares the Land*, 30) referred to an "army of migrant farm families" and "the army of dirt farmers." Steinbeck, *Harvest Gypsies*, 19.

104. Steinbeck, *Grapes of Wrath and Other Writings*, 475.

105. McWilliams, *Factories in the Field*, 8.

106. See Jean Lee, "Tenant Farmers in Oklahoma" and "General Caption no. 20," LOC.

107. Wixson, *On the Dirty Plate Trail*, 129.

108. Quotations from Steinbeck, *Grapes of Wrath and Other Writings*, 302–303, and *Harvest Gypsies*, 62; see also Walter Rundell, "Steinbeck's Image of the West," *American West* 1 (Spring 1964): 9.

109. Fischer, "Hardship Trail," *Fort Worth Star-Telegram*, 7.

110. Steinbeck, *Grapes of Wrath and Other Writings*, 416, 422–23.

111. Maynard Dixon, "Who Are the Dust Bowlers?" *San Francisco Examiner*, March 29, 1939, reprinted in Dixon, *Maynard Dixon: Images of the Native American* (San Francisco: California Academy of Sciences, 1981), 38. See also Gregory, *American Exodus*, 222–48.

112. P. Taylor, "Again the Covered Wagon," 349.

113. Gregory, *American Exodus*, 226.

114. Conrad, *Forgotten Farmers*, 16.

115. Steinbeck, *Grapes of Wrath and Other Writings*, 284.

116. Ibid., 377.

117. P. Taylor, "Again the Covered Wagon," 348–49.

118. "I Wonder Where We Can Go Now," 91.

119. Steinbeck, *Grapes of Wrath and Other Writings*, 315.

120. Steinbeck, *Harvest Gypsies*, 35.

121. Poore, "Books of the Times," 27.

122. Dunn, "Photographic License," 22.

123. Apparently the Thomases were not the only migrants to have a Model A Roadster; see Steinbeck, *Grapes of Wrath and Other Writings*, 466.

124. Ibid., 296–97, 312, 339, 385–86.

125. Jean Lee, "General Caption no. 19," LOC.

126. Steinbeck, *Grapes of Wrath and Other Writings*, 297.

127. Elder, *Children of the Great Depression*, 102.

128. See Horst Groene, "Agrarianism and Technology in Steinbeck's *The Grapes of Wrath*," in Robert Con Davis, *The Grapes*

of *Wrath: A Collection of Critical Essays* (Englewood Cliffs, NJ: Prentice-Hall, 1982), 132–33.

129. The original party consisted of twelve Joads (Grandpa, Grandma, Pa, Ma, Noah, Tom, Al, Ruthie, Winfield, and Rose of Sharon and her husband, Connie), Jim Casy, and one dog. Steinbeck, *Grapes of Wrath and Other Writings*, 330. Before they left Oklahoma Ma Joad proclaimed, "All we got is the family unbroken. Like a bunch of cows, when the lobos are ranging, stick all together. I ain't scared while we're all here, all that's alive, but I ain't gonna see us bust up" (390).

130. E. Lowry, *They Starve That We May Eat*, 18.

131. Finnegan, *Picturing Poverty*, 5–6. The images also contradict Curtis's assertion of a lack of affection among the migrants. Curtis, *Mind's Eye*, 63.

132. Benton, *Artist in America*, 74.

133. Lee to Stryker, July 7, 1939, Stryker Papers; Finnegan, *Picturing Poverty*, 5.

134. See Fischer, "Hardship Trail," *Fort Worth Star-Telegram*, 7. According to the 1930 census report the Thomas family was still in eastern Oklahoma in April, and in July they registered to vote in Muskogee County. Wally Waits, "Going to California—Which Time?" www.muskogeehistorian.com (accessed June 21, 2010).

135. The children of Florence Thompson experienced similar discrimination. Katherine McIntosh, one of the young daughters in Lange's famous image, also remembers being labeled a "dirty little Okie." Dunn, "Photographic License," 22.

136. Jean Lee, "General Caption no. 19," LOC.

137. Hurt, *Dust Bowl*, 97–98; McWilliams, *Ill Fares the Land*, 196, 198. Steinbeck was not ignorant of the complexities of the migration. Within the first few days of their odyssey, the Joads met a fellow migrant returning to Oklahoma and telling a grim tale of California. His forewarning goes unheeded, however, and the Joads stoically put this ominous bit of news behind them and journey onward. Steinbeck, *Grapes of Wrath and Other Writings*, 410–13, 427–28. On the complex nature of the American migration at the time see U.S. Congress, *Hearings*.

138. Data suggest that more than half of migrants in the 1930s followed and depended upon relatives who were already settled in California. Gregory, *American Exodus*, 27–28. See also Webb and Brown, *Migrant Families*, 17–19.

139. Keith Windschuttle, "Steinbeck's Myth of the Okies," *New Criterion* 20, no. 10 (June 2002): 24.

140. Gregory, *American Exodus*, 30.

141. Gordon, *Dorothea Lange: Life beyond Limits*, 235–36.

142. James Gregory notes that one of the distinctive features of the Dust Bowl migration was "the persistence of a strong emotional ties to places left behind." Gregory, *American Exodus*, 114–18.

143. See E. Lowry, *They Starve That We May Eat*, 14.

144. See Paul S. Taylor, "Migratory Farm Labor in the United States [1937]," in *Labor on the Land*, 91–100; "Testimony of Edith Lowry," in U.S. Congress, *Hearings*, 299.

145. According to Douglas Hurt, most migrants were not products of the Dust Bowl but refugees from the far more extensive drought that covered the entire Great Plains and Midwest. Hurt, *Dust Bowl*, 54–60, 92–101. Federal aid through the Agricultural Adjustment Administration (AAA), RA, FSA, WPA, and other sources was designed to help families stay in place through the Dust Bowl. This was true of the Coble family, whom Rothstein documented fleeing the dust in the Oklahoma Panhandle in 1936. Ganzel, *Dust Bowl Descent*, 20–21.

146. E. Lowry, *They Starve That We May Eat*, 13; Bird, *Invisible Scar*, 66.

147. E. Lowry, *They Starve That We May Eat*, 39, 70, quotations on 12, 14–15; Taylor quoted in McWilliams, *Ill Fares the Land*, 12; see also Paul Taylor, "Good-by to the Homestead Farm," in *Labor on the Land*, 179.

148. Russell Lee, caption to photograph LC-USF33-012255-M1.

149. Delano, *Photographic Memories*, 36–37; Pablo Delano, "Reflections on My Father's Railroad Photographs," in Gruber, *Railroaders*, 13; Lange and Taylor, *American Exodus*, 68.

150. "For every Historical Section photograph that appears to model the mythical narrative of 'the Joads,' or the sharecropper, or the 'dust bowl refugee,' there is another that vexes, challenges, subverts such a reading, calling for renewed historical contextualization and nuanced rhetorical analysis." Finnegan, *Picturing Poverty*, 5.

151. Quotation from McWilliams, *Ill Fares the Land*, 196; see also *Education of Carey McWilliams*, 76, and *Factories in the Field*, 309.

152. The actual photograph that accompanies this line in MacLeish's poem is Margaret Bourke-White's "Western Mountain Range." MacLeish, *Land of the Free*, 21.

153. Steinbeck, "Leader of the People," in *The Grapes of Wrath and Other Writings*, 204.

154. "I Wonder Where We Can Go Now," 91.

155. See Todd, "Okies Search for a Lost Frontier," 10.

156. Poore, "Books of the Times," 27.

157. "U.S. Dust Bowl," *Life*, June 21, 1937, 64; "Children of the Forgotten Man! . . . LOOK visits the Sharecropper," *Look*, March 1937: 18–19. see also Finnegan, *Picturing Poverty*, 169; Gold, "Changing Perceptions of Homelessness," in Shillinglaw and Hearle, *Beyond Boundaries*, 54–56.

158. Dixon, *Maynard Dixon: Images*, 38.

159. See Marling, *Wall-to-Wall America*, 19–21.

160. Writers' Program of the WPA, *Oklahoma*, 6.

161. According to Finis Dunaway, Rexford Tugwell and other "brain trusters" wanted to "reject the frontier legacy of individualism, hoping to replace the wasteful practices of the pioneer with the scientific knowledge of ecology." They believed that the pioneer had not propelled America's destiny but created a wasteland. Pare Lorentz shared this belief. Dunaway, *Natural Visions: The Power of Images in American Environmental Reform* (Chicago: University of Chicago Press, 2005), 35, 39–41, 55; W. Stein, "New Deal Experiment," 140.

162. In interviews Edwin Rosskam was quick to point out the frontier attributes of his former boss. According to Rosskam, Stryker "had a tremendous love for any of the romantic pioneering aspects in this country. He has the Westerner's . . . semi-belief in the western movie; quoted in Keller, *Highway as Habitat*, 25; Edwin and Louise Rosskam, oral history interview. For more on Stryker's worldview, see John Tagg, *The Burden of Representation: Essays on Photographies and Histories* (Minneapolis: University of Minnesota Press, 1993), 170.

163. P. Taylor, "From the Ground Up," 526; and "Again the Covered Wagon," 348–51. See also Goggans, *California on the Breadlines*, 23ff; Sackman, *Orange Empire*, 227–36; Lange and Taylor, *American Exodus*, 5.

164. Steinbeck, *Grapes of Wrath and Other Writings*, 416–23.

165. Upton Sinclair would disagree. He described Steinbeck's story as one of "hunger, want, and insecurity, fear and rage; a perpetual struggle, hopeless from the beginning." Sinclair, "Sinclair Salutes Steinbeck," 22.

166. See Guimond, *American Photography*, 105–109, 125; John Berger, "A Tragedy the Size of the Planet," in Berger, *Understanding a Photograph*, edited by Geoff Dyer (New York: Aperture, 2013), 136; Gordon, *Dorothea Lange: Life beyond Limits* 253.

167. Steinbeck, *Harvest Gypsies*, 22–23.

168. Steinbeck, *Grapes of Wrath and Other Writings*, 418.

169. Street, *Everyone Had Cameras*, 315.

170. Russell Lee to Roy Stryker, June 21, 1939, Stryker Papers.

171. The Joads first traveled along U.S. 64 to Oklahoma City, where they accessed Route 66. Steinbeck, *Grapes of Wrath and Other Writings*, 334, 350. Krim, *Route 66*, 98–100.

172. Steinbeck, *Grapes of Wrath and Other Writings*, 349. I thank Wally Waits for his help in identifying the location of Lee's image.

173. Steinbeck, *Grapes of Wrath and Other Writings*, 352–54, 418–23.

174. Ibid., 350. Goggans, *California on the Breadlines*.

175. Max Horkheimer, "Art and Mass Culture," (1937), in *Critical Theory: Selected Essays*, trans. Matthew J. O'Connell (New York: Continuum, 1972), 275–76; Allan Sekula, "Dismantling Modernism, Reinventing Documentary," in *Dismal Science: Photo Works, 1972–1996* (Normal: University Galleries, Illinois State University, 1999, 134).

176. Goggans, *California on the Breadlines*, 198–201, quotations on 200.

177. See Steinbeck, *Grapes of Wrath and Other Writings*, 372, 378–79; Pare Lorentz, *Lorentz on Film: Movies, 1927–1941* (New York: Hopkinson and Blake, 1971), 86. For more on Steinbeck's use of biblical symbolism in *Grapes of Wrath* see J. Paul Hunter, "Steinbeck's Wine of Affirmation," 39–47; and Peter Lisca, "The Grapes of Wrath: An Achievement of Genius," 60–62, both in Davis, *Grapes of Wrath: Critical Essays*.

178. See Keller, *Highway as Habitat*, 37. Gordon, *Dorothea Lange: Life beyond Limits*, 239–40; Ohrn, *Dorothea Lange and the Documentary Tradition*, 61–65.

179. Curtis, *Mind's Eye*, 84.

180. Keller, *Highway as Habitat*, 35.

181. Peeler, *Hope among Us Yet*, 91–93. Miles Orvell sees three types of photographs of people in the FSA files: the candid image, the posed portrait, and "the posed dramatic image, in which the subject is positioned by the photographer so as to represent some 'typical' action, feeling, or gesture." Orvell, foreword to Allen Cohen and Ronald L. Flippelli, *Times of Sorrow and Hope: Documenting Everyday Life in Pennsylvania during the Depression and World War II* (University Park, PA: Penn State University Press, 2003), xiii.

182. Delano, *Photographic Memories*, 55.

183. See, respectively, Gregory, *American Exodus*, 33–35; Steinbeck, *Grapes of Wrath and Other Writings*, 363; Jean Lee, "General Caption no. 19," LOC.

184. The Joads were not the only ones in Steinbeck's novel to encounter problems on the road. The Wilsons (a couple from Galena, Kansas, that befriended the Joads before they left Oklahoma) also had automotive trials shortly after heading out. The Joads experienced their first troubles east of Albuquerque. See Steinbeck, *Grapes of Wrath and Other Writings*, 365, 385–87.

185. Russell Lee to Roy Stryker, June 22, 1939, Stryker Papers. See Gordon, *Dorothea Lange: Life beyond Limits*, 274.

186. Another example of Lee's overreliance on *Grapes of Wrath* is his frequent misspelling of the Oklahoma town Henryetta. In his captions, as in Steinbeck's novel, he misspells it "Henrietta." Steinbeck, *Grapes of Wrath and Other Writings*, 339.

187. Russell Lee to Roy Stryker, July 7, 1939, Stryker Papers.

188. Fischer, "Hardship Trail," *Fort Worth Star-Telegram*, 7; For more on the process of transformation from Okie to Californian see Gregory, *American Exodus*, 120–22; Howarth, "Okies," 333–49.

189. P. Taylor, "Again the Covered Wagon," 368. See also Meltzer, *Dorothea Lange: Photographer's Life*, 105.

190. Oliver Carlson, "Up from the Dust," *U.S.A. The Magazine of American Affairs*, August 1952, 98. See also Gregory, *American Exodus*, 246; Gerald Haslam, "The Okies: Forty Years Later," *The Nation* 220, no. 10 (March 15, 1975): 299–302.

191. Haslam, "Okies: Forty Years Later." 299. Babb, *Whose Names Are Unknown*, 164.

192. Gordon, *Dorothea Lange: Life beyond Limits*, 241.

193. Alan Lomax, comp., *Hard Hitting Songs for Hard-Hit People*, foreword by John Steinbeck (Lincoln: University of Nebraska Press, 1999), 25.

194. While "Dust Bowler" became accepted, "Okie" was still a term that most migrants abhorred yet could not avoid. See Carlson, "Up from the Dust," 101.

195. Howarth, "Okies," 348; Gregory, *American Exodus*, 245; Fossey, "End of the Western Dream," 28–29; Michael Wallis, *Route 66: The Mother Road* (New York: St. Martin's Press, 1990), 90.

196. For more on the overall breakdown of *The Grapes of Wrath* see Warren French, *Film Guide to* The Grapes of Wrath (New York: Viking Press, 1963), 23; George Bluestone, "Grapes of Wrath," in Davis, *Grapes of Wrath: Critical Essays*, 80.

Chapter 6

1. Stryker noted that he covered 3,400 miles on this trip. Stryker to Victor Weybright, September 1, 1939, Stryker Papers. Stryker infrequently visited his photographers in the field, but he went out with Rothstein and Vachon, and went with Lee on at least two occasions, on trips to Minnesota and Wisconsin. Despite Dorothea Lange's numerous invitations, for some reason Stryker never visited her in the field. Gordon, *Dorothea Lange: Life beyond Limits*, 296; "Roy Stryker on FSA, SONJ, J & L (1972)," 142; Roy Emerson Stryker, oral history interview.

2. For more on Stryker's time in Minnesota with Lee see Robert L. Reid, *Picturing Minnesota, 1936–1943: Photographs from the Farm Security Administration* (St. Paul: Minnesota Historical Society Press, 1989), 6, 23, 55. Despite his leadership

of the Historical Section, Stryker remained somewhat ignorant of the photographic process. According to Gordon Parks, Stryker "couldn't even load a camera." For Stryker what the camera captured was more important than how it worked. Steven W. Plattner, *Roy Stryker: U.S.A., 1943–1950* (Austin: University of Texas Press, 1983), 16.

3. During their travels Stryker and the Lees visited many sites, including the ruins at Mesa Verde. On one occasion Lee photographed Stryker in New Mexico purchasing souvenirs from the children of Tesuque pueblo. It is also possible that Lee and Stryker visited Pie Town, New Mexico, on this trip in 1939. See Lee's photograph, "Tourist buying Indian pottery from children at Tesuque pueblo, New Mexico," LC-USF33-012352-M2.

4. "Roy Stryker on FSA, SONJ, J & L (1972)," 142.

5. Calvin Kytle, "Roy Stryker: A Tribute," in James C. Anderson, *Roy Stryker: The Humane Propagandist* (Louisville, KY: Photographic Archives, University of Louisville, 1977), 7.

6. Roy Stryker to Dorothea Lange, September 7, 1939, Stryker Papers.

7. Lange believed that Stryker did not dare leave Washington because of the internal political pressures that threatened the Historical Section and its photographs. Dorothea Lange, oral history interview.

8. Quoted in Hurley, "Farm Security Administration File," 251.

9. Constance B. Schulz, ed., *Bust to Boom: Documentary Photographs of Kansas, 1936–1949*, introduction by Donald Worster (Lawrence: University Press of Kansas, 1996), 83.

10. According to Peter Fearon, rehabilitation loans were the RA's/FSA's most significant contribution to the formidable challenges facing Kansan farmers. Borrowers who accepted loans were subjected to close supervision and were required to enhance their farming methods and plant subsistence gardens. Their wives were also required to attend classes on food preservation. See Peter Fearon, *Kansas in the Great Depression: Work Relief, the Dole, and Rehabilitation* (Columbia: University of Missouri Press, 2007), 171–72. For more see Schulz, *Bust to Boom*, 83; Baldwin, *Poverty and Politics*, 106.

11. For more see Patricia Junker, *John Steuart Curry: Inventing the Middle West* (New York: Hudson Hills Press, 1998), 58–59, 230–31.

12. Marion Post Wolcott to Roy Stryker, July 28 and 29, 1940, Marion Post Wolcott Archive, Center for Creative Photography, University of Arizona, Tucson.

13. Baldwin, *Poverty and Politics*, 198.

14. As early as June 1939 Stryker wrote that "we particularly need more things on the cheery side . . . where are the elm-shaded streets?" Quoted in Fleischhauer and Brannan, *Documenting America*, 5.

15. Kidd, *Farm Security Administration Photography*, 19.

16. Fossey, "'Talkin' Dust Bowl Blues,'" 27.

17. Marsha L. Weisiger, "Migrant Camps," Encyclopedia of Oklahoma History and Culture, http://digital.library.okstate.edu/encyclopedia/ (accessed May 22, 2010).

18. Jean Lee, "General Caption, no. 21," LOC. In this caption Lee noted the camps had several churches. See also Gregory, *American Exodus*, 14–15.

19. As the head of the John Steinbeck Committee Helen Gahagan Douglas traveled to Oklahoma to understand the root of the migrant problem in California. "Testimony to the Tolan Committee," Helen Gahagan Douglas Archive, Carl Albert Center, Congressional Research and Studies, University of Oklahoma, Norman.

20. Henry Hill Collins, Jr., *America's Own Refugees: Our 400,000 Homeless Migrants* (Princeton: Princeton University Press, 1941), 259. Although Mays Avenue captured the attention of many outsiders, including Henry Collins and the Lees, it was not the only story to be found along Route 66 in Oklahoma. Many sites and migrant experiences differed considerably from those in the squalid slums of the state. For more see Quinta Scott, *Along Route 66* (Norman: University of Oklahoma Press, 2000), 4, 107–53.

21. See Jean Lee, "General Caption no. 21," LOC.

22. Compare John Steinbeck, *Harvest Gypsies*, 26–31. Mays Avenue was similar to but probably worse than the Hoovervilles that stretched across the West. See also Ruth Fisher Lowry, "Analysis of One Hundred Families Residing in Community Camp, Oklahoma City, 1941" (MA thesis, University of Oklahoma Graduate College, Oklahoma City, 1945).

23. Guimond, *American Photography*, 120. See also Thomas Fahy, "Worn, Damaged Bodies in Literature and Photography of the Great Depression," *Journal of American Culture* 26, no. 1 (March 2003): 2–16.

24. See Maurice Berger, "FSA: Illegitimate Eye (1985)," in *How Art Becomes History: Essays on Art, Society, and Culture in Post–New Deal America* (New York: Icon Editions, 1992).

25. Susan Kismaric, *American Children: Photographs from the Collection of the Museum of Modern Art* (New York: Museum of Modern Art, 1980), 8.

26. For examples of the children's experiences, see Steinbeck, *Grapes of Wrath and Other Writings*, 348–49, 528–29. See also Shillinglaw, *On Reading* The Grapes of Wrath, 48. Steinbeck did not always take this approach in his writing. In *The Harvest Gypsies* Steinbeck often used migrant children as a way of eliciting reactions from his readers. For more on children during the Depression see Elder, *Children of the Great Depression*; Bruce Ouderkirk, "Children in Steinbeck: Barometers of the Social Condition" (Ph.D. diss., University of Nebraska–Lincoln, 1990).

27. For a broader discussion of how FSA photographers represented children see Anne Higonnet, *Pictures of Innocence: The History and Crisis of Ideal Childhood* (New York: Thames and Hudson, 1998); Jennifer Pricola, "Age of Lost Innocence: Photographs of Childhood Realities and Adult Fears During the Depression" (Master's thesis, University of Virginia, Charlottesville, 2003), http://xroads.virginia.edu/~ma03/pricola/fsa/innocence.html (accessed July 7, 2012).

28. Stryker and Wood, *In This Proud Land*, 8.

29. John Steinbeck, *Their Blood Is Strong* (San Francisco: Simon J. Lubin Society of California, 1938), 7. *Look* magazine also published images of "filth and flies" in 1937. "Caravans of Hunger," *Look*, May 25, 1937, 18–19.

30. Berger argues that the neutral caption of this image, "Children in the sleeping quarters of a family housed in a small shack," is an example of photographic illiteracy that "soften[s] the potential of the scene it describes." Quoting Walter Benjamin he

asks, Is "a photographer who can't read his own pictures worth less than an illiterate?" M. Berger, "FSA: Illiterate Eye," 15–16. Many of Lee's captions are completely generic, allowing the visual information to speak louder than words. In *Let Us Now Praise Famous Men*, 150–51, Agee talks about the flies that pestered the families in Alabama, but Walker Evans never photographed them.

31. Jean Lee, respectively, "Junior Chamber of Commerce Buffet Supper and Party at Eufaula, Oklahoma, General Caption no. 25"; "A Pie Supper in Muskogee County, Oklahoma, General Caption no. 24"; and "Play Party in McIntosh County, Oklahoma, General Caption no. 26," all in LOC.

32. In her unusually self-revealing "General Caption no. 26" Jean Lee recorded that she enjoyed learning and playing the games of the "rural folk," such as "Pleased and Displeased" and "Cross Questions and Silly Answers," but commented that Russell did not have much fun or success on account of the darkness, the cold, and the changing nature of the party. For more on the Lees' experience with the Jaycees in Eufaula see "General Caption no. 25," LOC.

33. See Jean Lee, "Pomp Hall, Negro Tenant Farmer of Creek County, Oklahoma, General Caption no. 23," LOC.

34. See Curtis, *Mind's Eye*, 106; Hurley, *Russell Lee Photographer*, 19; and *Portrait of a Decade*, 118–19.

35. Wood, *Heartland, New Mexico*, 10; Hurley, *Russell Lee, Photographer*, 20. For more background see J. B. Colson, "The Art of the Human Document: Russell Lee in New Mexico," in Colson et al., *Far from Main Street: Three Photographers in Depression-Era New Mexico* (Santa Fe: Museum of New Mexico Press, 1994), 5–8.

36. "Pie Town, New Mexico: America's Friendliest Little Town," www.pietown.com (accessed November 2, 2011).

37. Stryker encouraged Lee to make photographs that captured "an attempt to integrate their lives on this type of land in such a way as to stay off the highways and the relief rolls." Stryker to Lee, April 22, 1940, quoted in Myers, *Pie Town Woman*, 110.

38. Wood, *Heartland, New Mexico*, 10.

39. Ganzel, *Dust Bowl Descent*, 82; Wood, *Heartland, New Mexico*, 51–54.

40. Russell Lee, "Life on the American Frontier—1941 Version, Pie Town, N.M.," *U.S. Camera*, October 1941, 41; See Guimond, *American Photography*, 131.

41. Wood, *Heartland, New Mexico*, 67.

42. Lee, "Life on the American Frontier," 41; Colson, "Art of the Human Document," 8.

43. Curtis, *Mind's Eye*, 93, 111–22; Hurley, *Russell Lee, Photographer*, 20.

44. Lee, "Life on the American Frontier," 41.

45. Hurley, "Farm Security Administration File," 248; Curtis, *Mind's Eye*, 117.

46. Curtis, *Mind's Eye*, 113; Wood, *Heartland, New Mexico*, 72. In 1980 George Hutton, Jr., recounted to Bill Ganzel the secret of Lee's success in gaining access to people's homes and lives. "Russell and his wife was very, very likable people," he said, "very likable." Ganzel, *Dust Bowl Descent*, 84–85.

47. On how other members of the Pie Town community perceived the Huttons, see Myers, *Pie Town Woman*, 176.

48. Curtis, *Mind's Eye*, 113.

49. In a later interview Lee related how he used people's

photographs as a way of justifying his own work and presence. "Someday I realized that these photographs will have historic value." Lee professed, "I'd say, why do I want to take your picture? In part for this: you value your picture of your mother and father there. That is of a certain period. I want to take your picture because it too is a certain period. It is going to be of today [and] tomorrow's history." *Today, Tomorrow's History: Photographer Russell Lee*, VHS. Jean Lee noted that many homes in Pie Town featured photographs and images of "sturdy ancestors" as a way of maintaining a deeply rooted connection to the past. See "Tenant Farmers in Oklahoma, General Caption no. 20," LOC.

50. Ganzel, *Dust Bowl Descent*, 84. The Hutton family was not the only one pining for the fields and farms of their past. When Seema Weatherwax accompanied Woody Guthrie to the Shafter camp in 1941 she found a migrant woman who was proud to show her a painting of her home in Ada, Oklahoma, from around 1916. Like the Hutton photograph it displayed a prosperous home and farm and encapsulated the memories of what had been left behind. Sara Halprin, *Seema's Show: A Life on the Left* (Albuquerque: University of New Mexico Press, 2005), 130–34.

51. According to Geoffrey Batchen, "In a photograph, the thing pictured is transformed into a portable visual sign (mobilizing that thing, and also completing its commodification). . . . Photographs are nothing if not humble, ready to erase their own material presence in favor of the subjects they represent. Typically, we are expected to look through a photograph as if it were a sort of window, to penetrate its limpid, transparent surface with our eyes and see only what lies within." Batchen, *Forget Me Not*, 73.

52. Steinbeck, *Grapes of Wrath and Other Writings*, 306. Woody Guthrie also understood the transformative power of the photograph. In his novel *Bound for Glory* one character stated, "I'd like to be there" when looking at a photograph. Guthrie, *Bound for Glory* (New York: E. P. Dutton, 1943).

53. Steinbeck, *Grapes of Wrath and Other Writings*, 301.

54. According to Joan Myers, "In America we make no mention of failure. Yet, the efforts of the Pie Town homesteaders of the 1930s and 1940s, as documented by Russell Lee, were futile. The idea of planting a garden, milking a few cows, and thereby making a life for their families on a section of arid land did not square with reality. Eventually they had no choice but to leave." Myers, *Pie Town Woman*, 168.

55. In an interview with Joan Myers, Jean Lee confessed, "We knew these people probably couldn't make it. That land shouldn't ever have been stirred with a stick. There was not good topsoil, none at all. Actually, we really shouldn't have taken a photograph in Pie Town. They give a false impression. It was such a desperate period, but this was no answer. . . . It appealed to people elsewhere in the country. It was a nostalgia thing even then. It appealed to everybody, to Stryker, to the magazines." For her part Myers calls Lee's documentation of the town a "wonderful mythic story." Myers, *Pie Town Woman*, 175–77.

56. Stryker to Lee, April 22, 1940, quoted in Myers, *Pie Town Woman*, 110.

57. Jean Lee, "Tenant Farmers in Oklahoma," General Caption no. 20," LOC.

58. Ibid.

Chapter 7

1. Roy Stryker to Russell Lee, May 17, 1939, Stryker Papers.
2. Lesy, *Long Time Coming*, 320.
3. Russell Lee to Roy Stryker, May 11, 1939, Stryker Papers.
4. See Carlebach, "Documentary and Propaganda," 23.
5. Roy Stryker to Arthur Rothstein, May 17, 1939, Stryker Papers.
6. Roy Stryker to Russell Lee, June 22, 1939, Stryker Papers.
7. Edwin Locke to Roy Stryker, April 28, 1939, Stryker Papers.
8. Stevens, "Steinbeck's Uncovered Wagon," reprinted in McElrath, Crisler, and Shillinglaw, *John Steinbeck: Contemporary Reviews*, 158.
9. Leon Whipple, "Novels on Social Themes," *Survey Graphic*, June 1939, 401.
10. Brady quoted in Starr, *Endangered Dreams*, 263–64. See also Sackman, *Orange Empire*, 279–80; Wartzman, *Obscene in the Extreme*, 39–40.
11. Roy Stryker to Marion Post Wolcott, June 22, 1939, Stryker Papers; Clark, *Heart of Maynard Dixon*, 141. See also Nelson, *In the Direction of His Dreams*, 265.
12. Ralph Taylor, "Farmer's Corner: Views from the Dust Bowl," newspaper clipping, *Todd and Sonkin, Voices from the Dust Bowl*, LOC; Joan B. Barriga, "Lark on a Barbed-Wire Fence: Ruth Comfort Mitchell's *Of Human Kindness*," *Steinbeck Newsletter* 2, no. 2 (Summer 1989): 3–4.

In *Grapes of Gladness* M. V. Hartranft, a Los Angeles real estate developer, recounts the journey of the fictional Hoag family from Oklahoma through the Painted Desert to Barstow and eventually Los Angeles. On their arrival they realize that "California is not finished yet" and are welcomed and cared for. The novel ends with the Hoags driving to rescue fellow migrants and friends from the Shafter camp in Kern County. In addition to promoting the general theme of gladness, Hartranft took opportunities to criticize unnamed "fictional writers" for describing the Okies as profane, "belching, sex mongering" thieves. He also took the federal government to task for producing idlers (see pp. 45–46, 54, 105). His assertion that Los Angeles would be able to absorb many of these new refugees was in fact corroborated by the findings of Gregory in *American Exodus*, 42–52.

Ruth Comfort Mitchell, a native of California and wife of California state senator Sanborn Young, attempted to look at the migrant problem from the point of view of the California farmer. In *Of Human Kindness* she attempted to show that not all California growers were heartless capitalists. Rather, they could be kind and charitable to the hapless Okies. Like Steinbeck Mitchell ends her novel with a flood among fruit trees. Unlike in *Grapes of Wrath*, where there seems to be no rescue from the calamity, Mitchell has a farmer save stranded migrants with his tractor (see pp. 5–6, 117). In all, Mitchell's book was a far more successful rebuttal than Hartranft's. McWilliams, in fact, believed that Mitchell's book should be read in conjunction with *Grapes of Wrath*. On Mitchell and the literary campaign against Steinbeck see Sackman, *Orange Empire*, 280–81; Shillinglaw, *On Reading* The Grapes of Wrath, 169.

Among other rebuttals to *Grapes of Wrath*, Emory G. Hoffman, secretary of the Kern County Chamber of Commerce, produced a three-reel film titled *Plums of Plenty*, which was shown at the San Francisco Golden Gate International Exposition in 1939. Other writers were direct in their attack on Steinbeck. Among them was California writer George Miron who wrote of Steinbeck's missteps, which he called "Steinbeckisms." Miron, *Truth about John Steinbeck*.

13. Taylor, "Farmer's Corner"; Barriga, "Lark on a Barbed-Wire Fence," 3–4. See also Adamic, *My America*, 381.
14. In a delightful irony, which Frank J. Taylor certainly did not relish, the November 1939 issue of *The Forum* that contained "California's Grapes of Wrath" also featured an advertisement touting *The Grapes of Wrath* as "Steinbeck's great novel" and "The most famous book of its time—a landmark in world literature." *The Forum*, November 1939, v.

The two woodblock images that accompanied Taylor's article were taken from Clare Leighton's book *The Farmer's Year: A Calendar of English Husbandry* (Longmans, Green and Co., 1933). Leighton, a staunch proponent of leftist politics in England, likely would have appreciated Steinbeck's work more than Taylor's. In using Leighton's woodblocks entitled "August, Harvesting" and "September, Apple Picking," either Taylor or his publishers made a deliberate decision to make California's picking fields look like a bucolic English scene featuring well-clothed, well-fed men in idealized landscapes. This is the antithesis of the vision presented to readers in *The Grapes of Wrath*. See F. Taylor, "California's Grapes of Wrath," 234, 235. Taylor also issued his article as a pamphlet sans Leighton's work.

15. Probably the best remembered counter-image was a billboard campaign sponsored by the National Association of Manufacturers, which featured a white, middle-class family in their car with the caption: "There's No Way Like the American Way." Not surprisingly, the FSA photographers could not pass up the irony of the billboard and photographed it on several occasions. The most famous image containing this billboard came from *Life* photographer Margaret Bourke-White, who photographed African Americans waiting in a soup line in front of the blissful vision of the American dream. See Sackman, *Orange Empire*, 236, 253ff.
16. Shillinglaw, *On Reading* The Grapes of Wrath, 95. On Hader and his connection to *The Grapes of Wrath* see Arthur Krim, "Elmer Hader and *The Grapes of Wrath* Book Jacket," *Steinbeck Newsletter* 4 (Winter 1991): 1–3; Shillinglaw, *On Reading* The Grapes of Wrath, 95–96.
17. Krim suggests Hader composed this image from his own memories and "undoubtedly drew on Dust Bowl news photos for his depiction of migrant cars." Krim, "Elmer Hader," 3.
18. This article is filled with contradictions, which were noted at the time. In May 1939 the journal *Common Sense* commented that the article was "presented . . . both as human tragedy and as economic menace. And as both [the problem of migration] is overwhelming." "Migratory Labor," review, *Common Sense* 8, no. 5 (May 1939): 28; Lisca, "Grapes of Wrath: Achievement of Genius," in Davis, *Grapes of Wrath: Critical Essays*, 62.
19. "I Wonder Where We Can Go Now," 96. In addition to his work with *Fortune, Life,* and the Public Works of Art Project (under the direction of Edward Bruce and the aegis of the U.S. Treasury Department), Millard Sheets, a native of California, pursued a successful career as a teacher, designer, mosaicist, and architect.

He also deserves to be remembered for the poignant cityscapes he made in the 1930s. See *Millard Sheets: A Legacy of Art & Architecture* (Los Angeles: Los Angeles Conservancy, 2012).

20. Russell Lee to Roy Stryker, May 11, 1939, Stryker Papers.

21. "The Grapes of Wrath: John Steinbeck Writes a Major Novel about Western Migrants," *Life,* June 5, 1939, 66–67.

22. Finnegan, *Picturing Poverty,* 185–86.

23. "The Story behind 'The Grapes of Wrath': America's Own Refugees," *Look,* August 29, 1939, 16–23. See also Finnegan, *Picturing Poverty,* 204–19.

24. John Steinbeck, *Grapes of Wrath* (New York: Limited Editions Club, 1940). The original printing of this edition was issued on subscription at $15 and was touted as "an important addition to the all-too-short list of well-illustrated books." See also Shindo, *Dust Bowl Migrants,* 118–19. Thomas Craven, "Thomas Benton and *The Grapes of Wrath,*" in Steinbeck, *Grapes of Wrath* (1940 edition), xviii–xxi. See also Robert B. Harmon, "Thomas Hart Benton and John Steinbeck," *Steinbeck Newsletter* 1, no. 2 (Spring 1988): 1–2; Justin Wolff, *Thomas Hart Benton: A Life* (New York: Farrar, Straus, and Giroux, 2012), 323.

25. Benton, *Artist in America,* 65.

26. Shillinglaw, *On Reading* The Grapes of Wrath, 163.

27. John Ditsky, "*The Grapes of Wrath:* A Reconsideration," *Southern Humanities* 13 (Summer 1979): 216.

28. Quotation in Raeburn, *Staggering Revolution,* 159. I do not intend to suggest that Benton did not know of the "dust-blown realities of Oklahoma" and the plight of Negro and white sharecroppers. In his autobiography he discusses the "very poor and unfortunate people, ignorant and backward" who were "left to drift on the edges of the machine age." Benton, *Artist in America,* 72–74, 242.

29. Benson and Loftis, "John Steinbeck and Farm Labor Unionization," 196.

30. Bernarda Bryson Shahn, quoted in Kehl, "Steinbeck's 'String of Pictures,'" 2.

31. Adams asserts that Steinbeck's descriptive powers were less dependent on "the camera" than those of Sinclair Lewis, whom he called "the greatest photographer in our fiction." J. Donald Adams, *The Shape of Books to Come* (New York: Viking Press, 1945), 132–36. See also William Howarth, "The Mother of Literature: Journalism and *The Grapes of Wrath*"; and Leslie Gossage, "The Artful Propaganda of Ford's *The Grapes of Wrath,*" both in Wyatt, *New Essays on* Grapes of Wrath, 87, 95, 106–107.

32. In her "My Day" column of June 28, 1939, Mrs. Roosevelt stated, "Now I must tell you that I have just finished a book which is an unforgettable experience in reading. 'The Grapes of Wrath,' by John Steinbeck, both repels and attracts you. The horrors of the picture, so well drawn, make you dread sometimes to begin the next chapter, and yet you cannot lay the book down or even skip a page." Eleanor Roosevelt, "My Day," June 28, 1939, www.gwu.edu/~erpapers/myday/ (accessed July 18, 2013). See also Peter Lisca, *The Wide World of John Steinbeck* (1958; reprint, New York: Gordian Press, 1981), 166.

33. Benson and Loftis, "John Steinbeck and Farm Labor Unionization," 222.

34. Roy Stryker to Russell Lee, May 17, 1939, Stryker Papers.

35. For more on the history of exhibitions within the RA and FSA, see Severin, "Photographic Documentation by the Farm Security Administration," 24–28; Rebecca Walton O'Malley, "'How American People Live': An Examination of Farm Security Administration Images and Exhibition Spaces" (MA thesis, School of Art and Design, Pratt Institute, New York, 2012), 47–53, 60–89.

36. Jonathan Garst to Dr. Will Alexander, May 16, 1937, Hollenberg Collection.

37. Hurley, *Portrait of a Decade,* 144; Werner J. Severin, "Cameras with a Purpose: The Photojournalists of the F.S.A," *Journalism Quarterly* (Spring 1964): 194–97; Cohen, *The Like of Us,* xxvi. For a detailed analysis of FSA exhibition programs see Raeburn, *Staggering Revolution,* 183–93. See also Tagg, *Burden of Representation,* 88. Helen Hosmer, acting on behalf of the Simon Lubin Society, requested and received exhibition material from Roy Stryker in January 1939. The purpose of the exhibition, Hosmer reported, was to counteract the public relations work of the Associated Farmers. She promised "dynamite, only in a dignified, polite form." Stryker was happy to oblige, assuring her "our interests lie very close to yours." Hosmer to Stryker, January 25, 1939, and Stryker to Hosmer, February 1, 1939, FSA/OWI Written Records.

38. The exhibition *The Drama of America: Photographs from the Farm Security Administration,* featuring eighty FSA images, was sent to the Cleveland Museum of Art. The traveling exhibition at the Museum of Modern Art (MoMA) was titled *Documents of America: The Rural Scene* and featured thirty photographs from the FSA files. See Raeburn, *Staggering Revolution,* 186–87; Howe, "You Have Seen Their Pictures, 238; O'Malley, "'How American People Live,'" 74–75.

39. Roy Stryker to Edmund Teske, May 15, 1940, FSA/OWI Written Records.

40. Louise Rosskam, "Remembering the 20th Century: An Oral History of Monmouth County," interview by Gary Saretsky, March 24, 2000, http://www.visitmonmouth.com/oralhistory/bios/RosskamLouise.htm (accessed September 19, 2014).

41. Rosskam, "Not Intended for Framing," 11. Edwin Rosskam worked for the FSA intermittently between 1939 and 1943. Katzman and Brannan, *Re-viewing Documentary,* 13–15. Born in Germany to American parents, Rosskam migrated to the United States and eventually returned to Europe in the 1920s. There he was influenced by surrealism and other modernist ideas. Edwin and Louise Rosskam met around 1933 and were married three years later. Despite the merit of her photographs, many of which Stryker commandeered for the FSA/OWI files, Louise was not on Stryker's payroll. On Edwin Rosskam see Lesy, *Long Time Coming,* 319; on Louise Rosskam and her career consult Katzman and Brannan, *Re-viewing Documentary.*

42. Edwin Rosskam, *Washington, Nerve Center,* co-edited by Ruby A. Black, introduction by Eleanor Roosevelt, Face of America Series (New York: Longmans, Green, 1939), 7.

43. Edwin and Louise Rosskam, oral history interview.

44. Rosskam, "Not Intended for Framing," 11.

45. Frederick Soule to Grace E. Falke, June 15, 1936, Hollenberg Collection. Soule and Dorothea Lange organized exhibitions of RA/FSA photographs as early as 1935. Soule,

the regional information advisor for Region IX, was very active in pushing exhibitions to venues large and small in California, including expositions, fairs, and women's clubs. These exhibitions were not always sanctioned by the national office. In one letter to Soule, Lange admitted not wanting to go through the Exhibition Division of the RA. Instead, she hoped to "steal a print here, and steal a print there, pick up the prints that fall behind the desk— and we'll have some photographs yet." Lange to Soule, May 20, 1936, Hollenberg Collection. See also Jonathan Garst to Dr. Will Alexander, May 16, 1937, and July 8, 1937, Hollenberg Collection; Goggans, *California on the Breadlines*, 242–43.

46. According to Grace Falke Tugwell, Rexford Tugwell's second wife and former administrative assistant, who was closely associated with the FSA's exhibition program, "we were always torn between wanting to exhibit this material and not wanting to do it so flamboyantly that some local congressman could complain about the amount of money that was being spent. So our exhibits never amounted to anything in the eyes of anybody, any of us. We always felt that we were always pulling in horns while at the same time trying so hard to put the point over. It was always difficult." Rexford Tugwell, oral history interview.

47. "Roy Stryker on FSA, SONJ, J & L (1972)," 152.

48. Stuart Kidd notes that there were five sets of *Grapes of Wrath* exhibits traveling through the United States. Charlotte Aiken, Stryker's former assistant, also remembered the exhibition going "all over the United States." Kidd, *Farm Security Administration Photography*, 184; Charlotte Aiken and Helen Wool, oral history interview, April 17, 1964, Archives of American Art, Smithsonian Institution.

49. See Stange, *Symbols of Ideal Life*, 129.

50. The images in this exhibit included John Vachon's photograph of a migrant woman from Arkansas in a roadside camp, Berrien County, Michigan (July 1940); Marion Post Wolcott's photograph of the metal shelters in Belle Glade migrant camp, Florida (1941); Arthur Rothstein's images of an abandoned plow from Jackson County, Alabama (April 1937), of the Visalia camp nursery, and of the Tulare camp nurse (both 1940); and Dorothea Lange's images of an abandoned cabin in the Mississippi Delta (1937), of laundry facilities in an FSA migrant camp (LC-USF34-019483-C, 1939), of the deep empty furrows left by mechanical farming in Texas (1938), and of pea pickers in Imperial County, California (1939).

51. Almost thirty years later Rosskam reported to Richard Doud, "When Dorothea did her coverage on migration—I remember doing a number of exhibits, incidentally on the *Grapes of Wrath*." Edwin and Louise Rosskam, oral history interview. Rosskam also wanted information pertaining to the portable metal shelters, or units, that the FSA was using to aid migrants in the West. Roy Stryker and Edwin Rosskam to Dorothea Lange, September 16, 1939. Louise Rosskam was also involved with the migrants' cause as a member of the National Council to Aid Workers in Washington, DC. Carey McWilliams to Louise Rosskam, telegram, March 26, 1940, Carey McWilliams Papers.

52. Roy Stryker to Dr. Frederick Reustle, April 22, 1940, FSA/OWI Written Records. Dr. Reustle was minister of the Van Wyck Avenue Congregational Church in Jamaica, NY, which hosted the exhibition in 1940.

53. Charlotte Aiken and Helen Wool, oral history interview. "Unusual Photo Exhibit, June 7 at Casa Verde," *Carmel Cal Pine Cone*, June 2, 1939.

54. In 1936 Jonathan Garst organized a four-panel traveling exhibition on migratory workers that was shown at the San Diego County Fair and elsewhere. Frederick Soule to Mrs. Durning, October 13, 1936, and Garst to Rexford Tugwell, December 16, 1936, both in Hollenberg Collection.

55. Frederick Soule to Roy Stryker, March 14, 1939, Hollenberg Collection. See also Velma Shotwell to Susanna Paxton, information assistant, June 26, 1939, Hollenberg Collection; and Roy Stryker to Dorothea Lange, March 4, 1939, Stryker Papers.

56. Frederick Soule to Roy Stryker, October 17 and 28, 1939, Hollenberg Collection.

57. It is unclear whether the Steinbeck Committee possessed the full *Grapes of Wrath Picture Exhibit* or simply mounted photographs that referenced Steinbeck's work in some manner. Frederick Soule to Roy Stryker, October 28, 1939, Hollenberg Collection.

58. Ibid. For more on Douglas's involvement see Helen Gahagan Douglas, *A Full Life* (Garden City, NY: Doubleday, 1982), 141–46.

59. Willard Park to Roy Stryker, March 1, 1940, FSA/OWI Written Records. Park, a graduate of the University of California, Berkeley, was also interested in pursuing a collaborative work with Taylor, which never materialized. Roy Stryker to Dorothea Lange, September 7, 1939, and Russell Lee to Roy Stryker, May 27, 1939, Stryker Papers.

60. "Pictorial Display Will Portray Life of Rural America," *Oklahoma Daily*, February 29, 1940, 4; Severin, "Cameras with a Purpose," 194. See the following *Oklahoma Daily* articles: "FSA Photos Will Be Placed on Exhibit," March 5, 1940; "State Sharecropper's Plight Portrayed," March 6, 1940, 1; and "Additional Copies of 'Grapes of Wrath' Given to Library," April 3, 1940, 1. See also Raeburn, *Staggering Revolution*, 183.

61. Willard Park to Roy Stryker, March 1, 1940, FSA/OWI Written Records.

62. "Pictorial Display Will Portray Life of Rural America."

63. Jack Brumm, "Mr. Rogers and the Joad Family," *Oklahoma Daily*, March 15, 1940, 2.

64. Viola Van Duyne, "Joad-Like, Our Tower Town Folk Are Barely Getting By," *Oklahoma Daily*, March 31, 1940, 1, 3.

65. Severin, "Cameras with a Purpose," 194; Howe, "You Have Seen Their Pictures," 238.

66. FSA photographs were typically displayed on 32-inch-by-42-inch panels with wooden frames. Stryker also prepared smaller panels (15 by 20 inches) for smaller venues. Frederick Soule to Roy Stryker, October 17, 1939, Hollenberg Collection.

67. Frederick Soule to Roy Stryker, October 17, 1939, Hollenberg Collection.

68. Edwin Rosskam evidently used a similar tactic for the 1941 FSA exhibition *In the Image of America*, shown in the Science and Industry Exhibition at Rockefeller Center, New York City.

69. Russell Lee photographed the auction sale poster in 1937 near Charlson, South Dakota. It advertised the sale of nine horses and farm machinery.

70. Curtis, *Mind's Eye*, 66–67.

71. Daniel Dixon, "Dorothea Lange," *Modern Photography*, December 1952, 68; Edwin and Louise Rosskam, oral history interview.

72. Edward Steichen, "The F.S.A. Photographers," in Maloney, *U.S. Camera, 1939*, 44.

73. See F. Jack Hurley, *Marion Post Wolcott: A Photographic Journey*, foreword by Robert Coles (Albuquerque: University of New Mexico Press, 1989), 68, 38.

74. Quoted in Orvell, *John Vachon's America*, 165, 17. In 1943 Vachon also followed Lee's route through Texas and added to the latter's sizable documentation of San Augustine. Reid, *Picturing Texas*, 10–11.

75. In an oral history interview with Richard Doud, Vachon confirmed, "I went around looking for Walker Evans's pictures." He also recounted, "I remember once in Atlanta where I knew so well a certain house he had photographed, I would walk all over town looking for it, and when I'd find the real thing, you know, maybe three or four years after he had—because he did all his work quite early in '35, I think—and when I'd see the honest-to-God Walker Evans in reality, it was like a historic find." Vachon, oral history interview, April 28, 1964, Archives of American Art, Smithsonian Institution. Elsewhere Vachon noted, "I think it's just that the things he saw I also saw and liked the way he looked at them." O'Neal, *Vision Shared*, 70.

76. Quoted in Orvell, *John Vachon's America*, 17.

77. Ibid., 222. For more on Vachon's work in Oklahoma see ibid., 220, 290–91.

78. Russell Lee and Jean Lee, oral history interview, June 2, 1964, Archives of American Art, Smithsonian Institution.

Chapter 8

1. Mother Sue Sanders visited Arvin camp; "Woman Finds Migrants Clean, Ambitious Folk," newspaper clipping, *Todd and Sonkin, Voices from the Dust Bowl*, LOC. Also see Sue Sanders's autobiography, *Our Common Herd* (Garden City, NY: Barton Syndicate, 1939).

2. Roosevelt quoted in Brigod O'Farrell, *She Was One of Us: Eleanor Roosevelt and the American Worker* (Ithaca, NY: ILR Press/Cornell University Press, 2010), 78 n. 2. In the Central Valley Roosevelt and the Douglases were escorted by FSA officials, including regional director Lawrence Hewes, and experienced "hundreds of thousands of little farmers, sharecroppers, tenant farmers, and farm hands" on the road. They also visited the FSA camps at Kern, Shafter, and Visalia and the Mineral King Ranch cooperative. See Helen Gahagan Douglas, *The Eleanor Roosevelt We Remember* (New York: Hill and Wang, 1963), 21–22; E. Roosevelt, "My Day," April 4–6, 1940, quotation from April 6, www.gwu.edu/~erpapers/myday/ (accessed July 18, 2013).

3. Various reports state that Steinbeck received from $70,000 to $100,000 for the movie rights. See Mel Gussow, *Don't Say Yes Until I Finish Talking: A Biography of Darryl F. Zanuck* (Garden City, NY: Doubleday, 1971), 290–93.

4. During his background research for *The Grapes of Wrath* Steinbeck traveled to Hollywood in February 1938 to meet with Lorentz. Starr, *Endangered Dreams*, 257.

5. Clark Davis and David Igler, eds., *The Human Tradition in California* (Lanham, MD: Rowman and Littlefield, 2002), 143; Benson, *True Adventures of John Steinbeck*, 409.

6. Loftis, *Witness to the Struggle*, 173–74. There was also a story that Zanuck went out and stayed with the migrants in order to corroborate Steinbeck's story. Benson, *True Adventures of John Steinbeck*, 409.

7. Dan Ford, *Pappy: The Life of John Ford* (Englewood Cliffs, NJ: Prentice-Hall, 1979), 141–42.

8. The person responsible for the connection to Benton was the film's art director, Richard Day. It has also been claimed that Woody Guthrie, apparently at Steinbeck's suggestion, served as an uncredited "musical advisor" for the film. This seems unlikely given that Guthrie claimed the film was his first contact with Steinbeck's work. Goetzmann and Goetzmann, *West of the Imagination*, 445; Krim, *Route 66*, 108; Ford, *Pappy*, 143; Steinbeck, *Steinbeck: Life in Letters*, 195; Ed Cray, *Ramblin' Man: The Life and Times of Woody Guthrie* (New York: W. W. Norton, 2004), 154–55. See also Henry Adams, "Thomas Hart Benton's Illustrations for *The Grapes of Wrath*," *San Jose Studies* 16, no. 1 (Winter 1990): 6–18.

9. Girvin, "Photography as Social Documentation," 218.

10. The connection between Steinbeck and Lorentz deserves further consideration. Steinbeck's wife, Carol, introduced the two in 1938, and they quickly became friends and allies who supported each other's work. One example occurred in 1939, when Steinbeck secretly solicited assistance from President and Mrs. Roosevelt for Lorentz and the U.S. Film Service. See St. Pierre, *Steinbeck: California Years*, 104. See also Pare Lorentz, *FDR's Moviemaker: Memoirs and Scripts* (Reno: University of Nevada Press, 1992), 108–15.

11. Arthur Krim, "Filming Route 66: Documenting the Dust Bowl Highway," in Stuart C. Aitkin and Leo E. Zonn, eds., *Place, Power, Situation, and Spectacle* (Lanham, MD: Rowman and Littlefield, 1994), 191, 197.

12. Shillinglaw, *On Reading* The Grapes of Wrath, 178.

13. Wartzman, *Obscene in the Extreme*, 205; Rich Remsberg, *Hard Luck Blues: Roots Music Photographs from the Great Depression* (Urbana: University of Illinois Press, 2010), 116.

14. The farthest east Henry Fonda and the rest of the cast traveled during filming was the Colorado River, for the bathing scene. Condon, "Grapes of Raps," 23, 64; Krim, *Route 66*, 107–109.

15. Wartzman, *Obscene in the Extreme*, 200; Mayo, *Sallisaw Historical Highlights*, 66.

16. Condon, "Grapes of Raps," 67. According to Frank Condon, Brower purchased the jalopies from astonished dealers and outfitted them with new engines and axles. Ibid., 23.

17. Baskind, "'True' Story," 42.

18. Shillinglaw, *On Reading* The Grapes of Wrath, 177–78.

19. St. Pierre, *Steinbeck: California Years*, 104; Krim, *Route 66*, 108; See also George Bluestone, "Grapes of Wrath," in Davis, *Grapes of Wrath: Critical Essays*, 92. Girvin, "Photography as Social Documentation," 215. Edwin Locke, Stryker's former assistant and photographer, did not mention the use of FSA photographs in his review of the film, perhaps implying that the role of the FSA was overstated. In his review he mentioned Lange as "the most passionate observer at work in this country." Locke, "The Grapes of Wrath," *Films*, Spring 1940, reprinted in Stanley Kaufmann, ed.,

American Film Criticism: From the Beginnings to Citizen Kane (New York: Liveright, 1972), 387. Thomas Hart Benton's lithographs were apparently also consulted. Craven, "Thomas Benton and *The Grapes of Wrath*," in Steinbeck, *Grapes of Wrath* (1940), xx; Baskind, "'True' Story," 42; also Leslie Gossage, "The Artful Propaganda of Ford's *The Grapes of Wrath*," in Wyatt, *New Essays on* The Grapes of Wrath, 114–15.

20. Mayer does not cite a source for this information. As curator at MoMA under Edward Steichen, however, she was probably privy to many insights regarding the project. Edward Steichen, ed., *The Bitter Years, 1935–1941: Rural Life as Seen by the Photographers of the Farm Security Administration* (New York: Museum of Modern Art, 1962), vi; see Gordon, "Dorothea Lange: Photographer as Agricultural Sociologist," 698. Joseph R. Millichap suggested that Lange's images might also have served as the visual inspiration for Lewis Milestone's adaptation of *Of Mice and Men* (1940). Millichap, *Steinbeck and Film* (New York: Frederick Ungar, 1983), 19.

21. Girvin, "Photography as Social Documentation," 215; Ben Shahn, oral history interview.

22. Heyman et al., *Celebrating the Collection*, 78. In an interesting and somewhat strange conflation of imagery Paul S. Taylor's instructive pamphlet on migration "Adrift on the Land," printed in April 1940, featured photographs by Lange, a lithograph by Benton, a quotation from *Grapes of Wrath*, and a *Grapes of Wrath* film still. Thus, a shot of actors Henry Fonda, Jane Darwell, and Russell Simpson (Pa Joad) with the caption "The life of the migrant is hard" was presented along with FSA photographs of actual migrants without explanation (see p. 19). See also Meltzer, *Dorothea Lange: Photographer's Life*, 203; Shindo, *Dust Bowl Migrants*, 118–19; Starr, *Endangered Dreams*, 266.

23. According to Bluestone, Ford admitted "with just the slightest trace of whimsy and bravado" that 'I never read the book'"; Bluestone, "Grapes of Wrath," 99. Other sources assert that Ford knew the book well. St. Pierre writes, "John Ford, who claimed to never have read the book, pretty much shot it as it was on the page"; St. Pierre, *Steinbeck: California Years*, 103. See also Shindo, *Dust Bowl Migrants*, 159–60.

24. John Ford quoted in Shillinglaw, *On Reading* The Grapes of Wrath, 178.

25. "Darryl Zanuck Presents 'Hollywood's Most Controversial Film': *The Grapes of Wrath*," *Look* 4 (January 16, 1940): 52–53. It is easy to imagine the inspiration of the Beverly Hillbillies television series in this article. As the "Ballad of Jed Clampett" tells, the Clampetts also ended up in "Beverly (Hills, that is, swimming pools, movie stars)."

26. Zoe Brown, "Dorothea Lange: Field Notes and Photographs," 642.

27. "Grapes of Wrath," "Voice of the Agricultural Worker (VOTAW)," March 29, 1940, newspaper clippings, *Todd and Sonkin, Voices from the Dust Bowl*, LOC.

28. Steinbeck, *Steinbeck: Life in Letters*, 195; Jay Parini, *John Steinbeck: A Biography* (New York: Henry Holt, 1995), 236; on the film's realism, see George Bluestone, *Novels into Film* (Berkeley: University of California Press, 1966), 168.

29. See Condon, "Grapes of Raps," 23; Wartzman, *Obscene in the Extreme*, 201–202.

30. To ensure that the film conveyed the same message as his novel, Steinbeck worked closely with screenwriter Nunnally Johnson and expressed his satisfaction with the screenplay.

31. See Ford, *Pappy*, 146.

32. Lorentz, *Lorentz on Film*, 183. Lorentz also held the film up as a standard for other filmmakers, arguing that it possessed the correct finesse, speed, and excitement. Lorentz, "Movies 1940," *U.S. Camera* 2 (1941): 206; See also Lorentz, "Grapes of Wrath," *McCall's*, April 1940, reprinted in Lorentz, *Lorentz on Film*, 183–85, 191.

33. See Archibald MacLeish, *A Time to Act: Selected Addresses* (Boston: Houghton Mifflin, 1943), 150–51; Stott, *Documentary Expression and Thirties America*, 22–23.

34. Field notes, 1940, Arvin Camp, *Todd and Sonkin, Voices from the Dust Bowl*, LOC.

35. For more on Guthrie, including his early life in the Dust Bowl and trek to California, see Guthrie, *Bound for Glory*; and Lomax, *Hard Hitting Songs for Hard-Hit People*, 21–25. On his claim of knowing the towns, see "About Woody," in ibid., 21, 232.

36. Quoted in Cray, *Ramblin' Man*, 156.

37. Woody Guthrie, *Pastures of Plenty: A Self-Portrait, The Unpublished Writings of an American Folk Hero*, edited by Dave Marsh and Harold Leventhal (New York: Harper Perennial, 1990), 21. Guthrie's friend Ed Robbin contradicts him, claiming: "Once [Woody] heard about Steinbeck, he *had* to read *The Grapes of Wrath*." See Cray, *Ramblin' Man*, 154.

38. Quoted in Krim, *Route 66*, 110–11; Guthrie, *Pastures of Plenty*, 9.

39. Jeff Place, "Woody Guthrie's Recorded Legacy," in Robert Santelli and Emily Davidson, *Hard Travelin': The Life and Legacy of Woody Guthrie* (Hanover, NH: Wesleyan University Press; University Press of New England, 1999), 58.

40. Guthrie, *Pastures of Plenty*, 9.

41. Benson, *True Adventures of John Steinbeck*, 393.

42. "Speaking of Pictures," *Life*, February 19, 1940. 10–11.

43. According to Vivian Subchack, "Certainly, the Joads on screen are specific and particular in their photographic realization; it is the nature of the medium [film] to particularize 'characters' and 'place' far more exactly and idiosyncratically than written language.... But the visual treatment of Henry Fonda's Tom Joad, Jane Darwell's Ma, Charlie Grapewin's Grandpa, John Carradine's Casy and John Qualen's Muley softens through physical individuality and resonates photographic specificity into expressive metaphor." Subchack, "*The Grapes of Wrath* (1940): Thematic Emphasis through Visual Style," *American Quarterly* 31 (Winter 1979), 602.

44. Hurley, *Portrait of a Decade*, 140. The FSA camps were also portrayed as deliverance in Sanora Babb's novel *Whose Names Are Unknown*, 136–59. Her protagonists, the migrant Dunne family, benefit from a camp in the Imperial Valley.

45. See Kazin, *On Native Grounds*, 395.

46. Edwin Locke, "Grapes of Wrath," *Films*, Spring 1940, reprinted in Kaufmann, *American Film Criticism*, 390. In fact 18 percent of the film took place at the Weedpatch migrant camp. In comparison slightly more than 15 percent of Steinbeck's text dealt with the FSA camps. Bluestone, "Grapes of Wrath," 80.

47. At the time of Rothstein's assignment to California, Lange was working for the Bureau of Agricultural Economics in California. It was well known that the camps were Lange's purview and, according to Richard Steven Street, Stryker intended to downplay her importance by sending Rothstein across the country to the camps in California. Street, *Everyone Had Cameras*, 309–10. For more on Rothstein's cross-country trip see James R. Swensen, "Passing Through: Arthur Rothstein's Photographic Account of Utah, March 1940," *Utah Historical Quarterly* 74, no. 1 (Winter 2006): 66–79.

48. Rothstein would work with Stryker again. At the beginning of World War II he joined the Office of War Information section and worked briefly under his old boss before joining the Signal Corps as one of their top photographers. Hurley, *Portrait of a Decade*, 166.

49. Quoted in Fleischhauer and Brannan, "FSA Migratory Labor Camps," in *Documenting America*, 188–90.

50. Rothstein's images also formed part of the exhibition that Helen Gahagan Douglas presented to groups in her role on the John Steinbeck Committee. Fred Soule to Roy Stryker, May 7, 1940, Hollenberg Collection.

51. FSA, *Migrant Farm Labor*, 8. On the number of camps see Grey, *New Deal Medicine*, 80; Starr, *Endangered Dreams*, 236; Sullivan, *Days of Hope*, 126; Brian Q. Cannon, "'Keep On A-Goin': Life and Social Interaction in a New Deal Farm Labor Camp," *Agricultural History* 70, no. 1 (Winter 1996): 2.

52. See Benson, "Background to the Composition of *Grapes of Wrath*," 72.

53. Gordon, *Dorothea Lange: Life beyond Limits*, 227.

54. F. Taylor, "California's Grapes of Wrath," 235.

55. Babb, *Whose Names Are Unknown*, 205.

56. Quoted in Gregory, *American Exodus*, 98.

57. E. Lowry, *They Starve That We May Eat*, 53.

58. Lawrence Hewes, "Notes for a Talk on the Migrant Problem," c. 1940, Hollenberg Collection.

59. Partridge and Stein, *Quizzical Eye*, 132.

60. Meltzer, *Dorothea Lange: Photographer's Life*, 230; Street, *Everyone Had Cameras*, 310.

61. Street, *Everyone Had Cameras*, 310.

62. Quoted in Fleischhauer and Brannan, *Documenting America*, 190.

63. It was reported that Margaret Bourke-White and Erskine Caldwell visited the camps while touring the United States for *Life* in 1940. Interestingly, there is no mention of this visit in Bourke-White's biographies, nor do any photos appear in their collaboration *Say, Is This the U.S.A.?* (1941). See Goldberg, *Margaret Bourke-White*, 233–35.

64. "Charles L. Todd and Robert Sonkin Collecting Expedition," *Todd and Sonkin, Voices from the Dust Bowl*, LOC.

65. Street, *Everyone Had Cameras*, 310.

66. A combination of shelters, labor homes, and cabins made up the housing; for many the rent was $16 a month. O'Reilly, "'Oklatopia,'" 64; "New Apartment House Unit at Migratory Camp," August 5, 1940, newspaper clipping, *Todd and Sonkin, Voices from the Dust Bowl*, LOC.

67. During his visit Rothstein also documented a few of the modern-looking apartments and homes at the newly constructed but as yet unopened migrant camp at Firebaugh in Fresno County. By 1941 Firebaugh was reported to have 345 homes on 384 acres, making it one of the largest camps created and maintained by the FSA. See O'Reilly, "'Oklatopia,'" 64. "Agricultural Workers Get Camp at Shafter," *Lodi News-Sentinel*, November, 12, 1937.

68. The one-year residency rule and the stigma of living in a "government camp" kept the more fortunate and established migrants away. Gregory, *American Exodus*, 70.

69. Quoted in Street, *Everyone Had Cameras*, 10.

70. "Testimony of Edith Lowry," in U.S. Congress, *Hearings*, 298–302.

71. McWilliams, *Factories in the Field*, 300; Gordon, *Dorothea Lange: Life beyond Limits*, 109.

72. See E. Lowry, *They Starve That We May Eat*, 57–60.

73. Babb, "There Ain't No Food (1938)," in Wixson, *On the Dirty Plate Trail*, 103–104.

74. P. Taylor "Migrant Farm Labor: The Problem and Some Efforts to Meet It," in Miscellaneous Material on Migratory Farm Labor and Related Subjects, 5, ca. 1940, LOC. P. Taylor, "Adrift on the Land," 21.

75. Quoted in Katherine G. Morrissey, "Migrant Labor Children in Depression-Era Arizona," in Katherine G. Morrissey and Kirsten M. Jensen, *Picturing Arizona: The Photographic Record of the 1930s* (Tucson: University of Arizona Press, 2005), 35.

76. This assistance to children was vitally needed. A 1938 report on children in the cotton camps revealed that 17 percent were suffering from malnutrition, a portion of them from rickets. In San Joaquin Valley camps, 28 percent of children lacked an adequate diet. Gregory, *American Exodus*, 64.

77. Todd and Sonkin also visited the nursery at Tulare and noted that nearly seventy-five preschoolers were resting on cots, under WPA supervision from 8:00 A.M. to 5:00 P.M. every day. Field notes, *Todd and Sonkin, Voices from the Dust Bowl*, LOC.

78. "Testimony of Edith Lowry," in U.S. Congress, *Hearings*, 308; Grey, *New Deal Medicine*, 103–108.

79. Gordon, *Dorothea Lange: Life beyond Limits*, 162.

80. Wixson, *On the Dirty Plate Trail*, 125; Gordon, *Dorothea Lange: Life beyond Limits*, 162.

81. Sanora Babb, "Farmers without Farms," *New Masses* (June 21, 1938), in Wixson, *On the Dirty Plate Trail*, 115. Steinbeck, *Grapes of Wrath and Other Writings*, 537. Also Wartzman, *Obscene in the Extreme*, 12, 42.

82. See Grey, *New Deal Medicine*, 78–99.

83. Rothstein was not the only photographer who recorded the various social activities of the camp. On her visit Sanora Babb did so as well. See Wixson, *On the Dirty Plate Trail*, 27; Cannon, "'Keep on A-Goin," 10–11.

84. W. Stein, "New Deal Experiment," 135.

85. Steinbeck, *Grapes of Wrath and Other Writings*, 515–16.

86. FSA, *Migrant Farm Labor*, 9.

87. Starr, *Endangered Dreams*, 237; Todd, "Okies Search for a Lost Frontier," 10–11; Field notes, August 6, 1940, *Todd and Sonkin, Voices from the Dust Bowl*, LOC. For a detailed list of the camps' amenities see McWilliams, *Factories in the Field*, 300–303.

88. Field notes, August 3, 1940, *Todd and Sonkin, Voices from the Dust Bowl*, LOC.

89. Gregory, *American Exodus,* 145–48; W. Stein, "New Deal Experiment,"138.

90. Steinbeck, "Rich Growers' Fostering of Prejudice."

91. Steinbeck, foreword to Lomax, *Hard Hitting Songs for Hard-Hit People,* 8.

92. In August 1940 Todd and Sonkin came across the Westfall and Pond families from Muskogee, Oklahoma. For them these families represented the "self-chosen intellectual aristocracy of the camps." *Todd and Sonkin, Voices from the Dust Bowl,* LOC.

93. Lomax, *Hard Hitting Songs,* 225.

94. "Hillbilly Gal," quoted in Gregory, *American Exodus,* 234.

95. Steinbeck, foreword to Lomax, *Hard Hitting Songs,* 9.

96. Gregory, *American Exodus,* 226, 241. Citing Dwight Yoakum, Peter La Chapelle suggests that "the cultural ethnicity of country music is the '*Grapes of Wrath* culture.'" La Chapelle, *Proud to Be an Okie: Cultural Politics, Country Music, and Migration to Southern California* (Berkeley: University of California Press, 2007), 18–21.

97. At Visalia, local businessmen objected to the low prices of goods at the camp store, feeling that it cut into their profits, and migrants were disgruntled over being required to pay local taxes for schools, health care, and other services. Fleischhauer and Brannan, *Documenting America,* 190.

98. Charles L. Todd, "Trampling Out the Vintage: Farm Security Camps Provide the Imperial Valley Migrants with a Home and a Hope," *Common Sense* 8, no. 7 (July 1939): 30.

99. Collins quoted in field notes, August 18, 1940, *Todd and Sonkin, Voices from the Dust Bowl,* LOC. Also see O'Reilly, "'Oklatopia,'" 56–57; Steinbeck, *Grapes of Wrath and Other Writings,* 538–52; Shillinglaw, *On Reading* The Grapes of Wrath, 139–40.

100. Shillinglaw, *On Reading* The Grapes of Wrath, 140.

101. W. Stein, "New Deal Experiment," 136. For more on religion in the camps see O'Reilly, "'Oklatopia,'" 44–58; McDannell, *Picturing Faith,* 136–37; Gregory, *American Exodus,* 194–97.

102. Quoted in Gregory, *American Exodus,* 194.

103. O'Reilly, "'Oklatopia,'" 46.

104. McDannell, *Picturing Faith,* 14–15, 16, 174; Shillinglaw, *On Reading* The Grapes of Wrath, 140–42.

105. Quoted in O'Reilly, "'Oklatopia,'" 46–47, 49.

106. Ibid., 55, 44.

107. Guthrie, *Pastures of Plenty,* 44–45.

108. Lawrence W. Levine, "The Historian and the Icon," in Fleischhauer and Brannan, *Documenting America,* 23.

109. W. Stein, "New Deal Experiment," 132–46.

110. Sanora Babb, "Migratory Farm Workers (1938)," in Wixson, *On the Dirty Plate Trail,* 100–101. See also Steinbeck, *Grapes of Wrath and Other Writings,* 515. On the democratic nature of the camps see W. Stein, "New Deal Experiment," 141–45; O'Reilly, "'Oklatopia,'" 25–33.

111. Quoted in Todd, "Trampling Out the Vintage," 8. Osborn's rhetoric aligned well with his organization, the Associated Farmers, and their mandate to combat unionization. Gregory, *American Exodus,* 89.

112. Field notes, August 18, 1940, *Todd and Sonkin, Voices from the Dust Bowl,* LOC. See also F. Taylor, "California's Grapes of Wrath," 236; Gordon, *Dorothea Lange: Life beyond Limits* 255; Wixson, *On the Dirty Plate Trail,* 119; W. Stein, "New Deal Experiment," 139.

113. See Swensen, "Focusing on the Migrant," 195–96. Among the forces Cannon cited as creating disunity and divisions among the migrants in federal camps were religion, lack of privacy, theft, and different standards of cleanliness. Cannon, "'Keep on A-Goin,'" 22.

114. Jean Lee, "Tenant Farmers in Oklahoma," "General Caption no. 20," LOC.

115. Todd, "Trampling Out the Vintage," 30.

116. Roosevelt, "My Day," April 5, 1940, www.gwu.edu/~erpapers/myday/ (accessed July 18, 2013).

117. Sanora Babb, "There Ain't No Food," in Wixson, *On the Dirty Plate Trail,* 106.

118. Steinbeck, *Grapes of Wrath and Other Writings,* 445.

119. See Todd, "Okies Search for a Lost Frontier," 10.

120. Terkel, *Hard Times,* 243; "Testimony of Edith Lowry," in U.S. Congress, *Hearings,* 309.

121. Anne Wilkes Tucker, "Photographic Facts and Thirties America," in David Featherstone, ed., *Observations: Essays on Documentary Photography (Untitled 35)* (Carmel, CA: Friends of Photography, 1984), 48, 53; see also Szarkowski, *Looking at Photographs,* 116. Agee and Evans, *Let Us Now Praise Famous Men,* 145. Rothstein was not alone in creating portraits in the manner of Evans. Gordon noted that every FSA photographer, including Lange, made a few of these "Evans shots." Gordon, *Dorothea Lange: Life beyond Limits,* 260.

122. Susan Sontag, *On Photography* (New York: Farrar, Straus, and Giroux, 1977), 6.

123. Arthur Rothstein, oral history interview.

124. See Cannon, "'Keep on A-Goin,'" 8; Lawrence Hewes, "Notes for a Talk on the Migrant Problem," c. 1940, Hollenberg Collection; Works Projects Administration, *Rural Migration in the United States,* edited by C. E. Lively and Conrad Tauber (Washington, DC: Government Printing Office, 1939), 104–105.

125. Steinbeck, *Harvest Gypsies,* 40–41.

126. Raeburn, *Staggering Revolution,* 152, 328 n. 22.

127. Starr, *Endangered Dreams,* 254, 258.

128. Street, *Everyone Had Cameras,* 310.

129. Roy Stryker to Arthur Rothstein, August 39, 1939. Quoted in Lesy, *Long Time Coming,* 325. The *Faces of America* exhibition was already in circulation at the time Rothstein captured this portrait series at Visalia. Stryker was not the only one interested in the faces of America. Sherwood Anderson was also working on a book series titled Faces of America, which attempted to define the essence of the American. His book *Home Town* (1941), which was heavily illustrated with FSA photographs, was part of this short-lived series. Hurley, *Marion Post Wolcott,* 72.

130. In 1942 the OWI organized a different traveling exhibition also titled *Faces of America.* See John Ferrell's photograph LC-USF34-011512-D.

131. Steinbeck, *Harvest Gypsies,* 22–23.

132. Stryker and Wood, *In This Proud Land,* 14; see also Levine, "Historian and the Icon," 33.

133. Stein, "New Deal Experiment," 138; Street, *Everyone Had Cameras*, 310.

134. The image has also been variously dated to 1936, 1938, and 1939. See Arthur Rothstein, *The Depression Years* (New York: Dover, 1978), 39; Rothstein, *Words and Pictures* (New York: American Photographic Book, 1979), 50; and Rothstein, *Photojournalism* (Boston: Focal Press, 1984), 19. See also O'Neal, *Vision Shared*, 229. The Arthur Rothstein Archive labels the photograph: "Farmer, Lancaster County, Nebraska, May 1936," www.arthurrothsteinarchive.com/photographs.html (accessed October, 31, 2012).

135. Roy Stryker to Fred Soule, April 29, 1940, FSA/OWI Written Records.

136. See Lorentz, "Dorothea Lange: Camera with a Purpose," 103; S. Stein, "On Location," 192.

137. It is difficult to exactly date this entry but it was recorded around the first week of April. Lange made this image on April 9, 1940. Zoe Brown, "Dorothea Lange: Field Notes and Photographs," 665.

138. See Guimond, *American Photography*, 113. See also figure 161. Note also that at one point the Joads parked behind a large red billboard. Steinbeck, *Grapes of Wrath and Other Writings*, 386.

139. Lorentz, "Dorothea Lange: Camera with a Purpose," 96.

Chapter 9

1. Quoted in Spirn, *Daring to Look*, 38.

2. Starr, *Endangered Dreams*, 269. The Tolan Committee, or more officially the Select Committee to Investigate the Interstate Migration of Destitute Citizens, held proceedings during the summers of 1940 and 1941 and was chaired by Representative John H. Tolan, a Democrat from Oakland, California. During the proceedings the committee heard from a diverse group of individuals and experts, including farmers, migrant workers, unemployed miners, church charity groups, state superintendents, and even the mayor of New York City, Fiorello La Guardia. After 1941 the committee was renamed the House Select Committee Investigating National Defense Migration and began holding hearings into the removal of Japanese Americans following Roosevelt's signing of Executive Order 9066. See U.S. Congress, *Hearings*.

3. Cooke credited the change he witnessed in the Midwest to the actions of the Department of Agriculture. Alistair Cooke, *The American Home Front, 1941–1942* (New York: Atlantic Monthly Press, 2006), 210.

4. Lange and Taylor, *American Exodus*, 154.

5. Gregory, *American Exodus*, 99, 172–82. In her collaboration with photographer Ansel Adams to document the Kaiser Shipyard in Richmond, California, Lange continued, in effect, to work with many of the same individuals she had so poignantly documented years earlier as migrants. See Charles Wollenberg, *Photographing the Second Gold Rush: Dorothea Lange and the Bay Area at War, 1941–1945* (Berkeley, CA: Heyday Books, 1995).

6. "New Migration to California Reported by FSA," newspaper clipping, *Todd and Sonkin, Voices from the Dust Bowl*, LOC.

7. Gregory, *American Exodus*, 174.

8. FSA historian Sidney Baldwin noted that the FSA saw this moment as a "triple opportunity" (1) to "help rationalize and stabilize the farm labor supply, which shifted from labor surpluses to a problem with manpower distribution; (2) to do more than attack the symptoms of the farm labor problem, and to fulfill their dream of an ambitious reform of the system; and (3) to exploit the program as a means of strengthening the agency's justification at a time when the country's concerns had shifted from peace to war, from depression to rising prosperity." Baldwin, *Poverty and Politics*, 222–23.

9. This motto may be seen on the central panel of an FSA exhibition panel dating to around 1941. See "Farm Security Administration Exhibit," LC-USF345-007628-ZA-B.

10. St. Pierre, *Steinbeck: California Years*, 101.

11. See Ditsky, *Critical Essays*, 4–6.

12. Raeburn, *Staggering Revolution*, 144. Stryker's former assistants Charlotte Aiken and Helen Wool later recalled the challenges facing the Historical Section. Foremost among them, in their opinion, was the constant struggle for funding and persistent need to justify the existence of the program. Aiken and Wool, oral history interview. See also Hurley, *Portrait of a Decade*, 168–70; Rosskam, "Not Intended for Framing," 9.

13. In fairness to the Historical Section the *Life* editor admitted that despite the "turkeys" the "FSA photographers produced some excellent documentary works, especially of the "victims of the farm depression of the '30s." "Senator on Warpath: Indiana's Capehart Turns Up Some Pictures and Broadcasts That Make His Blood Boil," *Life*, June 7, 1948, 40–41; Guimond, *American Photography*, 141.

14. Bird, *Invisible Scar*, 311, xiii.

15. Steinbeck, *Travels with Charley*, 186.

16. At Standard Oil, Stryker also worked with other former FSA/OWI photographers, such as Esther Bubley, Gordon Parks, and John Collier, Jr. Following a seven-year tenure with Standard Oil Stryker went on to amass photographic archives for other companies, including Jones & Laughlin Steel Corp. See Plattner, *Roy Stryker: U.S.A.*

17. William Stott noted that by the 1970s the FSA, in particular, had attracted the interest of "Nostalgia Seekers." Stott, "Introduction to a Never-Published Book," 23; Rosskam, "Not Intended For Framing," 11.

18. Hammarlund, "Portrait of an Era," 72.

19. Davis, *Grapes of Wrath: Critical Essays*, 2ff; Ditsky, *Critical Essays*, 8.

20. Many believed that other authors were more deserving of the Nobel Prize. See Granville Hicks, "Writers in the Thirties," in *As We Saw the Thirties: Essays on Social and Political Movements of the Decade*, edited by Rita James Simon (Urbana: University of Illinois Press, 1967), 99.

21. Davis, *Grapes of Wrath: Critical Essays*, 2–11; Lisca, "Grapes of Wrath: Achievement of Genius," in Davis, ibid., 48–49.

22. Charles Poore, "Writer of the American Grain," *New York Times*, December 21, 1968, 31.

23. DeMott, "This Book Is My Life," 153.

24. Ibid., 178; Hicks, "Writers in the Thirties," 99.

25. Comments recorded from attendees at the International Photographic Salon, Grand Central Palace, New York City, reprinted in Steichen, "F.S.A. Photographers," in Maloney, *U.S. Camera, 1939*, 46–65.

26. McCamy, *Government Publicity*, 237.

27. For more see Lili Corbus Bezner, *Photography and Politics in America: From the New Deal into the Cold War* (Baltimore, MD: John Hopkins University Press, 1999).

28. Raeburn, *Staggering Revolution*, 144–45, quotation on 144.

29. Martha Rosler has called this period in photography's history the "aesthetic-historical" moment. Rosler, "In, Around, and Afterthoughts (On Documentary Photography)," in Bolton, *Contest of Meaning*, 317. See also Solomon-Godeau, *Photography at the Dock*, 168–73.

30. Stryker and Johnstone, "Documentary Photographs," 328. Quotation from Geoffrey Batchen, "Seeds of Plenty, Seeds of Want," *Afterimage* 15 (April 1988): 18. Tugwell's reassessment of the FSA photographs' aesthetic quality was a sharp departure from his earlier comments that the work was "a collection of pictures, purely documentary and utilitarian in purpose." Stange, *Symbols of Ideal Life*, 130; see also Doherty, "USA/FSA," 19; Finnegan, "Documentary as Art," 37–68.

31. Doherty, "USA/FSA," 12.

32. Dana Asbury, "Amarillo Symposium Reunites FSA Photographers," *Afterimage* 7 (March 1979): 4; Edward Miller, "Interview: Jack Delano," *Combinations: A Journal of Photography* 1, no. 4 (Fall–Winter, 1979–1980): 27.

33. Rosskam, "Not Intended for Framing," 11–12.

34. Robert J. Doherty, "The Elusive Roy Stryker," in Anderson, *Roy Stryker: Humane Propagandist*, 8.

35. For more on *Family of Man* see Eric J. Sandeen, *Picturing an Exhibition: The Family of Man and 1950s America* (Albuquerque: University of New Mexico Press, 1995).

36. Steichen, *Bitter Years, 1935–1941*, ii.

37. Edward Steichen, *A Life in Photography* (Garden City, NY: Doubleday, 1963), chap. 14, n.p.

38. According to Jean Back, Steichen valued Lange's commitment to migrant communities and her work with Paul S. Taylor. Back, "Vantage Point: 'The Bitter Years' Reconsidered," in Françoise Poos, *The Bitter Years: Edward Steichen and the Farm Security Administration Photographs* (New York: D.A.P., 2012), 6.

39. Wood, *Heartland, New Mexico*, xi.

40. Hammarlund, "Portrait of an Era," 70.

41. Nat Herz, "Dorothea Lange in Perspective: A Reappraisal of the FSA and an Interview," *Infinity*, April 1963, 6–7, quotation on 7.

42. Stange, *Symbols of Ideal Life*, 130; McElvaine, *Great Depression*, 302. The review of *The Bitter Years* in the periodical *Perspectives on Ideas and the Arts* (March 1963) paired chaps. 1 and 17 of *The Grapes of Wrath* with six FSA images—five by Lange and one by Carl Mydans.

43. Raeburn, *Staggering Revolution*, 143; Lesy, *Long Time Coming*, 11.

44. Guimond, *American Photography*, 142; P. Dixon, *Photographs of the Farm Security Administration*.

45. Stryker and Wood, *In This Proud Land*, 7.

46. Arthur Siegel, "Photography Is . . . ," in Peter C. Bunnell, *Aperture Magazine Anthology: The Minor White Years, 1952–1976* (New York: Aperture, 2012), 260–61; Doherty, "USA/FSA," 11–12; Thornton quoted in Arthur Rothstein, *Documentary Photography* (Boston: Focal Press, 1986), 41.

47. Quoted in Severin, "Cameras with a Purpose," 200.

48. Along with Ben Shahn, Evans and Lange became the "giants" of the FSA. Cohen, *The Like of Us*, xxii.

49. See Heyman et al., *Celebrating the Collection*, 46. Spirn argues that comparisons between Lange and Evans have led to a "pervasive and blatant" disparagement of Lange's work. While Rothstein clearly resented Evans, there is no evidence that Lange shared similar feelings. Moreover, it would be difficult to argue that her reputation has been injured by Evans's vaulted status. Her extensive bibliography suggests that "Lange's erasure" was nowhere near as complete as Spirn would have us believe. If anything Evans's reputation has probably benefited the entire FSA archive. Spirn, *Daring to Look*, xiii, 52; Amy Conger, "The Amarillo FSA Symposium," *Exposure* 17, no. 2 (Summer 1979): 53. On Lange's views of Evans, see Lange, oral history interview.

50. John Szarkowski, *Walker Evans* (New York: Museum of Modern Art, 1971), 17–18. Evans's influence was also felt within the FSA. John Vachon, Arthur Rothstein, and several others were particularly inspired by his images.

51. Orvell, foreword to Cohen and Flippelli, *Times of Sorrow and Hope*, xv; Tagg, *Burden of Representation*, 14; for Evans's influence on later photographers see Nathan Lyons and Bruce Davidson, *Towards a Social Landscape, Bruce Davidson, Lee Friedlander, Garry Winogrand, Danny Lyon, Duane Michals* (Rochester, NY: Horizon Press, 1966); Lewis Baltz, "American Photography in the 1970s," in Peter Turner, ed., *American Images: Photography 1945–1980* (New York: Viking Penguin and Barbican Art Gallery, 1985), 161.

52. Dorothea Lange and Daniel Dixon, "Photographing the Familiar," *Aperture* 1, no. 2 (1952): 15.

53. Quoted in D. Dixon, "Dorothea Lange," 68.

54. Taylor and Loftis, *In the Fields*, 2.

55. S. Stein, "Passing Likeness, 345. In 1969 it was estimated that Lange's photograph had been used in more than ten thousand separate editions and reproduced "many hundreds of thousands of times." Doherty, *Social Documentary Photography in the USA*, 79.

56. More specifically, Rothstein believed that the Historical Section was misrepresented by the apotheosis of Evans and William Stott's writings endorsing Evans. Conger, "Amarillo FSA Symposium," 53.

57. See Guimond, *American Photography*, 267, 280, 284; Chauncey Hare, *Interior America* (Millerton, NY: Aperture, 1978), 16.

58. Lange, oral history interview; Szarkowski, foreword to Lee, *Russell Lee: Photographer*, ix.

59. James Alinder, foreword to Sally Stein, *Marion Post Wolcott: FSA Photographs (Untitled 34)* (Carmel: Friends of Photography, 1983), 2.

60. Roberts, "Travels with Steinbeck," 50.

61. Newhall, *History of Photography*, 148. See also Christopher Phillips, *Steichen at War* (New York: Port House, 1981), 24–25.

62. Bristol, "Documenting *The Grapes of Wrath*," 47.

63. Batchen, "Seeds of Plenty," 17.

64. Citing Hammarlund in full:

The dreaded depression days of America were photographed so thoroughly and the pictures displayed so extensively, that

when the average citizen thinks of the depression he recalls
it in terms of the sorrowful plight of the sharecroppers'
children wallowing in filth and misery; the tragedy of a family
desperately fighting the elements and havoc of a dust storm;
the ugly reality of the dead steer's skull baking on sun-parched
wastelands; the stark nakedness of a southern child's burial
plot, or the pitiful old man cherishing his little tin cup in a
government breadline! (Hammarlund, "Portrait of an Era," 88)

Hammarlund's reference to the "pitiful old man" clearly
references Dorothea Lange's "White Angel Breadline, San
Francisco, 1933," which was not made under the aegis of the FSA.
Yet as early as 1941 that image was reprinted in articles on the FSA.
See Lorentz, "Dorothea Lange: Camera with a Purpose," 116.

65. See Richard H. Pells, *Radical Visions and American Dreams:
Culture and Social Thought in the Depression Years* (New York:
Harper and Row, 1973), 215.

66. Sam Walker, "Documentary Photography in America: The
Political Dimensions of an Art Form," *Radical America* 11, no. 1
(1977): 57; Robert J. Doherty, *Social Documentary Photography in
the USA*, 79.

67. Paul S. Taylor to Hank O'Neal, April 26, 1976, Taylor
Papers; O'Neal, *Vision Shared*, 305.

68. Therese Thau Heyman, "A Rock or a Line of Unemployed:
Art and Document in Dorothea Lange's Photography," in Heyman,
Phillips, and Szarkowski, *Dorothea Lange: American Photographs*, 59.

69. Dunn, "Photographic License," 21.

70. Benson, *Looking for Steinbeck's Ghost*, 8.

71. Rondal Partridge, interview with the author, June 23, 2010;
Stott, "Introduction to a Never-Published Book," 25.

72. Heyman et al., *Celebrating the Collection*, 77–78.

73. "Steinbeck Writes to Dorothea Lange," *Steinbeck Newsletter* 2,
no. 2 (Summer 1989): 6–7.

74. See Hurt, *Dust Bowl*, 157–59.

75. "What a Depression Is Really Like," *U.S. News & World
Report*, November 11, 1974, newspaper clipping in Taylor Papers.

76. Ditsky, *Critical Essays*, 9–13.

77. Cyrus Ernesto Zirakzadeh, "Revolutionary Conservative,
Conservative Revolutionary? John Steinbeck and *The Grapes
of Wrath*," in Simon Stow and Cyrus Ernesto Zirakzadeh, eds.,
Ambivalent American: The Political Companion to John Steinbeck
(Lexington: University Press of Kentucky, 2013), 21.

78. Quoted in Mark Rice, *Through the Lens of the City: NEA
Photography Surveys of the 1970s* (Jackson: University Press of
Mississippi, 2005), 24.

79. Senator Mondale proposed the American Bicentennial
Photography and Film Project, which would have hired
unemployed photographers and creates an archive of American life
in the 1970s. His proposal was also inspired by the death of Roy
Stryker in 1975. Ibid., 12–24.

80. See ibid., 10–11; John Vachon, "Tribute to a Man, an Era, an
Art," *Harper's*, September 1973, 96–99"; Rosskam, "Not Intended
for Framing," 9–12.

81. Doherty, *Social Documentary Photography in the U.S.A.*, 85.

82. Curated by Mark Haworth-Booth, *The Compassionate
Camera* featured sixty-six works from the FSA collection, twenty

of which were by Lange. For more consult Taylor Papers; O'Neal,
Vision Shared, 305.

83. Rosskam, "Not Intended for Framing," 10.

84. Martha Rosler, "Lookers, Buyers, Dealers, and Makers:
Thoughts on Audience," in Rosler, *Decoys and Disruptions*, 27.

85. Hurley, "Farm Security Administration File," 244–45. See
also Jonathan Green, *American Photography: A Critical History,
1945 to the Present* (New York: Harry N. Abrams, 1984), 42;
Asbury, "Amarillo Symposium Reunites FSA Photographers."

86. Reloy Garcia, introduction to Tetsumaro Hayashi, *John
Steinbeck and the Vietnam War (Part I)*, Steinbeck Monograph
Series No. 12 (Muncie, IN: Steinbeck Research Institute,
1986), x. See also Thomas F. Barden, ed., *Steinbeck in Vietnam*
(Charlottesville: University of Virginia Press, 2012), xi–xvi.

87. See McElvaine, *Great Depression*, 342. During the second
presidential debate on October 7, 2008, Senator Barack Obama
argued, "We are in the worst financial crisis since the Great
Depression, and a lot of you, I think, are worried about your jobs,
your pensions, your retirement accounts, your ability to send your
grandchild to college."

88. See Robert DeMott, "Grapes of Wrath, A Classic for
Today?" *BBC News Americas*, April 14, 2009, http://news.bbc.
co.uk/2/hi/americas/7992942.stm (accessed July 31, 2012); also
Jackson, "Finest Book John Steinbeck Has Written," in McElrath,
Crisler, and Shillinglaw, *John Steinbeck: Contemporary Reviews*, 162.

89. A. O. Scott, "Critics' Picks: 'The Grapes of Wrath,'" www.
nytimes.com (accessed December 8, 2008).

90. Carl Mydans, foreword to Dale Maharidge and Michael
Williamson, *And Their Children after Them* (New York: Pantheon
Books, 1989), xiii, xix. Through their work Williamson and
Maharidge befriended musician Bruce Springsteen, who shared
their interest in America's working poor. Springsteen's 1995 title
track "The Ghost of Tom Joad" was inspired by Steinbeck's novel,
Ford's film, and Guthrie's "The Ballad of Tom Joad." He also wrote
the foreword to Maharidge and Williamson's *Someplace Like
America: Tales from the New Great Depression* (Berkeley: University
of California Press, 2011).

91. Maharidge and Williamson, *Someplace Like America*, 2, 5–6,
27, 40, 83–85, 106–107, 7.

92. "Our Mission," http://americanpoverty.org/partners/
about-us/ (accessed July 31, 2012).

93. The Americanpoverty.org mission statement concludes:
"AmericanPoverty.org is a non-profit alliance of photojournalists
using visual storytelling to raise awareness about 'how the other
half lives.' Joining us are renowned American writers, filmmakers
and educators, all of whom seek to alleviate poverty and make it a
national priority. Together we are working to dispel stereotypes
and encourage actions that can create lasting impact in the lives of
disadvantaged people" (ibid.).

94. Steve Liss, e-mail correspondence with the author, October 16,
2012.

95. In a 1964 interview Dorothea Lange and Richard Doud
contemplated a similar question. Both were nonplussed by the
fact that contemporary photographs did not move people as
the FSA images did. For Lange there was "no bridge" between
modern photographs and their audience. One of the reasons she

suggested was that the eye can become calloused by overexposure to photographic images. She had other thoughts on this topic, but decided instead of discussing them during the interview she would write them down and send them to Doud. Unfortunately no correspondence from Lange on this topic has come to light. Lange, oral history interview.

96. Google searches conducted by the author, July 28, 2013.

97. See Anne B. W. Effland, "Migrant and Seasonal Farm Labor in the Far West," in R. Douglas Hurt, *The Rural West since World War II* (Lawrence: University Press of Kansas, 1998), 147.

Coda

1. John Steinbeck, *Grapes of Wrath* (Reprint, Franklin Center, PA: Franklin Library, 1989).

2. DeMott, "This Book Is My Life," 153.

3. Paula Rabinowitz, *They Must Be Represented: The Politics of Documentary* (London: Verso, 1994), 87; see also Robert Hariman and John Louis Lucaites, *No Caption Needed: Iconic Photographs, Public Culture, and Liberal Democracy* (Chicago: University of Chicago Press, 2007), 92.

4. O'Neal, *Vision Shared*, 305.

5. For an excellent discussion of the iconic nature of "Migrant Mother" see Hariman and Lucaites, *No Caption Needed*, 53–64.

6. Wartzman, *Obscene in the Extreme*, 153; Heyman et al., *Celebrating the Collection*, 60–61. In 2009 David Oshinsky declared that Lange's "Migrant Mother" is "perhaps the most iconic image" in the history of American photography. Oshinsky, "Picturing the Depression," *New York Times*, October 22, 2009.

Bibliography

Primary Sources

Archives

Archives of American Art. Smithsonian Institution, Washington, DC (hereafter AAA)

Douglas, Helen Gahagan Archive. Carl Albert Center, Congressional Research and Studies, University of Oklahoma

Hollenberg, Robert W. Collection of Materials Relating to the Farm Security Administration, Region IX, 1924–1941. Bancroft Library, University of California, Berkeley

Lee, Russell Collection. In Wittliff Collections, Albert B. Alkek Library, Texas State University, San Marcos, TX

McWilliams, Carey, Papers. Charles E. Young Research Library, Department of Special Collections, University of California, Los Angeles

Prints and Photography Reading Room, Prints and Photographs Division, Library of Congress, Washington, DC

Steinbeck, John, Collection, Stanford University Special Collections and University Archives, Stanford University, Stanford, CA

Stryker, Roy, Papers. University of Louisville Photographic Archives, Louisville, KY

Taylor, Paul Schuster, Papers. Bancroft Library, University of California, Berkeley

Wolcott, Marion Post, Archives. Center for Creative Photography, University of Arizona, Tucson

Oral History Interviews

Aiken, Charlotte, and Helen Wool. Oral history interview, April 17, 1964. AAA.

Baldwin, C. B. (Calvin Benham). Oral history interview, February 25, 1965. AAA.

Delano, Jack and Irene. Oral history interview, June 12, 1965. AAA.

Lange, Dorothea. "The Making of a Documentary Photographer," an interview by Suzanne B. Reiss, 1968. Regional Oral History Office, Bancroft Library, University of California, Berkeley.

————. Oral history interview, May 22, 1964. AAA.

Lee, Doris Emrick. Oral history interview, November 4, 1964. AAA.

Lee, Russell and Jean. Oral history interview, June 2, 1964. AAA.

Partridge, Rondal. Interview with the author, June 23, 2010. Transcript in author's files.

Rosskam, Edwin and Louise. Oral history interview, August 3, 1965. AAA.

Rosskam, Louise. "Remembering the 20th Century: An Oral History of Monmouth County" by Gary Saretsky, March 24, 2000. http://www.visitmonmouth.com/oralhistory/bios/RosskamLouise.htm (accessed September 19, 2014).

Rothstein, Arthur. Oral history interview, May 25, 1964. AAA.

Shahn, Ben. Oral history interview, April 14, 1964. AAA.

Stryker, Roy Emerson. Oral history interviews, 1963–65, AAA.

Tugwell, Rexford. Oral history interview, January 21, 1965. AAA.

Vachon, John. Oral history interview, April 28, 1964. AAA.

Wolcott, Marion Post. Oral history interview, January 18, 1965. AAA.

Online Archives

Arthur Rothstein Archive. www.arthurrothsteinarchive.com/photographs.html

Farm Security Administration/Office of War Information Negatives. Library of Congress. http://www.loc. gov/pictures/collection/fsa/

My Day by Eleanor Roosevelt: A Comprehensive, Electronic Edition of Eleanor Roosevelt's "My Day" Newspaper Columns. George Washington University. http://www.gwu.edu/~erpapers/myday/

Voices from the Dust Bowl: The Charles L. Todd and Robert Sonkin Migrant Worker Collection, 1940–1941. American Memory, Library of Congress. http://memory.loc.gov/ammem/afctshtml/tshome.html

Books, Book Chapters, and Articles

Adamic, Louis. *My America, 1928–1938.* New York: Harper and Brothers, 1938.

Adams, Henry. "Thomas Hart Benton's Illustrations for *The Grapes of Wrath.*" *San Jose Studies* 16, no. 1 (Winter 1990): 6–18.

Adams, J. Donald. *The Shape of Books to Come.* New York: Viking Press, 1945.

Agee, James, and Walker Evans. *Let Us Now Praise Famous Men: The American Classic, in Words and Photographs, of Three Tenant Families in the Deep South.* 1941. Reprint, New York: Mariner Books, 2001.

Aitken, Stuart C., and Leo E. Zonn, eds. *Place, Power, Situation, and Spectacle.* Lanham, MD: Rowman and Littlefield, 1994.

Alexander, William. "Paul Strand as Filmmaker, 1933–1942." In *Paul Strand: Essays on His Life and* Work, edited by Maren Stange. New York: Aperture Foundation, 1990.

Allen, Frederick Lewis. *Since Yesterday: The Nineteen-Thirties in America, September 3, 1929–September 3, 1939.* New York: Harper and Row, 1940.

Allred, Jeff. *American Modernism and Depression Documentary.* New York: Oxford University Press, 2010.

Anderson, James C., ed. *Roy Stryker: The Humane Propagandist.* Louisville, KY: Photographic Archives, University of Louisville, 1977.

Appel, Mary Jane. *Russell Lee: A Centenary Exhibition.* San Marcos: Wittliff Gallery of Southwestern and Mexican Photography, Texas State University, 2003.

Asbury, Dana. "Amarillo Symposium Reunites FSA Photographers." *Afterimage* 7 (March 1979): 4.

Auerbach, Jerold S. *Labor and Liberty: The La Follette Committee and the New Deal.* Indianapolis, IN: Bobbs-Merrill, 1966.

Babb, Sanora. *An Owl on Every Post.* New York: McCall, 1970.

———. *Whose Names Are Unknown.* Norman: University of Oklahoma Press, 2004.

Baldwin, Sidney. *Poverty and Politics: The Rise and Decline of the Farm Security Administration.* Chapel Hill: University of North Carolina Press, 1968.

Barden, Thomas E., ed. *Steinbeck in Vietnam.* Charlottesville: University of Virginia Press, 2012.

Barrow, Thomas, Shelley Armitage, and William E. Tydeman, eds. *Reading into Photography: Selected Essays, 1950–1989.* Albuquerque: University of New Mexico Press, 1982.

Baskind, Samantha. "The 'True' Story: *Life* Magazine, Horace Bristol, and John Steinbeck's *The Grapes of Wrath.*" *Steinbeck Studies* 15, no. 2 (Winter 2004): 41–74.

Batchen, Geoffrey. *Forget Me Not: Photography and Remembrance.* New York: Princeton Architectural Press, 2004.

———. "Seeds of Plenty, Seeds of Want." *Afterimage* 15 (April 1988): 17–18.

Beckman, Karen, and Liliane Weissberg, eds. *On Writing with Photography.* Minneapolis: University of Minnesota Press, 2013.

Behlmer, Rudy. *America's Favorite Movies: Behind the Scenes.* New York: Frederick Ungar, 1982.

Benson, Jackson J. "An Afterword and an Introduction." *Journal of Modern Literature* 5, no. 2 (April 1976): 194–210.

———. "The Background to the Composition of *The Grapes of Wrath.*" In *Critical Essays on Steinbeck's* The Grapes of Wrath, edited by John Ditsky. Boston: G. K. Hall, 1989.

———. *Looking for Steinbeck's Ghost*. Norman: University of Oklahoma Press, 1988.

———. "To Tom, Who Lived It: John Steinbeck and the Man from Weedpatch." *Journal of Modern Literature* 5, no. 2 (April 1976): 151–210.

———. *The True Adventures of John Steinbeck, Writer.* New York: Viking Press, 1984.

Benson, Jackson J., and Anne Loftis. "John Steinbeck and Farm Labor Unionization: The Background of 'In Dubious Battle.'" *American Literature* 25, no. 2 (May 1980): 194–223.

Benton, Thomas Hart. *An Artist in America*. Columbia: University of Missouri Press, 1983.

Berger, John. *Understanding a Photograph,* edited by Geoff Dyer. New York: Aperture, 2013.

Berger, Maurice. "FSA: The Illiterate Eye (1985)." In *How Art Becomes History: Essays on Art, Society, and Culture in Post–New Deal America*. New York: Icon Editions, 1992.

Berman, Patricia. "Horace Bristol's Photojournalism: Art, the Mass Media, and the Contingent Career." In *Stories from Life: The Photography of Horace Bristol,* edited by Horace Bristol. Athens: Georgia Museum of Art, University of Georgia, 1995.

Bernanke, Ben S. *Essays on the Great Depression*. Princeton, NJ: Princeton University Press, 2000.

Bezner, Lili Corbus. *Photography and Politics in America: From the New Deal into the Cold War*. Baltimore, MD: John Hopkins University Press, 1999.

Bird, Caroline. *The Invisible Scar*. New York: David McKay, 1966.

Blair, Sara, and Eric Rosenberg. *Trauma and Documentary Photography of the FSA*. Berkeley: University of California Press, 2012.

Bluestone, George. *Novels into Film*. Berkeley: University of California Press, 1966.

Bolton, Richard, ed. *The Contest of Meaning: Critical Histories of Photography*. Cambridge, MA: MIT Press, 1989.

Brannan, Beverly W., and Gilles Mora. *FSA: The American Vision*. New York: Abrams, 2006.

Bristol, Horace. "Documenting *The Grapes of Wrath*." *The Californians* (January–February 1988): 40–47.

———. *Stories from Life: The Photography of Horace Bristol*. Athens: Georgia Museum of Art, University of Georgia, 1995.

Brown, J. L. "Picture Magazines and Morons." *American Mercury* 45, no. 180 (December 1938): 404–408.

Brown, Zoe. "Dorothea Lange: Field Notes and Photographs." MA thesis, John F. Kennedy University, Pleasant Hill, CA, 1979.

Brunet, François. *Photography and Literature*. London: Reaktion Books, 2009.

Bunnell, Peter C. *Aperture Magazine Anthology: The Minor White Years, 1952–1976*. New York: Aperture, 2012.

Burg, David F. *The Great Depression: An Eyewitness History*. New York: Facts on File, 1996.

Burton, Orville Vernon. *Roll the Union On: As Told by Its Co-founder H. L. Mitchell*. Chicago: Charles H. Kerr, 1987.

Caldwell, Erskine, and Margaret Bourke-White. *You Have Seen Their Faces*. Foreword by Alan Trachtenberg. 1937. Reprint, Athens: University of Georgia Press, 1995.

Cannon, Brian Q. "'Keep On A-Goin': Life and Social Interaction in a New Deal Farm Labor Camp." *Agricultural History* 70, no. 1 (Winter 1996): 1–32.

Carlebach, Michael. "Documentary and Propaganda: The Photographs of the Farm Security Administration." *Journal of Decorative and Propaganda Arts* 8 (Spring 1988): 6–25.

Carlebach, Michael, and Eugene F. Provenzo, Jr. *Farm Security Administration Photographs of Florida*. Gainesville: University Press of Florida, 1993.

Clark, Philip Hone, comp. *The Heart of Maynard Dixon: Conversations with Herald R. Clark and Other Related Correspondence, 1937–1946*. Provo, UT: Excel Graphics, 2001.

Cohen, Allen, and Ronald L. Flippelli. *Times of Sorrow and Hope: Documenting Everyday Life in Pennsylvania during the Depression and World War II*. Foreword by Miles Orvell. University Park: Penn State University Press, 2003.

Cohen, Stu. *The Like of Us: America in the Eyes of the Farm Security Administration*. Edited and with a foreword by Peter Bacon Hales. Boston: David R. Godine, 2009.

Collins, Henry Hill, Jr. *America's Own Refugees: Our 400,000 Homeless Migrants.* Princeton, NJ: Princeton University Press, 1941.

Collins, Thomas A. [Windsor Drake]. "Bringing in the Sheaves." Introduction by John Steinbeck. *Journal of Modern Literature* 5, no. 2 (April 1976): 211–32.

Colson, J. B., Malcolm Collier, Jay Rabinowitz, and Steve Yates. *Far from Main Street: Three Photographers in Depression-Era New Mexico.* Santa Fe: Museum of New Mexico Press, 1994.

Condon, Frank. "The Grapes of Raps." *Collier's,* January 27, 1940, 23, 64, 67.

Conger, Amy. "The Amarillo FSA Symposium." *Exposure* 17, no. 2 (Summer 1979): 53.

Conner, Ken, and Debra Heimerclinger. *Horace Bristol: An American View.* San Francisco: Chronicle Books, 1996.

Conrad, David Eugene. *The Forgotten Farmers: The Story of Sharecroppers in the New Deal.* Westport, CT: Greenwood Press, 1965.

Cooke, Alistair. *The American Home Front, 1941–1942.* New York: Atlantic Monthly Press, 2006.

Covert, Alice Lent. *Return to Dust.* New York: H. C. Kinsey, 1939.

Cox, Martha Heasley. "Fact into Fiction in *The Grapes of Wrath:* The Weedpatch and Arvin Camps." In *John Steinbeck: East and West: Proceedings of the First International Steinbeck Congress,* edited by Tetsumaro Hayashi. Millwood, NY: Kraus, 1980.

Cray, Ed. *Ramblin' Man: The Life and Times of Woody Guthrie.* New York: W. W. Norton, 2004.

Curtis, James. *Mind's Eye, Mind's Truth: FSA Photography Reconsidered.* Philadelphia: Temple University Press, 1989.

Daniel, Pete, Merry A. Foresta, Maren Stange, and Sally Stein. *Official Images: New Deal Photography.* Washington, DC: Smithsonian Institution Press, 1987.

Davis, Clark, and David Igler, eds. *The Human Tradition in California.* Lanham, MD: Rowman and Littlefield, 2002.

Davis, Robert Con, ed. *The Grapes of Wrath: A Collection of Critical Essays.* Englewood Cliffs, NJ: Prentice-Hall, 1982.

Delano, Jack. *Photographic Memories.* Washington, DC: Smithsonian Institution Press, 1997.

DeLong, Lea Rosson. *Nature's Forms/Nature's Forces: The Art of Alexandre Hogue.* Norman: University of Oklahoma Press, 1984.

DeMott, Robert J. *Steinbeck's Reading: A Catalogue of Books Owned and Borrowed.* New York: Garland, 1984.

———. "This Book Is My Life." In *Steinbeck's Typewriter: Essays on His Art.* Troy, NY: Whitston, 1996.

Ditsky, John, ed. *Critical Essays on Steinbeck's* The Grapes of Wrath. Boston: G. K. Hall, 1989.

———. "*The Grapes of Wrath:* A Reconsideration." *Southern Humanities* 13 (Summer 1979): 215–30.

Dixon, Daniel. "Dorothea Lange." *Modern Photography,* December 1952, 68–77, 138–41.

Dixon, Maynard. *Maynard Dixon: Images of the Native American.* San Francisco: California Academy of Sciences, 1981.

Dixon, Penelope. *Photographs of the Farm Security Administration: An Annotated Bibliography, 1930–1950.* New York: Garland, 1983.

Doherty, Robert J. *Social Documentary Photography in the USA.* Garden City, NY: AMPHOTO, 1976.

———. "USA/FSA: Farm Security Administration Photographs of the Depression." *Camera,* October 1962, 9–19.

Doss, Erika. "Between Modernity and 'The Real Thing': Maynard Dixon's Mural for the Bureau of Indian Affairs." *American Art* 18, no. 3 (Fall 2004): 8–31.

———. "Looking at *Life:* Rethinking America's Favorite Magazine, 1936–1972." In *Looking at* Life *Magazine.* Washington, DC: Smithsonian Institution Press, 2001.

Douglas, Helen Gahagan. *A Full Life.* Garden City, NY: Doubleday, 1982.

———. *The Eleanor Roosevelt We Remember.* New York: Hill and Wang, 1963.

Dunaway, Finis. *Natural Visions: The Power of Images in American Environmental Reform.* Chicago: University of Chicago Press, 2005.

Dunn, Geoffrey. "Photographic License: The Story of Florence Owens Thompson—Dorothea Lange's 'Migrant Mother'—and How Her Famous Portrait Haunted Her for a Lifetime." *Metro* (San Jose, CA), January 19–25, 1995, 20–25.

Dykeman, Wilma, and James Stokely. *Seeds of Southern Change: The Life of Will Alexander.* Chicago: University of Chicago Press, 1962.

Edom, Clifton C. "Documentary Photography." *PSA Journal,* April 1946, 139–44.

Egan, Timothy. *The Worst Hard Time: The Untold Story of Those Who Survived the Great American Dust Bowl.* Boston: Houghton Mifflin, 2006.

Elder, Glen H. *Children of the Great Depression: Social Change in Life Experience.* Chicago: University of Chicago Press, 1974.

Evans, Walker. *American Photographs.* New York: Museum of Modern Art, 1938.

Fahy, Thomas. "Worn, Damaged Bodies in Literature and Photography of the Great Depression." *Journal of American Culture* 26, no. 1 (March 2003): 2–16.

Farm Security Administration (FSA). *Migrant Farm Labor: The Problem and Some Efforts to Meet It.* Washington, DC: Government Printing Office, 1940.

Fearon, Peter. *Kansas in the Great Depression: Work Relief, the Dole, and Rehabilitation.* Columbia: University of Missouri Press, 2007.

Featherstone, David, ed. *Observations: Essays on Documentary Photography (Untitled 35).* Carmel, CA: Friends of Photography, 1984.

Fensch, Thomas, ed. *Conversations with John Steinbeck.* Jackson: University of Mississippi Press, 1988.

Finnegan, Cara A. "Documentary as Art in 'U.S. Camera.'" *Rhetoric Society Quarterly* 31, no. 2 (Spring 2001): 37–68.

———. *Picturing Poverty: Print Culture and FSA Photography.* Washington, DC: Smithsonian Institution Press, 2003.

Fleischhauer, Carl, and Beverly W. Brannan, eds. *Documenting America, 1935–1943.* Essays by Lawrence W. Levine and Alan Trachtenberg. Berkeley: University of California Press, 1988.

Ford, Dan. *Pappy: The Life of John Ford.* Englewood Cliffs, NJ: Prentice-Hall, 1979.

Fossey, W. Richard. "The End of the Western Dream: *The Grapes of Wrath* and Oklahoma." *Cimarron Review* 22 (1973): 25–34.

———. "'Talkin' Dust Bowl Blues': A Study of Oklahoma's Cultural Identity during the Great Depression." *Chronicles of Oklahoma* 55 (Spring 1977): 12–33.

French, Warren, ed. *A Companion to* The Grapes of Wrath. New York: Viking Press, 1963.

———. *Film Guide to* The Grapes of Wrath. Bloomington: Indiana University Press, 1973.

Freund, Grisèle. *Photography and Society.* Boston: David R. Godine, 1980.

Gannett, Lewis. *John Steinbeck: Personal and Bibliographical Notes.* Brooklyn, NY: Haskell House, 1977.

Ganzel, Bill. *Dust Bowl Descent.* Lincoln: University of Nebraska Press, 1984.

Garst, Jonathan. *No Need for Hunger.* New York: Random House, 1963.

Garver, Thomas. *Just before the War.* Balboa, CA: Newport Harbor Museum; October House, 1968.

Girvin, Robert. "Photography as Social Documentation." *Journalism Quarterly* 24, no. 3 (September 1947): 214–20.

Godine, Amy. "Notes Toward a Reappraisal of Depression Literature." *Prospects* 5 (1980): 197–239.

Goetzmann, William H., and William N. Goetzmann. *The West of the Imagination.* Norman: University of Oklahoma Press, 2009.

Goggans, Jan. *California on the Breadlines: Dorothea Lange, Paul Taylor, and the Making of a New Deal Narrative.* Berkeley: University of California Press, 2010.

Goldberg, Vicki. *Margaret Bourke-White: A Biography.* New York: Harper and Row, 1986.

———. *The Power of Photography: How Photographs Changed Our Lives.* New York: Abbeville Press, 1991.

Gordon, Linda. *Dorothea Lange: A Life beyond Limits.* London and New York: W. W. Norton, 2009.

———. "Dorothea Lange: The Photographer as Agricultural Sociologist." *Journal of American History* 93, no. 3 (December 2006): 698–727.

Green, Jonathan. *American Photography: A Critical History, 1945 to the Present.* New York: Harry N. Abrams, 1984.

Gregory, James N. *American Exodus: The Dust Bowl Migration and Okie Culture in California.* New York: Oxford University Press, 1989.

Grey, Michael R. *New Deal Medicine: The Rural Health Programs of the Farm Security Administration.* Baltimore, MD: Johns Hopkins University Press, 1999.

Grubbs, Donald H. *Cry from the Cotton: The Southern Tenant Farmers Union and the New Deal.* Chapel Hill: University of North Carolina Press, 1971.

Gruber, John, ed. *Railroaders: Jack Delano's Homefront Photography.* Madison, WI: Center for Railroad Photography, 2014.

Guimond, James. *American Photography and the American Dream.* Chapel Hill: University of North Carolina Press, 1991.

Gussow, Mel. *Don't Say Yes Until I Finish Talking: A Biography of Darryl F. Zanuck.* Garden City, NY: Doubleday, 1971.

Guthrie, Woody. *Bound for Glory.* New York: E. P. Dutton, 1943.

———. *Pastures of Plenty: A Self-Portrait. The Unpublished Writings of an American Folk Hero,* edited by Dave Marsh and Harold Leventhal. New York: Harper Perennial, 1990.

Hagerty, Donald J. *Desert Dreams: The Art and Life of Maynard Dixon.* Salt Lake City, UT: Gibbs Smith, 1998.

Halprin, Sara. *Seema's Show: A Life on the Left.* Albuquerque: University of New Mexico Press, 2005.

Ham, Oleta Kay Sprague, and Roger Sprague, Sr. *Migrant Mother: The Untold Story, A Family Memoir.* Mustang, OK: Tate, 2013.

Hammarlund, Roger T. "Portrait of an Era." *U.S. Camera* 25, no. 11 (November 1962): 68–73, 88.

Hare, Chauncey. *Interior America.* Millerton, NY: Aperture, 1978.

Hariman, Robert, and John Louis Lucaites. *No Caption Needed: Iconic Photographs, Public Culture, and Liberal Democracy.* Chicago: University of Chicago Press, 2007.

Hartranft, M. V. *Grapes of Gladness.* Los Angeles: DeVorss, 1939.

Haslam, Gerald. "The Okies: Forty Years Later." *The Nation* 220, no. 10 (March 15, 1975): 299–302.

Hayashi, Tetsumaro. *John Steinbeck and the Vietnam War (Part I).* Steinbeck Monograph Series No. 12. Muncie, IN: Steinbeck Research Institute, 1986.

Hendrickson, Paul. *Looking for the Light: The Hidden Life and Art of Marion Post Wolcott.* New York: Alfred A. Knopf, 1992.

Herz, Nat. "Dorothea Lange in Perspective: A Reappraisal of the FSA and an Interview." *Infinity,* April 1963, 5–11.

Heyman, Therese Thau, Daniel Dixon, Joyce Minick, and Paul Schuster Taylor. *Celebrating the Collection: The Work of Dorothea Lange.* Oakland, CA: Oakland Museum, 1978.

Heyman, Therese Thau, Sandra Phillips, and John Szarkowski. *Dorothea Lange: American Photographs.* San Francisco: Chronicle Books and the San Francisco Museum of Art, 1994.

Hicks, Granville. "Writers in the Thirties." In *As We Saw the Thirties: Essays on Social and Political Movements of the Decade,* edited by Rita James Simon. Urbana: University of Illinois Press, 1967.

Higonnet, Anne. *Pictures of Innocence: The History and Crisis of Ideal Childhood.* New York: Thames and Hudson, 1998.

Hirsch, Jerrold. *Portrait of America: A Cultural History of the Federal Writer's Project.* Chapel Hill: University of North Carolina Press, 2003.

Hosmer, Helen. *A Radical Critic of California Agribusiness in the 1930s.* Santa Cruz: University of California, Santa Cruz, University Library Digital Collection, 1992.

Howarth, William. "The Okies: Beyond the Dust Bowl." *National Geographic* 166, no. 3 (September 1984): 322–49.

Howe, Hartley. "You Have Seen Their Pictures." *Survey Graphic* 29, no. 4 (April 1940): 236–38.

Hughes, Alex, and Andrea Noble. *Phototextualities: Intersections of Photography and Narrative.* Albuquerque: University of New Mexico Press, 2003.

Hunter, Jefferson. *Image and Word: The Interaction of Twentieth-Century Photographers and Texts.* Cambridge, MA: Harvard University Press, 1987.

Hurley, F. Jack. "The Farm Security Administration File: In and Out of Focus." *History of Photography* 17, no. 3 (Autumn 1993): 244–52.

———. *Marion Post Wolcott: A Photographic Journey.* Foreword by Robert Coles. Albuquerque: University of New Mexico Press, 1989.

———. *Portrait of a Decade: Roy Stryker and the Development of Documentary Photography in the Thirties.* Baton Rouge: Louisiana State University Press, 1972.

———. *Russell Lee: Photographer.* New York: Morgan and Morgan, 1978.

Hurt, R. Douglas. *The Dust Bowl: An Agricultural and Social History.* Chicago: Nelson-Hall, 1981.

———, ed. *The Rural West since World War II.* Lawrence: University Press of Kansas, 1998.

"I Wonder Where We Can Go Now." *Fortune* 19, no. 4 (April 1939): 91–120.

Jackson, Joseph Henry. "John Steinbeck and The Grapes of Wrath." In John Steinbeck, *The Grapes of Wrath.* Lithographs by Thomas Hart Benton. New York: Limited Editions Club, 1940.

———. *Why Steinbeck Wrote* The Grapes of Wrath. New York: Limited Editions Club, 1940.

Janis, Eugenia Parry, and Wendy MacNeil, eds. *Photography within the Humanities.* Danbury, NH: Addison House, 1977.

Jones, William E. *"Killed": Rejected Images of the Farm Security Administration.* New York: Andrew Roth, 2010.

Junker, Patricia. *John Steuart Curry: Inventing the Middle West.* New York: Hudson Hills Press, 1998.

Katzman, Laura, and Beverly W. Brannan. *Re-Viewing Documentary: The Photographic Life of Louise Rosskam.* Washington, DC: American University Museum, 2011.

Kaufmann, Stanley, ed. *American Film Criticism: From the Beginnings to Citizen Kane.* New York: Liveright, 1972.

Kazin, Alfred. *On Native Grounds: An Interpretation of Modern American Prose Literature.* New York: Reynal and Hitchcock, 1942.

Kehl, D. G. "Steinbeck's 'String of Pictures' in *The Grapes of Wrath.*" *Image* 17, no. 1 (March 1974): 1–10.

Keller, Ulrich. *The Highway as Habitat: A Roy Stryker Documentation, 1943–1955.* Santa Barbara, CA: University Art Museum, 1986.

Kidd, Stuart. *Farm Security Administration Photography, the Rural South, and the Dynamics of Image-Making.* Studies in American History No. 52. Lewiston, UK: Edwin Mellen Press, 2004.

Kismaric, Susan. *American Children: Photographs from the Collection of the Museum of Modern Art.* New York: Museum of Modern Art, 1980.

Klevar, Harvey L. *Erskine Caldwell: A Biography.* Knoxville: University of Tennessee Press, 1993.

Kozol, Wendy. "Madonnas of the Fields: Photography, Gender, and 1930s Farm Relief." *Genders* 2 (Summer 1988): 1–23.

Krim, Arthur. "Elmer Hader and *The Grapes of Wrath* Book Jacket." *Steinbeck Newsletter* 4 (Winter 1991): 1–3.

———. "Right Near Sallisaw." *Steinbeck Newsletter* 12, no. 1 (Spring 1999): 1–4.

———. *Route 66: Iconography of the American Highway.* Edited by Denis Wood. Santa Fe, NM: Center for American Places, 2005.

———. "Steinbeck, Lorentz, and Lange in 1941." *Steinbeck Newsletter* 6 (Summer 1993): 8–9.

La Chapelle, Peter. *Proud to Be an Okie: Cultural Politics, Country Music, and Migration to Southern California.* Berkeley: University of California Press, 2007.

Lange, Dorothea. "The Assignment I'll Never Forget: Migrant Mother." *Popular Photography* 46, no. 2 (February 1960): 42–43, 128.

Lange, Dorothea, and Paul S. Taylor. *American Exodus: A Record of Human Erosion.* 1939. Reprint, New York: Arno Press, 1975.

Lanham, Edwin. *The Stricklands: A Novel.* Introduction by Lawrence R. Rodgers. Norman: University of Oklahoma Press, 2002.

Lee, Russell. "Life on the American Frontier—1941 Version, Pie Town, N.M." *U.S. Camera*, October 1941, 39–54ff.

———. *Russell Lee: Photographs.* Foreword by John Szarkowski, introduction by J. B. Colson. Austin: University of Texas Press, 2007.

Lesy, Michael. *Long Time Coming: A Photographic Portrait of America, 1935–1943.* New York: W. W. Norton, 2002.

Light, Ken, ed. *Witness in Our Time: Working Lives of Documentary Photographers.* Washington, DC: Smithsonian Institution Press, 2000.

Lisca, Peter. *The Wide World of John Steinbeck.* 1958. Reprint, New York: Gordian Press, 1981.

Loengard, John. *LIFE Photographers: What They Saw.* Boston: Little, Brown, 1998.

Loftis, Anne. *Witness to the Struggle: Imaging the 1930s California Labor Movement.* Reno: University of Nevada Press, 1998.

Lomax, Alan, comp. *Hard Hitting Songs for Hard-Hit People.* Foreword by John Steinbeck. Lincoln: University of Nebraska Press, 1999.

Lookingbill, Brad D. *Dust Bowl USA: Depression America and the Ecological Imagination, 1929–1941.* Athens: Ohio University Press, 2001.

Lorentz, Pare. "Dorothea Lange: Camera with a Purpose." *U.S. Camera* 1 (1941): 93–116.

———. *FDR's Moviemaker: Memoirs and Scripts.* Reno: University of Nevada Press, 1992.

———. *Lorentz on Film: Movies, 1927–1941.* New York: Hopkinson and Blake, 1975.

Lowry, Edith E. *They Starve That We May Eat.* New York: Council of Women for Home Missions and Missionary Education Movement, 1938.

Lowry, Ruth Fisher. "Analysis of One Hundred Families Residing in Community Camp, Oklahoma City, 1941." MA thesis, University of Oklahoma Graduate College, Oklahoma City, 1945.

Lyons, Claire L. *Archeology and Photography: Early Views of Ancient Mediterranean Sites.* Los Angeles: J. Paul Getty Museum, 2005.

Lyons, Nathan, and Bruce Davidson. *Towards a Social Landscape, Bruce Davidson, Lee Friedlander, Garry Winogrand, Danny Lyon, Duane Michals.* Rochester, NY: Horizon Press, 1966.

MacLeish, Archibald. *Land of the Free.* New York: Harcourt, Brace, 1938.

———. *A Time to Act: Selected Addresses.* Boston: Houghton Mifflin, 1943.

Maharidge, Dale, and Michael Williamson. *And Their Children after Them.* Foreword by Carl Mydans. New York: Pantheon Books, 1989.

———. *Someplace Like America: Tales from the New Great Depression.* Berkeley: University of California Press, 2011.

Maloney, T. J. *U.S. Camera, 1939.* New York: William Morrow, 1939.

Marling, Karal Ann. *Wall-to-Wall America: A Cultural History of Post-Office Murals in the Great Depression.* Minneapolis: University of Minnesota Press, 1982.

———. *Woodstock: An American Art Colony, 1902–1977.* Poughkeepsie, NY: Vassar College Art Gallery, 1977.

Mayo, Jim. *Sallisaw Historical Highlights, 1888–1993.* Sallisaw, OK: Cookson Hills, 1993.

McCamy, James L. *Government Publicity: Its Practice in Federal Administration.* Chicago: University of Chicago Press, 1939.

McDannell, Colleen. *Picturing Faith: Photography and the Great Depression.* New Haven, CT: Yale University Press, 2004.

———. "Religious History and Visual Culture." *Journal of American History* 94 (June 2007): 112–21.

McElrath, Joseph R., Jr., Jesse S. Crisler, and Susan Shillinglaw, eds. *John Steinbeck: The Contemporary Reviews.* Cambridge: Cambridge University Press, 1996.

McElvaine, Robert S. *The Great Depression: America, 1929–1941.* New York: Times Books, 1993.

McWilliams, Carey. *The Education of Carey McWilliams.* New York: Simon and Schuster, 1978.

———. *Factories in the Field: The Story of Migratory Farm Labor in California.* Boston: Little, Brown, 1939.

———. *Ill Fares the Land: Migrants and Migratory Labor in the United States.* Boston: Little, Brown, 1942.

Meltzer, Milton. *Dorothea Lange: A Photographer's Life.* New York: Farrar, Straus, and Giroux, 1978.

Miller, Edward. "Interview: Jack Delano." *Combinations: A Journal of Photography* 1, no. 4 (Fall–Winter 1979–1980): 27.

Milis, Nicolaus. "John Steinbeck's Hurricane Katrina Lesson." *Dissent* 53, no. 4 (Fall 2006): 97–98.

Millichap, Joseph R. *Steinbeck and Film.* New York: Frederick Ungar, 1983.

Miron, George Thomas. *The Truth about John Steinbeck and the Migrants.* Los Angeles: Haynes, 1939.

Mitchell, H. L. *The Disinherited Speak.* New York: Workers Defense League, 1937.

———. *Mean Things Happening in This Land: The Life and Times of H. L. Mitchell Co-Founder of the Southern Tenant Farmers Union.* Montclair, NJ: Allanheld, Osum, 1979.

Mitchell, Ruth Comfort. *Of Human Kindness.* New York: D. Appleton-Century, 1940.

Morris, Errol. *Believing Is Seeing (Observations on the Mysteries of Photography).* New York: Penguin Press, 2011.

Morris, Wright. *Time Pieces: Photographs, Writing, and Memory.* New York: Aperture Foundation, 1999.

Morrissey, Katherine G., and Kirsten M. Jensen, eds. *Picturing Arizona: The Photographic Record of the 1930s.* Tucson: University of Arizona Press, 2005.

Murphy, Mary. "Picture/Story: Representing Gender in Montana Farm Security Administration Photographs." *Frontiers: A Journal of Women Studies* 22, no. 3 (2001): 93–115.

Myers, Joan. *Pie Town Woman: The Hard Life and Good Times of a New Mexico Homesteader.* Albuquerque: University of New Mexico Press, 2001.

Natanson, Nicholas. *The Black Image in the New Deal: The Politics of FSA Photography.* Knoxville: University of Tennessee Press, 1992.

Nelson, Lowry. *In the Direction of His Dreams: Memoirs.* New York: Philosophical Library, 1985.

Newhall, Beaumont. *The History of Photography.* Rev. ed. New York: Museum of Modern Art, 1964.

O'Farrell, Brigod. *She Was One of Us: Eleanor Roosevelt and the American Worker.* Ithaca, NY: ILR Press/ Cornell University Press, 2010.

Ohrn, Karin Becker. *Dorothea Lange and the Documentary Tradition.* Baton Rouge: Louisiana State University Press, 1980.

O'Malley, Rebecca Walton. "'How American People Live': An Examination of Farm Security Administration Images and Exhibition Spaces." MA thesis, School of Art and Design, Pratt Institute, New York, 2012.

O'Neal, Hank. *A Vision Shared: A Classic Portrait of America and Its People, 1935–1943.* New York: St. Martin's Press, 1976.

O'Reilly, Kelly R. "'Oklatopia': The Cultural Mission of California's Migratory Labor Camps." Senior thesis, Columbia University, New York, 2012.

Orvell, Miles, ed. *John Vachon's America: Photographs and Letters from the Depression to World War II.* Berkeley: University of California Press, 2003.

———. *The Real Thing: Imitation and Authenticity in American Culture, 1880–1940.* Chapel Hill: University of North Carolina Press, 1989.

———. "Walker Evans and James Agee: The Legacy," *History of Photography* 17 (June 1993): 166–71.

Owens, Louis. *The Grapes of Wrath: Trouble in the Promised Land.* Boston: Twayne, 1989.

Parfit, Michael. "The Dust Bowl." *Smithsonian* (June 1989): 44–57.

Parini, Jay. *John Steinbeck: A Biography.* New York: Henry Holt, 1995.

Partridge, Elizabeth, and Sally Stein. *Quizzical Eye: The Photography of Rondal Partridge.* San Francisco: California Historical Society Press, 2003.

Peeler, David P. *Hope among Us Yet: Social Criticism and Social Solace in Depression America.* Athens: University of Georgia Press, 1987.

Pells, Richard H. *Radical Visions and American Dreams: Culture and Social Thought in the Depression Years.* New York: Harper and Row, 1973.

Phillips, Christopher. *Steichen at War.* New York: Port House, 1981.

Plattner, Steven W. *Roy Stryker: U.S.A., 1943–1950.* Austin: University of Texas Press, 1983.

Poos, Françoise, ed. *The Bitter Years: Edward Steichen and the Farm Security Administration Photographs.* New York: D.A.P., 2012.

Pratt, Linda Ray. "Imagining Existence: Form and History in Steinbeck and Agee." *Southern Review* 11 (January 1975): 84–98.

Puckett, John Rogers. *Five Photo-Textual Documentaries from the Great Depression.* Ann Arbor, MI: UMI Research Press, 1984.

Rabinowitz, Paula. *They Must Be Represented: The Politics of Documentary.* London: Verso, 1994.

Raeburn, John. *Ben Shahn's American Scene: Photographs, 1938.* Urbana: University of Illinois Press, 2010.

———. *A Staggering Revolution: A Cultural History of Thirties Photography.* Urbana: University of Illinois Press, 2006.

Raper, Arthur F. *Tenants of the Almighty.* New York: Macmillan, 1943.

Reid, Robert L. *Picturing Minnesota, 1936–1943: Photographs from the Farm Security Administration.* St. Paul: Minnesota Historical Society Press, 1989.

———. *Picturing Texas: The FSA-OWI Photographers in the Lone Star State, 1935–1943.* Austin: Texas State Historical Association, 1994.

Remsberg, Rich. *Hard Luck Blues: Roots Music Photographs from the Great Depression.* Urbana: University of Illinois Press, 2010.

Rice, Mark. *Through the Lens of the City: NEA Photography Surveys of the 1970s.* Jackson: University Press of Mississippi, 2005.

Robbins, Jhan, and June Robbins. "The Man Behind the Man Behind the Lens, Roy Stryker." *Minicam Photography* 11 (November 1947): 52–61, 146–47.

Roberts, David. "Travels with Steinbeck." *American Photographer* 22 (March 1989): 44–51.

Rosler, Martha. *Decoys and Disruptions: Selected Writings, 1975–2001.* Cambridge, MA: MIT Press, 2004.

Rosskam, Edwin. "Not Intended for Framing: The FSA Archive." *Afterimage* 8, no. 8 (March 1981): 9–12.

———. *Washington, Nerve Center.* Co-edited by Ruby A. Black. Introduction by Eleanor Roosevelt. Face of America Series. New York: Longmans, Green, 1939.

Rothstein, Arthur. *The Depression Years.* New York: Dover, 1978.

———. *Documentary Photography.* Boston: Focal Press, 1986.

———. *Photojournalism.* Boston: Focal Press, 1984.

———. *Words and Pictures.* New York: American Photographic Book, 1979.

"Roy Stryker on FSA, SONJ, J & L (1972), An Interview Conducted by Robert J. Doherty, F. Jack Hurley, Jay M. Kloner, and Carl G. Ryant." In *The Camera Viewed: Writings on Twentieth-Century Photography,* vol. 2. Edited by Peninah R. Petruck. New York: E. P. Dutton, 1979.

Rundell, Walter. "Steinbeck's Image of the West." *American West* 1 (Spring 1964): 4–17.

Sackman, Douglas Cazaux. *Orange Empire: California and the Fruits of Eden.* Berkeley: University of California Press, 2005.

Sandeen, Eric J. *Picturing an Exhibition: The Family of Man and 1950s America.* Albuquerque: University of New Mexico Press, 1995.

Sanders, Sue. *Our Common Herd.* Garden City, NY: Barton Syndicate, 1939.

Santelli, Robert, and Emily Davidson. *Hard Travelin': The Life and Legacy of Woody Guthrie.* Hanover, NH: Wesleyan University Press; University Press of New England, 1999.

Schockley, Martin Staples. "The Reception of the *Grapes of Wrath* in Oklahoma." *American Literature* 15, no. 4 (January 1944): 351–61.

Schulz, Constance B. ed. *Bust to Boom: Documentary Photographs of Kansas, 1936–1949.* Introduction by Donald Worster. Lawrence: University Press of Kansas, 1996.

Scott, Quinta. *Along Route 66.* Norman: University of Oklahoma Press, 2000.

Sekula, Allan. *Dismal Science: Photo Works, 1972–1996.* Normal: University Galleries, Illinois State University, 1999.

Severin, Werner J. "Cameras with a Purpose: The Photojournalists of the F.S.A." *Journalism Quarterly* (Spring 1964): 191–200.

———. "Photographic Documentation by the Farm Security Administration, 1935–1942." MA thesis, University of Missouri, Columbia, 1959.

Shillinglaw, Susan. *Carol and John Steinbeck: Portrait of a Marriage.* Reno: University of Nevada Press, 2013.

———. *On Reading* The Grapes of Wrath. New York: Penguin Books, 2014.

Shillinglaw, Susan, and Kevin Hearle, eds. *Beyond Boundaries: Rereading John Steinbeck.* Tuscaloosa: University of Alabama Press, 2002.

Shindo, Charles. *Dust Bowl Migrants in the American Imagination.* Lawrence: University Press of Kansas, 1997.

Shloss, Carol. *In Visible Light: Photography and the American Writer, 1840–1940.* Oxford: Oxford University Press, 1987.

Sinclair, Upton. "Sinclair Salutes Steinbeck." *Common Sense* 8, no. 5 (May 1939): 22–23.

Smith, J. Russell. *North America: Its People and the Resources, Development, and Prospects of the Continent as Home of Man.* New York: Harcourt, Brace, 1925.

Snyder, Robert L. *Pare Lorentz and the Documentary Film.* Norman: University of Oklahoma Press, 1968.

Solomon-Godeau, Abigail. *Photography at the Dock: Essays on Photographic History, Institutions, and Practices.* Minneapolis: University of Minnesota Press, 1991.

Sontag, Susan. *On Photography.* New York: Farrar, Straus, and Giroux, 1977.

———. *Regarding the Pain of Others.* New York: Picador, 2003.

Spirn, Anne Whiston. *Daring to Look: Dorothea Lange's Photographs and Reports from the Field.* Chicago: University of Chicago Press, 2008.

St. Pierre, Brian. *John Steinbeck: The California Years.* San Francisco: Chronicle Books, 1983.

Stange, Maren. *Symbols of Ideal Life: Social Documentary Photography in America, 1890–1950.* New York: Cambridge University Press, 1989.

Starr, Kevin. *Endangered Dreams: The Great Depression in California.* New York: Oxford University Press, 1996.

Steichen, Edward, ed. *The Bitter Years, 1935–1941: Rural Life as Seen by the Photographers of the Farm Security Administration.* New York: Museum of Modern Art, 1962.

———. *A Life in Photography.* Garden City, NY: Doubleday, 1963.

Steigerwald, Bill. *Dogging Steinbeck: How I Went in Search of John Steinbeck's America, Found My Own America, and Exposed the Truth about* Travels with Charley. Pittsburgh, PA: Fourth River Access, 2012.

Stein, Sally. *Marion Post Wolcott: FSA Photographs.* (Untitled 34). Foreword by James Alinder. Carmel, CA: Friends of Photography, 1983.

———. "On Location: The Placement (and Replacement) of California in 1930s Photography." In *Reading California: Art, Image, and Identity, 1900–2000,* edited by Stephanie Barron, Sheri Bernstein, and Ilene Susan Fort. Berkeley: University of California Press, 2000.

———. "Passing Likeness: Dorothea Lange's 'Migrant Mother' and the Paradox of Iconicity." In *Only Skin Deep: Changing Visions of the American Self,* edited by Coco Fusco and Brian Wallis. New York: Harry N. Abrams, 2003.

Stein, Walter J. *California and the Dust Bowl Migration.* Westport, CT: Greenwood Press, 1973.

———. "A New Deal Experiment with Guided Democracy: The FSA Migrant Camps in California." *Historical Papers* 5, no. 1 (1970): 132–46.

Steinbeck, John. *America and Americans.* New York: Viking Press, 1966.

———. "Dubious Battle in California." *The Nation,* September 12, 1936, 303–304.

———. *The Grapes of Wrath.* Illustrated by Thomas Hart Benton. New York: Limited Editions Club, 1940.

———. *The Grapes of Wrath and Other Writings, 1936–1941,* edited by Robert DeMott. New York: Library of America, 1996.

———. *The Harvest Gypsies: On the Road to the Grapes of Wrath.* Introduction by Charles Wollenberg. Berkeley: Heyday Books, 1988.

———. *In Dubious Battle.* Introduction by Warren French. New York: Penguin Books, 1992.

———. "Rich Growers' Fostering of Prejudice Backed by Common Bond." *People's World,* April 1938.

———. *A Russian Journal.* With pictures by Robert Capa. New York: Viking Press, 1948.

———. *Steinbeck: A Life in Letters,* edited by Elaine Steinbeck and Robert Wallsten. New York: Viking Press, 1975.

———. *Their Blood Is Strong.* San Francisco: Simon J. Lubin Society of California, 1938.

———. *Travels with Charley: In Search of America.* New York: Viking Press, 1963.

———. *Working Days: The Journals of* The Grapes of Wrath, edited and with an introduction by Robert DeMott. New York: Penguin Books, 1990.

Steinbeck, John, and John Swope. *Bombs Away: The Story of a Bomber Team.* New York: Viking Press, 1942.

Steiner, Michael C., ed. *Regionalists on the Left: Radical Voices from the American West.* Norman: University of Oklahoma Press, 2013.

Steiner, Ralph. *Ralph Steiner: A Point of View.* Middletown, CT: Wesleyan University Press, 1978.

Stott, William. *Documentary Expression and Thirties America.* New York: Oxford University Press, 1973.

———. "Introduction to a Never-Published Book of Dorothea Lange's Best Photographs of Depression America." *Exposure* 22, no. 3 (Fall 1984): 22–30.

Stow, Simon, and Cyrus Ernesto Zirakzadeh, eds. *Ambivalent American: The Political Companion to John Steinbeck.* Lexington: University Press of Kentucky, 2013.

Street, Richard Steven. *Everyone Had Cameras: Photography and Farmworkers in California, 1850–2000.* Minneapolis: University of Minnesota Press, 2008.

———. "Lange's Antecedents: The Emergence of Social Documentary Photography of California's Farmworkers," *Pacific Historical Review* 75, no. 3 (August 2006): 385–428.

———. "Paul S. Taylor and the Origins of Documentary Photography in California." *History of Photography* 7, no. 4 (October–December 1983): 293–308.

Stryker, Roy E., and Paul H. Johnstone. "Documentary Photographs." In *The Cultural Approach to History,* edited by Caroline F. Ware. New York: Columbia University Press, 1940.

Stryker, Roy E., and Nancy Wood. *In This Proud Land: America, 1935–1943, as Seen in the FSA Photographs.* Greenwich, CT: New York Graphic Society, 1973.

Subchack, Vivian C. "*The Grapes of Wrath* (1940): Thematic Emphasis through Visual Style." *American Quarterly* 31 (Winter 1979): 596–615.

Sullivan, Patricia. *Days of Hope: Race and Democracy in the New Deal Era.* Chapel Hill: University of North Carolina Press, 1996.

Swensen, James R. "Focusing on the Migrant: The Contextualization of Dorothea Lange's Photographs of the John Steinbeck Committee, 1938." In *Ambivalent American: The Political Companion to John Steinbeck,* edited by Simon Stow and Cyrus Ernesto Zirakzadeh. Lexington: University Press of Kentucky, 2013.

———. "Passing Through: Arthur Rothstein's Photographic Account of Utah, March 1940." *Utah Historical Quarterly* 74, no. 1 (Winter 2006): 66–79.

Szarkowski, John. *Looking at Photographs: 100 Pictures from the Collection of the Museum of Modern Art.* New York: Museum of Modern Art, 1973.

———. *Walker Evans.* New York: Museum of Modern Art, 1971.

Taft, Robert. *Photography and the American Scene.* Reprint, New York: Dover, 1938.

Tagg, John. *The Burden of Representation: Essays on Photographies and Histories.* Minneapolis: University of Minnesota Press, 1993.

———. *The Disciplinary Frame: Photographic Truths and the Capture of Meaning.* Minneapolis: University of Minnesota Press, 2009.

Taylor, Frank J. "California's Grapes of Wrath." *The Forum,* November 1939, 232–38.

Taylor, Paul S. "Adrift on the Land." Public Affairs Pamphlet No. 42. New York: Public Affairs Committee, 1940.

———. "Again the Covered Wagon," *Survey Graphic,* July 1935: 348–51, 368.

————. "From the Ground Up." *Survey Graphic*, September 1936: 524–29ff.

————. *Labor on the Land: Collected Writings, 1930–1970.* New York: Arno Press, 1981.

————. "Migrant Mother: 1936." In *Photography in Print: Writings from 1816 to the Present,* edited by Vicki Goldberg. Albuquerque: University of New Mexico Press, 1981.

Taylor, Paul S., and Anne Loftis. *In the Fields: Photographs by Ken Light, Roger Minick, and Reesa Tansey.* Oakland, CA: Harvest Press, 1982.

Taylor, Paul S., Suzanne B. Riess, Malca Chall, Lawrence I. Hewes, and Paul Wallace. *Paul Schuster Taylor: California Social Scientist.* Berkeley: Bancroft Library, University of California, Berkeley, Regional Oral History Office, Earl Warren Oral History Project, 1973.

Terkel, Studs. *Hard Times: An Oral History of the Great Depression.* New York: Pantheon Books, 1970.

Thomsen, Alice Barnard. "Erich H. Thomsen and John Steinbeck." *Steinbeck Newsletter,* Summer 1990: 1–3.

Thompson, Edward K. *A Love Affair with* Life *and* Smithsonian. Columbia: University of Missouri Press, 1995.

Todd, Charles L. "The Okies Search for a Lost Frontier." *New York Times Magazine,* August 27, 1939, 10–11ff.

————. "Trampling Out the Vintage: Farm Security Camps Provide the Imperial Valley Migrants with a Home and a Hope." *Common Sense* 8, no. 7 (July 1939): 30.

Townsend, Kim. *Sherwood Anderson.* Boston: Houghton Mifflin, 1987.

Trachtenberg, Alan. *Reading American Photographs: Images as History: Mathew Brady to Walker Evans.* New York: Hill and Wang, 1989.

Tugwell, Rexford, Philip Bancroft, Carey McWilliams, and Hugh Bennett. "What Should America Do for the Joads?" *Town Meeting: Bulletin of America's Town Meeting of the Air,* March 11, 1940, 3–30. Audio file available online at Internet Archive: https://archive.org/details/ATMOTA.

Turner, Peter, ed. *American Images: Photography 1945–1980.* New York: Viking Penguin and Barbican Art Gallery, 1985.

U.S. Congress, House. *Hearings before the Select Committee to Investigate the Interstate Migration of Destitute Citizens, Seventy-sixth Congress . . . pursuant to H. Res. 63 and H. Res. 491.* Washington, DC: Government Printing Office, 1940–41.

U.S. Department of Labor. *Labor Unionism in American Agriculture.* Bulletin No. 836 [1945]. Reprint, New York: Arno Press, 1975.

Vachon, John. "Tribute to a Man, an Era, an Art." *Harper's,* September 1973, 96–99.

Van Dyke, Willard. "The Photographs of Dorothea Lange—A Critical Analysis." *Camera Craft,* October 1934: 461–67.

Wallis, Michael. *Route 66: The Mother Road.* New York: St. Martin's Press, 1990.

Wartzman, Rick. *Obscene in the Extreme: The Burning and Banning of John Steinbeck's* The Grapes of Wrath. New York: Public Affairs, 2008.

Webb, John N., and Malcolm Brown. *Migrant Families.* Works Progress Administration, Division of Social Research, Research Monograph 18. 1938: New York: Da Capo Press, 1971.

Webb, Todd. *Looking Back: Memoirs and Photographs.* Foreword by Michael Rowell. Albuquerque: University of New Mexico Press, 1991.

Webb, Walter Prescott. *The Great Plains.* New York: Grosset and Dunlap, 1931.

Weber, Derva. *Dark Sweat, White Gold: California Farm Workers, Cotton, and the New Deal.* Berkeley: University of California Press, 1996.

Wilder, Laura Ingalls. *Little House on the Prairie.* New York: Harper Trophy, 1971.

Windschuttle, Keith. "Steinbeck's Myth of the Okies." *New Criterion* 20, no. 10 (June 2002): 24.

Wixson, Douglas, ed. *On the Dirty Plate Trail: Remembering the Dust Bowl Refugee Camps.* Austin: University of Texas Press, 2007.

Wolff, Justin. *Thomas Hart Benton: A Life.* New York: Farrar, Straus, and Giroux, 2012.

Wollenberg, Charles. *Photographing the Second Gold Rush: Dorothea Lange and the Bay Area at War, 1941–1945.* Berkeley, CA: Heyday Books, 1995.

Wood, Nancy. *Heartland, New Mexico: Photographs from the Farm Security Administration, 1935–1943.* Albuquerque: University of New Mexico Press, 1989.

Works Projects Administration (WPA). *Rural Migration in the United States,* edited by C. E. Lively and Conrad Tauber. Washington, DC: Government Printing Office, 1939.

Wright Richard, and Edwin Rosskam. *12 Million Black Voices.* New York: Thunder's Mouth, 2002.

Writers' Program of the Work Projects Administration in the State of Oklahoma. *Oklahoma: A Guide to the Sooner State.* Norman: University of Oklahoma Press, 1941.

Wyatt, David, ed. *New Essays on* The Grapes of Wrath. Cambridge: Cambridge University Press, 1990.

Illustrations

Index